Marc Chagall

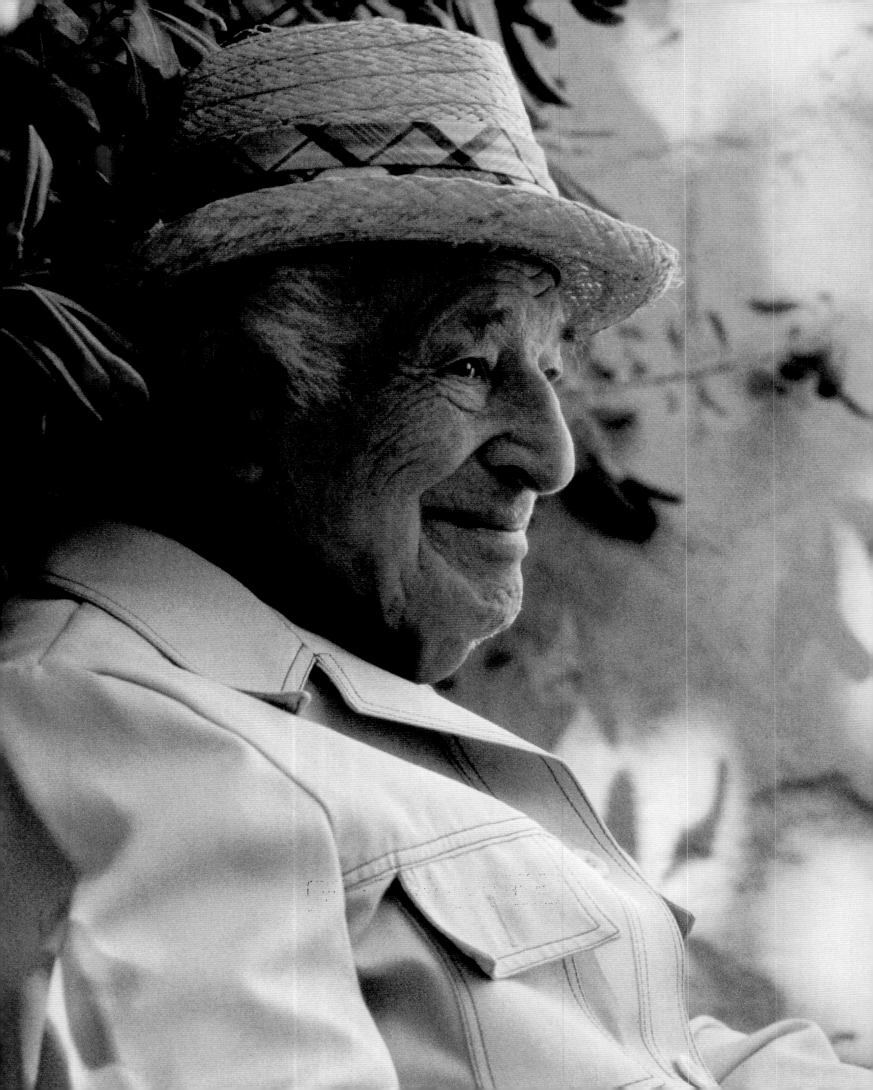

Jacob Baal-Teshuva

MARC CHAGALL

1887 – 1985

TASCHEN

HONG KONG KÖLN LONDON LOS ANGELES MADRID PARIS TOKYO

Illustration Page 2:
The last photograph of Marc Chagall, 1985
Courtesy Cinquini

This book is dedicated
to the memory of
IDA CHAGALL
(1916–1994),
the artist's daughter,
who devoted her life
to her father's art.
JACOB BAAL-TESHUVA

To stay informed about upcoming TASCHEN titles, please
request our magazine at www.taschen.com/magazine or
write to TASCHEN America, 6671 Sunset Boulevard, Suite 1508,
USA-Los Angeles, CA 90028, contact-us@taschen.com,
Fax: +1-323-463-4442. We will be happy to send you a free copy
of our magazine which is filled with information about all of our books.

Original edition: © 1998 Benedikt Taschen Verlag GmbH
© 2008 for the reproductions: VG Bild-Kunst, Bonn
Managing editor: Simone Philippi, Cologne
Supplementary editing: Chris Goodden, Bungay, UK; Frances Wharton,
Deborah Ffoulkes, Cologne
Cover design: Sense/Net, Andy Disl and Birgit Reber, Cologne

Printed in China
ISBN 978-3-8228-3128-1

Contents

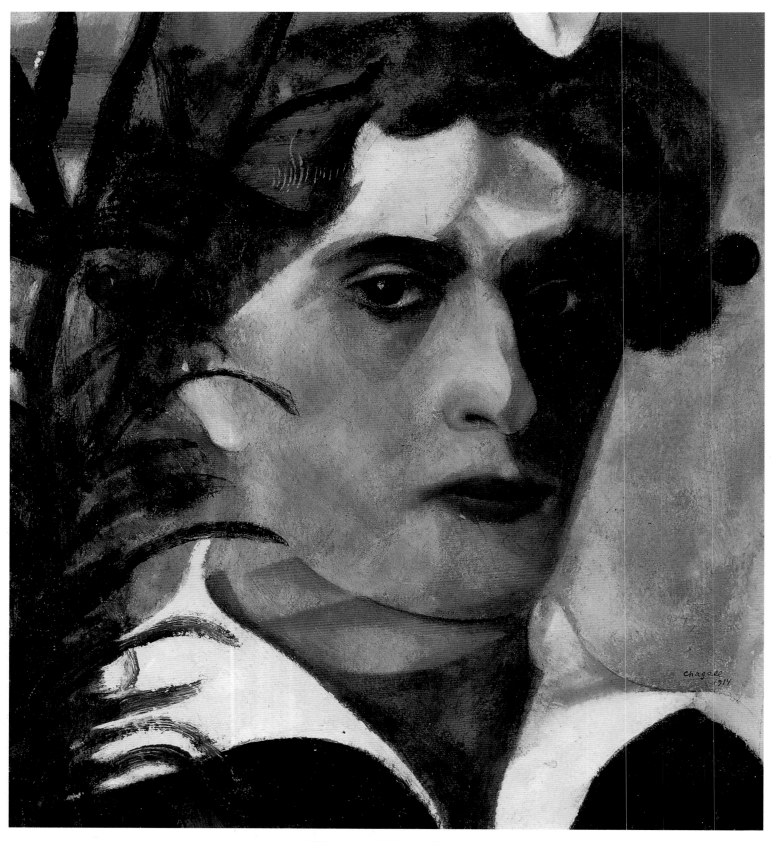

Self-Portrait with White Collar, 1914
Oil on paperboard, 29.9 x 25.7 cm
Philadelphia (PA), Philadelphia Museum of Art, The Louis E. Stern Collection

Introduction

"A poet with the wings of a painter."

Marc Chagall, who died on 28 March 1985 at the age of 97, was the last great representative of the École de Paris. He reached out to people like no other artist this century, inspiring fascination and admiration across the world. Henry Miller described him as a "poet with the wings of a painter". Throughout his life he preferred the company of poets to that of painters, mistrusting theories of painting, especially dogmatic ones. Thus he did not fall under the sway of either Cubism or Surrealism, founded no school of his own, and had no followers or successors. He remained the great one-off, whose work still defies all attempts at classification.

Chagall's pictures are pervaded with mythology and mysticism. His colourful dreamscapes and narratives are deeply rooted in his Russo-Jewish past. His memories and longings are embodied in his birthplace Vitebsk, revolving around the big events in the lives of the humble people of the village or ghetto – birth, love, marriage and death. Despite a wealth of stimuli in the Parisian metropolis, he remained true to his origins, which were rooted in Hasidism, with its love of storytelling, and in Jewish pantheism, with its belief in the indissoluble link between God and man, which enables the believer to do wonders, work miracles. And thus Chagall's paintings portray an everyday world full of the wonderful and miraculous – the lovers' room, the streets of Vitebsk, or beneath the Eiffel Tower. Often in this topsy-turvy pictorial world heaven and earth seem to meet, and people, cows, cocks and birds float happily through the air, defying Newton's law of gravity.

The fairytale qualities of the Chagallian pictorial world, with its oriental magic, have often led to the darker side of his work being overlooked, such as is evinced in his depictions of the pogroms and humiliations of Jews that he witnessed as a young man in tsarist Russia. Later, in the 30s and 40s, he was distraught at the plight of the Jews under the Nazi terror. The oppression and misery of this period are symbolized by the numerous crucifixions that he painted at the time, a New Testament theme that exposed the painter to harsh criticism from the Jewish community. Nevertheless, Chagall repeatedly returned to this subject over the years, while from a much less tragic side of Jewish life and history he incorporated into his multi-layered work Jewish rituals and Yiddish proverbs and jokes. The artist painted synagogues, Jewish weddings, cemeteries, and his uncle playing the fiddle on the roof of his house.

"Were I not a Jew", Chagall said, "I would not have become an artist." The many facets of Jewish tradition influenced him to the end of his life. This can be seen not least in his profound interest in the Bible and in the words of the prophets – witness the artist's many etchings, lithographs and paintings on biblical subjects as well as his series the *Biblical Message* in the 'Musée National Message Biblique Marc Chagall' in Nice. Chagall's paintings are also rich in symbols taken from Russian iconography, Byzantine art and the type of narrative Russian folk art

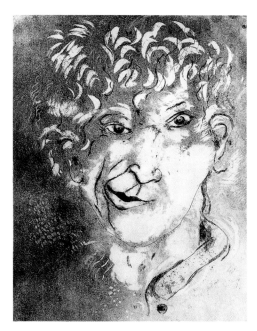

Self-Portrait with Grimace, 1924–25
Etching and aquatint, 37.4 x 27.4 cm
Private collection

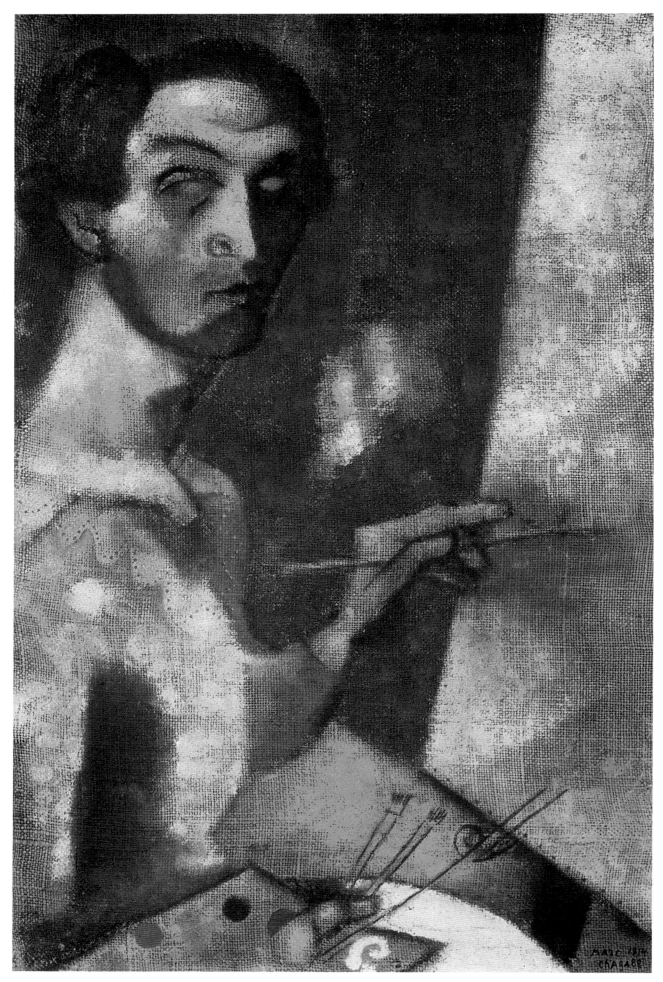

Self-Portrait, 1914
Oil on canvas, 62 x 96 cm
Private collection

known as 'lobok'. His work is a diary in images, and to read between the lines is to appreciate a painter in unbroken dialogue with his birthplace and religious background. However, Chagall was unhappy when people stressed the religious or 'literary' aspect of his work. What concerned him was translating fantasies garnered from experience, dreams and memory into an adequate pictorial form.

If Chagall's Eastern European Jewish background decisively affected his choice of artistic subject matter, his extended stays in Paris and France had a profound impact on the formal scaffolding and the colour of his paintings. "In France", Chagall said, "I was born a second time."

In 1910, after student years in St Petersburg, the 23-year-old painter arrived in his longed-for cosmopolitan Paris, where the leading lights of the artistic avant-garde were gathered. Five years earlier Matisse and the 'Fauves', building on the work of Gauguin and Seurat, had championed the use of colour as an independent expressive value. In 1907, in his *Demoiselles d'Avignon*, Picasso had replaced perspectivistic representation with an aperspectivistic multi-dimensional view, thereby founding Cubism. By the time Chagall reached Paris, the traditional expressive modes in painting had already been transformed.

His confrontation with these seething avant-garde trends gave the young Russian the liberating impulse to develop his own original pictorial syntax, building on the experiences of his artistic forerunners. Through the Fauvists Chagall discovered the individual dynamism of colour, which increasingly came to underpin his composition. He grappled with the formal problems of the Cubists, acquiring for his painting a constructive framework. After a while, however, the strict geometrical structures of Cubism too much cramped the dreamy spirit of his Russian soul, leading Chagall to integrate his dreams, visions and legends derived from irrational insights and unconscious ideas into the formalistic grammar of French iconography. In this way he expanded the thematic canon of the Cubists and Fauvists, which remained tied essentially to landscapes, nudes and still lifes.

During his early years in Paris Chagall became friends with Robert Delaunay, for whose colouristic Cubism the poet Guillaume Apollinaire had coined the term 'Orphism' in 1912. Colour for Chagall, however, against a background of Russian folklore and icon painting, took on symbolic value quite at odds with Delaunay and his chromatic circle. His colours blazed with a now legendary vibrancy and radiance.

Visiting Chagall in his studio in 1913, Apollinaire called the artist's paintings "sur-naturel", accurately describing the 'super-' or 'trans-natural' pictorial contents of the unconscious, of dream-like memory. Some ten years later the Surrealists drew their images from the same source. "The good old days have passed when art nourished itself exclusively on elements from the external world, the world of forms, lines and colours. Today we are interested in everything, not just the external world, but also in the inner world of dream and imagination", Chagall said many years later in a lecture on the nature of his painting. In 1941 André Breton, the founder, theoretician and spokesman of Surrealism, wrote in a late tribute to Chagall when both were in 'exile' in America: "His great lyrical explosion happened around the year 1911, when solely through Chagall metaphor made its triumphant entry into modern painting." Although, with his imagery, Chagall was in effect one of the major pioneers of Surrealism, in the 20s he refused an invitation from Max Ernst and of his poet friend Paul Eluard to publicly align himself with the movement. The Russian held the theory of 'automatism', the generation of images from the unconscious without the mediation of any artistic considerations, to be utter nonsense. He remained an individualist, not just during the prodigiously productive first Paris years from 1910-1914, but also in his second period in France from 1923, after his return to Russia where he had spent during the First World War.

Hitherto Chagall had known only Paris; now he discovered the French countryside. The experience of its glorious light, such as he had never seen in Russia, transformed his painting. His palette became brighter, the colours seemingly suffused with sparkling light. At this time he turned into the great colourist, of whom Picasso later said: "Now that Matisse is dead, Chagall is the only painter who really

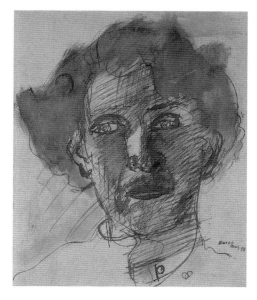

Self-Portrait, 1913
Indian ink and watercolour, 22 x 17.5 cm
Basle, Collection Marcus Diener

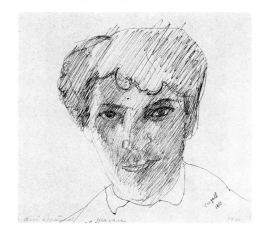

Self-Portrait, 1910
Indian ink on paper, 14.7 x 13.1 cm
Paris, Musée national d'art moderne,
Centre Georges Pompidou

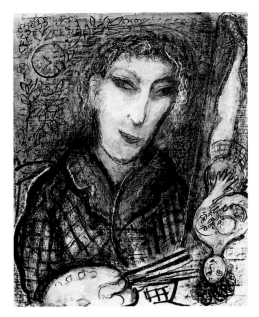

Self-Portrait with a Model, 1952
Gouache, 65 x 49.9 cm
Paris, Musée national d'art moderne,
Centre Georges Pompidou

understands what colour is… There's never been anybody since Renoir who has the feeling for light that Chagall has."

It was in France too that the artist painted his first autonomous flower compositions, which show Chagall's quiet loving immersion in the wonders of nature. His happy mood of the 20s and early 30s is also reflected in other subject matter: lovers, animals, musicians and the circus.

As the first signs of the persecution of the Jews in Germany became manifest, Chagall devoted himself to biblical themes, in particular to that of the crucifixion. In 'exile' in America his pictorial statements condensed, on the basis of the old iconographies, to hermetic picture parables with a dark serious character. At the same time, however, he had an unexpected opportunity to design stage sets. This decor shows Chagall's colours singing freely again. As in Turner's landscapes, the colour formations in his broad landscapes for *Aleko* (ill. p. 159), a ballet first performed in Mexico City, rotate like cloud formations, creating a cosmic panorama. This was the emergence of the monumental Chagall of later years, when the emigrant returned to France. Work on numerous public commissions characterizes his tremendous late output. His whole life long Chagall was fascinated by new materials, and at an advanced age he tackled and mastered the new and difficult media of ceramics, stained-glass, tapestry and the mosaic – with outstanding success. In his rich life this immensely vital artist created an incredibly comprehensive œuvre: paintings (with his famous Chagallian blue), gouaches, drawings, sculptures, ceramics, stained-glass windows, tapestries, mosaics, an enormous body of graphic art, including lithographs, etchings and book illustrations, and sets and costumes for the theatre, ballet and opera. His gloriously colourful stained-glass windows have been acclaimed by critics as a magnificent contribution to this venerable form of art.

Chagall lived through the most turbulent years of the 20th century. He was in the eye of the hurricane when Fauvism, Cubism, Expressionism, Dadaism and Surrealism whirled into existence, and saw the emergence of the Russian avant-garde movements of Constructivism and Suprematism. He experienced the rise of abstract art, of American Abstract Expressionist painting, and of Pop Art. He endured war and revolution, escaped the Holocaust, spending the war in exile in the United States, and witnessed the rebirth of Israel and the struggle of the young state to survive.

Nevertheless, the central theme of Chagall's oeuvre is that of love. "Despite all the troubles of our world, in my heart I have never given up on the love in which I was brought up or on man's hope in love. In life, just as on the artist's palette, there is but one single colour that gives meaning to life and art – the colour of love." This conviction was Chagall's lifelong credo.

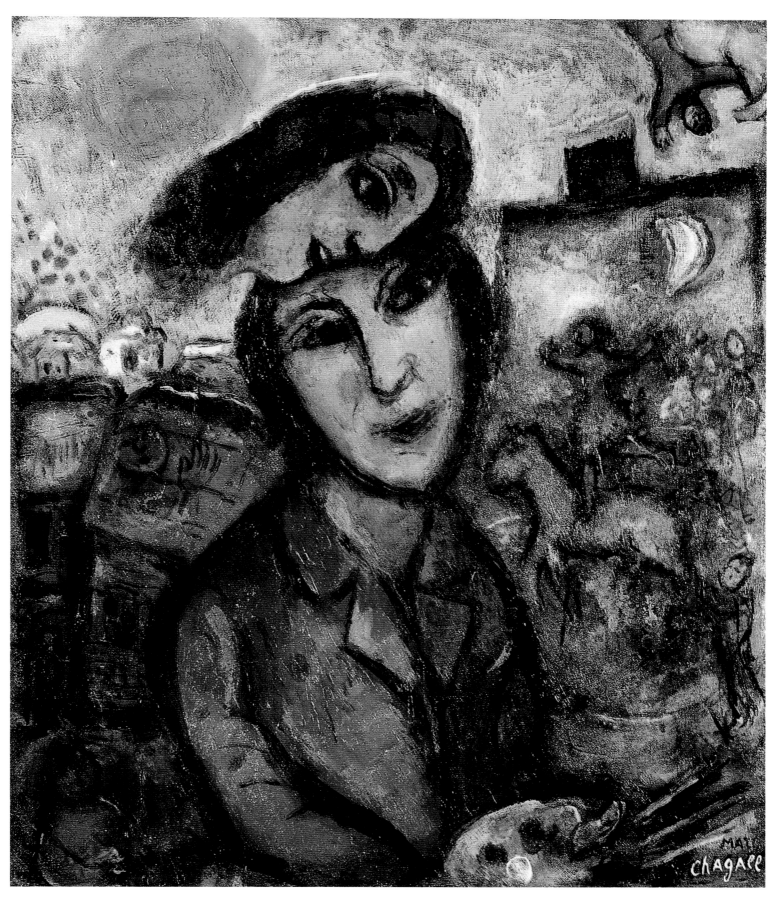

Artist at his Easel, 1955
Oil on canvas, 55 x 46 cm
Private collection

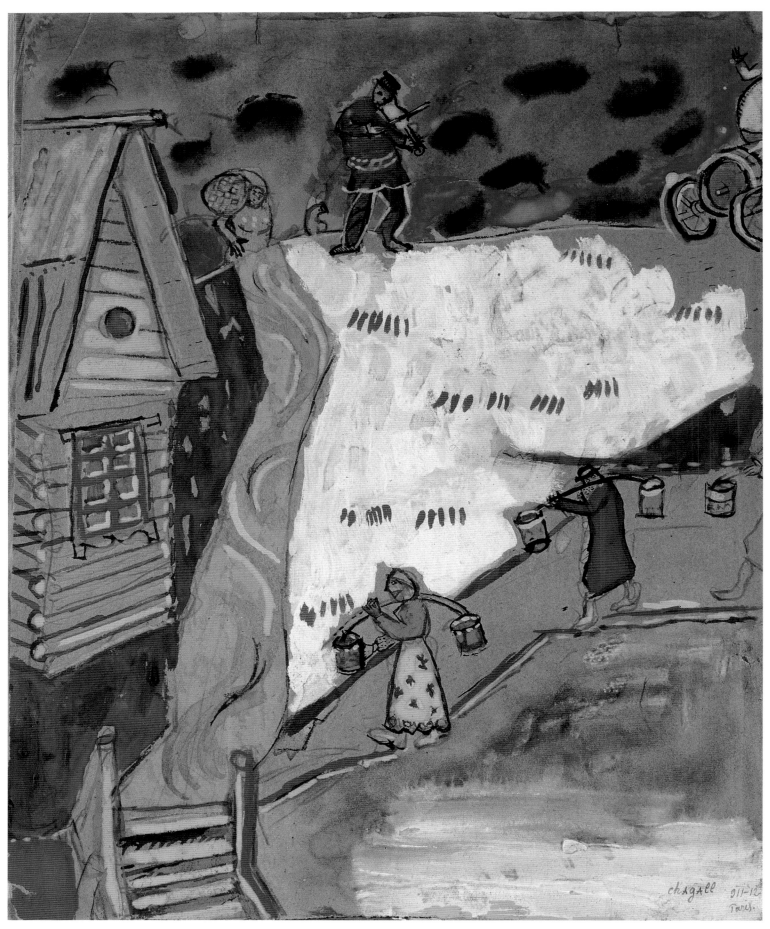

Village with Water Carriers, 1911–12
Gouache on paper, 22 x 27.9 cm
Private collection

Vitebsk 1887–1906

"This mysterious word 'artist'"

Marc Chagall was born as Moische Segal on 7 July 1887 in Vitebsk. This small town is situated not far from the Lithuanian border straddling the River Dvina in Byelo Russia (White Russia), better known today as the Republic of Belarus. A pre-1914 edition of the *Encyclopaedia Britannica* describes it as "an old town with decaying patrician houses and shabby Jewish quarters, half of its 50,000 inhabitants being Jewish." But Marc Chagall, reflecting upon his youth in later years, saw it in a completely different light. To him, Vitebsk was "simple and eternal, like the buildings in the frescoes of Giotto".

The Jewish population of Vitebsk, mainly tradespeople, manufacturers and shopkeepers, was close to 48,000 out of a total population of about 65,000. They had survived pogroms, prejudice, segregation and discrimination, and had their own schools, synagogues, hospitals, a cemetery and other community institutions. The Jews of Vitebsk manufactured clothing that was sold in many large Russian cities. They also exported sugar and timber, and produced ploughs and other agricultural implements. There were cabinet-makers and several linen-making mills.

Vitebsk had been a stronghold of Hasidic Judaism since the end of the 18th century, the Hasidic movement having been founded in the 1730s by the Baal-Shem Tov (meaning in Hebrew 'master of the good name'), near the Polish and Lithuanian borders. Its teachings were derived from the cabbalah (a body of mystical writings, among them the 13th-century *Zohar* or 'Book of Splendour'), and it was very popular, since it opposed the elitist intellectualism of Talmudic Judaism, encouraging intuitive communion with God and universal love. The Hasidic Jews loved to dance and chant, their hearts fired with ecstasy. Chagall's work undoubtedly sought to communicate this love, this joyfulness, to the world.

Several years after his birth Chagall's family moved from a poor wooden dwelling in the Pestkovatic suburb to a modest stone-built house, more centrally located on Vitebsk's right bank, near the railway station and the 17th-century Ilynsky church. Almost everything that we know about Chagall's family comes from his autobiography, *My Life*, which he wrote at the age of 34, finishing it in Moscow in 1922. This book, however, written in Russian and later translated into French by his wife Bella, was not published until many years later, in 1931 in Paris. Unfortunately, the original Russian manuscript has been lost. Interspersed with over 30 of his own illustrations, the book's text resembles Chagall's canvases: events from the artist's life and descriptions of his parents, of other family members and of his home town are interwoven with poetry and drama, laced with an element of nostalgia, and enlivened by imaginative touches. There must once have been Chagall family records in Vitebsk, but they were destroyed during the Second World War, when the town was razed to the ground. Accordingly, *My Life* is virtually the only source of information we have about the artist's early life. True, the

Vitebsk, c. 1914
Gouache and Indian ink on paper
24.8 x 19.2 cm
Private collection

Our Dining Room, 1911
Pen and ink on paper, 19 x 22 cm
Paris, Musée national d'art moderne,
Centre Georges Pompidou

autobiography provides us with only a limited insight into the everyday circumstances of the young Chagall, but on the other hand it shows us clearly how he viewed and categorized this period in retrospect.

Marc Chagall was the oldest of nine children. A girl, Rachel, died at birth, and two boys and six girls survived. Chagall was a handsome boy with soft blue eyes, and from an early age he contributed to the upkeep of the big family. His father Sahar, who later changed the family name 'Segal' to 'Chagal' (the artist himself added the second 'l'), was employed by a herring merchant. He worked very hard, carrying heavy barrels of herring, but earned only a paltry 20 roubles a month. Coming home tired after a hard day's work, he used to fall asleep during dinner, his head dropping till it almost touched the table. Nevertheless, every morning at dawn, before going to work, this pious man went to the synagogue to pray. Chagall drew and painted his sad weary-looking father several times. Later, out of respect for his father, he frequently introduced fish motifs into his pictures.

In *My Life* Chagall describes his father in touching and poetic words: "Have you ever seen in Florentine paintings one of those figures whose beard is never shaved, whose eyes are at once brown and ashen, and whose wrinkled face is the colour of burnt ochre? That was my father [...]. He lifted heavy barrels, and my heart ached to see him hoist those loads, his frozen hands fumbling in the little herrings, while his fat boss stood idly by like a stuffed animal. My father's clothes sometimes shone with herring brine. Only his face occasionally betrayed a faint smile. What a smile! Where did it come from?" This image of his father evidently haunted the artist throughout his life. Chagall continues: "Everything about my father seemed enigma and sadness to me. An inaccessible image. Always tired, careworn, only his eyes had a lustre, of grey-blue. The evening started with his homecoming, when from his pockets he would draw a pile of cakes and frozen pears. With his brown wrinkled hand he distributed these to us children. [...] An evening without cakes and pears from Papa's pockets was for us a sad evening. I was the only one to whom he was close, this man of simple heart, poetic and dulled with silence."

Chagall's mother, Feiga-Ita, ran a small grocery and rented out three simple properties to supplement the family's income. She was a lively little lady, enterprising and full of energy – in contrast to her worn-out husband. Born in Liozno, where her father had been a butcher, she was a typical Jewish mother, the pillar of the family. In *My Life* Chagall describes his mother with great love and affection: "I see her running the whole house, bossing my father around, ceaselessly building little houses, setting up a grocery store, stocking it with a whole cartload of goods, without money, on credit. [...] So many years have passed since she died! Where

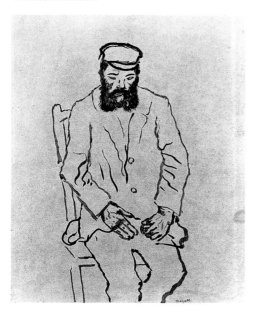

The Artist's Father, 1907
Ink and sepia on paper, 23 x 18 cm
Private collection

Sabbath, 1910
Oil on canvas, 90.5 x 94.5 cm
Cologne, Museum Ludwig,
Donation Haubrich

are you now, little mother? In heaven, on earth? I am here, far from you. I would feel much better if I were nearer to you, if at least I could see your grave, touch your tombstone. Oh Mama! I can't pray anymore, and I weep less and less often, but my soul thinks of you, of myself, and my mind is consumed with grief. I don't ask you to pray for me. You know yourself what cares I have. Tell me, little mother: in the other world, in paradise, in the clouds, wherever you are, does my love console you? Can my words spin for you some sweetness, tender and caressing?" Feiga-Ita Chagall loved her handsome, first-born son Marc, just as his sisters did. Many years later Chagall said: "If I have made pictures, it is because I remember my mother, her breasts, which warmly nourished and enraptured me, and which made me reach for the stars."

Chagall remembers his uncle Neuch, who played the violin while sitting cross-legged on the roof, relaxing after a day's work buying cattle from the local peasants. He must have been the first fiddler on the roof, inspiring the famous Broadway

musical. Young Marc loved to accompany his bearded uncle on cattle-buying trips. "How happy I was when you let me come on your jolting cart!" Both of these memories – his uncle playing the violin on the roof and the cattle-buying trips – were later transmuted into art, for example in his famous painting *The Cattle Dealer* (1912, ill. p. 60).

The young Marc Chagall loved also to visit his grandfather, the Liozno butcher, where his grandmother fed him hearty meals. Given this background, it is surprising that living cows and other animals came to inhabit so many of Chagall's paintings, and rarely their carcasses, as in *The Flayed Ox* (1947).

Jewish children were unable to attend regular Russian schools, and so, like many another Jewish boy, Chagall went to the 'cheder' or Jewish religious primary school, where he studied Hebrew and the Bible. Young Marc spent several years at the 'cheder' until, when he was 13, his enterprising mother engineered a solution. She bribed the headmaster of Vitebsk school with 50 roubles – a lot of money in those days – to allow her son to attend. There he learned Russian and, like all Russian schoolboys, wore a semi-military uniform. He spent six years at this school, developing a particular fondness for geometry. In his autobiography, penned at a time when the artist was experimenting with cubist forms, Chagall writes that lines, angles, triangles, squares, all held a peculiar fascination for his budding adolescent spirit. In the light of this, one wonders why his subsequent flirtation with Cubism was so brief and why abstraction remained quite alien to him.

Later, when he was living in Paris, Chagall told the art historian Edouard Roditi that in Vitebsk there was not a single painting or drawing on the walls of his family home, except for photographs of family members. Until 1906 he had never seen a picture, either painted or drawn. In *My Life* Chagall recounts how at the Russian communal school one of the pupils copied an illustration from a magazine. The young Marc was flabbergasted to see a fellow student draw. The drawing was like a vision, a revelation in black and white. When he asked the school chum how he did it, the boy replied: "Go and find a book in the library, idiot, choose any picture you like, and just copy it." The first drawing the schoolboy Chagall copied was a portrait of the Russian composer Anton Rubinstein. He then copied

My Father, my Mother and Myself, 1911
Pen on paper, 21 x 13 cm
Paris, Musée national d'art moderne,
Centre Georges Pompidou

The Village Store, 1911
Gouache on paper, 19 x 22 cm
Basle, Collection Marcus Diener

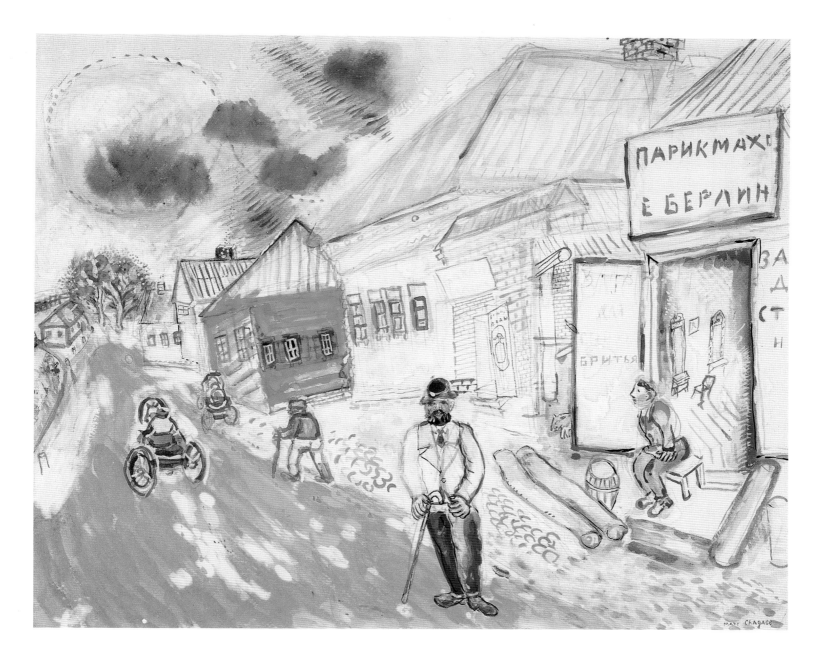

Russian Village Street, 1914
Gouache, watercolour and pencil on paper
45.1 x 56 cm
Private collection

some other drawings, which he hung on the walls at home. That was how, the artist said, he decided to become a painter. Actually, Chagall makes the process sound simpler than it was. On the one hand, his decision to become an artist was beset with doubts, and on the other there was no precedent for him to follow. The basis of his doubts was Judaism's prohibition of the making of graven images, which has sometimes extended to include not just representations of God, but also of all creatures. Depending on the prevailing socio-political conditions, this prohibition has always been relatively freely interpreted, as numerous artworks attest. Nevertheless, even in a comparatively liberal and strongly Russified Jewish community such as Vitebsk, it still applied to some extent. As a result there was no painting tradition a young Jewish artist like Chagall could refer to and continue. Sceptical at first, Feiga-Ita did in the end support her son's artistic leanings.

Never in his wildest dreams did Chagall at that time really imagine that he would become an artist. When he tentatively broached the subject with his mother in the kitchen one day, she thought he was off his head, and sent him outside to get some fresh air – to no avail. Chagall had been smitten by art and decided to look for an art teacher. He discovered Yehuda (Yuri) Pen, a Jewish artist who painted genre scenes and portraits in the style of academic salon painting at the turn of the century, and who also ran an art school in Vitebsk. Accompanied by his mother, schoolboy Marc visited Pen, taking along his drawings. Did the boy have any talent,

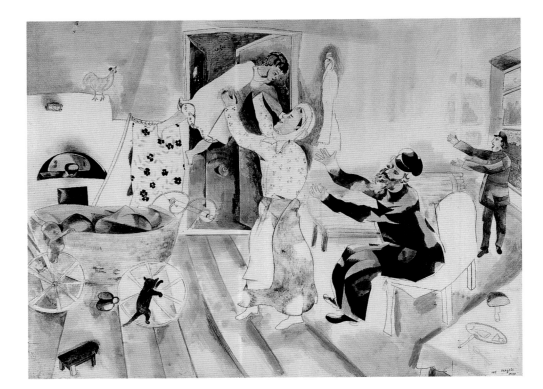

Visit to my Grandparents, 1915
Watercolour, pen, ink and
pencil on paper, 46.3 x 62.5 cm
Basle, Collection Marcus Diener

Feiga-Ita asked? Evasively Pen replied that there was perhaps something there. This was good enough for Mrs Chagall, who consented to her son joining the school.

Chagall, however, remained only a few months at the school, having quickly grasped that Pen was unable to teach him the kind of art that he vaguely intimated and aspired to. He had made good progress in realism – as can be seen in his *Woman With a Basket* (1906–07) – but at the same time he quickly realized that academic portrait painting was not for him. Nevertheless, in the autobiographical *My Life*, Chagall writes affectionately of Yehuda Pen, who even, as he told Roditi, offered to teach him free of charge. While Chagall was studying with Pen, he worked for two months as an apprentice retoucher with the local photographer A. Miestshaninoff, a job which he detested. He saw no point in touching up faces to make them look twenty years younger.

At this time Chagall struck up a close friendship with a fellow student, Viktor Mekler, the son of a well-to-do Jewish family. The two friends decided to move away from Vitebsk to St. Petersburg, then the capital of Russia and the centre of the country's artistic life, boasting famous art schools. During the winter of 1906–1907 Chagall and Mekler set off together for St. Petersburg – not an easy decision, considering that Jews needed to get a special permit in order to reside there. Permits were issued only to artisans and academicians in gainful employment, or to the employees of local merchants. But Chagall was in luck. A merchant friend of his father's finally acquired the necessary certificate, authorizing the art student to go to the capital to pick up goods.

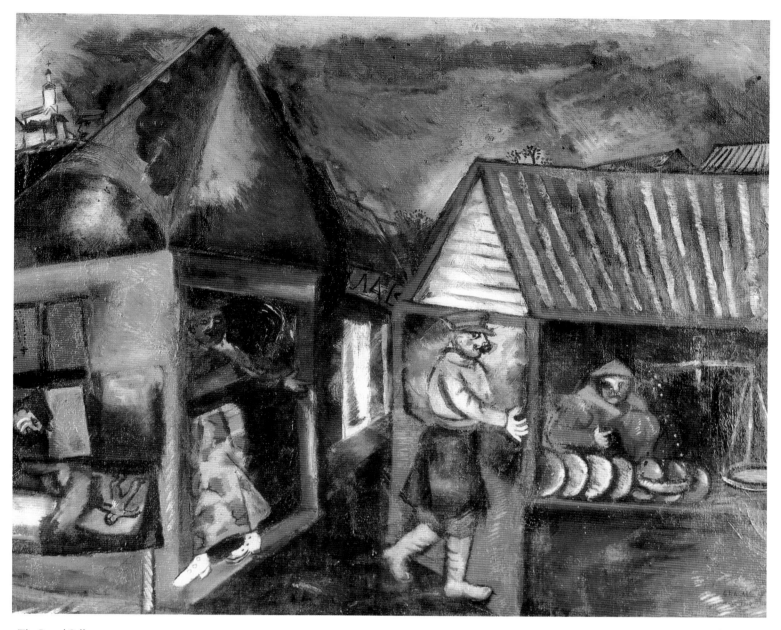

The Bread Seller, 1910
Oil on canvas, 65.4 x 75 cm
Private collection

"The soil that nourished the roots of my
art was Vitebsk. […] my paintings are my
memories." Through his paintings, Chagall
remained true to his home Vitebsk his whole
life long. He paints a corpse laid out in the
street, the fiddler on the roof (his uncle), the
people and the streets of Vitebsk, his family.
His mother ran a grocery store and, again
and again, Chagall painted little shops he
remembered, like this wooden bakery. The
bread seller is offering fresh bread to an eager
customer.

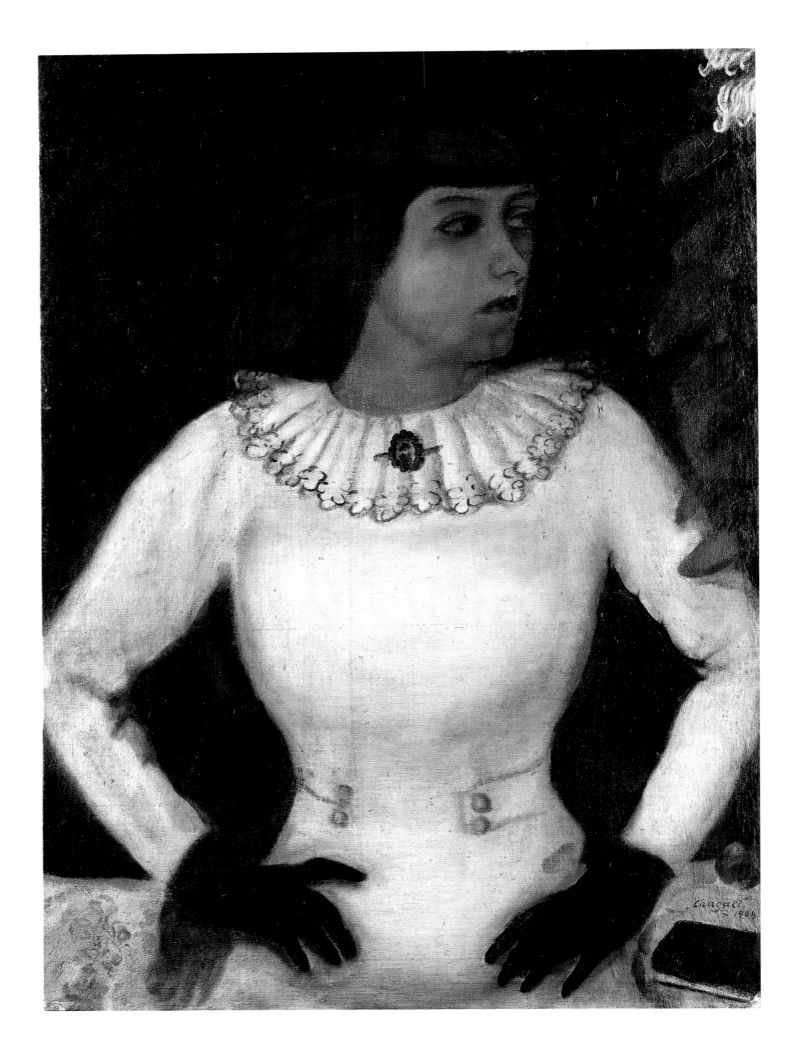

St. Petersburg 1906–1910

"All my works of this first period are now lost."

At the age of twenty Marc Chagall – handsome, energetic and ambitious – moved to St. Petersburg. It was not his first visit to the city – his uncle had once taken him as a child to a hospital there after he had been bitten by a mad dog in Vitebsk. Although he came from a very religious family and grew up within a devout Hasidic tradition, there was only one thing that interested Chagall in St. Petersburg, and that was art.

Chagall came to St. Petersburg in the wake of the short-lived 1905 Revolution, which had triggered several pogroms against the Jews. At that time Jews did not have equal rights, they were not admitted to schools or universities, and their movement in the city was restricted. None of this deterred Chagall from seeking his fortune as an artist there. Considering his religious upbringing, it seems at first sight paradoxical that as early as 1912 the subject of the crucifixion should appear in his work (*Golgotha*, ill. p. 71). For Chagall, however, it was a universal theme and not necessarily a Christian one. Christ on the cross represented the persecuted and suffering Jew. Ambition notwithstanding, when Chagall arrived in the capital, he had only the 27 roubles in his pocket his father had given him, which would not last very long. On the recommendation of his former Vitebsk teacher Yehuda Pen, he initially worked again as a retoucher with a photographer, Jaffe, who by way of recompense provided food.

Chagall describes his first St. Petersburg days thus: "My means did not allow me to rent a room; I had to be content with corners of rooms. I did not even have a bed to myself; I had to share one with a workman [...] he was so kind to me he even flattened himself against the wall to give me more room." In one such lodging Chagall had a dream about an angel, saying later that it was the inspiration for his celebrated painting *The Apparition (Self-Portrait with Muse)* (1917–18, ill. p. 97). Another time he rented half a room, separated by a curtain from a Russian who, drunk and violent, would on occasion threaten his wife with a knife.

In his privation Chagall turned to the sculptor I. S. Ginsburg, who had studied with the famous Russian academic sculptor Antokolsky, a friend of the writers Leo Tolstoy and Maxim Gorky. Ginsburg, who came from a prominent banking family, introduced the struggling artist to his brother, art patron Baron David Ginsburg, who sponsored Chagall for barely half a year to the princely tune of ten roubles a month. It embarrassed the young painter to meet rich Jews in this way. In his book *My Life* he writes that, coming out of one of their salons "I felt as if I had just come out of a steam bath, my face red and burning." At about the same time Chagall met another art patron, the lawyer Goldberg, who was allowed to hire Jewish servants as long as they stayed in his house. He took Chagall under his wing, giving him the position of a servant in the Goldberg household.

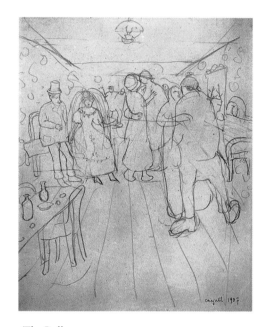

The Ball, 1907
Pencil on paper, 28.8 x 22 cm
Paris, Musée national d'art moderne,
Centre Georges Pompiodou

PAGE 20:
My Fiancée in Black Gloves, 1909
Oil on canvas, 88 x 65.1 cm
Basle, Öffentliche Kunstsammlung Basel,
Kunstmuseum

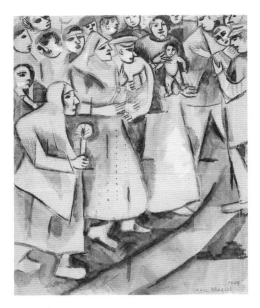

The Procession, 1909
Watercolour and pencil on paper,
36.3 x 29.1 cm
Paris, Musée national d'art moderne,
Centre Georges Pompidou

The Fruit Seller, 1909–10
Watercolour on paper, 19 x 14 cm
Basle, Collection Marcus Diener

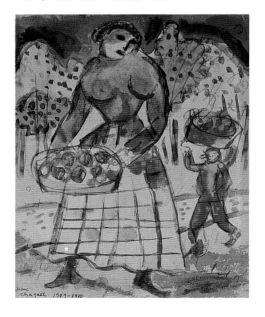

Chagall took the entrance examination to the School of Art and Crafts, whose principal was Baron Steglitz. Acceptance would have given him the right to stay in St. Petersburg – a desirable prize, since until then his residency status had been based on the flimsiest of pretexts: a letter from a Jewish merchant in St. Petersburg to Chagall's father in Vitebsk, stating that Chagall was collecting merchandise from him. Unfortunately, Chagall failed the examination, which required the applicant to copy plaster ornaments. However, luck was on his side because he managed to gain admission to another school, the Imperial Society for the Protection of the Fine Arts. This school was directed by the painter Nicolas Roerich, who obtained for Chagall a deferment, and later even an exemption, from military service. Chagall spent two years in this school, copying plaster heads of Roman and Greek citizens. He was bored stiff, and very cold during the winter, and although at the school he managed to win a scholarship of 15 roubles a month, he was not happy there, leaving in July 1908 without collecting his last grant instalment. It was around this time, from 1907 onwards, that Chagall started painting naturalistic self-portraits and landscapes.

For a number of months Chagall studied at the private school of the genre and academic painter Pavel Saidenberg, a conservative teacher. Virtually destitute at the time, he still managed to make frequent visits to Vitebsk. During one of these visits home the young artist had a traumatic experience, which resolved him once and for all to try to acquire a proper residence permit for St. Petersburg. Returning on one occasion to the capital from Vitebsk, he was arrested at the frontier because he had forgotten to pay the expected bribe to the guard, resulting in the artist's spending several weeks in jail. When he got out, he started an apprenticeship as a sign painter. Craftsmen such as sign painters had no problem getting a work permit and hence residency in the capital. About his signmaking Chagall says: "I took a real interest in signs, and painted a whole series of them. I enjoyed seeing my first signs swinging in the market over the entrance to a butcher's or green-grocer's shop, a pig or a chicken scratching itself nearby, while the heedless wind and rain spattered them with mud." Chagall did not successfully conclude his apprenticeship, but enjoyed the job of signmaker and was proud to see his handi-work hanging all over the city. The sign-painting interlude left traces in the artist's subsequent work – the Hebrew and Russian words found in many of his later paintings no doubt derive from this period.

On one of Chagall's visits to Vitebsk, his friend Viktor Mekler introduced him to a girl called Thea Brachmann, a St. Petersburg student who was regularly to pose as a model for the artist in the capital. In October 1909, through Thea, he met Bella Rosenfeld, who later became his wife. In *My Life* Chagall describes his first encounter with Bella: "Her silence is mine, her eyes mine. It is as if she knows everything about my childhood, my present, my future, as if she can see right through me, fathoming my innermost soul, even if I am seeing her for the first time. I have a feeling that this is my wife. Her pale complexion, her eyes. How large, round and black they are! They are my eyes, my soul."

Bella's parents, devout Jews like Chagall's own mother and father, owned a number of jewellery shops in Vitebsk – the Rosenfelds ranked among the town's richest families. Bella, a keen theatre fan and aspiring actress, was a gifted student at the girls' college in Moscow. In her book *Die Ershte Begegnish* (First Encounter), written in Yiddish, she in turn describes meeting Chagall: "To look into his eyes is to gaze into a blueness as if from heaven. They are strange eyes, not like everyone else's, long, almond-shaped. They are wide apart, each eye floating off on its own like a little barque. I have never seen such eyes before, unless it was in a book illustrating animals. His wide mouth is open, the corners stretching up to his ears. I don't know if it means to speak to me or to bite me with those white nipping teeth. Everything about him has the crouched lurking attitude of an animal ready to bound at any instant."

Shortly after this first meeting Chagall painted *My Fiancée in Black Gloves* (1909, ill. p. 20), a portrait reminiscent of an old master. In the years following he expressed his passionate love for Bella in a number of works, one of the most

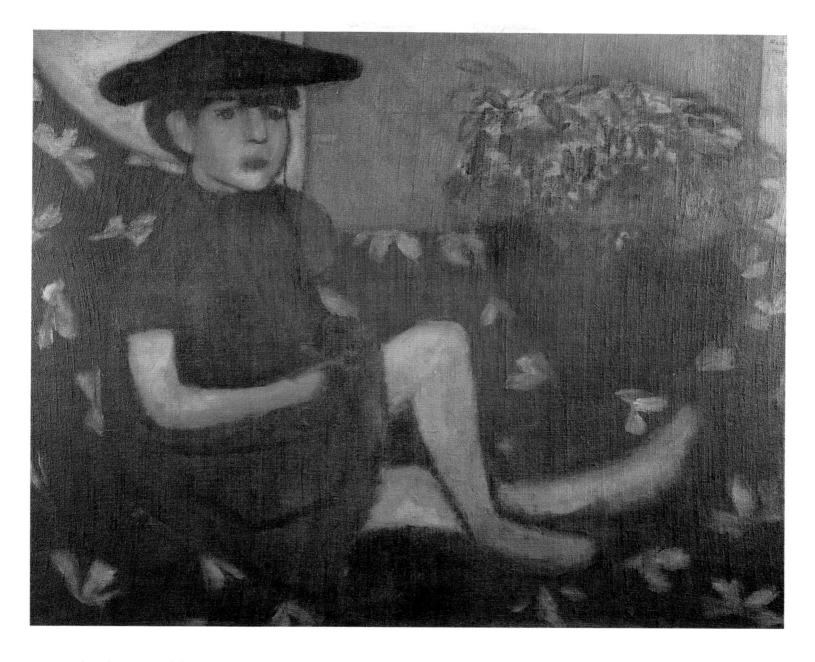

outstanding being *Birthday (L'Anniversaire)* (1915, ill. p. 76), painted just before their marriage, and inspired by a real birthday visit described by Bella in *First Encounter*. Of his relation to Bella, Chagall said: "I had only to open the window of my room, and blue air, love and flowers entered with her. Dressed all in white or black, she seemed to float over my canvases, for a long time guiding my art. I never finish a picture of an engraving without asking for her 'yes' or 'no'." Several years later Chagall painted a replica of this painting, which hung in New York's Guggenheim Museum until it was sold at auction to a private Japanese collector for 13 million dollars, a record price for a Chagall painting.

In St. Petersburg someone entered Chagall's life who was greatly to influence the artist's further career, Maxim M. Vinaver, a member of the 'Duma' or Russian parliament. In his speeches Vinaver championed equality of rights for Russian Jews, and after his death Chagall recalled him in the following words: "… in him I have lost someone who was very close to me, almost like a father. I still remember his shining eyes, those eyebrows that slowly rose and fell, his finely chiselled mouth, his chestnut-brown beard, that whole noble profile, which I – shy as always, alas – did not dare to paint." Chagall also got to know Vinaver's brother-in-law Leopold Sev, as well as the critic N. G. Syrkin and the writer Pozner. They were all on the editorial board of the liberal Russian-language Jewish magazine *Voshod* or 'Dawn', and lent their support to the young painter.

Young Girl on a Sofa, 1907
Oil on canvas, 75 x 92.7 cm
Private collection

As early as 1907, shortly after his arrival in St. Petersburg, Chagall began painting members of his large family. In this warm but striking portrait, his sister Mariaska is sitting on a sofa against a simple background, accentuated only by the leaves on the fabric and the bouquet behind. The artist gives his model a certain childlike innocence and immaturity. Marussio, his youngest sister whom he affectionately calls Mariaska, was then about 8 years old. Chagall has fitted her out in a dark dress to make her look older. The painting was done while Chagall was studying with Léon Bakst.

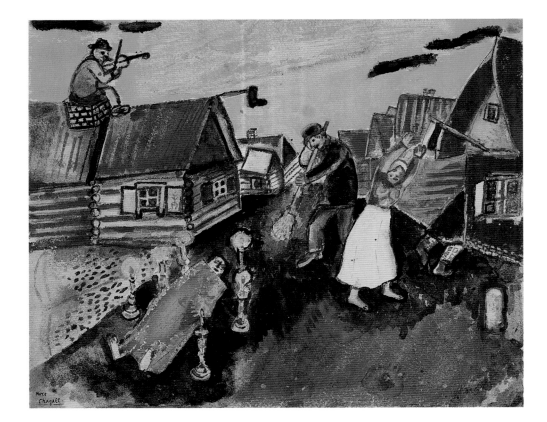

The Dead Man (Village and Violinist), 1913
Gouache, 34.6 x 42.2 cm
New York, Private collection

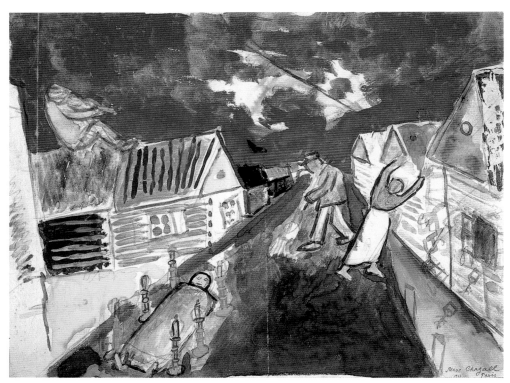

The Dead Man, 1911
Gouache on paper, 24.1 x 31.1 cm
Basle, Collection Marcus Diener

PAGE 25:
This astonishing early work produced in
1908 in St. Petersburg is the best of the many
narrative paintings depicting scenes from
Vitebsk. It was chosen, together with paintings
of other students of the Svanseva school for
an exhibition in 1910, in the premises of the
journal "Apollon". A corpse is lying on a dark
street, surrounded by several burning candles;
the warm light of the breaking dawn in the
background contrasts with the tragic darkness
of the street. Chagall asked himself: "How
could I paint a street with psychic force but
without literature; how could I compose a
street as black as a dead man without symbol-
ism?" This picture is an impressive and
convincing answer to that question. While a
woman mourns the dead, a road sweeper goes
about his work unmoved and Chagall's uncle
sits on the roof playing his fiddle, as if nothing
had happened.

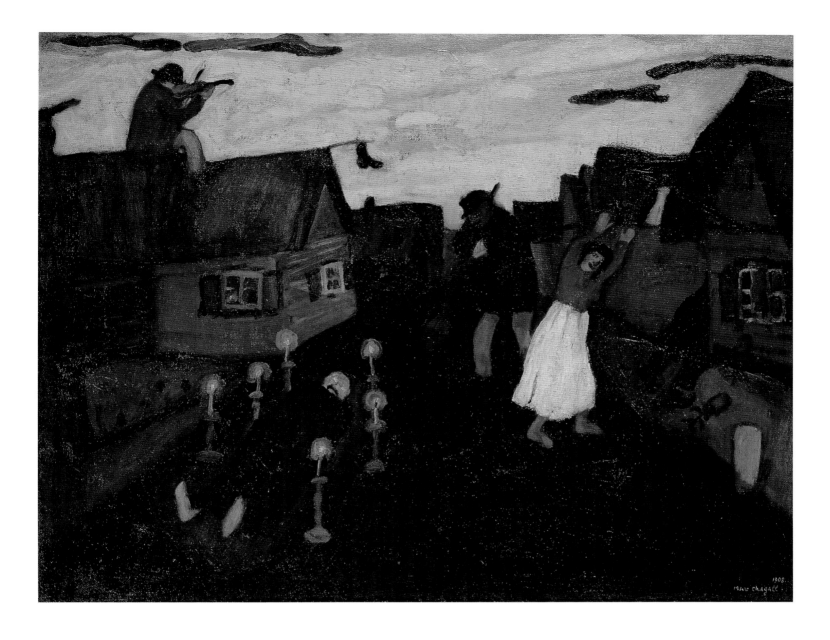

The Dead Man, 1908
Oil on canvas, 68.2 x 87 cm
Paris, Musée national d'art moderne,
Centre Georges Pompidou

Leopold Sev introduced Chagall to Léon Bakst, a teacher at the Svanseva School. Bakst (whose real name was Rosenberg) was a famous draftsman, who had designed many stage sets and costumes for the 'Ballets Russes'. He had also been a founding member together with Sergei Diaghilev and Alexander Benois of the avant-garde group *Mir Iskusstva* ('World of Art'), which organized exhibitions and published from 1898 to 1903 a magazine of the same name. When Chagall showed Bakst his work, he was very nervous. "His fame, after the Russian season abroad, turned my head, I don't know why. 'Let me see your studies,' he said to me. I … oh, well! … No chance now to draw back or to be timid. If my first visit to Penne was important only to my mother, the one I was making to Bakst was tremendously important to me, and his opinion (whatever it might be) decisive. I wanted only one thing: that there should be no mistake. Would he consider that I had talent, yes or no? As he turned my sketches over which, one by one, I picked up from the floor where I had piled them up, he said, drawling out the words in his lordly accent: 'Yes! There's talent here; but you've been sp-oi-led, you're on the wrong track …'"

Nevertheless, Chagall stayed for a year and a half at the liberal Svanseva School, and learnt from Bakst to treat colour as a basic element of composition. Although Bakst was immersed in Art Nouveau influences and primarily produced decorative stage sets, working in his studio was a little like being in Paris. So, when Bakst decided to move to Paris to work full-time for Diaghilev's 'Ballets Russes', Chagall applied to join him as an assistant, only to be turned down.

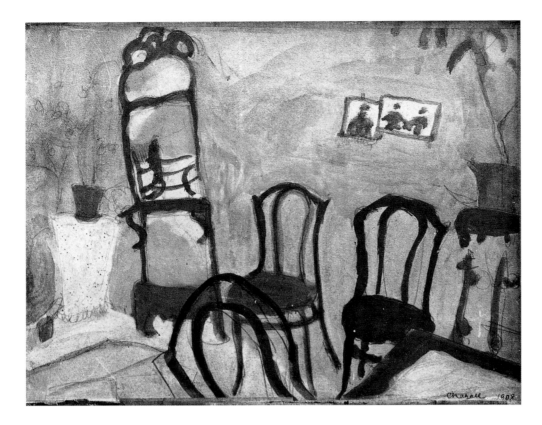

The Small Drawing Room, 1908
Oil on paper, mounted on canvas
22.5 x 28.9 cm
Private collection

Interior, 1908
Oil on canvas, 45.7 x 61 cm
New York, Collection L. Lipchitz

The Family (Maternity), 1909
Oil on canvas, 74 x 67 cm
Private collection

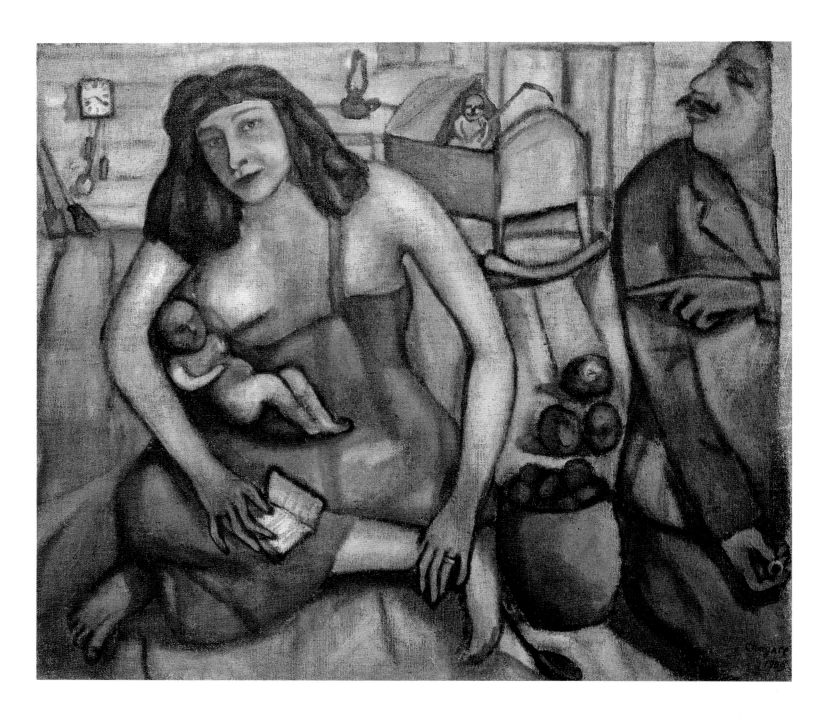

The Couple (The Holy Family), 1909
Oil on canvas, 91 x 103 cm
Paris, Musée national d'art moderne,
Centre Georges Pompidou

The early works that Chagall painted in St. Petersburg are full of elements from Russian folk art, and as such resemble the pictures that Mikhail Larionov was painting in faraway Moscow. During these years Chagall continued to paint portraits of his sisters and of other family members: *Young Girl on a Sofa* (1907, ill. p. 23), *The Dead Man* (1908, ill. p. 25), *The Seated Violinist* (1908), *The Small Drawing Room* (1908, ill. p. 26), *The Familiy (Maternity)* (1909, ill. p. 27), *The Fruit Seller* (1909–10, ill. p. 22), *Russian Wedding* (1909, ill. p. 29), and *Self-Portrait with Brushes* (1909). From 20 April to 9 May 1910 an exhibition of works by the students of the Svanseva School was held, which became a manifesto of the 'new art'. Chagall showed *The Wedding* (1910, ill. p. 36), *The Dead Man* (1908, ill. p. 25), and *Peasant Eating* (now lost).

Most of the paintings Chagall did in Russia – about 50 – were stolen by a St. Petersburg framemaker by the name of Antokolsky, to whom the artist had brought all his paintings, hoping that the framer might sell some of them on commission. When Chagall returned a week later, Antokolsky denied ever having received any paintings and even pretended not to know the artist. Chagall was dumbfounded, but there was nothing he could do about the theft – he had

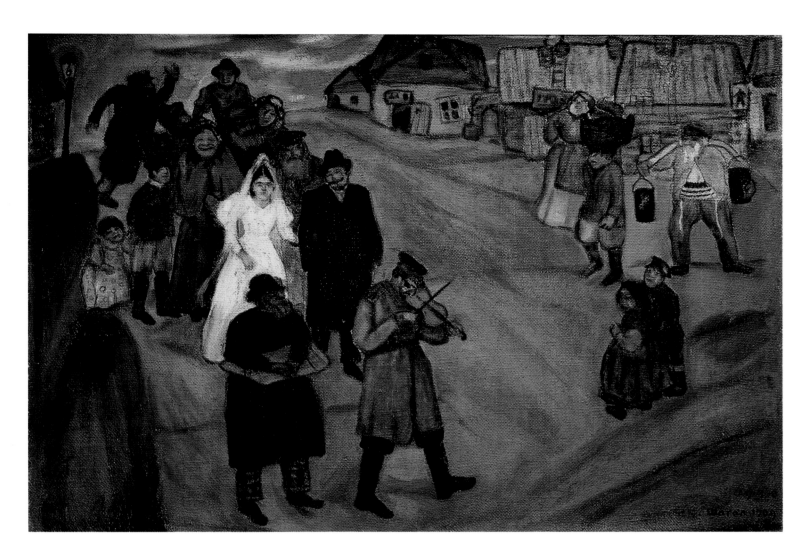

no receipt. Later some of these pictures surfaced in Russian collections and in the West.

It was Maxim Vinaver who made Chagall's dream of going to Paris, in those days the centre of the art world, come true. Not only did he buy some of the artist's first paintings, such as *The Wedding*, but he also greatly encouraged the young painter. He allowed Chagall to sleep in the editorial offices of the magazine *Voshod*, whose walls were covered with Chagall's paintings and drawings, and enabled Chagall to go to Paris by giving him a stipend of 40 roubles a month. It was the opportunity of a lifetime, which Chagall took up with alacrity. In *My Life* the artist later wrote: "My father brought me into the world, and Vinaver got me to Paris. Without him I would probably have remained a photographer in Vitebsk without any notion of Parisian life. [...] Vitebsk, I am leaving you. Stay behind, alone with your herrings!" Chagall's four-year stay in St. Petersburg had been crucial for his artistic development. It was the time when his ideas and plans for the future began to take shape. But now he was ready for the next step – to turn these dreams into reality, in Paris.

The Wedding (Russian Wedding), 1909
Oil on canvas, 68 x 97 cm
Zurich, Collection G. Bührle

Weddings were one of the subjects Chagall enjoyed painting all his life. In contrast to *The Dead Man*, this painting depicts a joyful event in the everyday life of the people of Vitebsk. Townsfolk look on as the procession comes down the hill, led by the fiddler, indispensable to any Jewish wedding celebrations. The white dress of the bride shines out against the sombre colours around her, linking up with the brighter background.

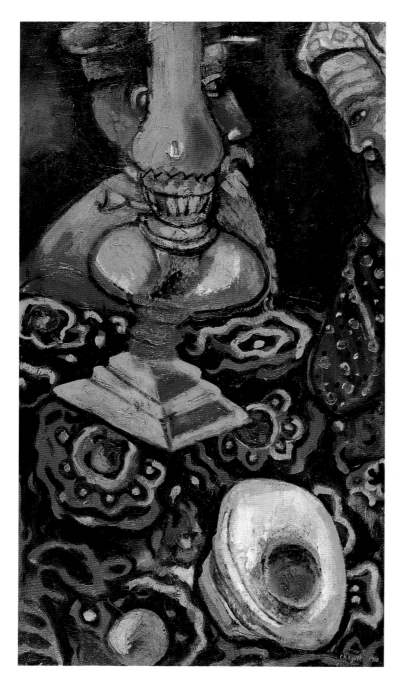

Still-Life with Lamp, 1910
Oil on canvas, 70 x 45 cm
Private collection
Courtesy Galerie Rosengart, Luzerne

Shofar (The Ram's Horn), 1911
Gouache, 26.3 x 32.7 cm
Paris, Musée national d'art moderne,
Centre Georges Pompidou

Soldiers, 1912
Gouache on cardboard, 38.1 x 31.7 cm
Private collection

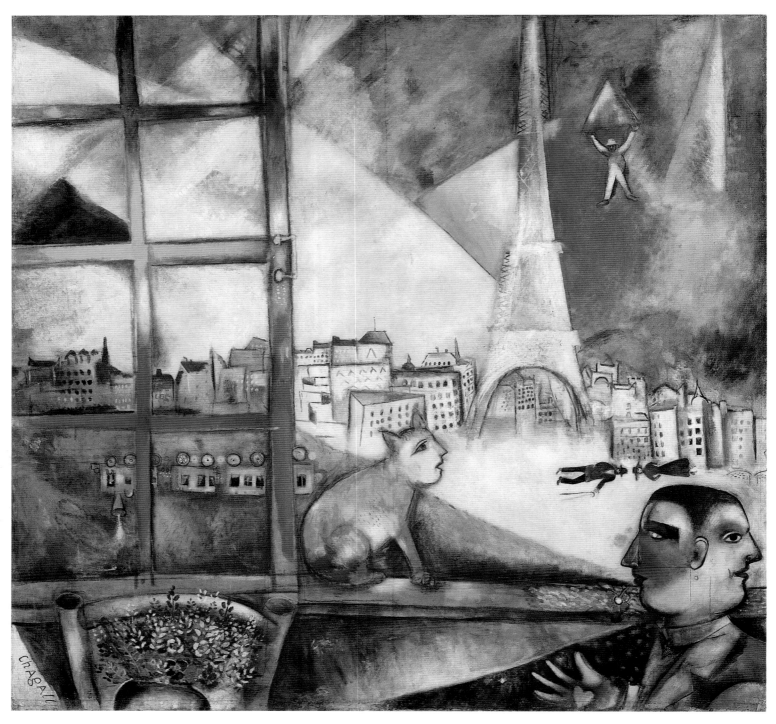

Paris Through My Window, 1913
Oil on canvas, 135.8 x 141.4 cm
New York, The Solomon R. Guggenheim
Museum, Gift of Solomon R. Guggenheim

"My art needs Paris just as a tree needs water.
I had no other reason for leaving my homeland,
and I believe that in my paintings I have always
remained true to it." Chagall called Paris "my
second Vitebsk". Many artists enjoy painting
the view through an open window. Through
his window, Chagall shows us the Eiffel Tower,
a parachutist, an upside-down train, two walk-
ing figures turned on their side, and the city

panorama. Everything is displaced, and the sky
is lit by strange patches of colour. The double
head in the foreground looks back nostalgically
towards Vitebsk and fowards towards Paris,
simultaneously. The painting is reminiscent of
Delaunay's simultaneist cycle, with the colour
contrasts of Orphism and elements of Synthetic
Cubism too.

Paris 1910–1914

"Paris, you are my second Vitebsk."

In August 1910, after a four-day train journey across Europe, Chagall arrived at the Gare du Nord, bringing with him all his paintings and drawings. He was met at the railway station by his Vitebsk school friend Viktor Mekler, who was already living in Paris. Chagall's dream of Paris, the city of light and above all of freedom, had come true. From the painter Ehrenburg, a relative of the Russian writer Ilya Ehrenburg, he rented a studio at No. 18 Impasse du Mai (now the Impasse Bourdelle), and only two days after his arrival went to see the 'Salon des Indépendants', where for the first time he saw the works of French painters.

The first days were very difficult for the 23-year-old Chagall, who found himself alone in the big city, unable to speak French. Some days he felt like fleeing back to Russia, so persistent in his thoughts, as he worked in his studio, were Russia and Vitebsk, the riches of Russian folklore, his Hasidic background, as well as his family and Bella.

He attended the art academies La Palette, where the painters Segonzac and Le Fauconnier taught, and La Grande Chaumière, where he also found employment. In the galleries and salons, and above all in the Louvre, he studied the works of Rembrandt, the Le Nain brothers, Chardin, Watteau, van Gogh, Renoir, Pissarro, Matisse, Gauguin, Courbet, Millet, Manet, Monet, Delacroix, Géricault, and many other painters. In the Durand-Ruel gallery he encountered Renoir and the Impressionists, at the Bernheim gallery van Gogh, Gauguin and Matisse. It was in Paris that Chagall discovered the gouache technique, which he used to paint nostalgic Russian scenes and other subjects. He visited Montmartre and the Latin Quarter, and was happy just breathing Parisian air. "Thus it was that I arrived in Paris, as if driven there by destiny."

Chagall was exhilarated, intoxicated, as he strolled through the streets and along the banks of the Seine. Everything about the French capital excited him: the shops, the smell of fresh bread in the morning, the markets with their fresh fruit and vegetables, the wide boulevards, the cafés and restaurants, and above all the Eiffel Tower. Another completely new world that opened up for him was the kaleidoscope of colours and forms in the works of French artists. Chagall enthusiastically reviewed their many different tendencies, having to rethink his position as an artist and decide what creative avenue he wanted to pursue. Did he want to follow in the footsteps of the French masters, or should he remain true to his own ideas? Did he want to paint in the Impressionist or Cubist style? Neither really suited him. He admired Cézanne, whose cubes and grids and flat compositions were later adopted by the Cubists as a model for structuring their paintings, and he was no less impressed by the leading French artists Corot, Chardin and Delacroix. Yet in the end Chagall remained true to his feelings, to his memories of Vitebsk, and to his Russian homeland. He also remembered the old masters he

Chagall in Paris, 1911

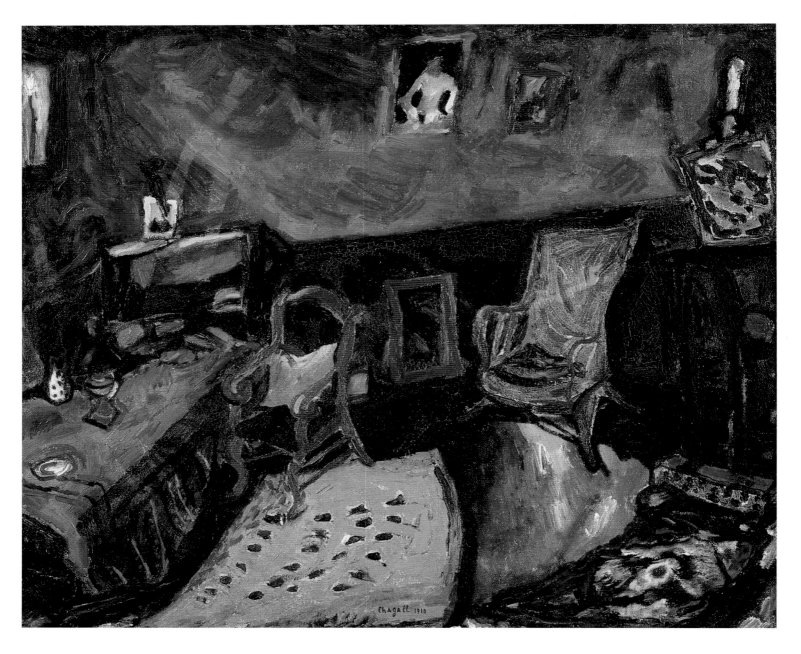

The Studio, 1910
Oil on canvas, 60 x 73 cm
Paris, Musée national d'art moderne,
Centre Georges Pompidou

had seen in the Hermitage in St Petersburg, including the paintings of Tintoretto and El Greco.

At the two art academies that he sporadically attended in Paris, Chagall drew and painted mainly nudes, which bored him. He did not want to become just another painter of impressionist, naturalist or realist works. Nor did he have any desire to adapt himself to the prevailing trends in the Paris art scene. The Parisian art academies, too, he soon felt, had little to offer him other than a certain veneer of technique.

Chagall, who had never been a 'good student', was convinced that he would learn more by visiting galleries and museums, or by simply walking the streets and breathing the air and freedom of Paris.

Chagall was so fascinated by what he saw during the daytime, by the light and the intensity of the colours, that he needed all night in his studio to get it down on canvas. One of his first Paris paintings, clearly influenced by van Gogh, is *The Studio* (1910, ill. p. 34), which depicts his furniture, easel and some pictures hanging on the wall. Another is the nostalgic *To Russia, Asses and Others* (1911, ill. p. 35). Here we see the beginnings of Chagall's flirtation with Cubism, which he later mostly repudiated. *Sabbath* (1910, ill. p. 15) portrays the Sabbath table and around it his family, whom he sorely missed. In Paris he was constantly reminded of home – in those days the capital was full of Russian painters, writers, poets, composers,

(continued on page 40)

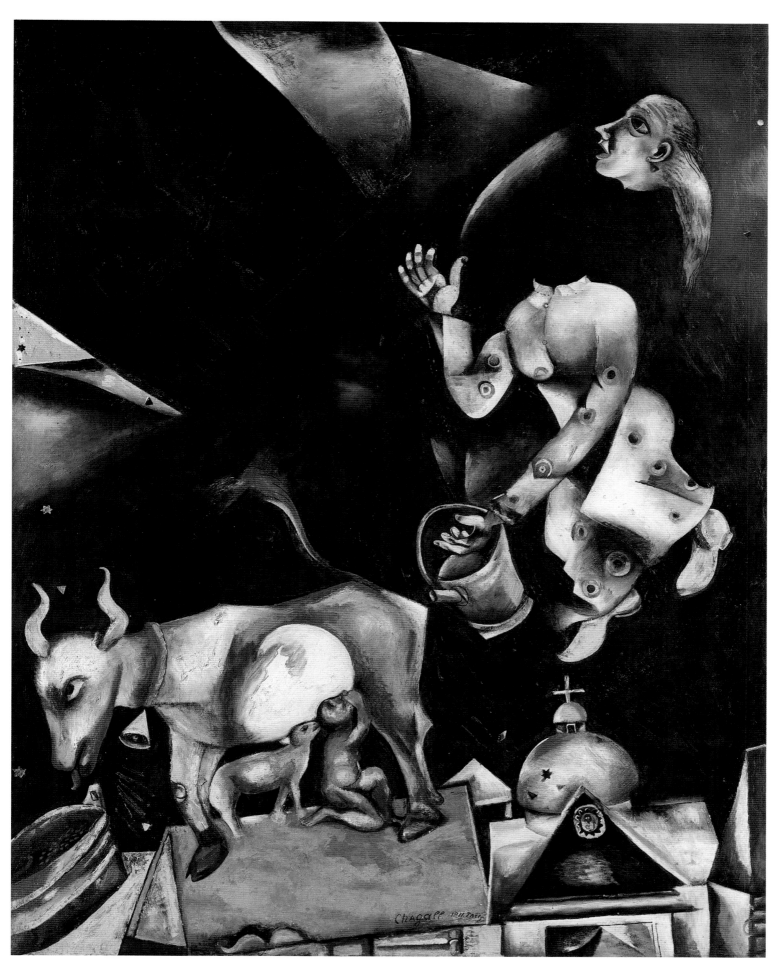

To Russia, Asses and Others, 1911
Oil on canvas, 157 x 122 cm
Paris, Musée national d'art moderne, Centre Georges Pompidou

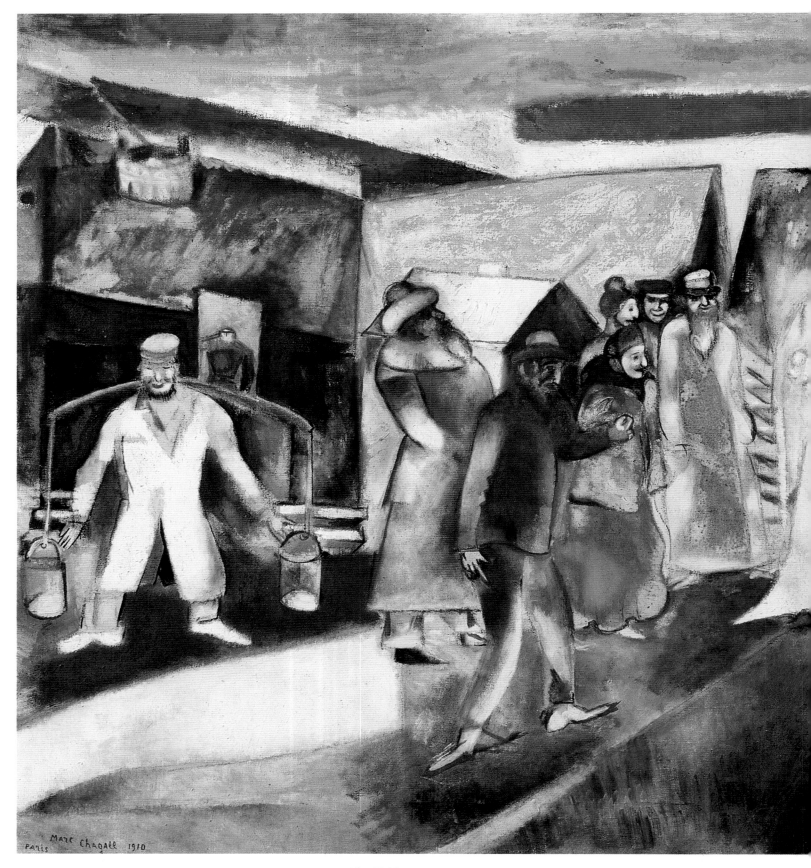

The Wedding, 1910
Oil on canvas, 99.5 x 188.5 cm
Paris, Musée national d'art moderne, Centre Georges Pompidou

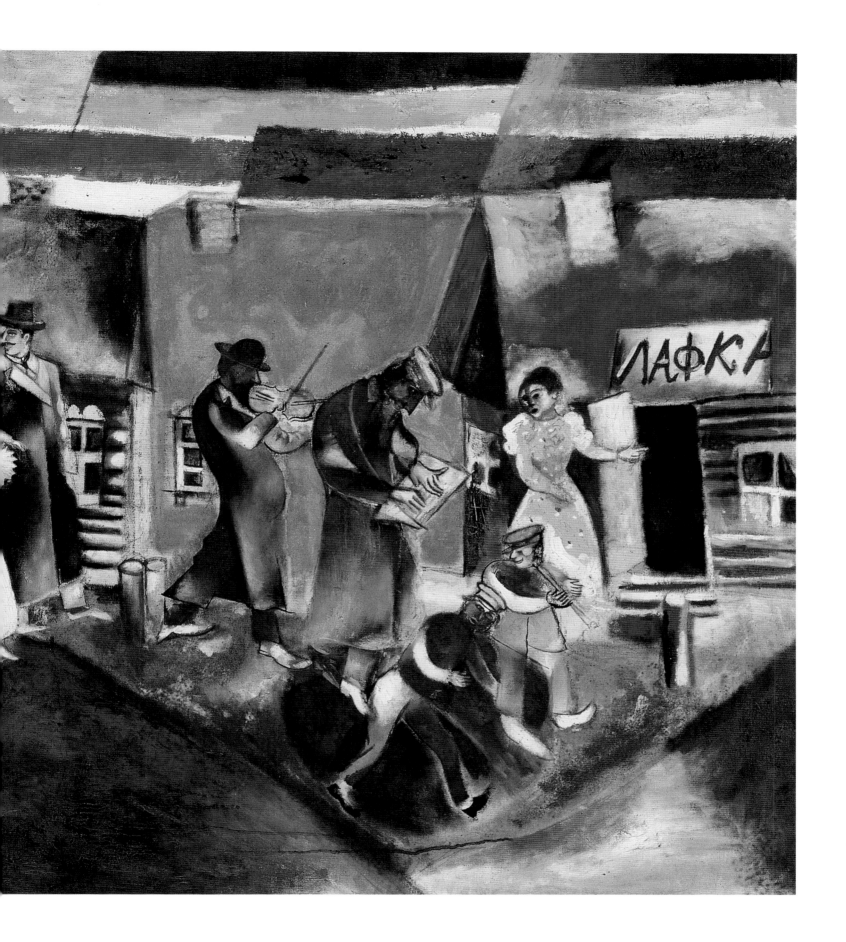

1910 – 1911

Paris

Seule la grande distance qui sépare Paris de ma ville natale m'a retenu d'y revenir immédiatement ou du moins après une semaine, ou un mois. Je soulais même inventer des vacances quelconques, rien que pour pouvoir revenir. C'est le Louvre, qui mit fin à toutes ces hésitations.

PAGE 39:
The Poet (Half Past Three) 1911
Oil on canvas, 196 x 145 cm
Philadelphia (PA), Philadelphia Museum of Art,
The Louise and Walter Arensberg Collection

In this masterpiece, the 24-year-old Chagall makes full use of the techniques of Cubism, the all-pervading style of art in Paris at the time. Most noticeable are the geometric and, to some extent, fragmented forms, and the flatness of the composition. The colour holds the fragmented parts together. The man's body is a meditative blue, the table a luminous red and the background white; colours that make up the French tricolour. Strong accents are added by the green head and the cat. The work was also known under the titles *A Quarter to Five* and *The Rendezvous.* Chagall, who wrote poetry himself, was a close friend of Blaise Cendrars at that time, but the painting seems more closely related to portrait studies of another poet, Mazin.

LEFT:
The writer Blaise Cendrars

RIGHT:
Marc Chagall and Alexander Rom in the Jardin du Luxembourg, Paris, on 15 June 1911 (Marc Chagall sent this photograph to his father).

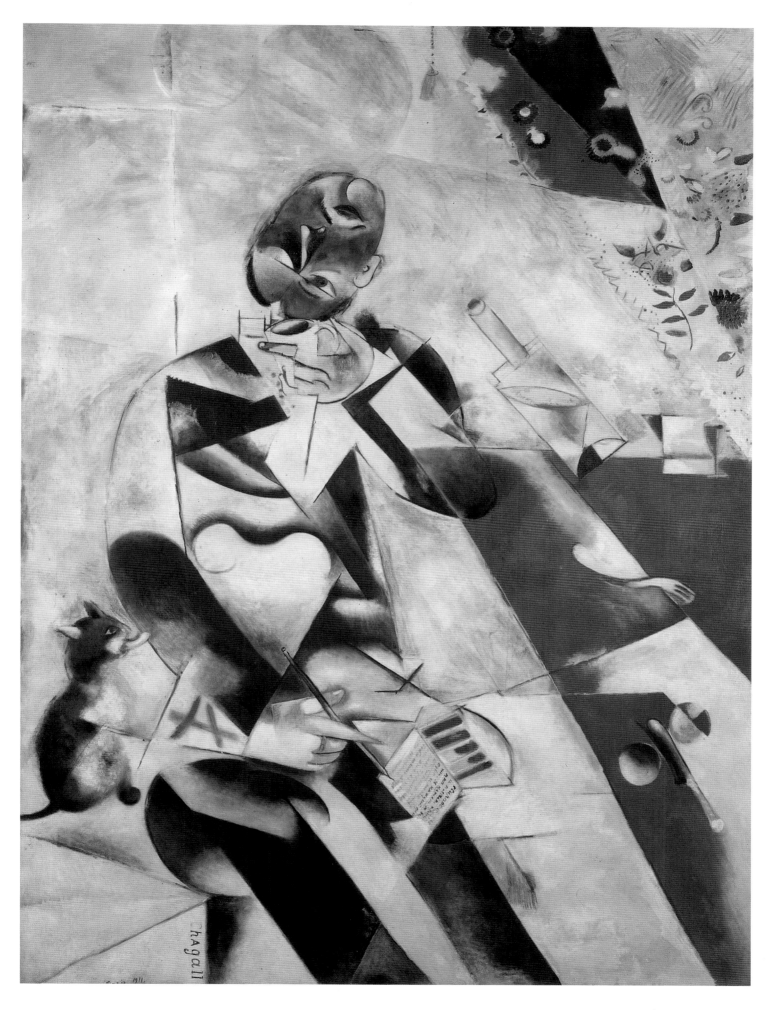

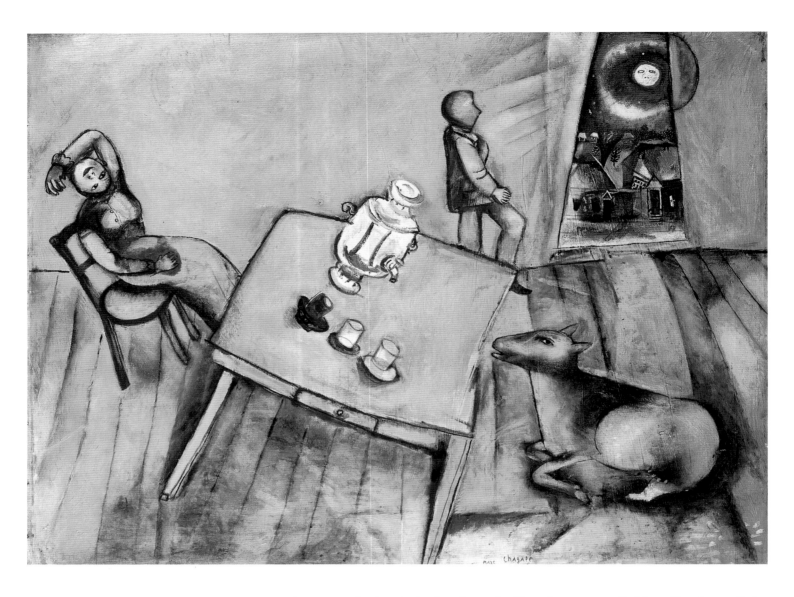

The Yellow Room, 1911
Oil on canvas, 84 x 112 cm
Private collection
Courtesy Christie's, London

dancers and other émigrés, whom the French, open to all things Russian, called 'White' Russians.

Although the Fauve group had already disbanded before Chagall's arrival in Paris, many of his paintings clearly show the influence of the bold vivid colours of the Fauves ('wild beasts'), who numbered, among others, Derain, Matisse and de Vlaminck. An example of a picture with Fauvist influences is *The Wedding*, painted in 1910 (ill. p. 36).

In Montparnasse Chagall met Robert Delaunay, Albert Gleizes, Jean Metzinger, Fernand Léger, Louis Marcoussis, and André Lhote, discussing with them Cubism and Italian Futurism. One of the most celebrated Russians in Paris was the ballet impresario Sergei Diaghilev, whose performances, with their Léon Bakst stage sets and Michail Fokine choreography, were much admired by the French public. At this time Igor Stravinsky was composing his *The Firebird, The Rite of Spring* and *Petrouchka*.

In 1911 Chagall met up again with Léon Bakst – his former teacher who had advised him against going to Paris. "You came after all?" Bakst asked, promising to call on the artist in his studio, which in fact he did. When he saw the canvases Chagall had painted in Paris, Bakst remarked: "Now your colours sing." This was the last time Chagall saw Léon Bakst, who never returned to Russia, dying in Paris in 1924.

During the winter of 1911/12 Chagall moved into one of the 140 studios of 'La Ruche' (The Beehive), an artists' colony, situated at No. 2 Passage de Danzig, near the large slaughterhouses of the Vaugirard quarter. Built around 1900 by the sculptor and painter Alfred Boucher, a descendant of the Rococo painter François

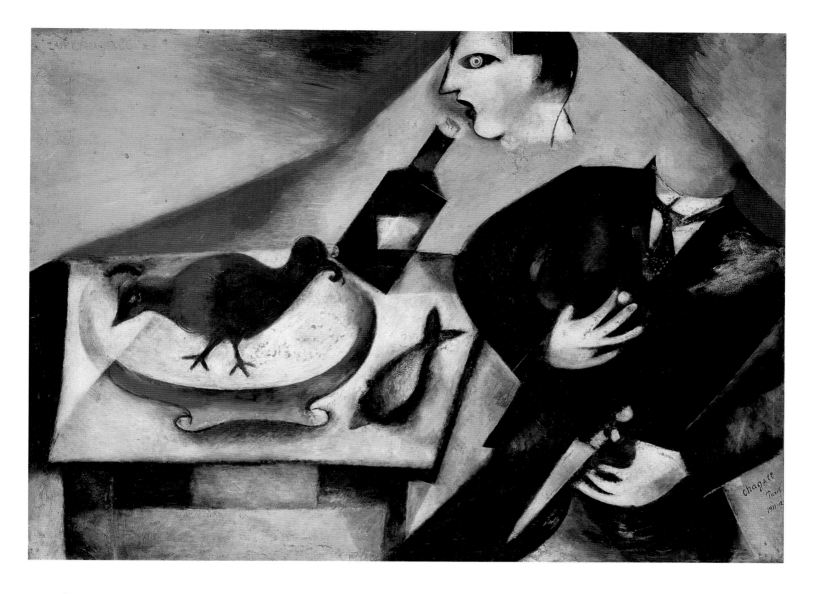

Boucher, La Ruche was designed to house artists and writers from all over the world at a modest rent. Among Chagall's neighbours were Amadeo Modigliani, who lived next door, Fernand Léger, Henri Laurens, Alexander Archipenko, Moische Kogan and Chaim Soutine. The rent was about 50 francs a year, allowing Chagall, who enjoyed a grant of 125 francs a month, to take a large studio on the top floor with plenty of light. By and by, Ossip Zadkine, Jacques Lipchitz, Jean Metzinger, Pincus Kremegne, Michel Kikoine, the poet Blaise Cendrars and the writer and critic André Salmon moved into La Ruche. Even Vladimir Ilich Ulianov, better known as Lenin, lived there briefly. Most of the painters working in the colony came to be known as members of the 'School of Paris', although they had absolutely nothing in common.

Chagall describes his studio and the atmosphere of La Ruche as follows: "The studio has not been cleaned for a week. Stretchers, eggshells, empty soup tins lie around in a mess. [...] On the floor reproductions of El Greco and Cézanne lie cheek by jowl with the remains of a herring, which I had cut in two, the head for the first day, the tail for the next, and – thank God – crusts of bread. [...] While in the Russian studios a slighted model can be heard sobbing, from the ateliers of the Italians comes the sound of guitars and singing, and from the Jews heated discussions. Meanwhile I am quite alone in my studio, working by my petrol lamp, surrounded by pictures painted not onto canvases, but rather onto tablecloths, or my bedsheets, or my shirts, which I have cut up. Two, three o'clock in the morning. The sky is blue – it is getting light. Somewhere they are slaughtering cattle, the cows are lowing, and I paint them."

Night after night Chagall painted until dawn, only then going to bed for a few

The Drunkard, 1910–12
Oil on canvas, 85 x 115 cm
Private collection

This painting in powerful red, yellow and black tones still betrays a strong Cubist influence. A man is portrayed, detached from his head, his knife and his bottle, beside a table bearing a red fowl and a blue fish (a reference to Chagall's father), superimposed against a flat background of bright, geometric shapes. This lively painting is one of the masterpieces of Chagall's first Paris period.

PAGE 40 BOTTOM:
The Drunkard, 1911
Indian ink and gouache on paper,
22.3 x 17.6 cm
Basle, Collection Marcus Diener

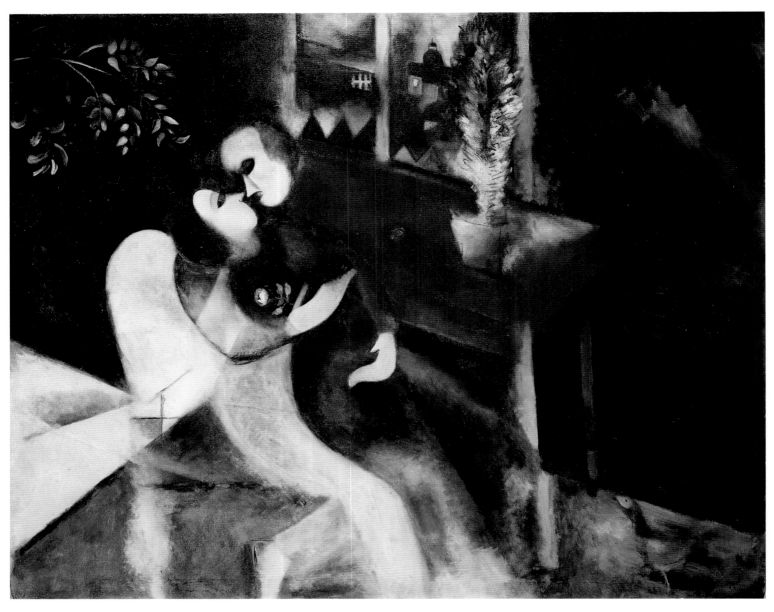

The Lovers (Vision), 1911–1914
Oil on canvas, 109 x 134.5 cm
Private collection
Courtesy Galerie Rosengart, Luzerne

PAGE 43:
Dedicated to My Fiancée, 1911
Oil on canvas, 196 x 114.5 cm
Berne, Kunstmuseum

When this unusual painting, originally entitled *The Ass and the Woman*, was exhibited in the "Salon des Indépendants" in Paris in March 1912 it caused a scandal. It was considered pornographic and was ordered to be removed. The picture shows a man with a bull's head lying back contentedly, his head on his hand, while a woman drapes her thighs around his neck and spits in his face. The dominant colours are the red robe of the beast-man and the woman's pink legs. "A little gold colour scattered on the offending lamp smoothed matters over", wrote Apollinaire in *L'Intransigeant*, where he describes the picture as "a golden donkey smoking opium". Chagall mentions this incident in his book *My Life*. He claims to have painted the picture overnight in a train, without switching on the lights. Strangely wild and impetuous, this is one of the first works Chagall produced after moving to the artists' colony La Ruche.

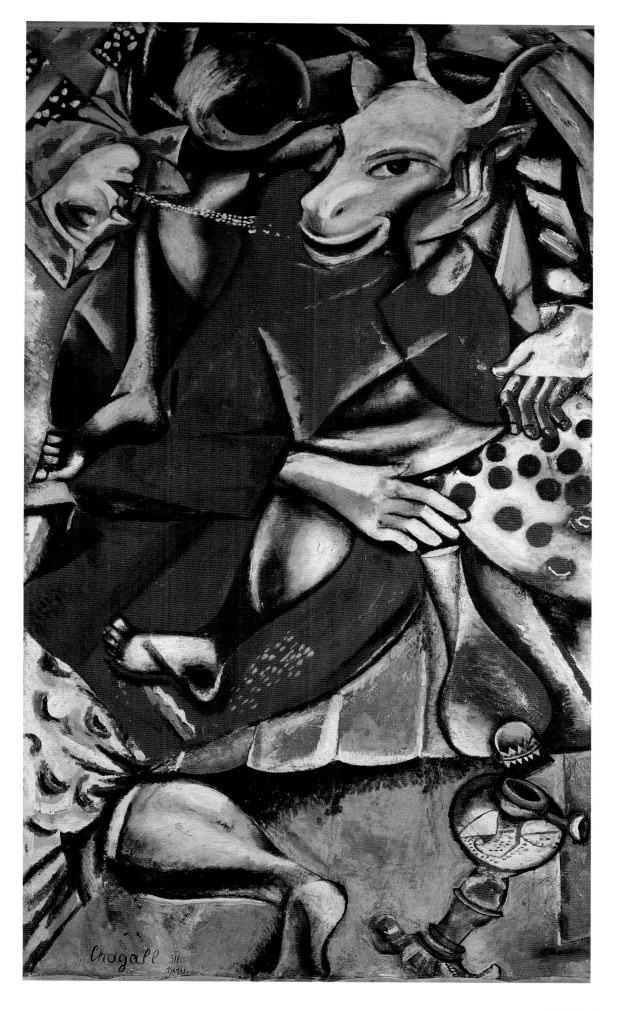

Odalisque, 1913–14
Watercolour, pen and ink,
mounted on three coloured papers
20.2 x 28.8 cm
Berne, Collection E. W. K.

Nude with a Fan, 1910
Watercolour, pen and ink, mounted on three
coloured papers
17.3 x 30.2 cm
Paris, Musée national d'art moderne,
Centre Georges Pompidou

hours and managing to resist the many temptations of the big city by night. Some-times his neighbour would knock on his door to cadge some food or money. Chagall always obliged, but before opening the door, would hide whatever canvases he was working on at the time.

After having been in Paris for a while, Chagall heard about Picasso, who was then living in Montmartre. He asked the poet Apollinaire to introduce him to Picasso. Apollinaire replied: "Picasso? Are you feeling suicidal?" And in fact it was not until 1923 that Chagall met the great man, although a drawing from 1914 already bore the title *Thinking about Picasso* (1914, ill. p 184). Chagall's relations with Picasso were strained, and we shall return to them in more detail later (see pp. 184–188).

In La Ruche Chagall painted many of his masterpieces, among them: *I and the Village* (1911, ill. p. 51), *Homage to Apollinaire* (1911–12, ill. p. 47), *The Soldier Drinks* (1911–12, ill. p. 58), and *Paris Through the Window* (1913, ill. p. 32). In *I and the Village,* one of the artist's key works, we see for the first time a picture with a thoroughly planned, integrated structure, its disparate elements all hanging together. Chagall commented on this development as follows: "Depending on what the structure of the picture requires, I fill up the empty space on my canvas with a

PAGE 45 TOP LEFT:
Nude with Flowers, 1911
Gouache on paper, 33.6 x 23.8 cm
Private collection
Courtesy Julian Barran Ltd., London

PAGE 45 TOP RIGHT:
Red Nude, 1911
Gouache on paper, 34.5 x 25 cm
Private collection

PAGE 45 BOTTOM LEFT:
Nude with a Fan, 1910–11
Ink, pen and gouache on paper, 22.6 x 21.2 cm
Berne, Collection E. W. K.

PAGE 45 BOTTOM RIGHT:
The Raised Blouse, 1911
Ink on paper, 29 x 21.5 cm
Basle, Collection Marcus Diener

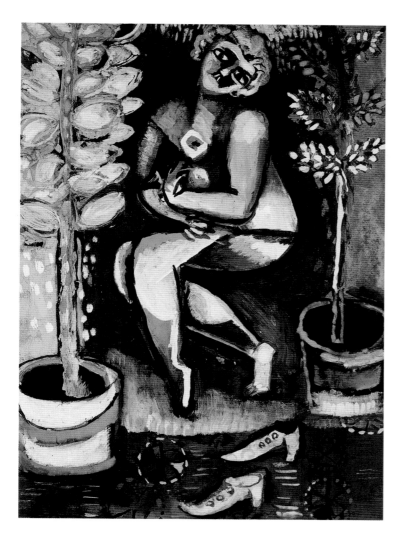

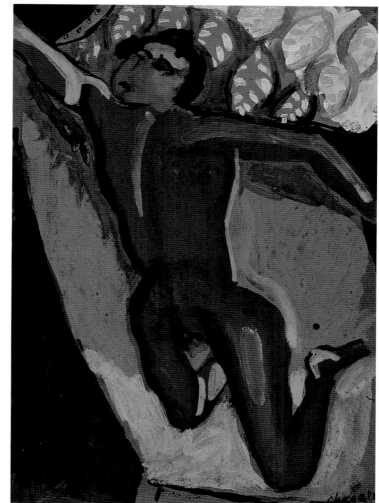

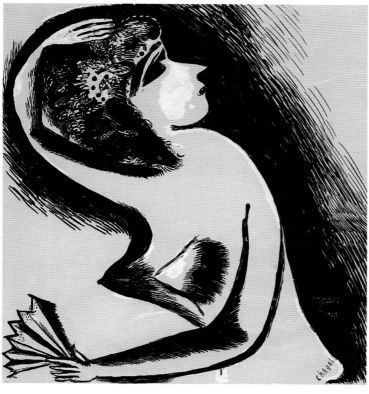

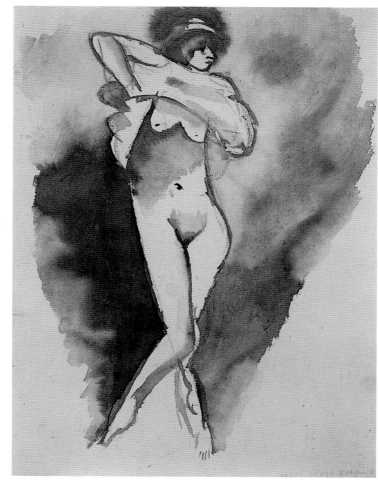

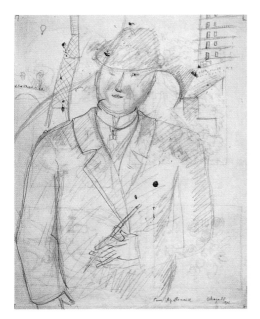

For Apollinaire, 1911
Drawing on paper, 33 x 26 cm
Paris, Musée national d'art moderne,
Centre Georges Pompidou

Apollinaire, 1913–14
Violet ink and watercolour on paper
27.8 x 21.5 cm
Paris, Musée national d'art moderne,
Centre Georges Pompidou

body or object, just as the mood takes me. First comes the overall composition, then the details, such as the milkmaid, the farmer, the neighbourhood church, and so on." Chagall uses colour and line to render his emotions, and the influence of Cubism is obvious here. However, whereas Cubism with its almost architectural structure is analytical or synthetic, the driving forces in Chagall's work are of poetic and nostalgic origin.

During this period Chagall became acquainted with various poets, and Blaise Cendrars, who spoke Russian, became his closest friend. Cendrars thought up titles for some of the painter's compositions – for example *To Russia, Asses and Others* (1911, ill. p. 35) – and he dedicated several poems to Chagall, including *Studio* and *Portrait*.

Portrait

He's asleep
He's awake
Suddenly he's painting
He takes a church and paints with a church
He takes a cow and paints with a cow
With an anchovy
With heads, with hands, with knives
He paints with a bull's pizzle
He paints with all the dirty passions of a little Jewish town
With all the fired-up sexuality of provincial Russia
For the French
Without sensuality
He paints with his thighs
He has eyes in his backside
And all at once it is your portrait
It's you gentle reader
It's me
It's him
It's his fiancée
It's the corner grocer
The girl who brings home the cows
The midwife
Buckets of blood
They are washing newborn babies in them
Skies gone mad
Mouth of modernity
Corkscrew tower
Hands
Christ
He's Christ
He spent his childhood on the cross
He commits suicide every day
Suddenly he's not painting anymore
He was awake
But now he's asleep
He throttles himself with his tie
Chagall is astonished that he is still alive.

<div align="right">BLAISE CENDRARS, OCTOBER 1913</div>

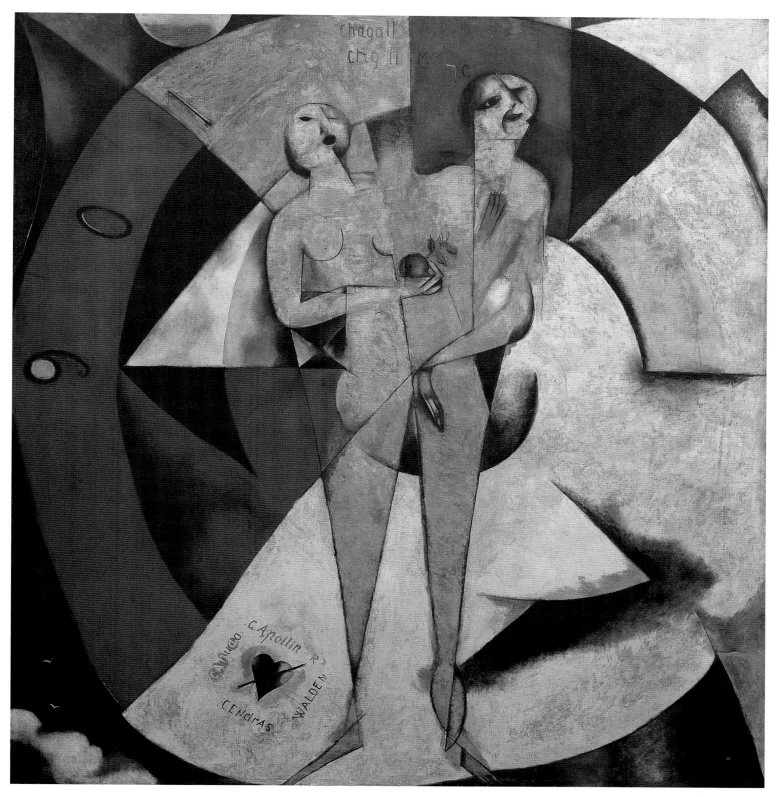

Homage to Apollinaire, 1911–12
Oil on canvas, 209 x 198 cm
Eindhoven, Stedelijk Van Abbe Museum

This painting is one of Chagall's largest. The names inscribed underneath, around a heart, show it was dedicated not only to Apollinaire but also to Herwarth Walden, Blaise Cendrars and Ricciotto Canudo. In this strongly Cubist painting, Chagall has developed his own ideas for structural organisation of the canvas. The two central figures (the female holding an apple) are taken from studies for *Adam and Eve.* A multitude of meanings can be read into this amazing work. It can be seen as a symbolic representation of the Creation Story, the dial being the Clock of Eternity, the arms of the figures, its hands, and the letters and numbers on its face, the Word of God. In it, Chagall links his admiration for Cubism and Orphism with the Jewish mysticism embodied in Hasidism and the Cabbala. The painting was first exhibited in 1914 in Berlin's Sturm Gallery.

Study for *Homage to Apollinaire*
(Adam and Eve), 1912
Gouache on paper, 25 x 20 cm
Private collection
Courtesy Gallery Piltzer, Paris

Study for Homage to Apollinaire, 1911
Pencil on paper, 33 x 26 cm
Paris, Musée national d'art moderne,
Centre Georges Pompidou

When Cendrars died in 1961, Chagall wrote: "I love his poems, just as I do the town of my birth, my past and sunlight. His soul and his colours are laid out on my palette, they lament and weep."

It was through the writer and poet André Salmon that Chagall had come to know Guillaume Apollinaire, the illegitimate son of a Polish nobleman, whose real name was Wilhelm Apollinaris de Kostrovitzki. Apollinaire, who earned his living by turns as a pornographer and bank clerk, had become well-known for his *Calligrammes*, poems incorporating visual elements through their typography, 'poem-pictures' or concrete poems. He was also an art critic, collector of African sculpture and ardent promoter of the avant-garde. In *My Life* Chagall wrote, "that gentle Zeus […] blazed a trail for all of us […] in verses, in numbers, in flowing syllables […]". Both Chagall and Picasso drew and painted Apollinaire's portrait several times.

Chagall was afraid that Apollinaire would not like his work, hesitating to invite the advocate of Cubism into his 'La Ruche' studio. But one evening Apollinaire came nevertheless and, after seeing several paintings, murmured only: "Supernatural". The next day he sent Chagall a letter, which included the poem *Rotsoge*.

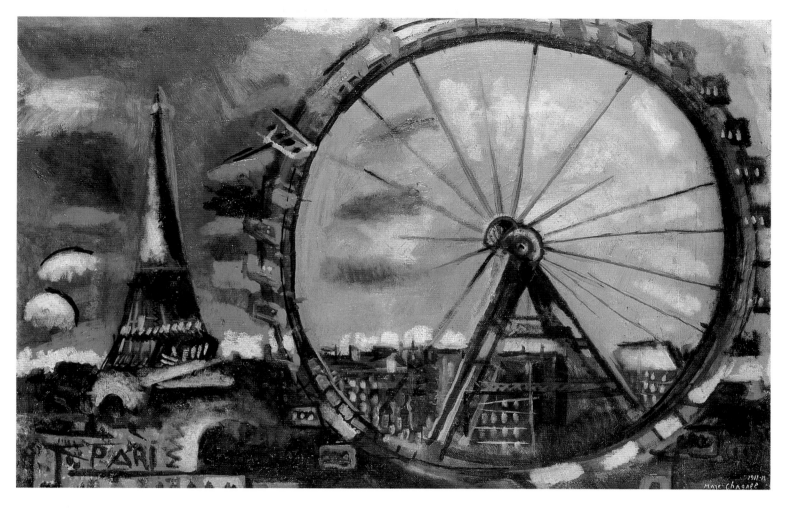

The Big Wheel, 1911–12
Oil on canvas, 60.5 x 89 cm
Private collection
Courtesy Christie's, London

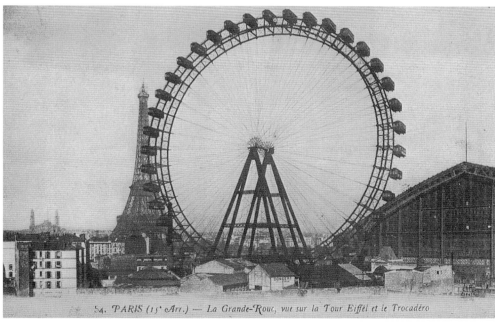

Paris. The 100 metre-high ferris wheel
constructed for the 1900 Universal Exhibition

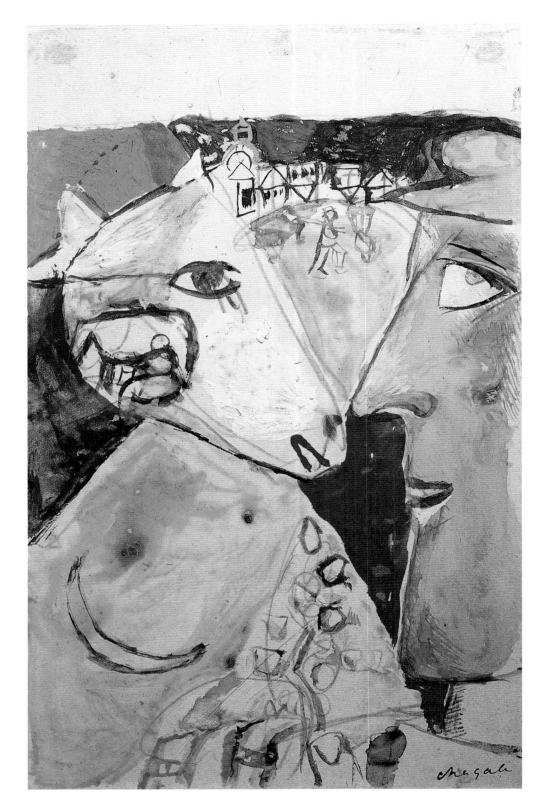

Study for *I and the Village*, 1911
Gouache and watercolour, 21.5 x 13.5 cm
Basle, Collection Marcus Diener

PAGE 51:
This painting is one of the key works of the
first Paris period. It is one in which Chagall
draws heavily on his Russian past and is a
mirror of his memories. Although full of nostal-
gia for Vitebsk, it is formally influenced by
French Cubism. The title was thought up by
his friend Blaise Cendrars. The green portrait
on the right hand side could well be Chagall
himself. The colourful head of a cow looks him
in the eye while, inside the head, another cow
is being milked by a peasant. In the back-
ground are two other figures, one upside down.
Chagall mixes humour with nostalgia, reality
with ambiguity, the rational with the irrational
and fills all this with his own symbolism. He
once again divides up the canvas geometrically
and has been clearly influenced by Synthetic
Cubism and Robert Delaunay's colourful
Orphism. The painting appeared in a one-
man show in Berlin in 1914, where it created
a sensation.

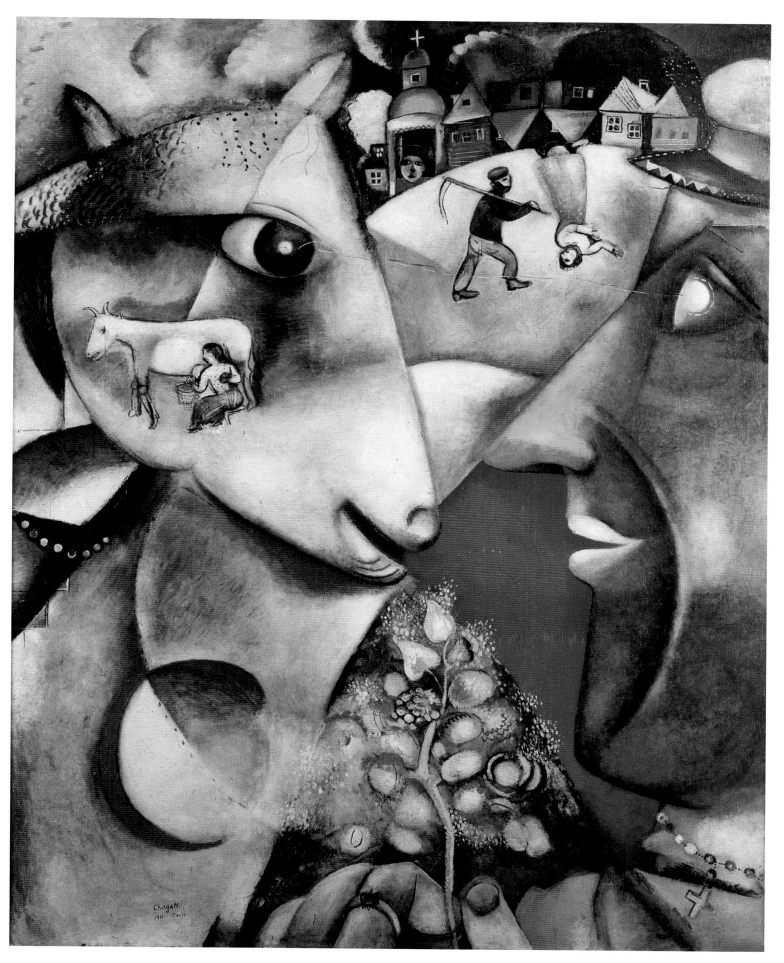

I and the Village, 1911
Oil on canvas, 192.1 x 151.4 cm
New York, The Museum of Modern Art, Mrs. Simon Guggenheim Fund

FOR MARC CHAGALL

Rotsoge

Your scarlet face your biplane convertible into a seaplane
Your round house where a smoked herring swims
I need the key to eyelids
It's a good thing we saw Mr Panado
And we are easy on that score
What do you want my old pal M.D.
90 or 324 a man in the air a calf that gazes out of its mother's belly

I looked a long while along the roads
So many eyes are closed at the roadside
The wind sets the willow groves weeping
Open open open open open
Look, go on, look
The old man is bathing his feet in the basin
Una volta ho inteso say Ach du lieber Gott
And I had to cry when I recalled your childhood years
And you show me a dreadful purple

(continued on page 55)

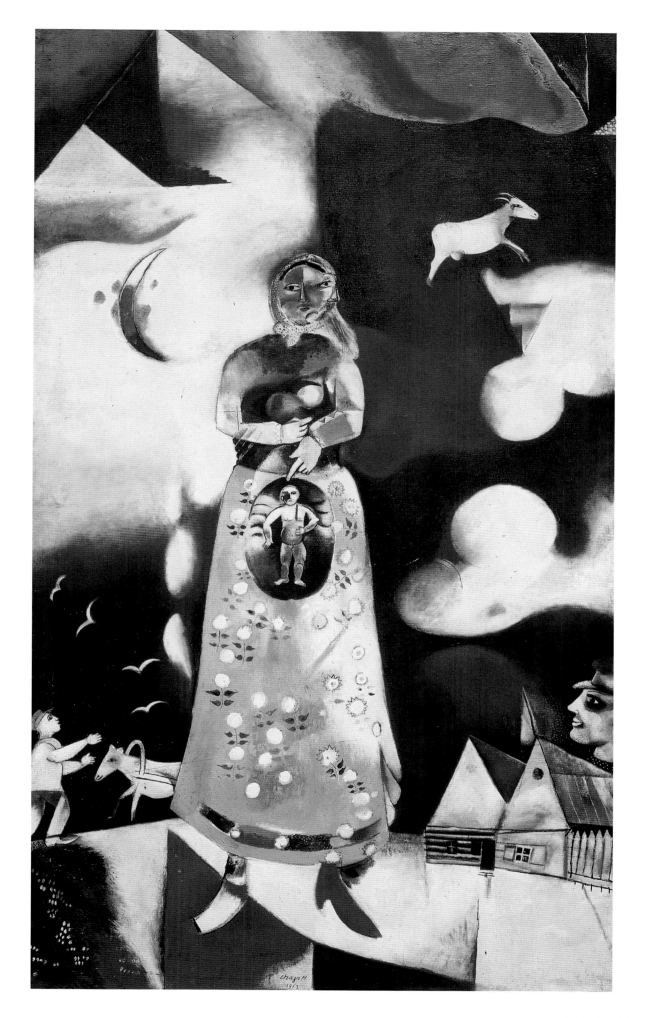

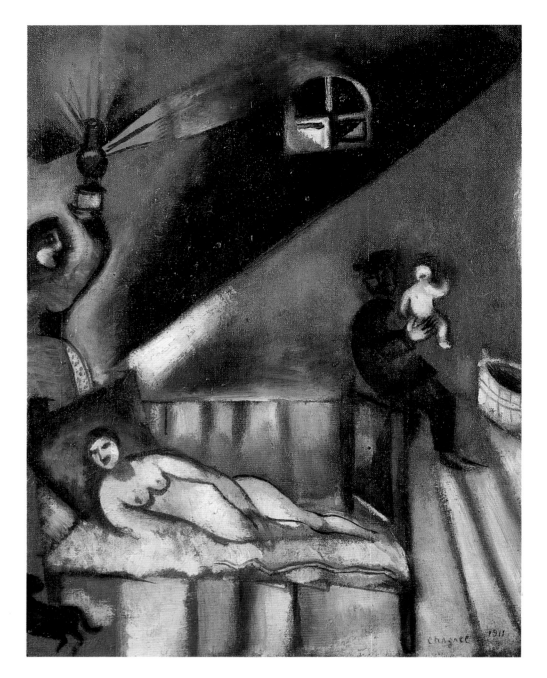

The Birth, 1911
Oil on canvas, 46 x 36 cm
Private collection

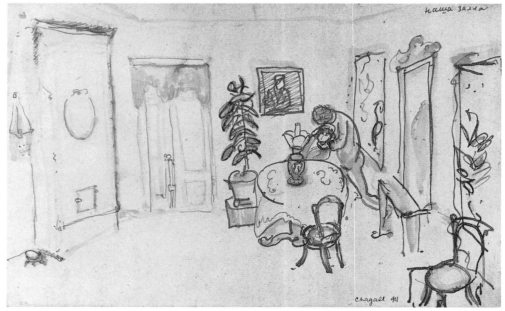

Our Room, 1911
Ink and watercolour on paper, 13.3 x 20.9 cm
Paris, Musée national d'art moderne,
Centre Georges Pompidou

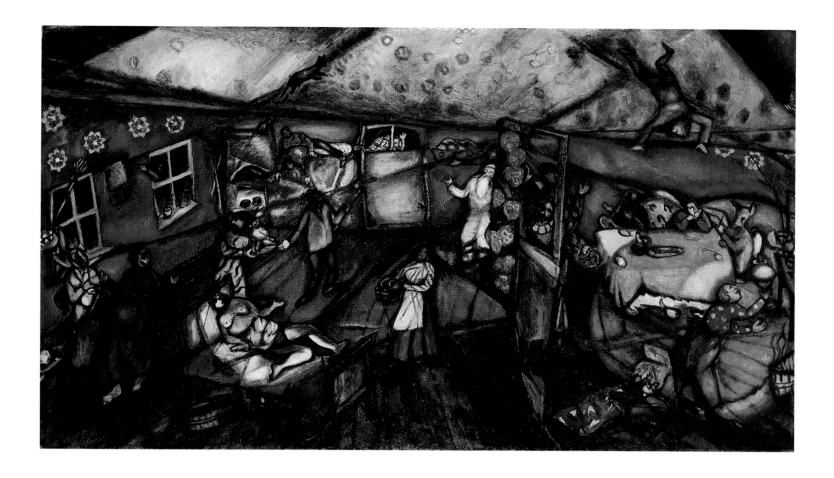

This little painting with the cart reminded me of the day
A day made out of mauve yellow blue green and red fragments
When I went into the country with a charming chimney holding its
bitch on a lead
That no longer exists, you no longer have your little reed pipe
Far away from me the chimney smokes Russian cigarettes
Its bitch barks at the lilacs
And the night light has burned down
On the dress petals have fallen
Two gold rings by some sandals
Have kindled in the sun
But above your hair the trolley cable draws its power
Travelling right across Europe arrayed with colourful little sparks

SPRING 1914

One of the most important paintings of Chagall's first Paris period is *Homage to Apollinaire* (1911–12, ill. p. 47), which was painted after Apollinaire's visit and which shows a strong Cubist influence. The dedication, visible bottom left is addressed not only to Apollinaire, but also to the writers Cendrars and Canudo and the Berlin art dealer Herwarth Walden. Walden, editor of the magazine *Der Sturm* ('The Storm'), ran a gallery in Berlin of the same name, in which he was later to mount Chagall's first solo exhibition in 1914. It was Apollinaire who had drawn Walden's attention to Chagall, and Apollinaire's poem served as the preface to the exhibition catalogue.

Ricciotto Canudo, the editor of the avant-garde magazine *Montjoie*, had furnished Chagall with a letter of recommendation to the well-known French collector Jacques Doucet, who had purchased many works, including Picasso's *Demoiselles d'Avignon*. When Chagall went to meet him, taking along a portfolio of water-

The Birth, 1911
Oil on canvas, 113.3 x 195.3 cm
Chicago (IL), The Art Institute of Chicago,
Gift of Mr. and Mrs. Maurice E. Culberg

PAGE 56:
The Violinist, 1912–13
Oil on canvas, 188 x 158 cm
Amsterdam, Stedelijk Museum

PAGE 57:
The Violinist, 1911
Oil on canvas, 94.5 x 69.5 cm
Düsseldorf, Kunstsammlung
Nordrhein-Westfalen

PAGE 58:
The Soldier Drinks, 1911–12
Oil on canvas, 109.1 x 94.5 cm
New York, The Solomon R. Guggenheim
Museum

PAGE 59:
The Temptation (Adam and Eve), 1912
Oil on canvas, 160.5 x 114 cm
Saint Louis (MO), The Saint Louis Art
Museum, Gift of Morton D. May

(continued on page 62)

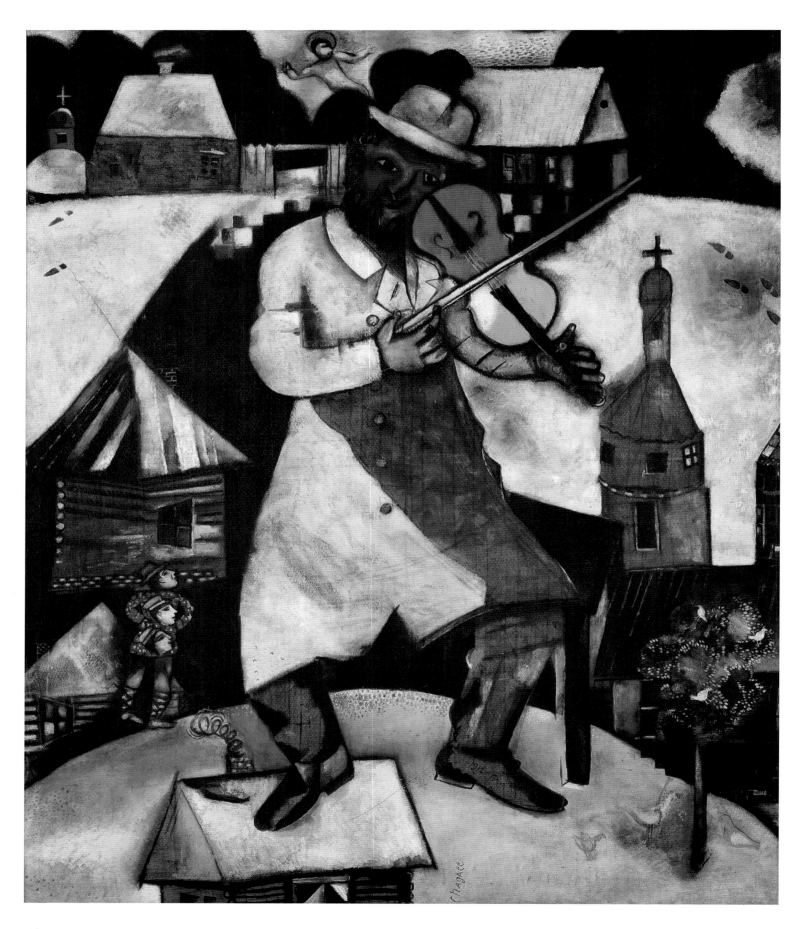

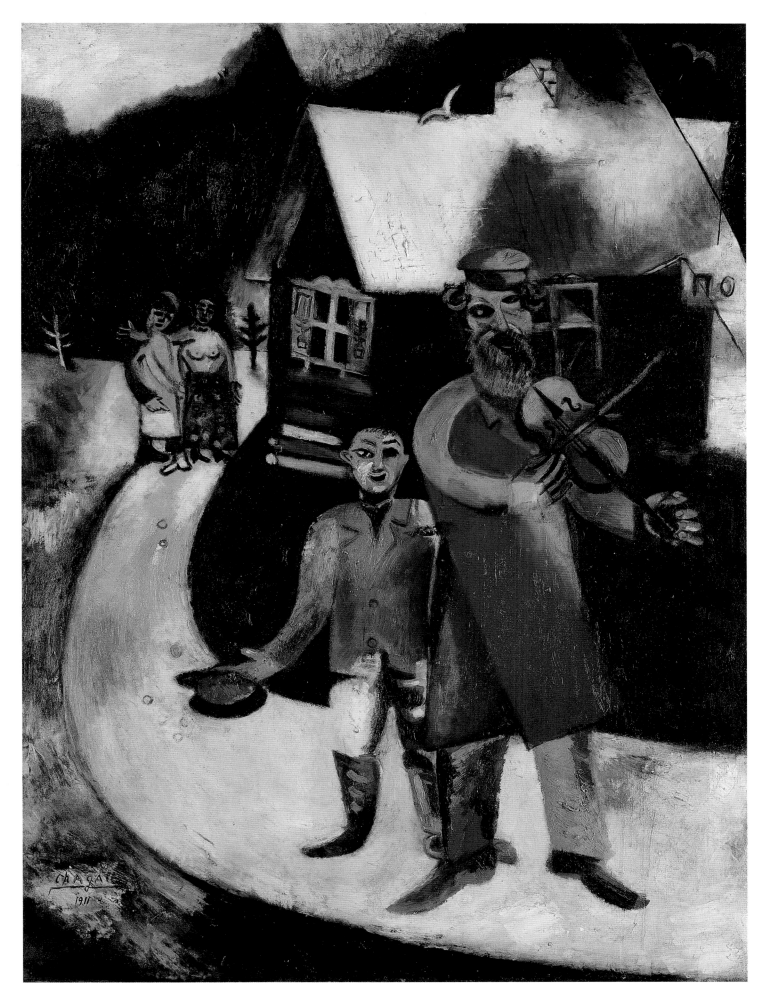

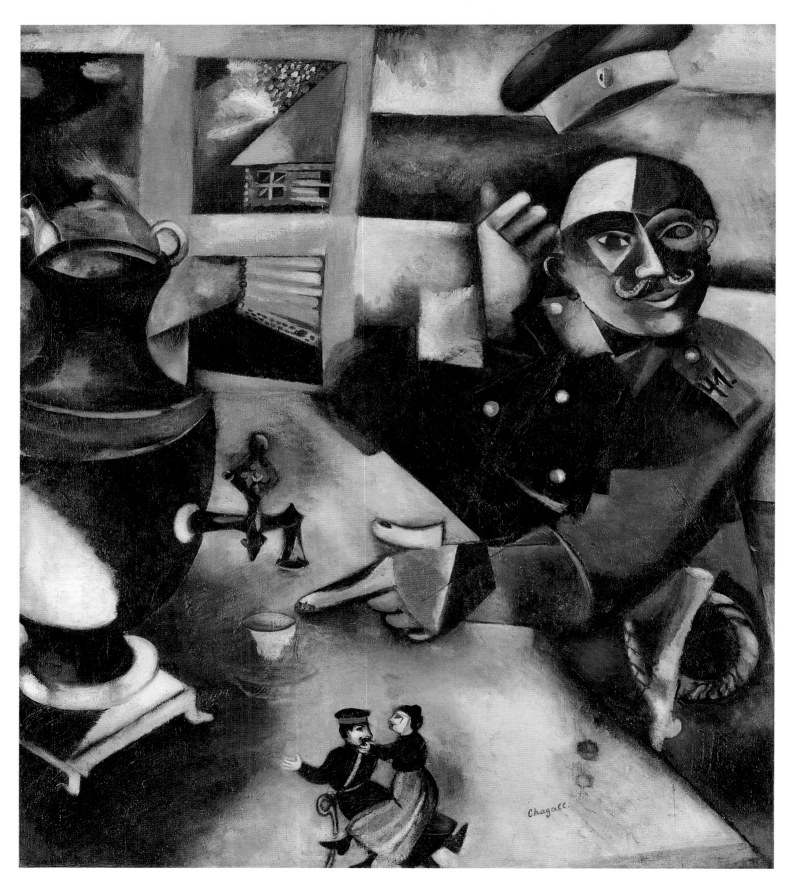

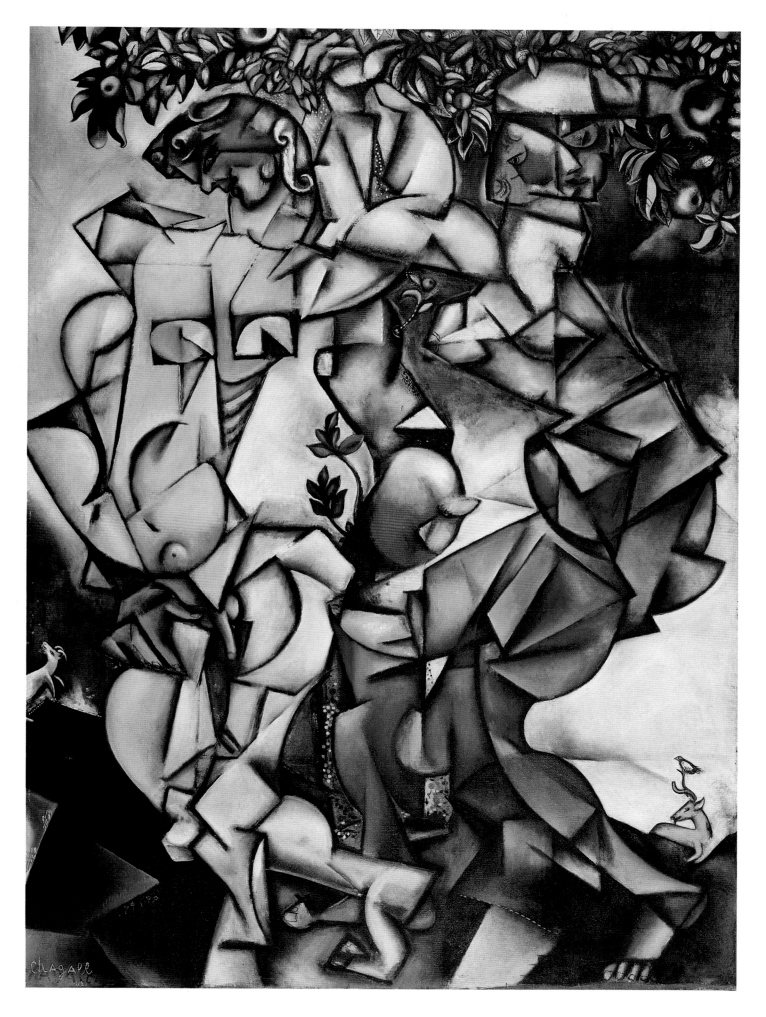

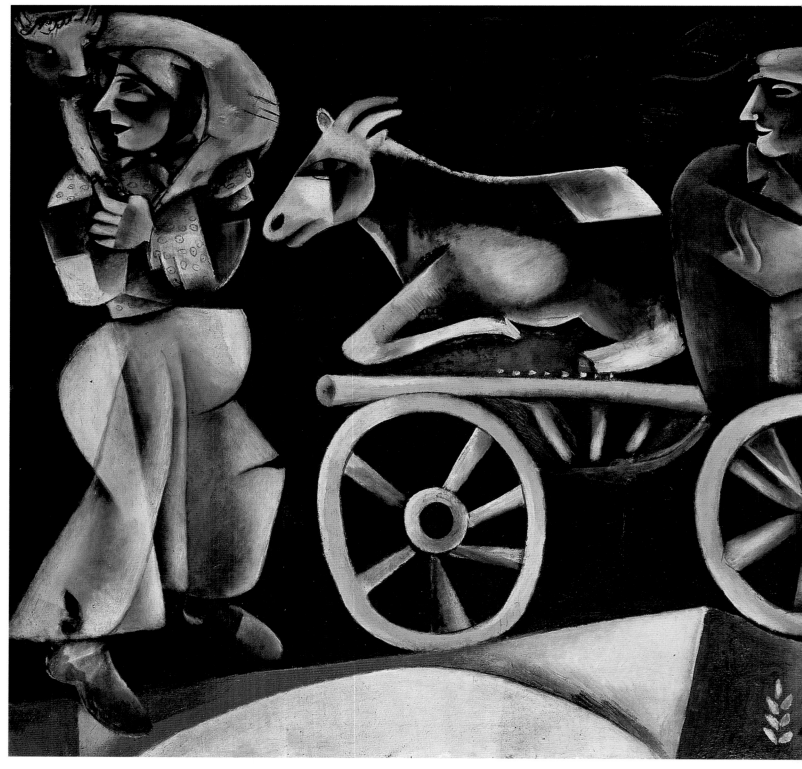

The Cattle Dealer, 1912
Oil on canvas, 97 x 200.5 cm
Basle, Öffentliche Kunstsammlung Basel,
Kunstmuseum

As a child, Chagall used to love to visit his
Uncle Neuch, a cattle dealer. In *My Life* he
describes how much he enjoyed riding through
the countryside in his uncle's cart, on their
way to buy cattle. There are traces of Cubism in
this painting too. The farmer's wife on the left
is carrying a young animal on her shoulders.
There is a cow on the cart and in the transpar-
ent belly of the mare, a foal. In the foreground,
a Russian farmer is talking to his wife. Chagall
portrays both the visible and the invisible. He
exhibited this painting in 1914 in the Sturm

Gallery in Berlin, where he had stopped on his
way from Paris to Russia. It was admired by
the German Expressionists, especially August
Macke and Franz Marc, who were also well-
known for their animal paintings. Chagall's
Cattle Dealer is not only a vivid depiction of
rural life in Russia at the turn of the century
but also a symbolic picture on many levels.
With masterly perception, Chagall reveals to
us the never-ending dialogue between man and
nature, animals and man.

colours, Doucet's valet returned after a quarter of an hour with the tidings: "We have no requirement for the 'best colourist of our day'."

On the subject of Cubism, which at that time was all the rage, Chagall wrote in *My Life*: "Personally I do not think a scientific bent is a good thing for art. Impressionism and Cubism are foreign to me. Art seems to me to be above all a state of soul.

All souls are sacred, the soul of all the bipeds in every quarter of the globe." By contrast Chagall's work is pure poetry, shot through with a distinct sense of humour. This is why it is no great surprise that his significance was first recognized by poets and writers. Whenever Chagall was asked to explain his paintings, he replied: "I don't understand them myself. They are not literature. They are only pictorial arrangements, which obsess me. The theories that I could make up to explain myself and those which others elaborate regarding my work are nonsense. My paintings are my *raison d'être*, my life, and that is all there is to say." Chagall's contribution to 20th-century art has been to discover poetry for painting.

Among Chagall's other friends in Paris were the writer and artist Max Jacob and the painter Robert Delaunay. Every Friday, at the home of Ricciotto Canudo, he would meet the painters Albert Gleizes, Jean Metzinger, Roger de la Fresnaye, André Dunoyer de Segonzac and André Lhote. Chagall was also visited by his St Petersburg patron Maxim Vinaver and the Russian journalist Anatoly Lunatscharsky, who later rose to occupy the influential position of Soviet Minister of Culture.

In 1912 Chagall exhibited for the first time at the 'Salon des Indépendants', showing three canvases: *The Drunkard* (1910–12, ill. p. 41), *Dedicated To My Fiancée* (1911, ill. p. 43) and *To Russia, Asses and Others* (1911, ill. p. 35). Robert Delaunay, who according to Chagall was always nervous and excitable, tried to steal the show at the 'Salon' by submitting his largest canvases. Chagall later reported that Delaunay was fond of him, but was also given to criticizing him. Other participants at the 'Salon' were the sculptors Raymond Duchamp-Villon, whose magnificent and mysterious work made a great impact on Chagall, and Alexander Archipenko,

The Cattle Dealer, 1912
Gouache and watercolour, 26.2 x 47 cm
Berne, Collection E. W. K.

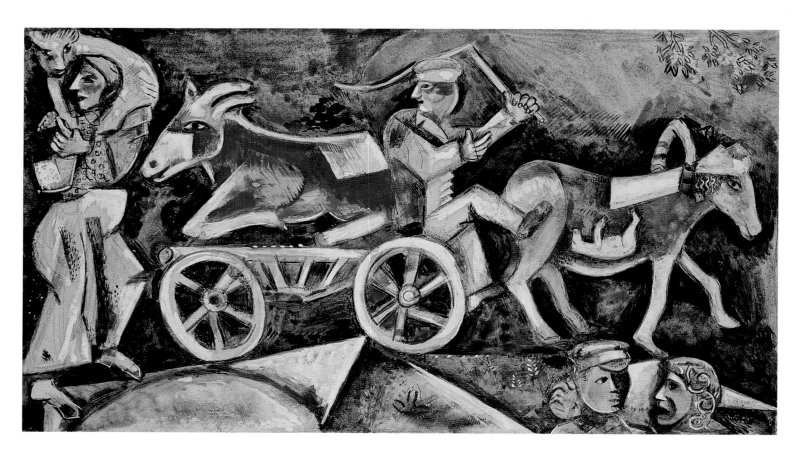

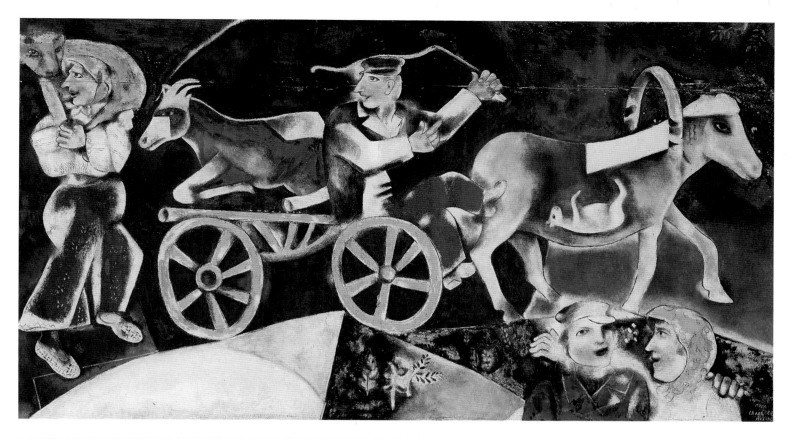

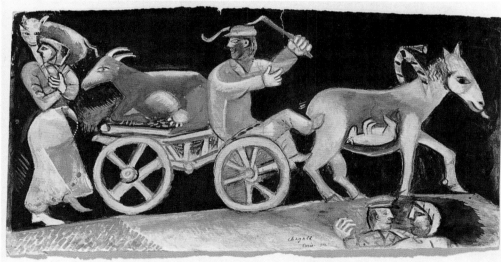

The Cattle Dealer, 1922–23
Oil on canvas, 99.5 x 180 cm
Paris, Musée national d'art moderne,
Centre Georges Pompidou

The Cattle Dealer, 1912
Gouache and ink with pencil on paper,
15.2 x 31 cm
Private collection

whom Chagall was later to meet again in Berlin and during the Second World War in the United States.

At the invitation of Robert Delaunay, Henri Le Fauconnier and Moische Kogan, Chagall exhibited the same year at the 'Salon d'Automne'. One of the three canvases he submitted was *Golgotha (Calvary)* (1912, ill. p. 71), his first painting depicting Christ on the cross. The cold, green storm clouds contrast dramatically with the warm, earthy colours in the foreground. Here again Chagall demonstrated his independence from any school in vogue in Paris at that time. Many regarded Chagall as a primitive painter, others as a naive artist, but this exhibition proved that he was neither.

In 1897 Pissarro had painted, looking out from his window, impressionistic Parisian boulevard scenes, and Chagall's *Paris Through My Window* (1913, ill. p. 32), a painting full of emotions, ambiguity, playfulness and nostalgia for Vitebsk, forms an obvious contrast to them. One half of a double head looks back to the past,

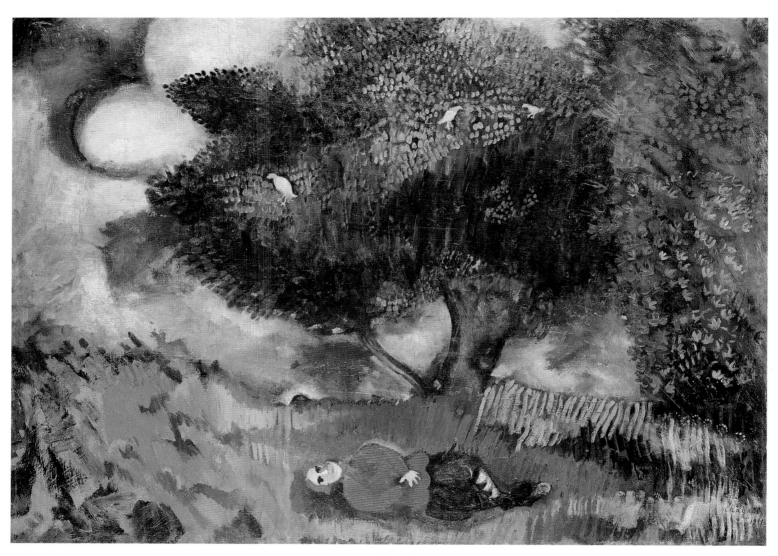

Poet with Birds, 1911
Oil on burlap, 72.3 x 100 cm
Minneapolis (MN), The Minneapolis Institute of Arts,
The Putnam Dana McMillan Fund

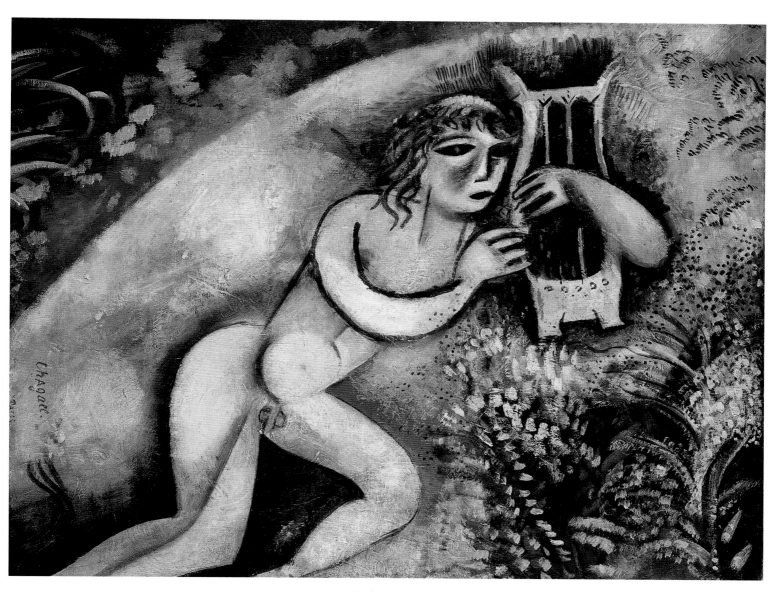

Orphée, 1913–14
Oil on canvas, 42.5 x 56.2 cm
Private collection

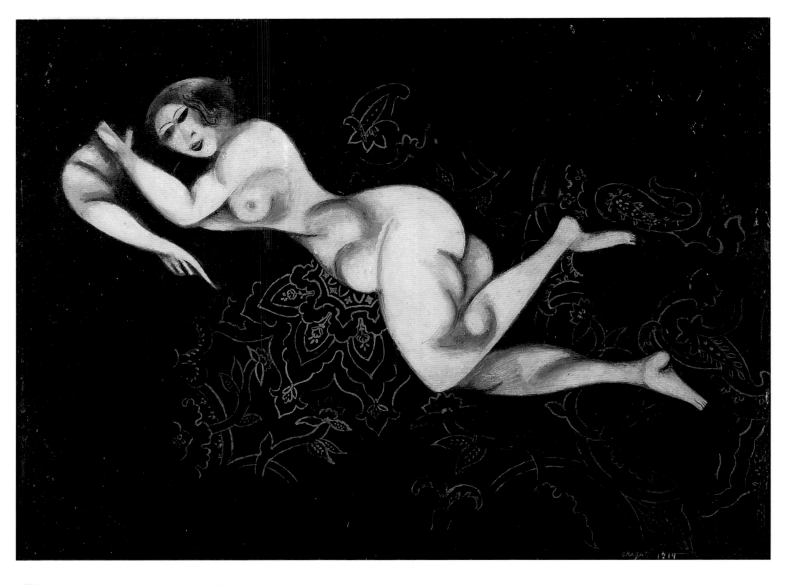

Reclining Nude, 1914
Oil on cardboard, 37.5 x 50 cm
Private collection
Courtesy Gallery Daniel Malingue, Paris

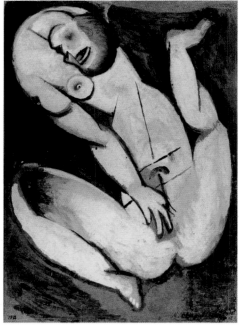

Nude in Movement, 1913
Gouache on brown paper, 34.7 x 23.9 cm
Paris, Musée national d'art moderne,
Centre Georges Pompidou

Yellow Nude, 1913
Gouache and Indian ink on paper, 34.4 x 24 cm
Berne, Collection E. W. K.

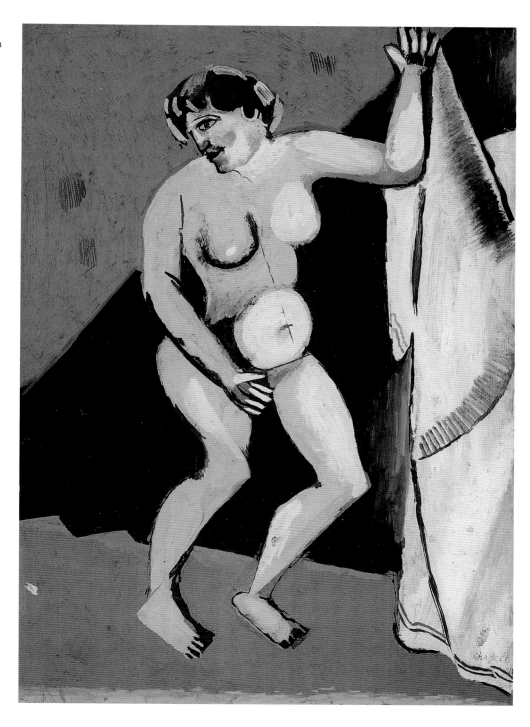

while the other looks forward, to Paris, with its exciting colours and its disorient-ating influences. In this painting too, a masterpiece of Chagall's, certain Cubist elements are at play, dream and reality intermingling.

 With *The Soldier Drinks* (1911–12, ill. p. 58) Chagall returned to the theme of the soldier, which he had already treated a number of times. The soldier's cap hovers above his head, and in front of him stands a massive samovar and a teacup. His native village is glimpsed through the window. The work is rich in colour and shapes derived from post-Cubism, but displays at the same time Chagall's distinct imprint. Likewise, in *The Drunkard* (1910–12, ill. p. 41) the detached head, the man's body, his knife and his bottle all float against a flat table and background, where depth is substituted by bright colours and geometric shapes. *Dedicated to My Fiancée* (1911, ill. p. 43) is painted with an ardent vitality, the details laying the picture open to sexual and erotic interpretation, which led the censors of the 'Salon des Indépendants' to clamour for its withdrawal.

The Holy Carter, 1911–12
Oil on canvas, 148 x 118.5 cm
Private collection

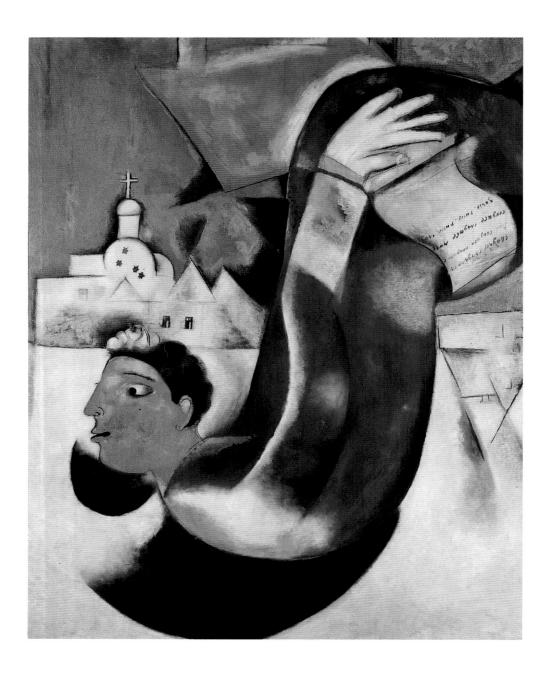

However, as Chagall describes in *My Life*, he and his friends denied any pornographic intent, and the guardians of morality relented. This picture was the first work of Chagall's to be mentioned in the Paris press. Apollinaire wrote in *L'Intransigeant*: "The Russian painter Chagall is showing a golden donkey smoking opium. The painting got up the noses of the police, but a little gold scattered over the offending lamp smoothed matters over."

In Paris Chagall continued to paint Jewish motifs and Vitebsk subjects, although during his last year there he expanded his repertoire to include Parisian scenes – the Eiffel Tower in particular crops up in a number of canvases. And, as in the past, he painted more portraits and self-portraits. In the two following years Chagall again exhibited at the 'Salon des Indépendants', showing in 1913 *The Birth* (1911, ill. p. 55) and *The Temptation (Adam and Eve)* (1912, ill. p. 59), and in 1914, on the eve of his return to Russia, *The Violinist* (1912–13, ill. p. 58), *Maternity* (1912–13, ill. pp. 52, 53), and *Self-Portrait with Seven Fingers* (1913–14, ill. p. 73). This last extraordinary painting generated considerable interest. For Chagall the number seven had mystical and magical properties – he himself had been born on the seventh day of the seventh month of the year 1887. Along with some other works from the 'Salon' the painting was sent to Amsterdam to be subsequently purchased by the collector Regnault. Today it hangs in the Stedelijk Museum in Amsterdam.

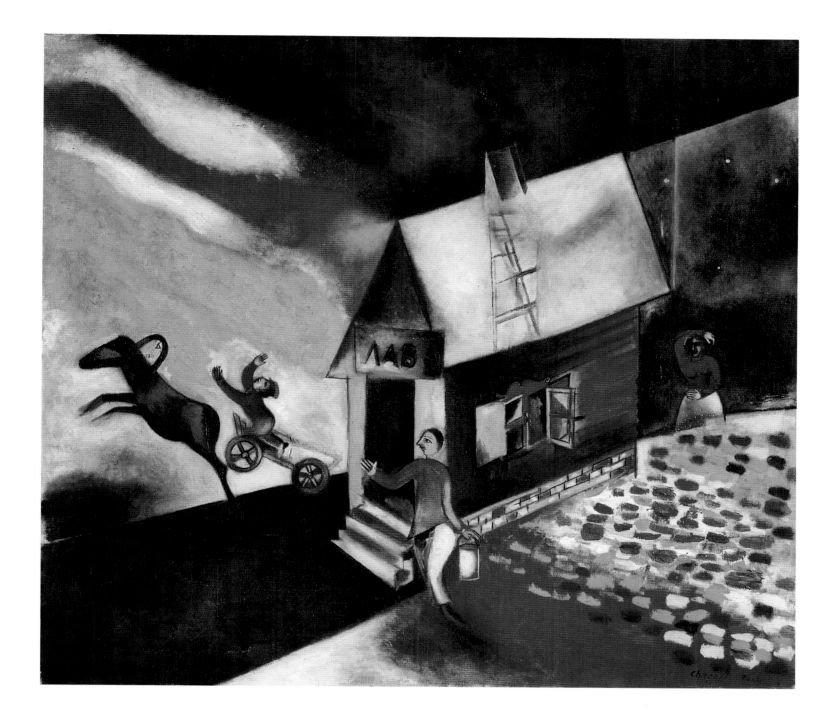

The Burning House, 1913
Oil on canvas, 107.2 x 120.5 cm
New York, The Solomon R. Guggenheim
Museum

Chagall missed his fiancée, Bella. He thought about her day and night, and, living so far away from her, was afraid of losing her. So he decided to take up Herwarth Walden's invitation to exhibit his work in Berlin, his intention being to travel on from there to Russia, marry Bella, and then return with her to Paris. After four fruitful years in the French capital Chagall arrived in Berlin in May 1914 to make preparations for his first solo exhibition that June. Walden was deeply impressed by Chagall's work and made available to the artist two small rooms at the editorial offices of *Der Sturm*, where Chagall showed 40 unframed canvases and – laid out on tables – 160 gouaches, watercolours and drawings, that he would never see again.

At that time *Der Sturm* was one of the mouthpieces of the avant-garde in Germany – associated with it were artists such as Wassily Kandinsky and Franz Marc – and Chagall's exhibition at Walden's *Sturm* gallery in June and July was an unqualified success. The German critics positively sang his praises. In a review Apollinaire wrote of Chagall as "a young Russian painter, a truly inspired colourist, who draws on the whimsical imagery of Slavic folk art, but always transcends it. He is an artist

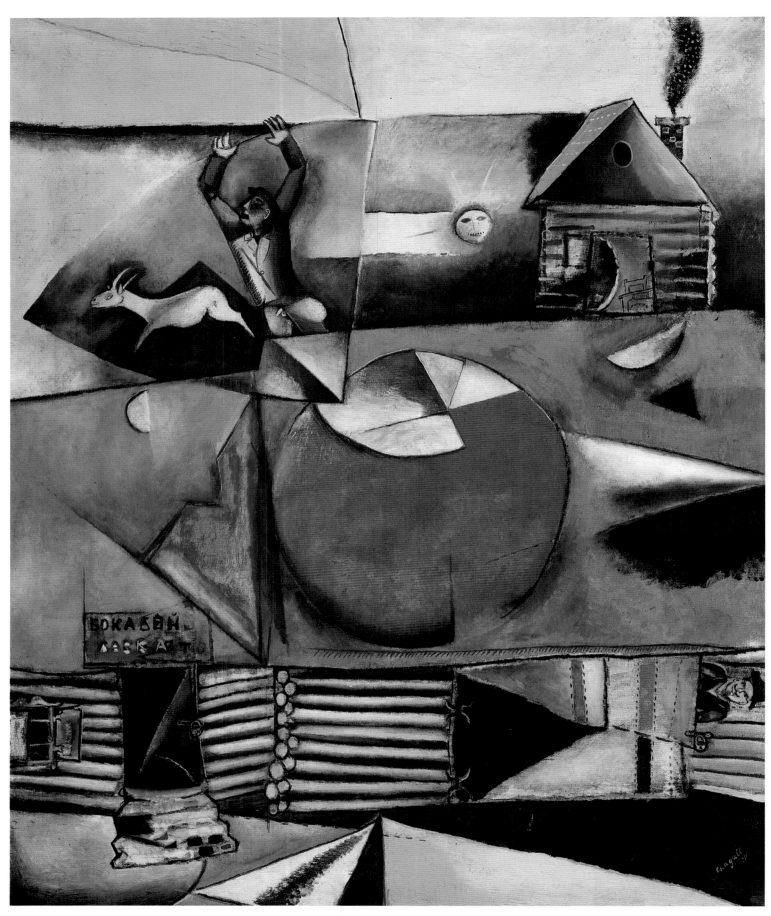

Russian Village under the Moon, 1911
Oil on canvas, 126 x 104 cm
Munich, Bayerische Staatsgemäldesammlungen, Staatsgalerie moderner Kunst

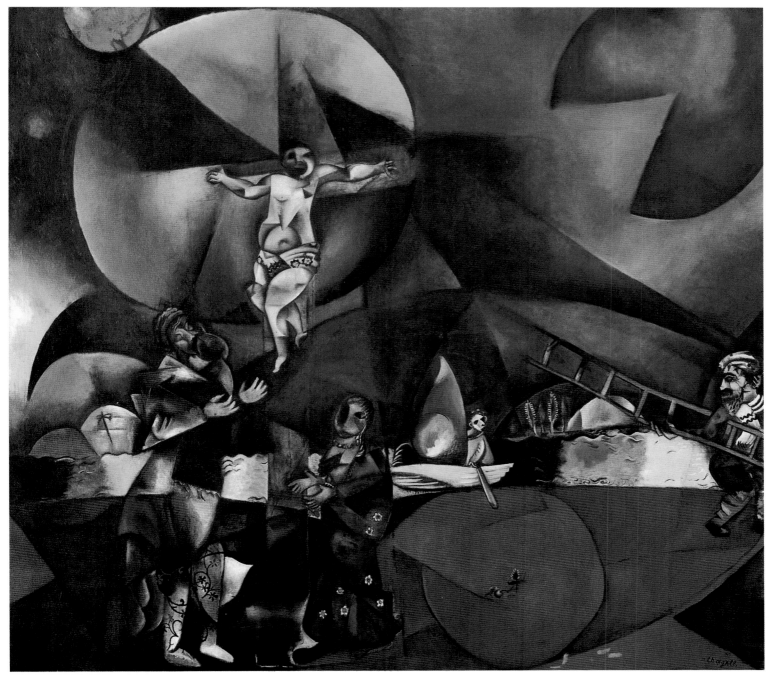

Golgotha (Calvary), 1912
Oil on canvas, 174.6 x 192.4 cm
New York, The Museum of Modern Art,
Acquired through the Lillie P. Bliss Bequest

Chagall was fascinated by the Christian theme of the Crucifixion which, for him, also symbolised the suffering of the Jewish people. This important painting was his first portrayal of the Crucifixion and was to be followed by many more during the course of his life. His intensive treatment of the topic met with heavy criticism within the Jewish community. This work is often seen as a challege to and departure from Russian iconography. Like many Russian icons, it is divided into a number of narrative elements and structures. When interviewed about this painting in 1949, Chagall explained: "I wanted to portray Christ as an innocent child. Now, or course, I see things differently. When I painted this work in Paris, I wanted to free myself psychologically from the outlook of the icon painters and from Russian art altogether". Here, Chagall has taken up the idea of disc compositions, developed by Robert Delaunay and the Cubists. The painting was first exhibited in 1913, under the title *Dedicated to Christ* at the "Ersten Deutschen Herbstsalon" (First German Autumn Salon) in Berlin. It was one of the first of Chagall's works to be sold in Western Europe. The purchaser was Bernhard Koehler, a Berlin collector and patron of the "Blaue Reiter".

Study for Self-Portrait with Seven Fingers, 1911
Gouache and pencil, 23 x 20 cm
Basle, Collection Marcus Diener

of enormous versatility, who subscribes to no theory." This was the last time Apollinaire wrote about Chagall. When Chagall returned to Paris in 1922, he found that his friend had died in 1918 from Spanish influenza.

On 15 June 1914, after the opening of his Berlin exhibition, Chagall embarked on the long journey by train back to Vitebsk, where he planned to remain only briefly. All the works he had brought with him from Paris he left in Berlin. But in his planning he had not reckoned on the intervention of fate. Just a few weeks later the First World War broke out, closing the Russian border for an indefinite period. Chagall was compelled to remain for an unforseeable length of time in Russia.

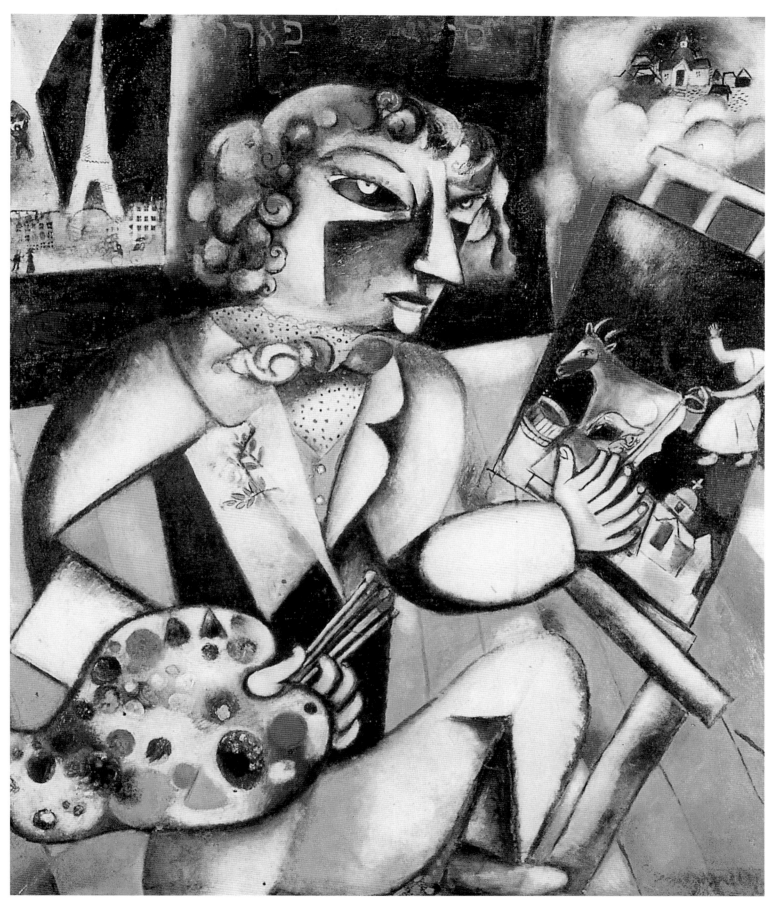

Self-Portrait with Seven Fingers, 1913–14
Oil on canvas, 128 x 107 cm
Amsterdam, Stedelijk Museum

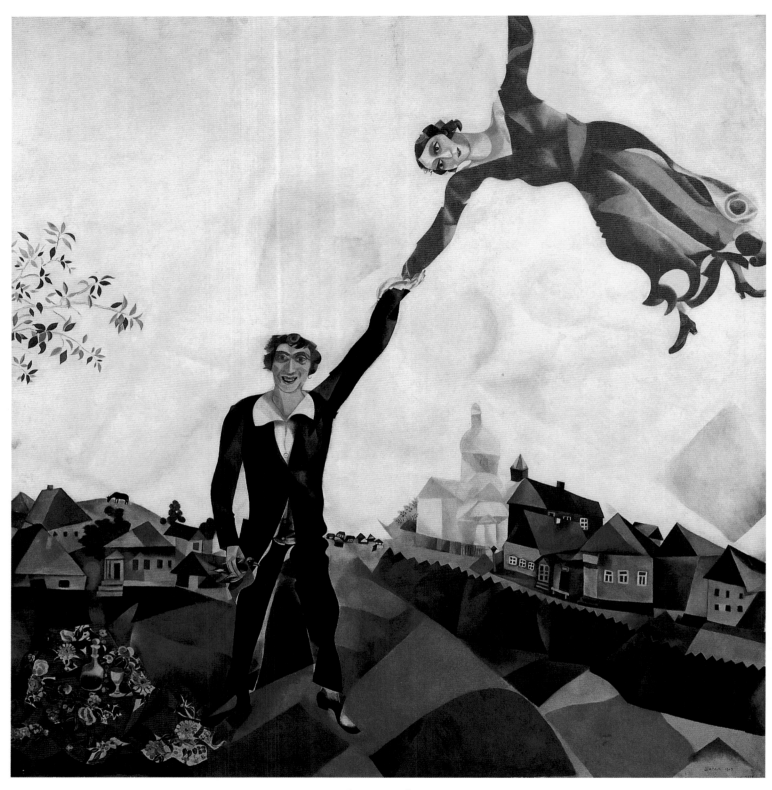

The Promenade, 1917
Oil on canvas, 170 x 163.5 cm
St. Petersburg, State Russian Museum

Russia 1914–1922

"The most productive years of my whole career"

After a fairytale eye-opening stay of four years in Paris, Chagall was back in his home town of Vitebsk, for him "a world all of its own, a singular town, a hapless town, a boring town". He had returned to his origins, his childhood memories, his family. The artist set himself to work, while the rumble of the First World War drew ever closer. Lacking canvas, he painted on cardboard and paper. He painted everything around him: his parents, sisters, brother David, friends, neighbours, beggars and hawkers.

During 1914 and 1915 he produced some 60 works, among them *The News-paper Vendor* (ill. p. 91), *The Black and White Jew, The Green Jew* and *The Red Jew* (ill. p. 81). But uppermost in his thoughts was Bella, who had just returned from Moscow, where she was studying acting with the famous director Konstantin Stanislavsky. For four long years the couple had only been in touch by letter, and with the passage of time these letters had understandably become increasingly perfunctory. Before his first reunion with Bella, Chagall was nervous and apprehensive, but he need not have feared because Bella greeted him very warmly. Chagall rented a small studio, which Bella constantly went in and out of. The Rosenfelds, Bella's affluent parents, were none too pleased about their daughter's intention to marry a painter from a poor family, whose father laboured for a herring-monger. They wondered how Chagall could support their daughter.

Despite strong opposition from Bella's parents, the couple were married on 25 July 1915 by Vitebsk's rabbi under a red 'chuppa' or wedding baldachin. Chagall's marriage inspired him to paint wedding pictures, a subject he repeatedly returned to in later years. The young newly-weds spent their honeymoon in the country, where Chagall painted lyrical landscapes. Here he produced *The Poet Reclining* (1915, ill. p. 89), which now hangs in the Tate Gallery in London.

Chagall's efforts to return to Paris proved futile. Even in Vitebsk there was no mistaking that a war was in progress. In vain did the artist try to have himself exempted from military service, and his suggestion that as a painter he would be well placed to do camouflage work also fell on deaf ears. Instead he went to work in the press department of the War Economy Office in St. Petersburg, where Bella's brother Jacob Rosenfeld secured him a position as a clerk. Off he journeyed, therefore, to the Russian capital in a cattle truck bursting with soldiers.

Chagall hated office work, but he managed to survive somehow. Whenever he could, he visited Bella and, as in Paris, got to know poets and writers. In St. Petersburg his friends included Vladimir Mayakovsky, Alexander Blok, Sergei Essenin and Boris Pasternak. The war did not prevent him completely from painting, and the year 1917 was even an unusually productive one. Chagall's love for Bella grew ever deeper, a development he described many years later in the afterword to her first book *First Encounter:* "As the years went by, her love became palpable in my

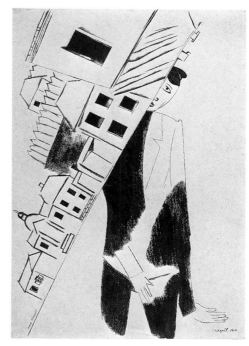

Behind the Village (Man Carrying a Street), 1916
Pen and ink on paper, 31.9 x 22.2 cm
Paris, Musée national d'art moderne,
Centre Georges Pompidou

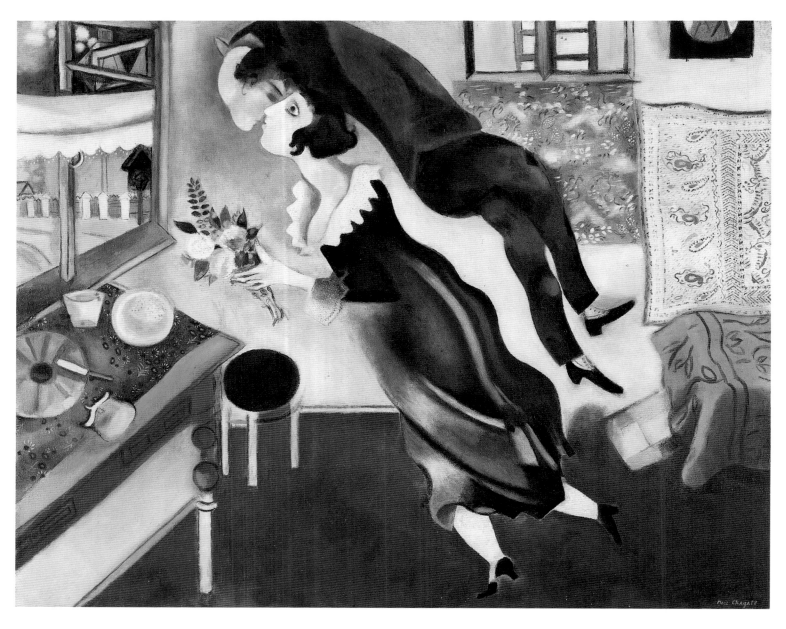

Birthday (L'Anniversaire), 1915
Oil on canvas, 81 x 100 cm
New York, The Museum of Modern Art.
Acquired through the Lillie P. Bliss Bequest.

In 1914 Chagall returned to Russia to marry his
beloved fiancée Bella Rosenfeld and bring her
back to Paris. He expressed his deep love for
her in several paintings from 1915–1917. In her
book *First Encounter*, Bella describes how she
wanted to decorate Chagall's room on his
birthday with flowers and coloured shawls.
While she was still holding the flowers in her
hand, he asked her to stand still so that he
could paint her. Bella wrote: "You flung your-
self upon the canvas so that it quaked under
your hand; you snatched the brushes and
squeezed out the paint – red, blue, white, trans-
porting me in a stream of colour. United we
float over the decorated room, come to the
window and want to fly out. The brightly hung
walls whirl around us. We fly out over fields full
of flowers, over shuttered houses, roofs, yards,
churches."

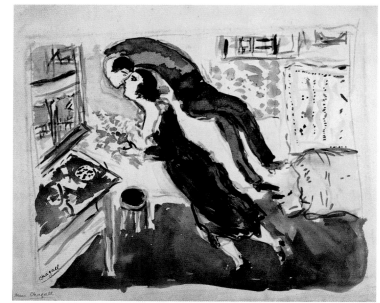

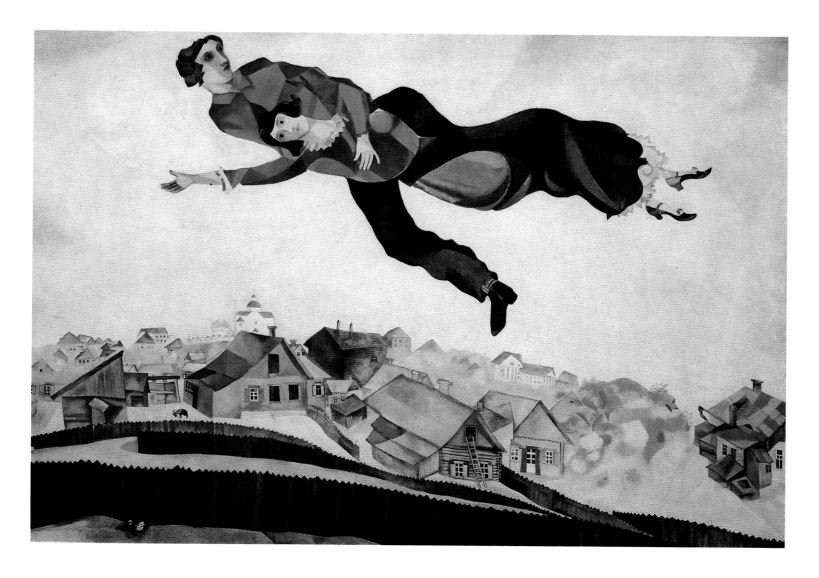

Over the Village, 1914–1918
Oil on canvas, 141 x 198 cm
Moscow, Tretiakov Gallery

paintings. But I always had the feeling that she was holding something back. I thought that Bella was concealing buried treasure at the bottom of her heart. Her lips bore the scent of her first kiss, a kiss like a thirst for justice."

In March 1915 Chagall exhibited 25 of his works in the Michailova art salon in Moscow, and in April 1916 showed 63 pictures in the Dobitchina gallery in St. Petersburg, now renamed Petrograd. In November of the same year he was represented with 45 works at the Moscow exhibition of the avant-garde artists' group 'Jack of Diamonds'. This exposure caused Chagall's fame to spread, and many of his pictures were acquired by the collectors Kagan-Shabshay and Vissotsky. Even the celebrated Russian collector Ivan Morosov bought his first Chagalls. At this time Chagall produced his first book illustrations – small ink drawings for two books written in Yiddish. On 18 May 1916 his daughter Ida was born. The Chagalls were over the moon, and in the years that followed the artist repeatedly painted the little girl.

With the February Revolution of 1917, which in March led to the abdication of the tsar, Lenin's Bolshevik Revolution began to cast its long shadow. Chagall, like many Russian Jews welcomed the 1917 Revolution, which seemed to bring Jews full equality of rights. Thus segregation was ended and college admission restrictions lifted. Many leading Bolsheviks were Jews – Trotsky, for example – and it is noticeable how several of Chagall's paintings of this period depict Russian soldiers.

Chagall was now 30 and had meanwhile made a name for himself. The revolution demanded of sculptors and painters, composers and poets, new forms of artistic expression. Led by Kasimir Malevitch and Vladimir Tatlin, the Suprematists and Constructivists began to fight for their ideas, and El Lissitsky, who at that time was still working representationally, illustrating Yiddish books and the Passover

PAGE 76 BOTTOM:
Study for Birthday, 1915
Watercolour, 22 x 26.6 cm
Paris, Musée national d'art moderne,
Centre Georges Pompidou

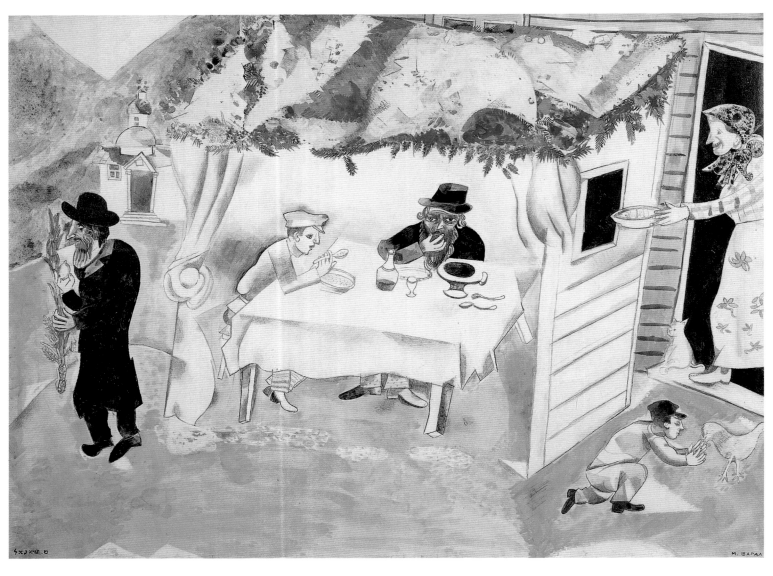

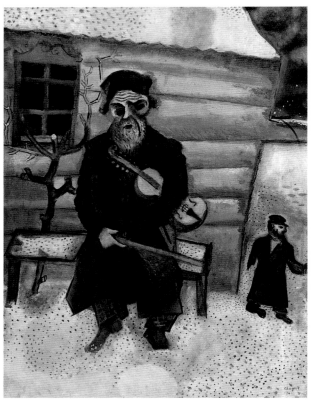

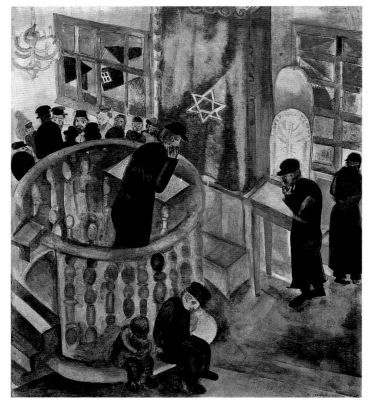

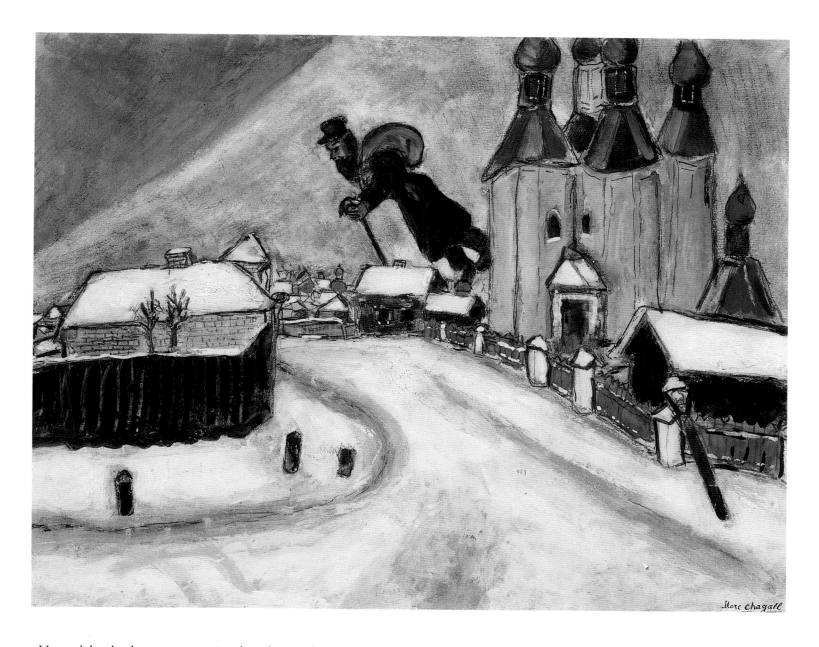

Haggadah, also became committed to the revolution. Anatoly Lunatcharsky, who had been living in exile in Paris, returned to Russia to be appointed by the Bolsheviks 'People's Commissar for Cultural and Educational Policy' – a kind of Minister of Culture. Because Chagall had a reputation as an avant-garde artist, Lunatcharsky considered the idea of nominating him director of the fine arts department within the Ministry of Culture, complementing Mayakovsky and Meyerhold, who would head respectively the Ministry's poetry and theatre departments.

Bella was not at all happy with the idea of her husband entering the political fray, and she prevailed upon him to return to Vitebsk, where they could live comfortably in the big Rosenfeld family house. During the first winter of the revolution (1917–18), Chagall painted large compositions revolving around Bella and Ida, such as: *Over the Village* (ill. p. 77), *The Promenade* (ill. p. 74), *Double Portrait With a Glass of Wine* (ill. p. 99), and *Apparition (Self-Portrait with Muse)* (ill. p. 97). The paintings articulate the artist's profound happiness and his love for his wife and daughter, and are among Chagall's most outstanding works.

1918 saw the publication in Moscow of the first monograph on Chagall's work, written by Abraham Efross and Jacob Tugendhold. At about this time Chagall conceived the idea of founding an art school in Vitebsk. He informed Lunatcharsky, who reacted to the idea with enthusiasm, inviting Chagall to his Moscow office in the Kremlin for a discussion. On 12 September 1918 Chagall was officially appointed – to Bella's chagrin – Fine Arts Commissar in Vitebsk, responsible for museums,

Over Vitebsk, c. 1914
Oil, gouache, pencil and ink on paper,
31 x 39 cm
Philadelphia (PA), Philadelphia Museum of Art,
The Louis E. Stern Collection

PAGE 78 TOP:
Succoth (Feast of the Tabernacles), 1917
Gouache on paper, 47 x 62.9 cm
Basle, Collection Marcus Diener

PAGE 78 BOTTOM LEFT:
The Violinist on a Bench, 1914
Oil on cardboard, mounted on canvas
46 x 38 cm
Paris, Private collection
Courtesy Gallery Daniel Malingue, Paris

PAGE 78 BOTTOM RIGHT:
The Synagogue, 1917
Gouache on paper, 40 x 35 cm
Basle, Collection Marcus Diener

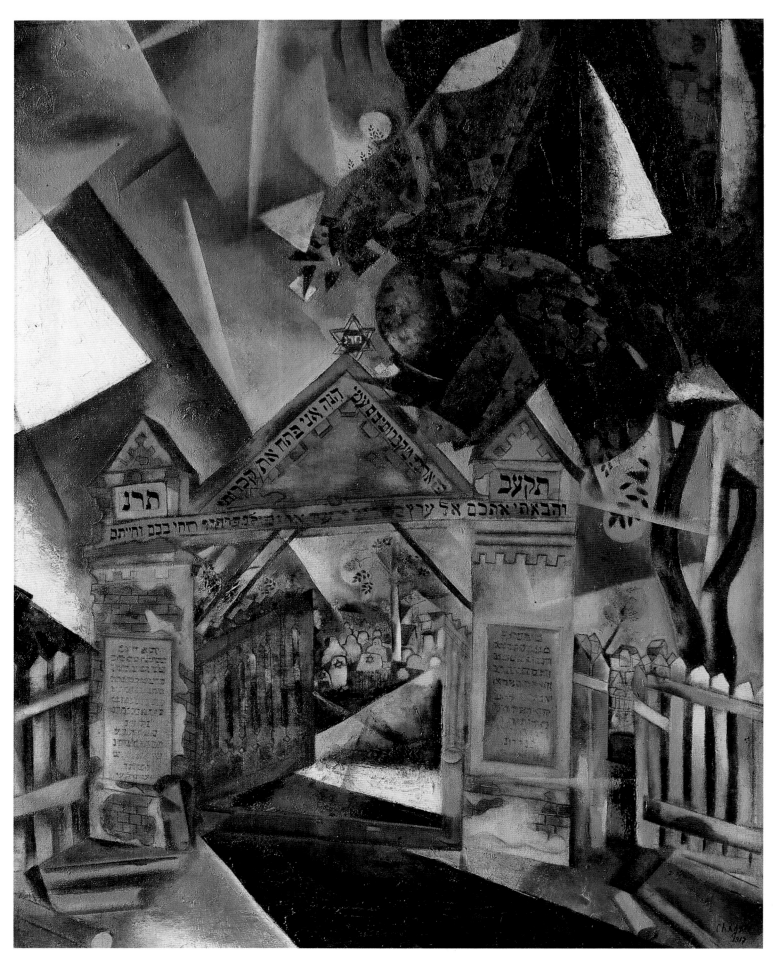

The Cemetery Gates, 1917
Oil on canvas, 87 x 68.5 cm
Paris, Musée national d'art moderne,
Centre Georges Pompidou, Gift of Ida Chagall

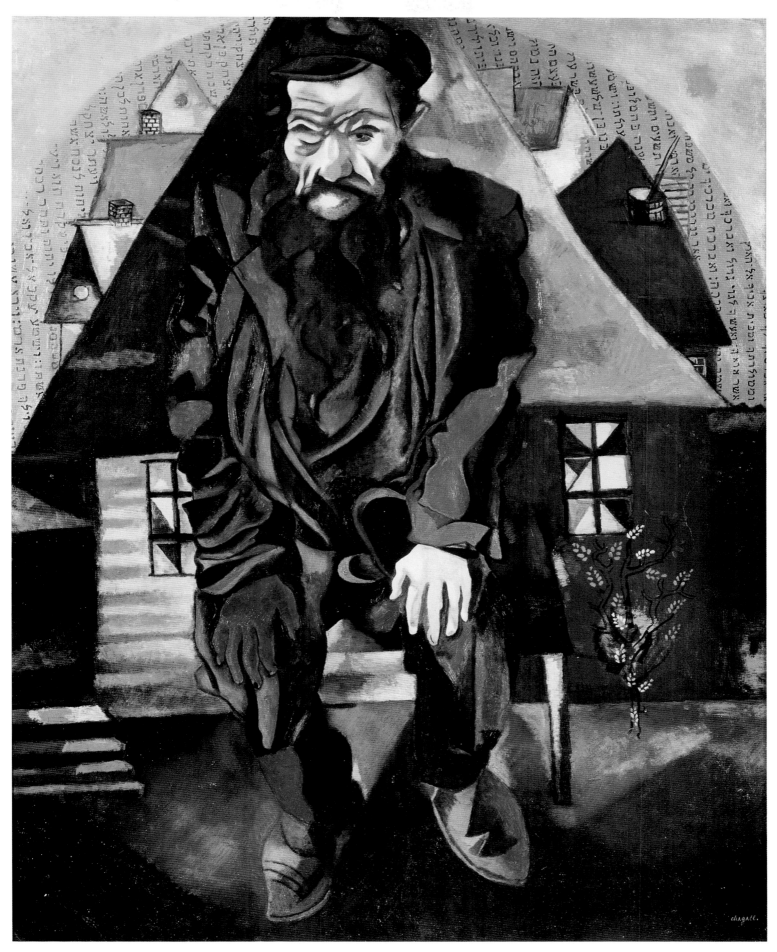

The Red Jew, 1915
Oil on cardboard, 100 x 80.6 cm
St. Petersburg, State Russian Museum

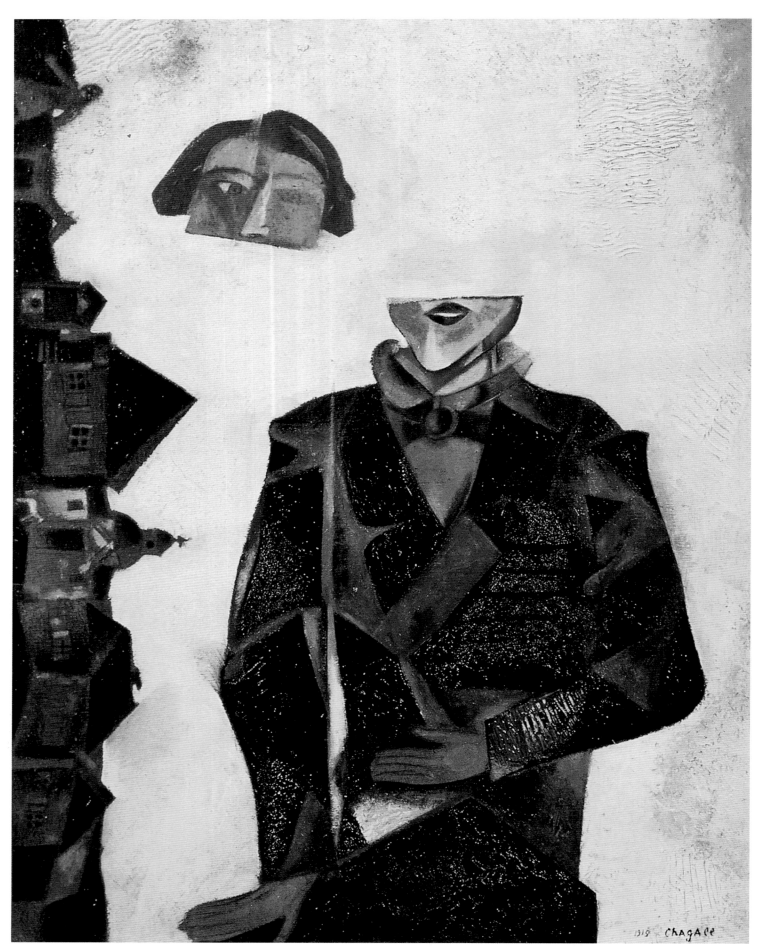

Anywhere Out of the World, 1915
Oil on cardboard, mounted on canvas, 61 x 47.3 cm
Takasaki, Gunma Museum of Modern Art

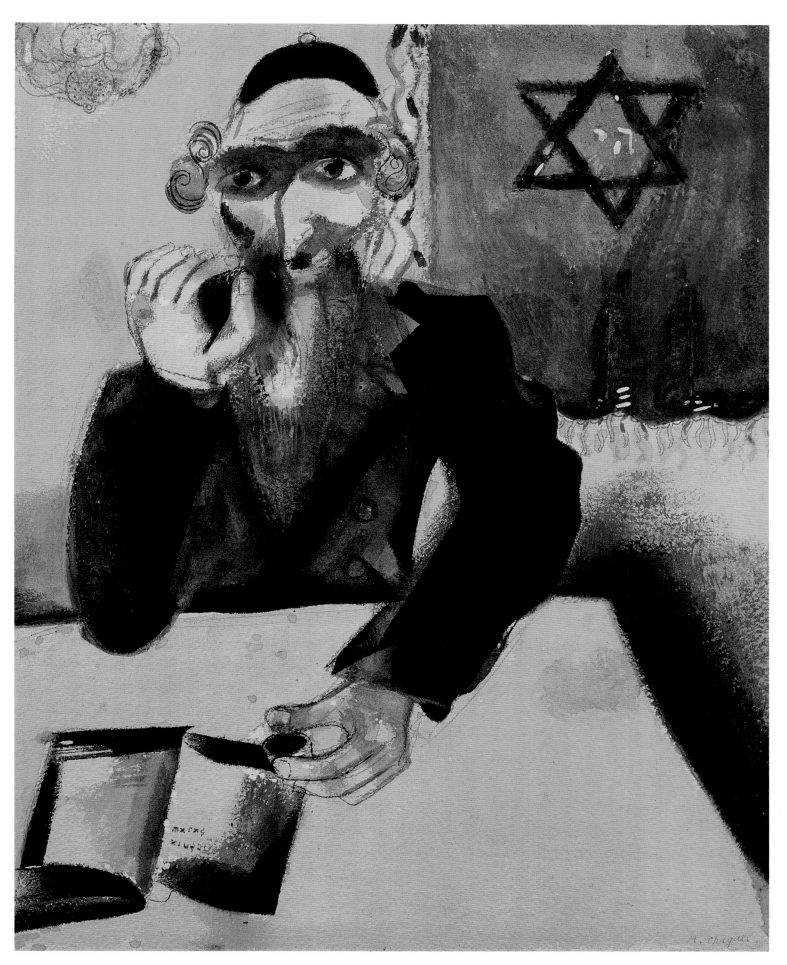

The Pinch of Snuff, 1923–24
Watercolour on cardboard, 42.7 x 35 cm
Milwaukee, Collection M. B. Katz

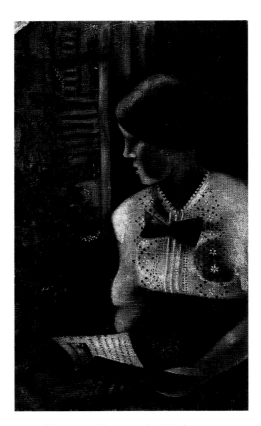

Lisa (the Artist's Sister) at the Window, 1914
Oil on canvas, 76 x 46 cm
Private collection
Courtesy Galerie Beyeler, Basle

Aniuta (the Artist's Sister), 1910
Oil on canvas, 92.8 x 70.8 cm
New York, The Solomon R. Guggenheim
Museum

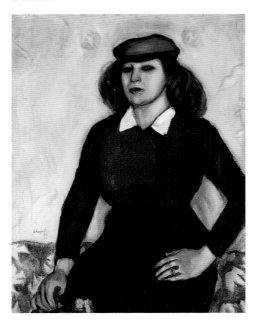

exhibitions, art schools, lectures and other artistic activities. From September 1918 to May 1920 he devoted himself heart and soul to his new duties, constantly pestering the authorities for more resources for his art projects. He organized a major exhibition of Vitebsk artists, involving among others Yehuda Pen and Viktor Mekler. However, central to his efforts was the art school in Vitebsk. Chagall enlisted Russia's greatest artists, including the leading lights of the Russian avant-garde, who all came from Petrograd and Moscow. He managed to persuade Mstislav Dobushinsky, a former teacher of Chagall's at the Svanseva School, to join his institution, which in January 1919 was opened as the 'Art Academy of Vitebsk'. Other teachers were Ivan Puni and his wife Xenia Boguslavskaya. At Puni's urging Chagall invited Kazimir Malevitch and El Lissitzky to Vitebsk, which soon proved to be a fatal mistake. Somewhat belatedly he also managed to win over his first teacher, Yehuda Pen, for the academy, who had been hurt because he had not been appointed at the outset.

To celebrate the first anniversary of the Russian Revolution on 6 November 1919 (according to the newly introduced Gregorian calendar), festivals were organized across the land, and in Vitebsk Chagall mobilized all the artists and craftsmen to get involved. One of his own design ideas was a green horse with a tuba-playing rider. Seven specially constructed triumphal arches graced the town, as well as 350 painted red banners, making it look as if it were carnival or fair time in Vitebsk. There was a firework display, and people sang and danced in every street and alleyway. Chagall had wanted to bring art to the people, but the functionaries were not exactly enamoured of green cows and people flying upside down, and in the press the whole spectacle was attacked as having nothing to do with Marx and Lenin.

In 1919, in an article published in *Revoluzionnoya Iskusstvo*, entitled 'Revolution in Art', Chagall wrote: "The art of today, like that of tomorrow, needs no 'content'. Real proletarian art will succeed with simple wisdom in breaking inwardly and outwardly with everything that can only be branded as 'literature'."

Chagall had been naive in thinking that in his school Suprematists and Constructivists would happily work alongside academic artists such as Yehuda Pen and Viktor Mekler, and as early as the summer of 1919 disputes broke out. Malevitch, who had started out in 1900 as an Impressionist artist and meanwhile embraced a geometrical art dominated by pure colour, bitterly opposed Chagall's art and artistic concepts. El Lissitsky, who taught graphic art and architecture at the school, had abandoned the Chagall-like style of his book illustrations and gone over to Malevitch, who was already painting white on white, or black on black. He had also developed new pedagogical methods based on his manifesto on the theory of colour and form, which proclaimed the 'death of painting'. That Lissitsky, whom Chagall regarded as a follower of his, had now joined the camp of his opponent, hurt Chagall deeply.

The heated debates led to a split in the Vitebsk art school. A painting done by Chagall at that time, *Self-Portrait With Palette* (1917, ill. p. 88), shows the artist deep in thought about his dilemma. The picture is dominated by the red colour of revolution. White counter-revolutionary smoke clashes with red smoke rising from Chagall's house, which ultimately transcends the white. The way the town looms out of the canvas can be seen as art entering the real world. That it has been up-ended is another symbol of the revolution. In *My Life* Chagall writes: "Russia lay under a blanket of ice. Lenin had turned the country's sense of top and bottom upside down, just as I invert my pictures." This 1917 painting, only recently discovered, is published here for the first time. Another work from the period, *Anywhere Out of the World* (1915, ill. p. 82), depicts a figure with its head sliced in two, symbolizing the divisive ructions caused by Chagall's adversaries. By contrast, the *Cubist Landscape* of 1918 (ill. p. 101) incorporates geometrical forms, recalling the post-cubist influences of the artist's first Parisian period.

In 1919 the 'First State Exhibition of Revolutionary Art' was held in Petrograd's Winter Palace. Some 3000 works by 359 artists were shown, and Chagall had pride of place, being accorded the first two rooms, where he hung 15 large paintings

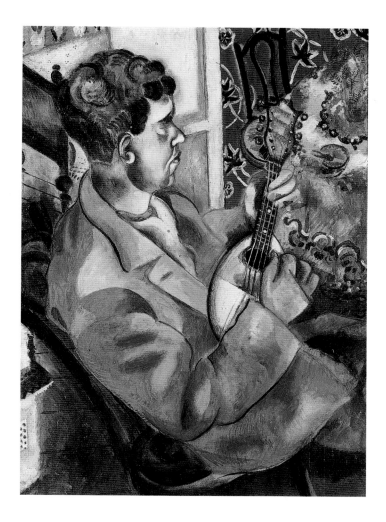

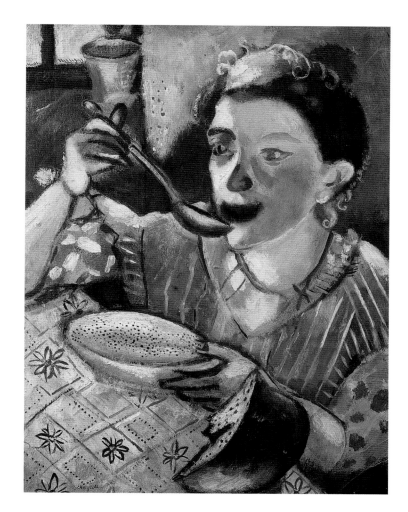

and numerous works on paper in black and white. The State purchased twelve pictures – a resounding success for Chagall.

In the autumn of 1919 Chagall had to travel repeatedly to Moscow to beg money for his academy from Culture Commissar Anatoly Lunatcharsky, who always remained well-disposed towards him. Famine and civil war jeopardized the survival of the infant, two-year old Soviet state, and there was chaos throughout the country. Upon returning to Vitebsk from one of his Moscow fund-raising trips, Chagall discovered, to his great indignation, that his school's sign 'Free Academy of Vitebsk' had been replaced by a banner proclaiming 'Suprematist Academy'. In his absence Malevitch and his supporters had fired the rest of the teaching staff, installing themselves as directors. Chagall felt betrayed, stabbed in the back. Enraged, he forthwith submitted his resignation. His only loyal supporter was Bella, who had never been happy about this official function of his, which had too often caused him to neglect his artistic work. The majority of the academy's students, who were on Chagall's side, urged him to withdraw his resignation, but he was not to be dissuaded, and, as once before, boarded a cattle truck to travel to Moscow.

Late 1919 Chagall did once return briefly to Vitebsk. His father had been hit by a car at work and fatally injured. Shortly afterwards the artist also learned that his brother David had died in a TB sanatorium in the Crimea. In May 1920, taking his wife and daughter with him to Moscow, Chagall left Vitebsk forever. Malevitch renamed the Vitebsk academy 'Institute of New Art', directing it until 1922.

Like Bella, who had originally wanted to become an actress, Chagall was very interested in the world of the theatre, in particular Jewish theatre. He had designed a stage set as far back as 1911, when he was a student in St. Petersburg. This was a monumental enlargement of his painting *The Drunkard*, done at that time (ill. p. 41). He followed this up with designs for Gogol's plays *The Wedding* and *The Gamblers*, which, however, were never staged. Then, for the Moscow 'Theatre

TOP LEFT:
David (the Artist's Brother), playing the Mandolin, 1914–15
Oil on cardboard, 50 x 37.5 cm
Helsinki, Atheneum

On his return to Vitebsk, Chagall took up painting members of his close family again. This is a portrait of his younger brother David who was 22 years old at the time and suffering from tuberculosis. It was done just before David left to convalesce in the Crimea, where he died soon after. In *My Life* Chagall recollects how, as boys, they used to sleep together in the same bed, and bitterly regrets that he can do nothing to help the brother he so lovingly portrays. A companion piece to this painting also shows David playing the mandolin, but does not have the rather overworked background.

TOP RIGHT:
Mania (the Artist's Sister) eating Kasha, 1914–15
Oil on paper, mounted on board,
49.2 x 35.7 cm
Private collection

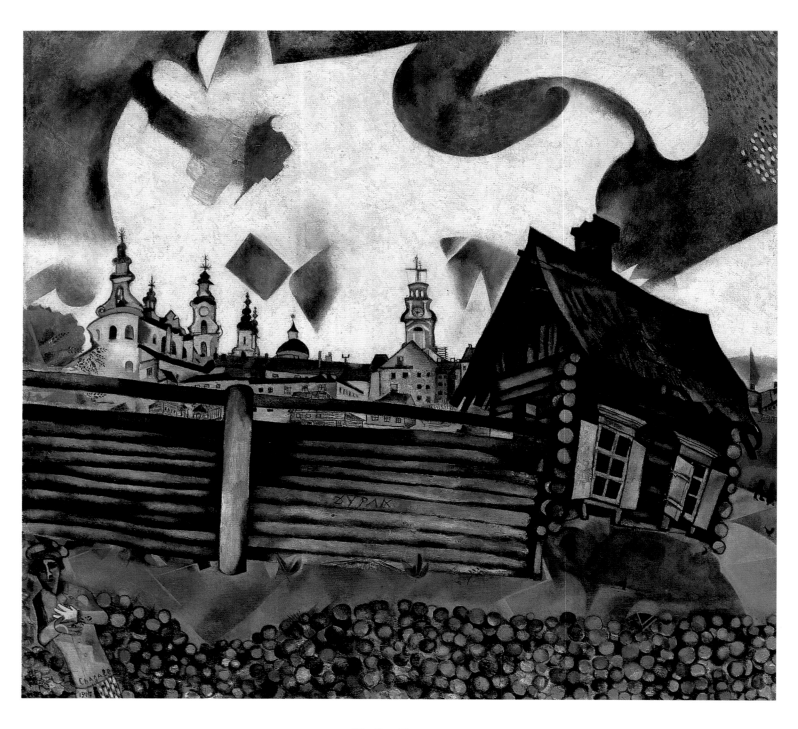

The Grey House, 1917
Oil on canvas, 68 x 74 cm
Madrid, Fundación Colección Thyssen-Borneminsza

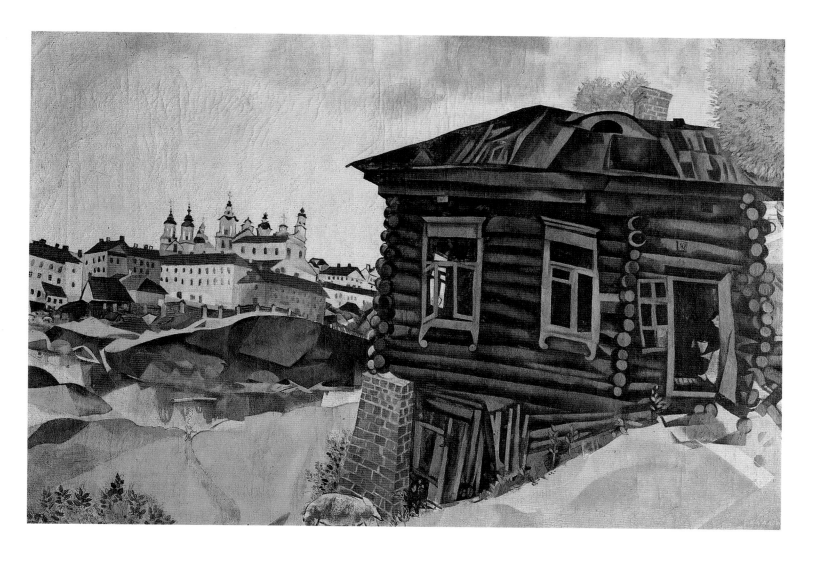

of Revolutionary Satire', Chagall designed the set and costumes for Gogol's *Government Inspector*. He also submitted sketches for John M. Synge's *Playboy of the Western World*, but these were rejected by Stanislavsky's 'Moscow Artists' Theatre' as too fantastic. Chagall was delighted to get an invitation from Alexander Granovsky and his deputy director and assistant the art critic Abraham Efross to work for the 'Kamerny State Jewish Theatre' in Moscow. This studio theatre, founded in 1919 in St. Petersburg, had established itself in November 1920 in Moscow in a small hall with 90 seats. Other Jewish artists working for the theatre were Nathan Altman, Rybock, Tischler and Rabinovitch. Efross accompanied Chagall to the theatre and said: "These walls are yours; do whatever you like with them." Granovsky, a pupil of the legendary director Max Reinhardt, quickly struck up a good relationship with Chagall, whose innovative imaginative ideas matched his own visions of a renewal of the theatre. Chagall, for his part, was ready for a fresh start after the bitter disappointments in Vitebsk. His first tasks included painting murals for the theatre auditorium and designing sets and costumes for three one-act plays by the Yiddish writer and humorist Sholem Aleichem, which were to mark the opening of the theatre on 1 January 1921. The huge murals, the largest Chagall ever painted, constitute a landmark both in the artist's career and in the history of the theatre, and were the forerunners of later large-scale works by the artist, such as the murals of the Metropolitan Opera in New York and the ceiling paintings of the Paris Opera.

Chagall worked continuously for seven weeks on the seven murals, spreading the canvases out on the floor to paint them. He also created a ceiling painting and the stage curtain. The set of works were enthusiastically received, and soon the small auditorium became known as 'Chagall's box'. Chagall's contributions were central to the success of the theatre, and the artist himself considered his

The Blue House, 1917
Oil on canvas, 66 x 97 cm
Liège, Musée des Beaux-Arts

Once in a while, a shaft of realism penetrates Chagall's world of phantasy and magic, and we are left searching in vain for the hovering couples, upside-down figures and headless men and women. Here the artist turns his attention to conventional landscape, applying elements of Cubism and his new approach to colour and light. He depicts a ramshackle wooden house, propped up by a red brick wall, on the banks of the river Dvina. Behind, high up on the oposite embankment, are the stone town houses of Vitebsk, with a Baroque monastery towering above them. The impossible perspective of the cabin, the rhythmic interplay of the geometric shapes and intrinsic force of the colours transform this realistic scene into abstract art.

(continued on page 94)

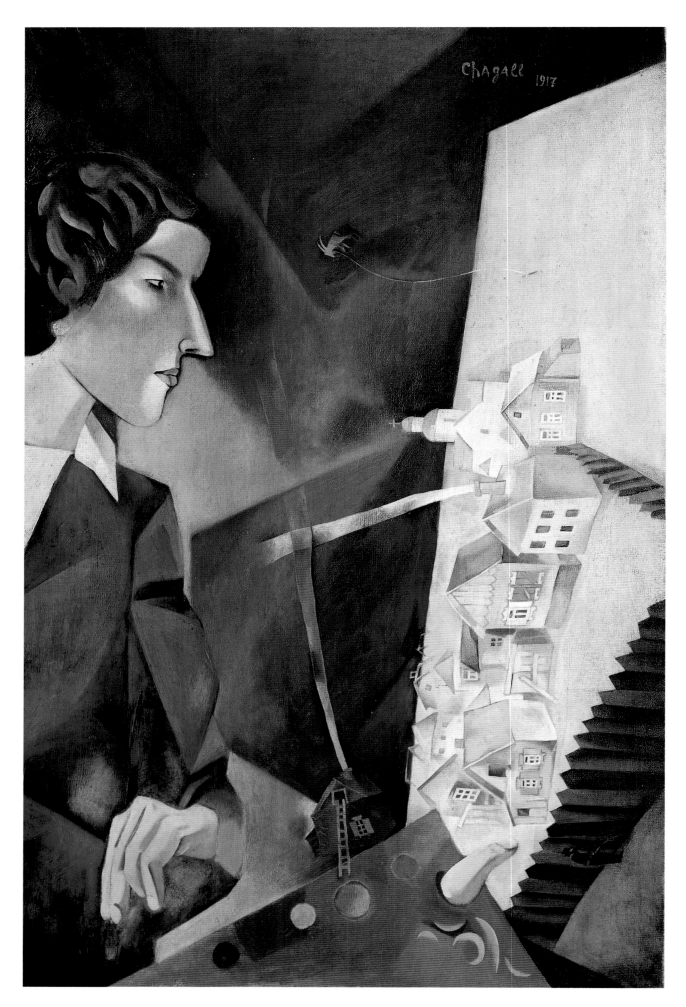

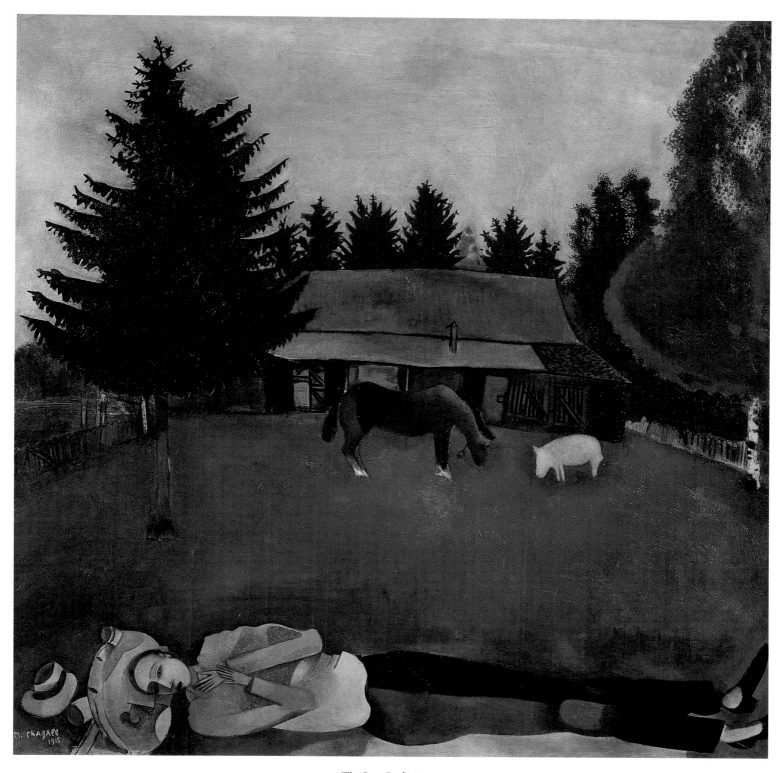

The Poet Reclining, 1915
Oil on canvas, 77 x 77.5 cm
London, Collection of the Trustees of the Tate Gallery

PAGE 88:
Self-Portrait with Palette, 1917
Oil on canvas, 88.9 x 58.4 cm
Private collection

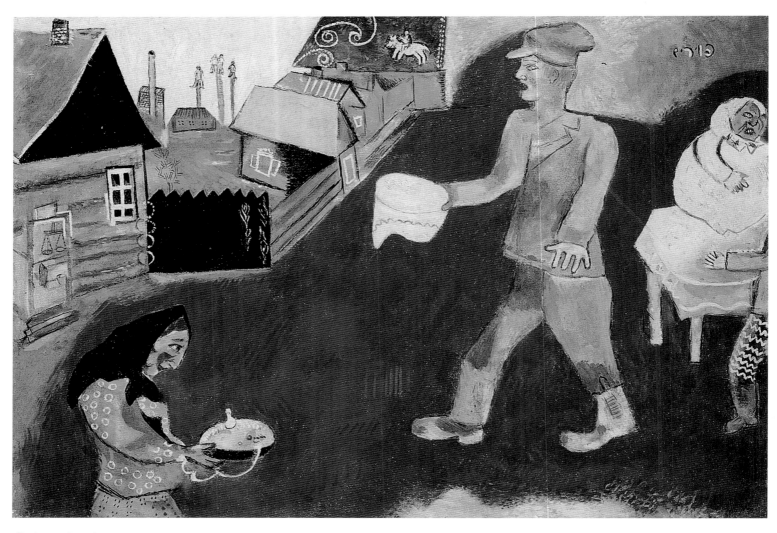

Purim, 1916–1918
Oil on canvas, 47.8 x 64.7 cm
Philadelphia (PA), Philadelphia Museum of Art,
The Louis E. Stern Collection

In the Book of Esther it says that on the 14th
day of the month Adar, the 6th month in the
Jewish calendar, joy and feasting should take
place to honour the decree of King Ahasuerus
giving the Jews in every city in Persia the free-
dom to live according to their own religious
laws. This he did after his wife, Esther, together
with her brave uncle Mordechai had warned
the King of the conspiracy of Haman who
intended to kill all the Jews in the kingdom.
This victory of good over evil has been cele-
brated ever since as the Feast of Purim, when
the Jewish people feast and rejoice, exchange
presents and give alms to the poor. In this
bright red painting, Pinja, the man who brings
and takes the gifts, strides towards an old
woman who eagerly holds out hers. Behind
them is Vitebsk with its wooden houses and
church.

The Old Woman, 1914
Pen and white gouache on paper, 25 x 16.7 cm
Paris, Musée national d'art moderne,
Centre Georges Pompidou

The Old Man, 1914
Pen and white gouache on paper, 25 x 16.7 cm
Paris, Musée national d'art moderne,
Centre Georges Pompidou

The Newspaper Vendor, 1914
Oil on canvas, 98 x 78.5 cm
Paris, Musée national d'art moderne,
Centre Georges Pompidou, Gift of Ida Chagall

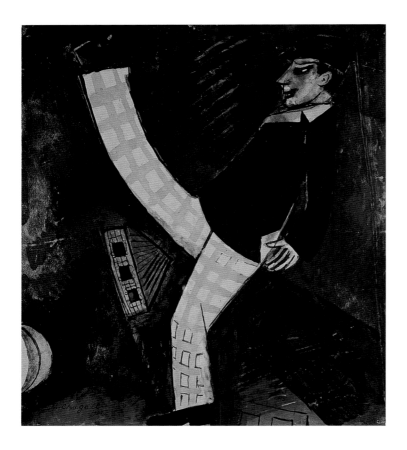

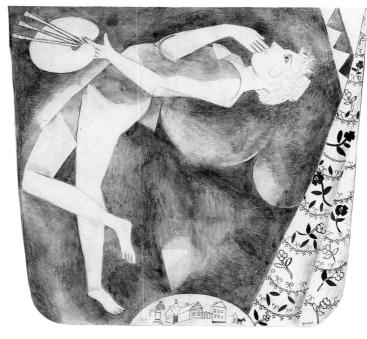

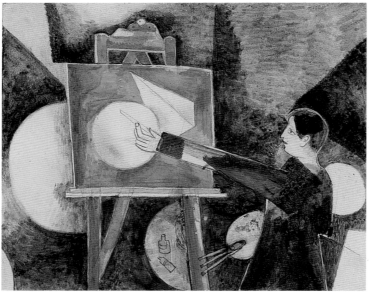

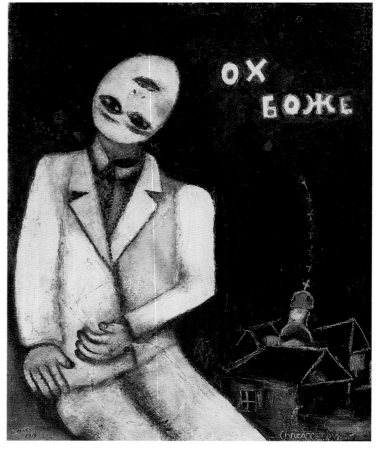

TOP LEFT:
The Traveller, 1914
Gouache on paper, 20 x 18 cm
Basle, Collection Marcus Diener

TOP RIGHT:
The Moon Painter, 1916
Gouache, watercolour, ink and pencil on paper,
32 x 30 cm
Basle, Collection Marcus Diener

BOTTOM RIGHT:
Self-Portrait at the Easel, 1919
Gouache and pencil on paper, 18.5 x 22.5 cm
Basle, Collection Marcus Diener

Oh God, 1919
Oil, tempera, crayon and distemper on cardboard,
56.8 x 26.6 cm
Philadelphia (PA), The Philadelphia Museum of Art

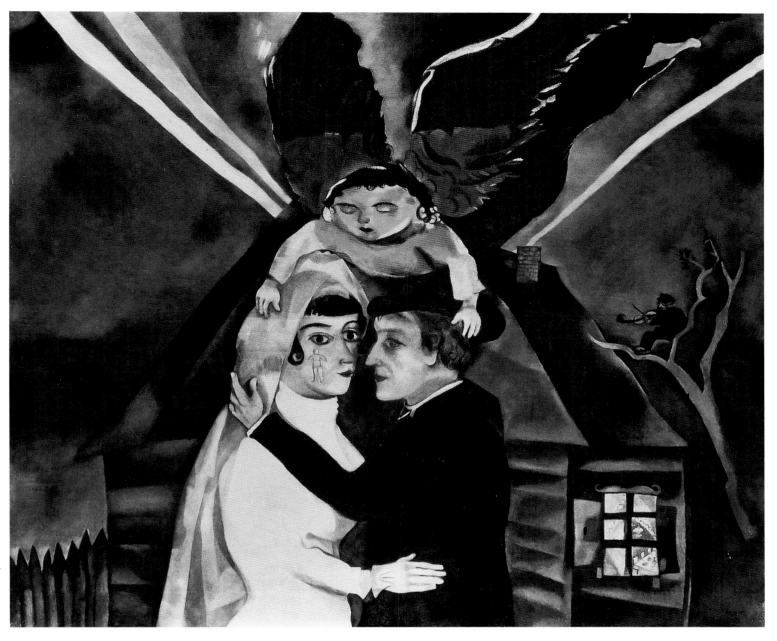

The Wedding, 1918
Oil on canvas, 100 x 119 cm
Moscow, Tretiakov Gallery

imaginatively created murals to be some of his very best work. The largest mural, *Introduction to the Jewish Theatre* (1920, ill. pp. 106–107), which measures some 3 x 8 metres, shows the entire theatrical ensemble against a coloured geometrical background: actors, acrobats, dancers and musicians, and the audience along with chickens, goats and cows. Chagall himself is being carried into the theatre's arena by Efross, where Granovsky, the actors (among them his friend Salomon Michoels), clowns, musicians and a goat await them. The *Introduction*, like another mural, *The Wedding Table*, which is likewise 8 metres long although much narrower, contains many Hebrew words and letters. Four smaller murals represent music, dance, drama and literature (ill. pp. 108–109). A green fiddler, playing at a wedding, symbolizes music. In 1923–24 Chagall chose the same subject for a painting now in the collection of the Guggenheim Museum in New York, *Green Violinist* (ill. p. 115). *Literature* depicts a scribe with a scroll, *Dance* a woman dancing at a wedding, and *Drama* the 'badkhen', a Hasidic 'wedding jester', who has a unique position in Jewish culture because he can make fun of subjects considered sacred. A further, very lyrical mural is entitled *Love on the Stage* (ill. p. 107). All these themes, in particular the wedding scenes, are to be found in many of Chagall's subsequent paintings.

When the 'Jewish Studio Theatre' moved to more spacious premises in 1924, the stage curtain and the ceiling painting disappeared. The murals were installed in the foyer of the new building. In 1937, when under Stalin Jewish theatrical groups were subject to strict censorship and became the target of growing anti-Semitism, the murals were removed, rolled up and deposited under the stage. In 1950 they were transferred to the Tretiakov gallery in Moscow, where for nearly 40 years they languished rolled up in storage, never being exhibited. No painting of Chagall's or

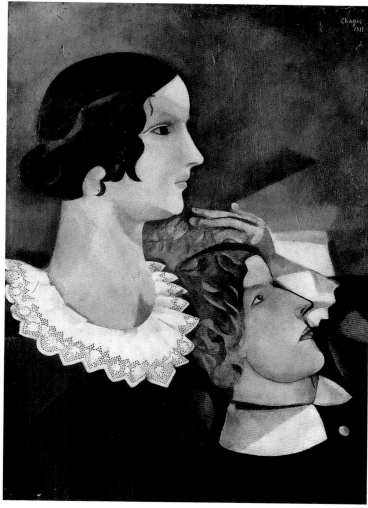

of any other Jewish painter was permitted to be shown. Only in 1973, when after an absence of 50 years Chagall revisited Russia for the first time, did he see his murals again. He was deeply moved, unable to restrain his tears. Museum curators stood to hand with paintbrushes, asking him to sign the murals.

According to Susan Compton, a British authority on Chagall, the artist's murals and stage sets went far beyond traditional theatre decoration and turned the whole auditorium into an extension of the stage. Professor Benjamin Harshav of Yale University, writing in the exhibition catalogue of the Guggenheim Museum about these decorations of the Moscow Jewish Theatre, says that: "the murals challenged the boundaries between stage and audience, the artist and the object of his painting, realism and abstraction, the religious past and the secular present. They embodied the intersection of a quadruple revolution: revolution in the theatre, revolution in painting, social and political revolution in Russia, and the modern Jewish revolution, which brought Jews centre stage in European culture."

With financial support from the Pierre Gianada Foundation in Martigny (Switzerland) the murals were restored in Russia. This work was completed in 1990, and in 1991 the works left Russia for the first time to be exhibited in Martigny in a major exhibition devoted to Chagall's Russian years. From there the murals embarked on a world tour, bringing in much-needed revenue for Russia's cash-strapped museums. They went to the Schirn art gallery in Frankfurt am Main, the Guggenheim Museum in New York, the Art Institute of Chicago, to Helsinki, the Israel Museum in Jerusalem, the Jewish Museum of the City of Vienna, and finally, in 1955, to the Museum of Modern Art of the City of Paris. The exhibitions everywhere drew large enthusiastic crowds.

Chagall became a close friend of the famous Russo-Jewish actor Salomon

TOP LEFT:
The Lovers, 1916
Oil on board, 70.7 x 50 cm
Private collection

TOP RIGHT:
Lovers in Grey, 1916–17
Oil on canvas, 69 x 49 cm
Paris, Musée national d'art moderne,
Centre Georges Pompidou

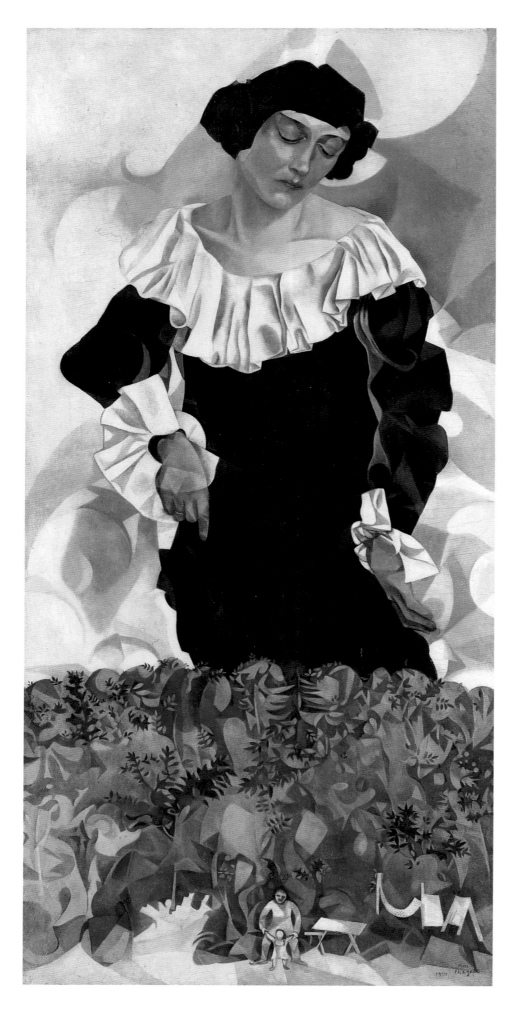

Bella with a White Collar, 1917
Oil on canvas with varnish, 149 x 72 cm
Paris, Musée national d'art moderne,
Centre Georges Pompidou

This beautiful portrait of Bella was painted in
the summer of 1917, on their return from a
short holiday in a rural dacha. Her tall figure is
looking down over the trees and plants. Chagall
himself is in the foreground, guiding their
daughter Ida in her first steps. Near him, are a
table, a bench and a hammock. Chagall restricts
himself to three basic colours in this monumen-
tal work. It is a tribute to his most beloved
Bella, whom he portrays like a madonna. In
My Life he says: "Dressed all in white or all in
black, she seemed to float over my canvases,
for a long time guiding my art."

Bella Chagall, 1917

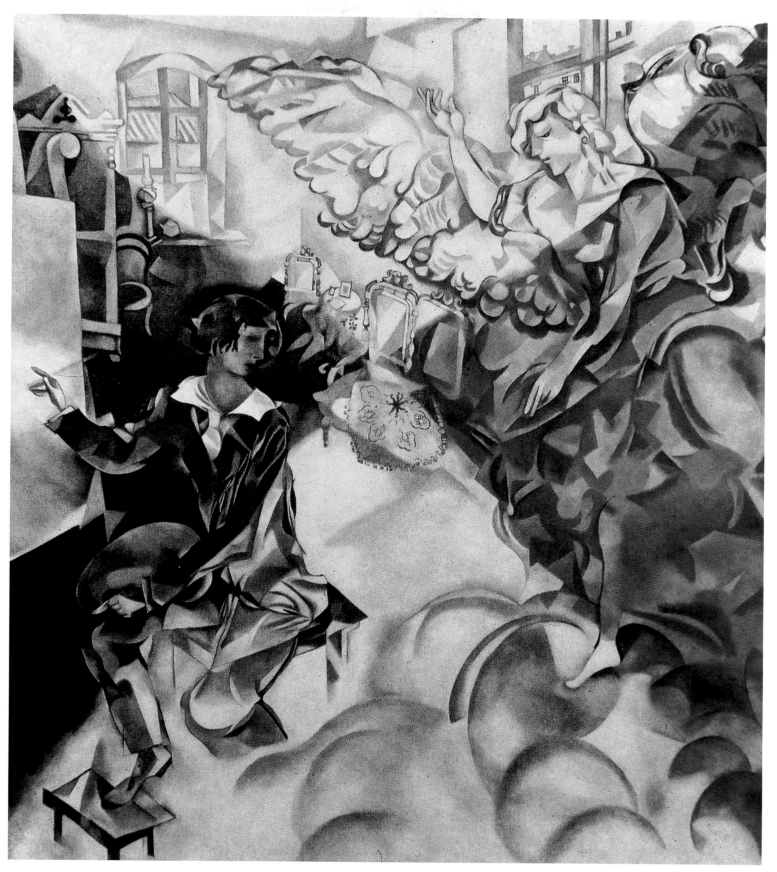

The Apparition (Self-Portrait with Muse), 1917–18
Oil on canvas, 148 x 129 cm
Private collection

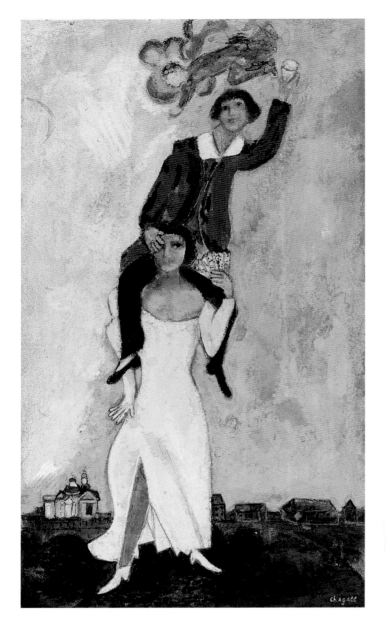

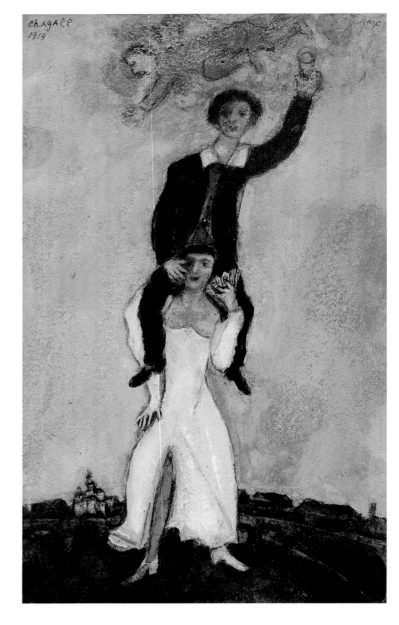

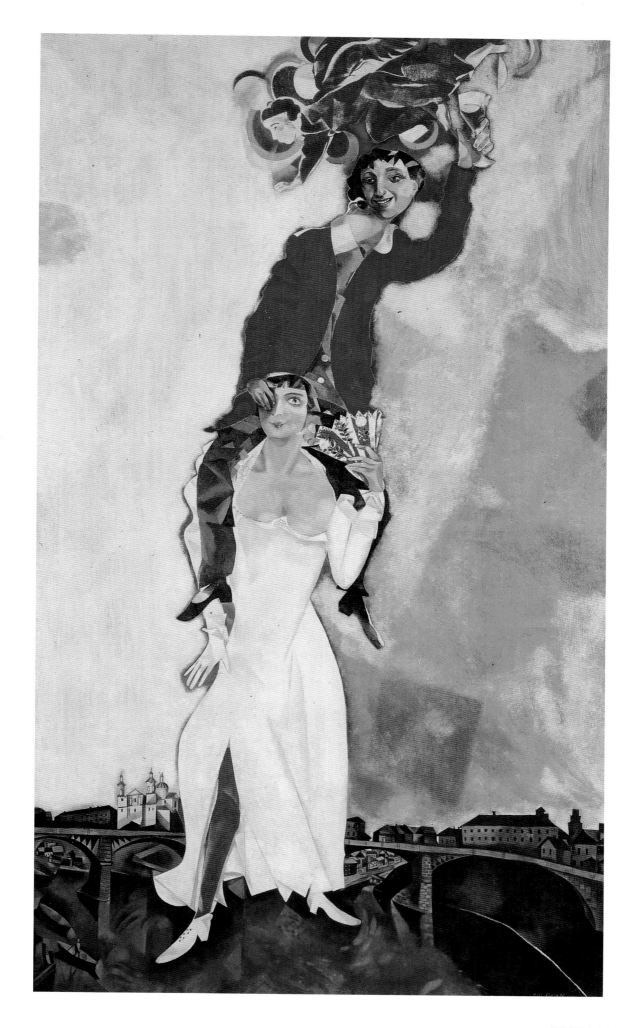

Michoels, whom he portrayed in the large mural *Introduction to the Jewish Theatre.* Michoels, like the other 'Jewish Theatre' actors mentioned, loved Chagall's work and was captivated by the artist. Chagall not only designed these actors' theatrical costumes, but even made up their faces. They looked one and all as if they had stepped out of a Chagall painting.

But not all theatregoers approved of Chagall's creations. He was accused of caricaturing the Jewish character and encouraging anti-Semitism. About this time Chagall, along with leftists, artists, the Suprematists and the Rayonists, fell into disfavour with political functionaries. Under Stalin Social Realism became the order of the day, soon dominating the entire Soviet art scene. While the 3-year-old Soviet Republic was starving, a little group of Jewish actors, so the commissars claimed, danced and sang in their studio theatre with complete disregard for the misery throughout the land.

Only with great difficulty was it possible to keep the three Sholem Aleichem one-act plays in the programme. For the decor and sets, the theatre had to resort to recycling used materials, and theatre-director Granovsky was unable to pay anybody's wages. Chagall was asked by Yevgerni Wachtangov, the director of the Hebrew 'Habimah' theatre, to help stage *The Dibbuk*, written by the playwright Anski, who came like the artist from Vitebsk. But Chagall rejected the offer because Wachtangov's productions were too naturalistic for his taste. The 'Habimah' theatre later transferred to Palestine, acquiring in 1956 the status of Israel's national theatre.

Chagall moved with his family to Malachovska, a small country town near Moscow, where life was less expensive. As long as he worked at the theatre, he commuted daily from there to Moscow in crowded trains. Soon, however, he was offered a new job by the Ministry of Education and the Arts teaching war orphans in a Malachovska children's home. The children loved comrade Chagall, just as he loved them, finding inspiration in their naive work. Here Chagall spent 1921 and the first few months of 1922 in primitive conditions, planning his next move. One thing was clear to him, that he and his family had to leave Russia. There was nothing for them there any more. Ever more artists, writers, musicians and other intellectuals were leaving the country for the West. Meanwhile in Vitebsk Malevitch and Lissitsky had left the art academy, Malevitch going to Moscow, where his art fell into disfavour with the regime, and Lissitsky proceeding to Berlin to teach

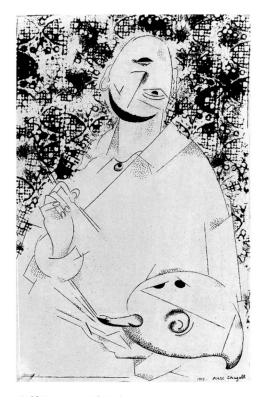

Self-Portrait with Palette, 1918
Drawing and gouache on paper, 26.7 x 16.2 cm
Paris, Musée national d'art moderne,
Centre Georges Pompidou

Rider Blowing a Trumpet, 1918
Aquatint, pencil and gouache on paper
23 x 30 cm
Private collection

PAGE 101:
Cubist Landscape, 1918
Oil on canvas, 100 x 59 cm
Paris, Musée national d'art moderne, Centre
Georges Pompidou, Gift of Ida Chagall

"Chagall", 1918
Gouache and mixed media, 47.6 x 34 cm
Paris, Musée national d'art moderne,
Centre Georges Pompidou

BOTTOM LEFT:
Cover of the first monograph in Russian on
Chagall by Abram Efros and Jacob Tugend-
hold, Moscow, 1918
New York, Collection of Jacob Baal-Teshuva

BOTTOM RIGHT:
Composition with Goat, 1917–1922
Oil on cardboard, 16.5 x 23.5 cm
Private collection

at the Bauhaus. For two years Chagall tried unsuccessfully to get his pay from the authorities for his work at the Jewish Theatre in Moscow – he never did get any money for his great murals.

Resolved to leave Russia, Chagall moved back to Moscow, where he worked on his autobiography *My Life.* He remembered the pictures he had left with Herwarth Walden in Berlin. Some considerable time earlier he had received a letter from Berlin written by his friend the poet Ludwig Rubiner, whose wife was a friend of Bella's: "Do you know that you are famous here? Your paintings have created Expressionism. They are being sold for huge amounts. But don't count on getting the money Walden owes you. He won't pay you, because he maintains that fame will be enough for you." Chagall formulated the plan to go first to Berlin, to collect the money for his pictures, and then on to Paris.

While waiting for an exit visa, Chagall completed his book *My Life,* which is written in Russian. He was now almost 35 years old. The autobiography, which he had worked on from 1920 to 1921, was an astonishing achievement. It is a nostalgic account of his home town Vitebsk, his parents, family and friends, his struggles and desire to become an artist. When he later supplemented the book with illustra-tions, *My Life,* which covers only a fraction of his life, came to resemble a colourful picture book (ill. pp. 219, 220, 221). Chagall was often asked to continue his mem-oirs, but his many other projects never left him time to do so. Chagall once said: "All kinds of people have been pressing me to write the second volume of *My Life,* to bring the story up to date after the year 1923. I would like to, but I am tired; I have no energy left. Besides, writing is not my métier. Perhaps I am lazy, but I just can't get round to it."

Despite the grave economic and political conditions, anti-Semitism and attacks on his work, Chagall did not leave Russia for political reasons, but rather, as he later said, "on purely personal and artistic grounds". Finally, through the intervention of his influential friend Culture Minister Lunatcharsky, Chagall got his passport and exit visa, while the collector Kagan-Shabshay put up his travel money. Another friend also proved helpful, the poet Jurgis Baltrusaitis, who had been appointed Lithuanian ambassador in Moscow. He made it possible for Chagall to send his paintings, gouaches and drawings – 65 works in all – as diplo-matic baggage to Kaunas, where they were exhibited at the Author's Club. When Chagall stopped off at this Lithuanian border town on his way to the West, he gave a reading of excerpts from *My Life* within the context of the exhibition.

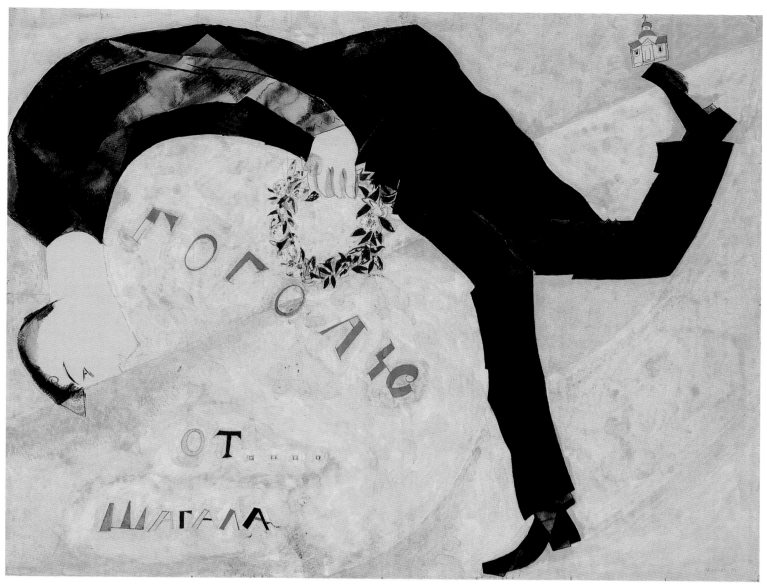

Homage to Gogol, 1919
Watercolour on paper, 39.4 x 50.2 cm
New York, The Museum of Modern Art,
Acquired through the Lillie P. Bliss Bequest

According to Franz Meyer, Chagall's biographer, this work was commissioned as a backdrop or scenery for one of Gogol's plays: either *The Gamblers* or *The Wedding.* The imagination and vitality Chagall has put into it show how much he loved of the theatre. The picture is dominated by a huge black figure against a bright yellow background, who seems to be bowing like an actor to his audience. Some see

this figure as Chagall himself in a dramatic pose, holding a laurel wreath and balancing a church on his foot, while bowing to Gogol whom he much admired. The pose appears again in later works. A message "To Gogol from Chagall" in Russian is incorporated into the picture. Some years later in Paris, Chagall was commissioned by Ambroise Vollard to illustrate Gogol's novel *The Dead Souls.*

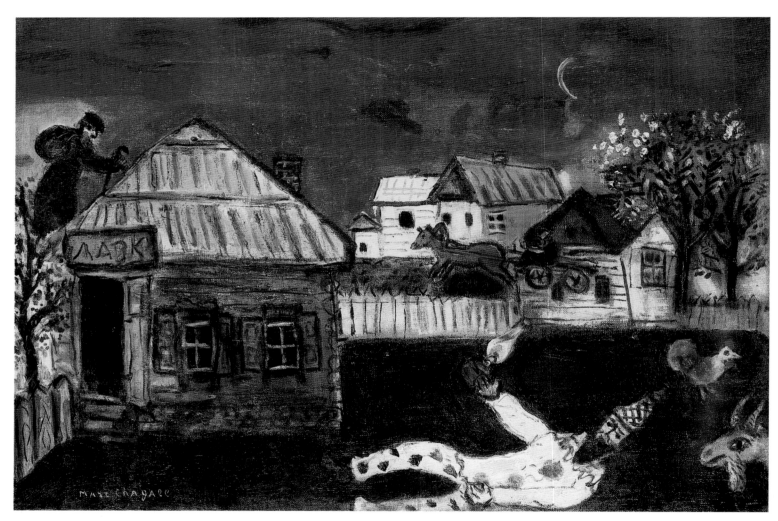

Vitebsk, Village Scene, 1917
Oil on canvas, 37.5 x 54.5 cm
Private collection

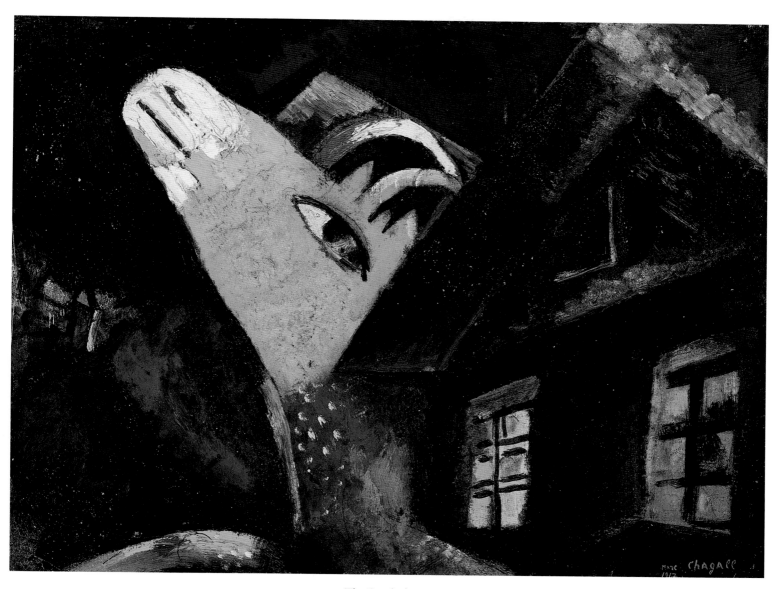

The Cowshed, 1917
Oil on canvas, 47.5 x 62 cm
Hanover, Sprengel Museum

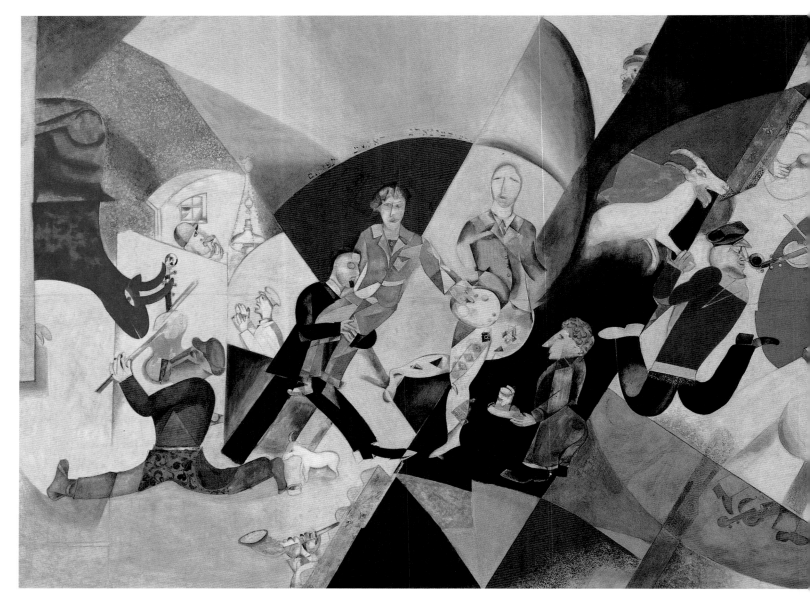

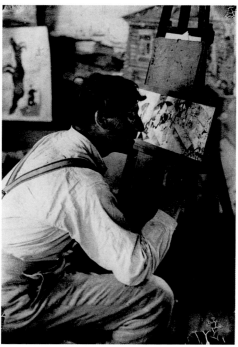

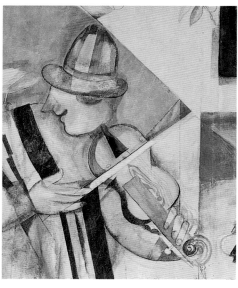

Chagall painting the sketch for the
Introduction to the Jewish Theatre, 1919–20

Introduction to the Jewish Theatre
(detail: Violinist), 1920

Introduction to the Jewish Theatre
(detail: Portrait of Marc Chagall), 1920

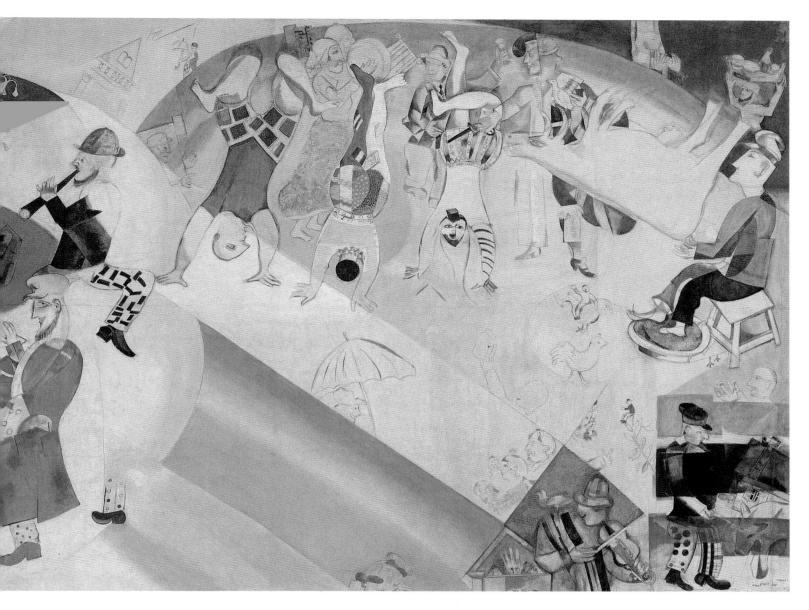

Introduction to the Jewish Theatre, 1920
Tempera, gouache and kaolin on canvas,
284 x 787 cm
Moscow, Tretiakov Gallery

Love on the Stage (Jewish Theatre, frieze), 1920
Tempera, gouache and white chalk on canvas,
183 x 248 cm
Moscow, Tretiakov Gallery

Marc Chagall with the actor Salomon Michoels
who is wearing a Chagall-designed costume
for his role as Rabbi Alter for the Sholem
Aleichem evening at the National Jewish
Chamber Theatre in Moscow, January 1921

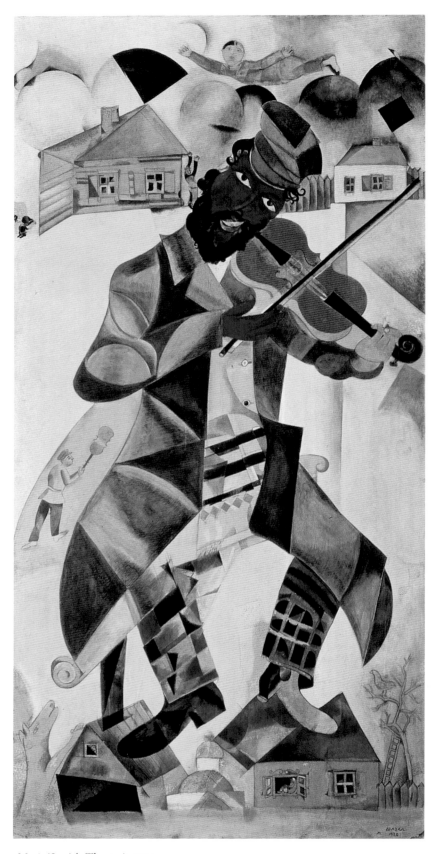

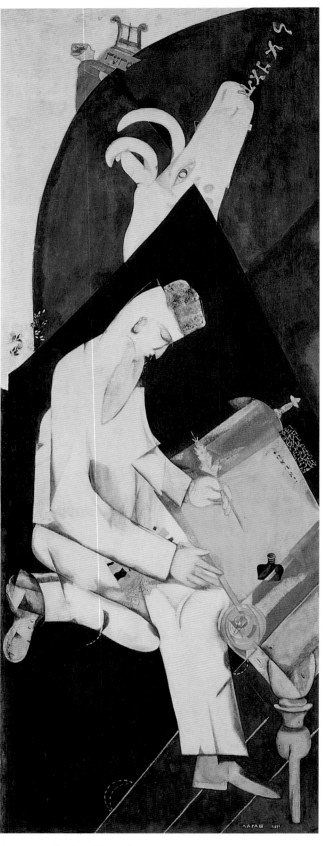

Music (Jewish Theatre), 1920
Tempera, gouache and kaolin on canvas
213 x 104 cm
Moscow, Tretiakov Gallery

Literature (Jewish Theatre), 1920
Tempera, gouache and kaolin on canvas
216 x 81.3 cm
Moscow, Tretiakov Gallery

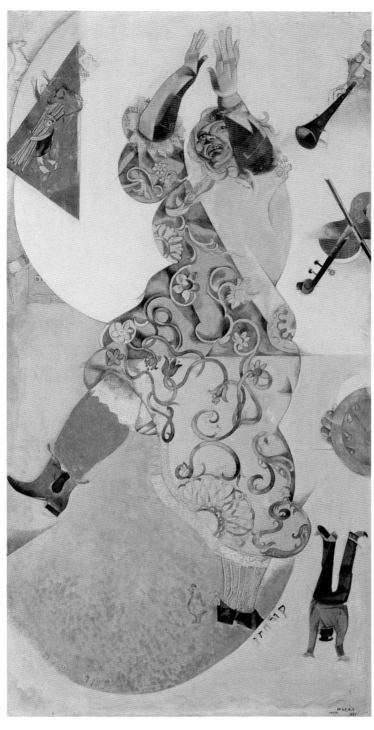

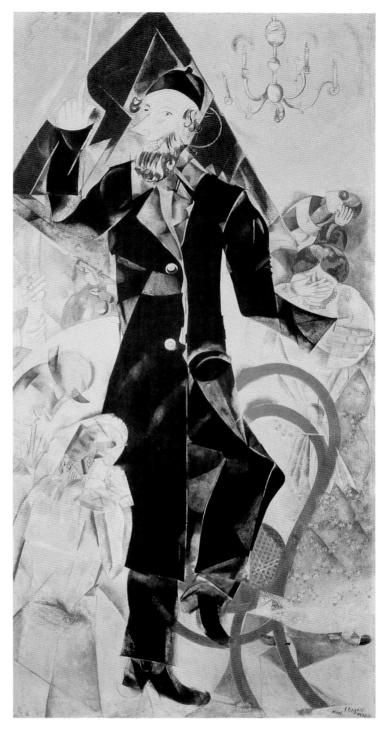

Dance (Jewish Theatre), 1920
Tempera, gouache and kaolin on canvas
214 x 108.5 cm
Moscow, Tretiakov Gallery

Drama (Jewish Theatre), 1920
Tempera, gouache and kaolin on canvas
212.6 x 107.2 cm
Moscow, Tretiakov Gallery

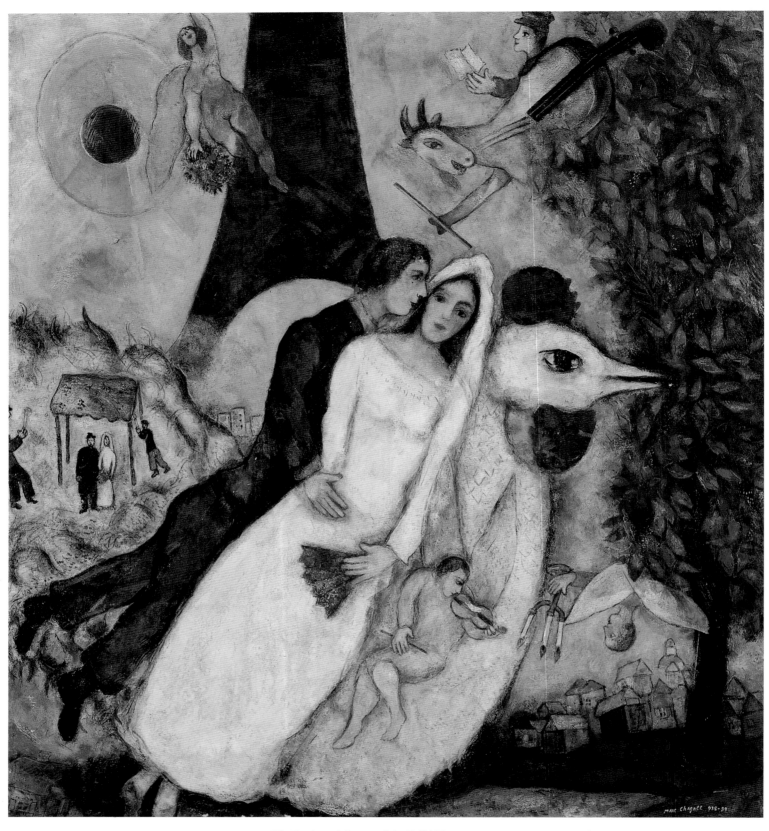

The Bride and Groom of the Eiffel Tower, 1938–39
Oil on canvas, 150 x 136.5 cm
Paris, Musée national d'art moderne, Centre Georges Pompidou

France 1923–1941

"France is my real home."

Journeying alone – his wife and daughter were only able to join him later –
Chagall left Russia in May 1922. His first destination in the West was Berlin, where
he was fetched from the station by Bella's friend Frida Rubiner, the widow of the
poet Ludwig Rubiner, who had died in 1920. The artist's first priority in Berlin
was to look up Herwarth Walden, in whose editorial premises he had had his first
solo exhibition in the summer of 1914. It was with Walden that Chagall had left
40 paintings and 160 gouaches and drawings done during his time in Paris, among
them a number of his greatest masterpieces. Following the debacle in St. Peters-
burg, when he had been swindled out of many of his youthful works by a bent
framer, Chagall had no desire to repeat the experience. During the eight years
that had meanwhile elapsed, Walden had organized several exhibitions of the
artist's works in Germany, sold numerous pieces, and promoted the painter in his
magazine *Der Sturm*, one issue of which – from 1919, meanwhile very rare – was
even exclusively devoted to Chagall. The publisher had made the Russian painter
famous in Germany, many artists drawing inspiration from his works. At one time
a rumour had gone around that Chagall had died in the war or during the revolu-
tion, prompting Walden to try to have the Russian painter traced – but without
success.

Kurt Schwitters, the artist and poet known for his collages, dedicated a poem
to Chagall after seeing the painter's works in Berlin.

TO A DRAWING OF MARC CHAGALL
POEM 28

Playing card drones out fish, head in window.
Animal head greedily yaws bottle.
At the hopscotch mouth.
Man with no head.
Hand waves sour knife.
Playing card fish dumpling bottle.
And a table drawer.
Stupid.
And button fervently rounds on table.
Fish presses table, belly ails sword stroke.
Drunkard's stem dumbly eyes plaintive animal.
Eyes greedily lust after bottle's bouquet.

Chagall tracked down Herwarth Walden, but to his horror learned that the
publisher had sold all his works to private collectors. One of his most important

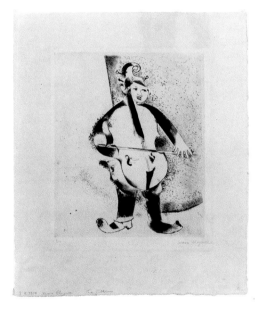

The Musician, 1922
Etching and dry point, 27.5 x 21.6 cm
Private collection

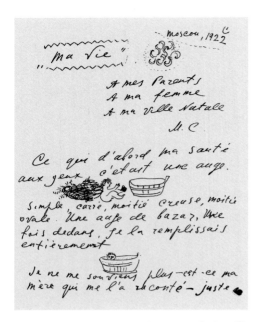

First page from the original version of Chagall's autobiography *My life*, Moscow 1922

paintings of 1912, for example, *Golgotha*, also known as *Calvary* (ill. p. 71), was bought by the German collector Bernhard Koehler. As a result of Walden's promotion Chagall had meanwhile become well-known in Germany. Walden told Chagall that he had deposited the money from the sales with a lawyer. For a moment Chagall thought that he was rich, but then he realized that owing to the ravages of inflation the amount due him was practically worthless – hardly enough to buy a loaf of bread. His fury knew no bounds, but there was nothing he could do. Chagall refused point-blank to accept the money offered to him, demanding instead the names of all the collectors who had purchased his pictures. Walden in turn refused to supply this information, causing Chagall to engage a Berlin lawyer to sue him. At court Walden was ordered to divulge the names, and the amount of compensation money due to the artist was increased, but Chagall's demand that certain paintings be returned to him was rejected. The painter appealed against the court's ruling, and the case dragged on for years. In 1926 Walden's ex-wife Nell agreed to hand over some of the works transferred to her during the war: ten gouaches and three important paintings, *I and the Village* (1911, ill. p. 51), *To Russia, Asses and Others* (1911, ill. p. 35) and *Half Past Three (The Poet)* (1911, ill. p. 39). Chagall was never to forget this bitter experience, which for him was like losing his artistic past.

This artistic expropriation and feeling of loss explains why four or five years later in Paris Chagall painted replicas of many of his major earlier works. He did so not for financial reasons, but because the works had been lost or stolen. Unlike many other artists, for example Giorgio de Chirico, he did not backdate the new versions. His concern was to preserve his early works, which were like chapters in a diary of his life.

Soon the artist was joined in Berlin by Bella and Ida. From the summer of 1922 until autumn 1923 the Chagalls lived in this city, which in the interim had developed into an important art centre. Despite all their problems, they enjoyed their stay, revelling – like many other Russian émigrés – in the contrast to dark and dreary Russia. Berlin was like a magnet in those days, attracting many Russian artists who had left their homeland in search of better living and working conditions, and who often used the city as a stopping place on their way to Paris, London or New York. One of them was a former enemy of Chagall's, El Lissitzky, who had once worked with him, before ganging up with Malevitch to oust Chagall from his position at the Vitebsk Art Academy, a betrayal which Chagall was never able to forget or forgive his whole life long.

Lissitsky was greatly influenced by Malevitch, which can be seen especially in the series of abstract paintings for which he coined the term 'proun' (an abbreviation of Russian words meaning 'project for affirming new forms in art') and which he defined as 'way stations' between painting, sculpture and architecture. He was the first to present to the West the fusion of Malevitch's Suprematism and Tatlin's and Rodchenko's Constructivism, and together with Ilya Ehrenburg published the magazine *Veshtsh* (Object). Chagall avoided Lissitsky like the plague and was none too happy when the van Diemen gallery, which had previously shown Chagall's work, put on an El Lissitsky exhibition in 1922.

Among the many important artists living at that time in Berlin and Germany were, to name but a few, George Grosz, Otto Dix, Max Beckmann, Emil Nolde, Ernst Ludwig Kirchner, Käthe Kollwitz and Wassily Kandinsky. George Grosz, who with his satirical and sarcastic works mocked the Weimar Republic and military hierarchy, moved in 1932 to New York, becoming an American citizen. Otto Dix expressed in his paintings disgust at the horrors of war, Käthe Kollwitz conveyed in her drawings, lithographs and sculptures her strong social and moral convictions, and Max Beckmann, who left Germany in 1937 to move in 1947 to the United States, combined social criticism with a brutal realism that later became imbued with allegory and symbolism. Both Ernst Ludwig Kirchner, the dominant figure in the group *Die Brücke* (The Bridge), who favoured harsh opposing planes and boldly contrasting colours, and Emil Nolde, one of the most powerful Expressionists, were then at the peak of their creative powers.

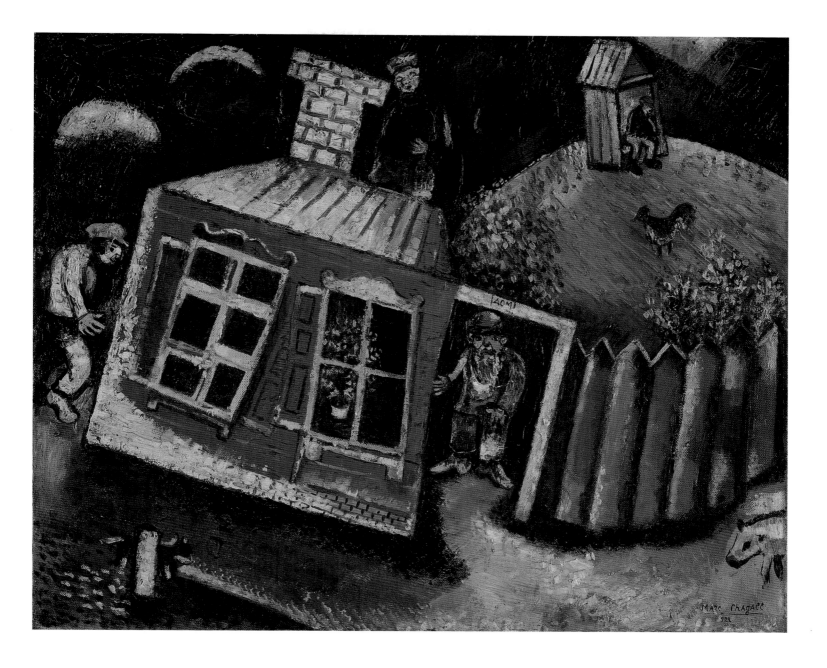

Chagall's influence on the German Expressionists – and to some extent their influence on him – is obvious. His friend Boris Aronson, the painter and set designer, whom he had got to know in Moscow and who later emigrated to New York, even described him as the 'progenitor of Expressionism'. Chagall was a keen observer of the Berlin art scene, eagerly absorbing the new impressions. One artist he had a particular affinity with was Franz Marc, a founder of *Der Blaue Reiter* (The Blue Rider), whose animal pictures are distinguished by an almost shamanistic use of colour.

Chagall became a well-known personality not just among artists, many of whom belonged to groups and schools such as *Die Brücke, Der Blaue Reiter* and the *Neue Sachlichkeit* (New Objectivity), but also among intellectuals and writers, not least owing to a monograph about him, written by Abraham Efross and Jacob Tugendhold, published in 1918, translated from Russian into German by Frida Rubiner and republished in Potsdam in 1923. A year later another book on Chagall came out, this time by Boris Aronson in Berlin. It containing 30 pages of text and numerous reproductions of the artist's work. In an interview in New York Aronson told the writer Sidney Alexander that Chagall, after Aronson had read him the text, told the author that "he would be happy if it were not published. He found it was too intimate. It was as if I had entered the room where he slept with his wife. He

Red Houses, 1922
Oil on canvas, 80 x 90 cm
Private collection

PAGE 114:
Praying Jew, 1923
Oil on canvas, 116.9 x 88.9 cm
Chicago (IL), The Art Institute of Chicago

PAGE 115:
Green Violinist, 1923–24
Oil on canvas, 198 x 108.6 cm
New York, The Solomon R. Guggenheim Museum

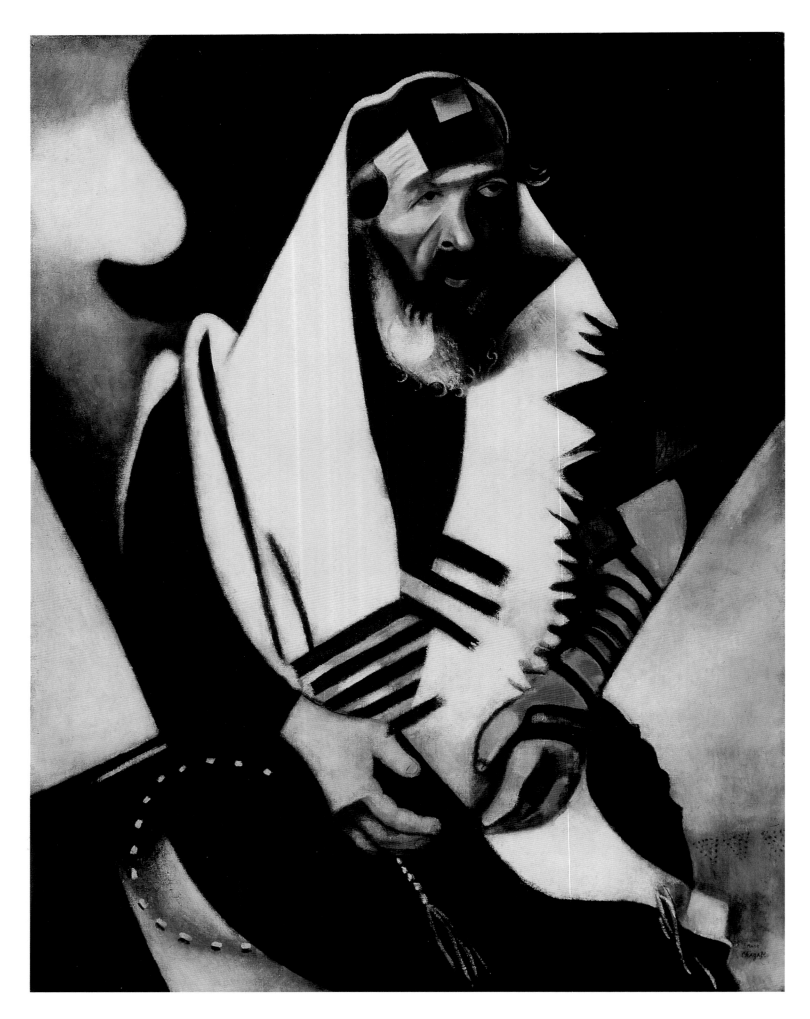

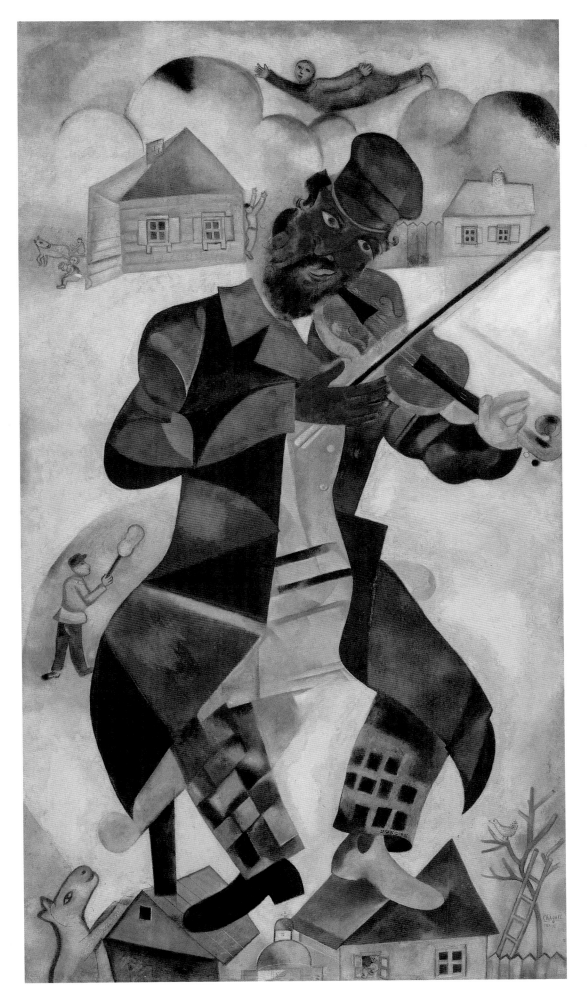

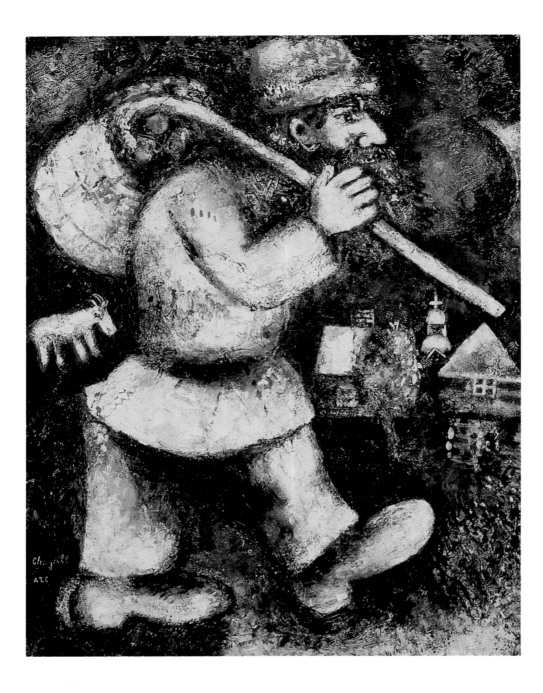

On the Way, 1924
Oil on canvas, 72 x 57 cm
Geneva, Petit Palais

This powerful work depicts an old bearded Jew holding a sack on his back with a cane. In the background are a goat, wooden houses and the church of Vitebsk. The bundle contains all the wandering Jew's possessions as he tramps from place to place, the victim of persecution and discrimination. The figure is sometimes seen as Chagall himself who, for both political and artistic reasons, often had to move from country to country. This painting was done in 1924 in Paris, after Chagall had left Russia for good.

even offered to pay me not to publish it. […] He did not want intimacy expressed in a way he could not deny."

An important aspect of Chagall's stay in Berlin was his introduction there to graphic art. In Berlin he produced his first engravings and etchings. Germany had been renowned since the 15th century for its achievements in this field, and Chagall was not slow to profit from the tradition. This aspect of his Berlin stay will be described in more detail in the chapter dealing with Chagall's graphic work (see pp. 218–241).

Despite all the acclaim, Chagall knew that in the long run he could not feel at home in Berlin, and he was anxious to move on with his wife and daughter to Paris. It was not easy for Russian citizens to obtain a visa for France, but luckily he still had his Paris residence permit, issued by the French police in 1916, and this helped him to get a visa. Late summer 1923 Chagall, Bella, and Ida boarded a train to Paris. If back in 1910 he had arrived in Paris almost without a penny to his name, this time, after two successful exhibitions in the van Diemen gallery, he had enough money to keep himself and his family afloat there for the time being. On 1 September 1923 the Chagalls steamed into Paris' Gare de l'Est, opening a new chapter in the life of the 'magician of Vitebsk'.

PAGE 117:
Jew with Torah, 1925
Gouache on paper, mounted on board
68 x 51 cm
Tel Aviv, Tel Aviv Museum of Art

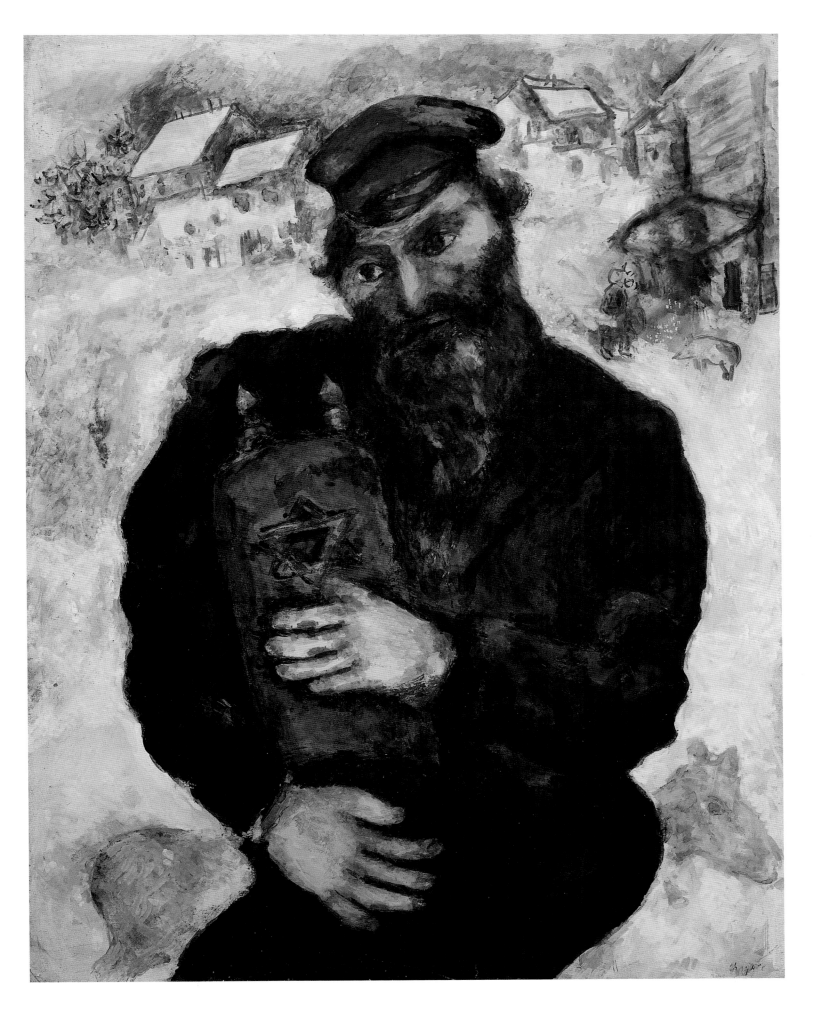

The Rabbi, 1922
Etching with dry point, 25.1 x 18.7 cm
Private collection

Chagall and his family spent their first few months in France living in a room at the Hôtel Médical, 28 rue du Faubourg St. Jacques. On his first arrival in Paris he had been 23 years old; now he was 35, a mature married man with a small daughter. In 1910 he had been a struggling impecunious art student, while now he was a successful artist, known and respected in both France and Germany.

When he had returned to Russia in 1914 to marry Bella, Chagall could not remotely have anticipated that war and revolution would detain him there for eight years. Back in Paris his immediate concern was for the paintings he had left behind before the war. However, at his former studio in the 'Ruche' colony the third great shock of his career – after the losses in St. Petersburg and Berlin – befell him. The wire he had used to secure the door to his studio was long since gone, and he found the room now inhabited by an old refugee, who had been quartered there during the war.

Every one of the some 150 works he had deposited in the room had disappeared. Eventually Chagall found out that the lady concierge of the building had simply got rid of most of the canvases, completely unaware of their value. Some she had even used to make roofs for her rabbit hutches and chicken coops – probably the most valuable roofing in art history. There was also a rumour that Blaise Cendrars, thinking that Chagall had died during the war in Russia, had been involved in selling some of the paintings, before himself being drafted into the army. The artist never got to the bottom of this rumour, but he did discover that Cendrars' friend, the writer Gustave Coquiot, had bought some of the missing works, and thus the finger firmly pointed at Cendrars. In 1928 twenty-two Chagall works from the collection of Madame X were sold at a Paris auction – Mme Coquiot being the provenance of every one.

Chagall broke off all relations with Cendrars. Neither in his memoirs, nor in a biographical description is there any mention of his friendship with the poet. For many years the artist refused to see Cendrars, and it was only in 1960, shortly before the poet's death, that the two did meet briefly through the mediation of Aimé Maeght, Chagall's French dealer.

Early 1924 the Chagalls moved from their damp room in the Hôtel Médical to a studio at No. 10 Avenue d'Orleans, where they lived until the end of 1925. Having lost so many of his pictures, Chagall decided to paint replicas and recreations of those early works that were of special significance for him. Among the first were: *The Black and White Jew* and *Birthday* (ill. p. 76). In addition he painted variants of *Introduction to the Jewish Theatre* (ill. p. 106/107) and new versions of *The Cattle Dealer* (ill. pp. 60, 61), *The Circus, The Harlequins, Double Portrait with a Glass of Wine* (ill. p. 99) and *Bella with Pink*. Other subjects he repeated, in oil or gouache, on canvas or paper, were *I and the Village* (ill. p. 51), *The Dead Man* (ill. p. 25) and *To Russia, Asses and Others* (ill. p. 35). Chagall was happy to be in Paris again, a fact reflected in these recreations. The colours are vivid and radiant, the forms freer and transfused with light.

Not long after his arrival Chagall made friends with the poets Claire and Ivan Goll, whose books of poetry he later illustrated. He also got to know the art dealer and artbook publisher Ambroise Vollard, who represented Cézanne, Renoir and the Fauvists Derain and de Vlaminck. Vollard asked Chagall to illustrate a children's book by the Comtesse de Ségur, and when Chagall made the counter-suggestion that he illustrate Gogol's *Dead Souls*, Vollard agreed immediately. Between 1923 and 1925 the artist created 107 etchings, in which he not only captured the spirit of Russia and Gogol, but also demonstrated his prowess in this medium.

In Paris Chagall met up again with his former teacher Léon Bakst and his patron Maxim Vinaver, who was now teaching Russian law at the Sorbonne. But he also lost a friend. The death of Guillaume Apollinaire from Spanish influenza in 1918, two days before the armistice, took away a close friend and an admirer. But the spirit of the poet and artist lived on in Surrealism – it was Apollinaire who in 1917 coined the name of this furious artistic and literary movement, which encompassed Duchamp and Dalí, Arp and Tzara, Kahlo and Breton, as well as numerous other artists and poets.

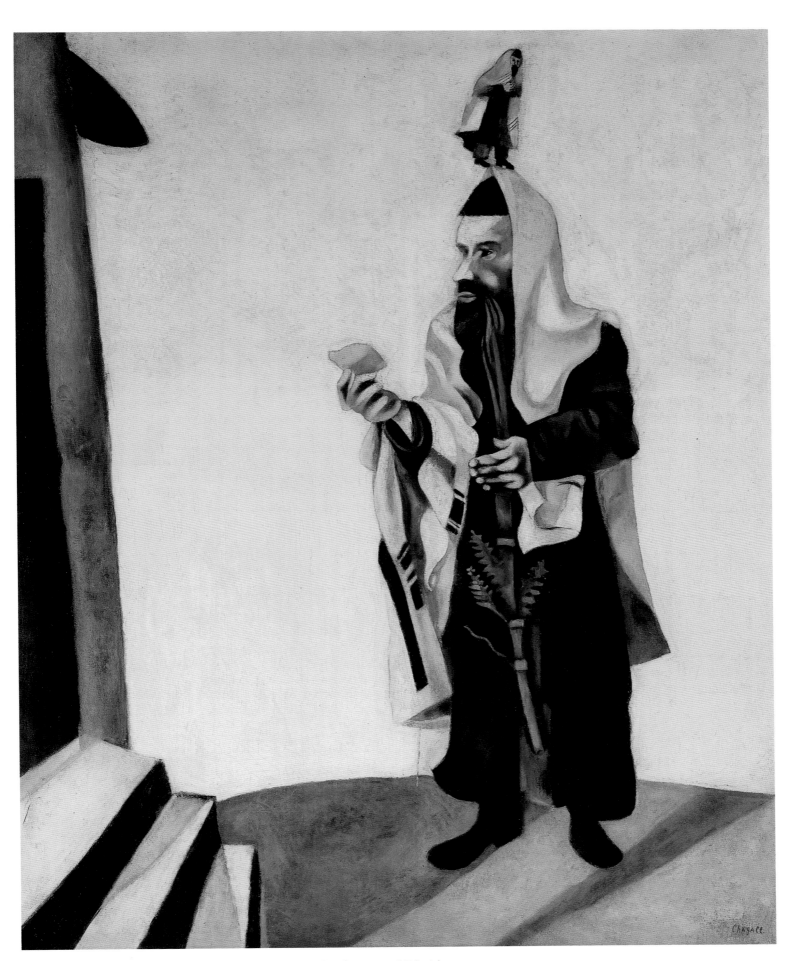

Landscape near L'Isle-Adam, 1925
Oil on canvas, 100 x 81 cm
Private collection

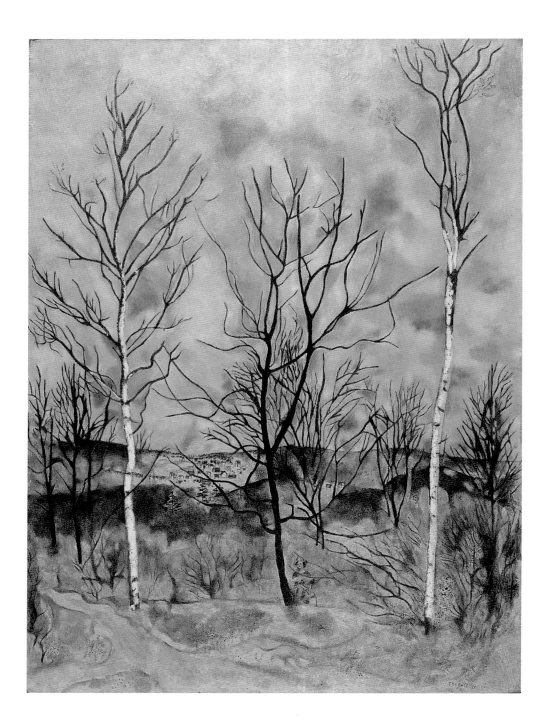

Landscape near L'Isle-Adam, 1925
Oil on canvas, 100 x 81 cm
Private collection

The first Surrealist manifesto was written and published by Breton in 1924. The origins of this avant-garde movement, whose heyday was in the 1920s and 1930s, lay in the nihilistic ideas of Dadaism, an anti-aesthetic and anti-rational movement founded in 1916 in Zurich's Cabaret Voltaire by Hans Arp, Hans Richter, Tristan Tzara, Man Ray, Marcel Janco and Marcel Duchamp. Propounding an 'anti-art' protest, the Dadaists' aim was to topple the ivory tower of traditional harmonious academic art, replacing it with 'non-art', which made use of forms of expression such as sound poems and ready-made objects. The term 'ready-made' had been coined by Duchamp for manufactured utilitarian items which, without making any changes to them, he declared works of art. In 1913 Duchamp exhibited the first ready-mades in New York, including his notorious *Fountain*, a standard-issue, industrially produced, enamel urinal, which he signed R. Mutt and *Bottle rack* (1914).

Surrealism took up Dada's cause in a positive way. In his Surrealist manifesto Breton wrote: "I believe that the two apparently contradictory conditions of dream and reality will soon be resolved into a kind of absolute reality, if you like, a super

PAGE 121:
The Black Glove, 1923–1948
Oil on canvas, 111 x 81.5 cm
Private collection

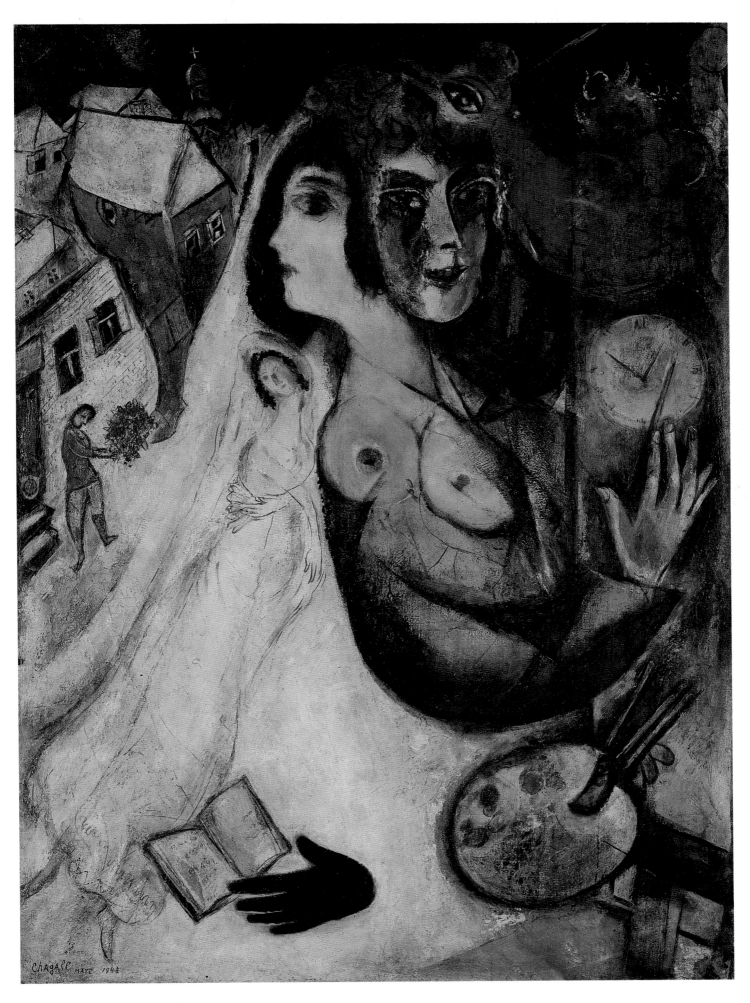

Peony and Lilac, 1926
Oil on canvas, 99.6 x 76.2 cm
Private collection

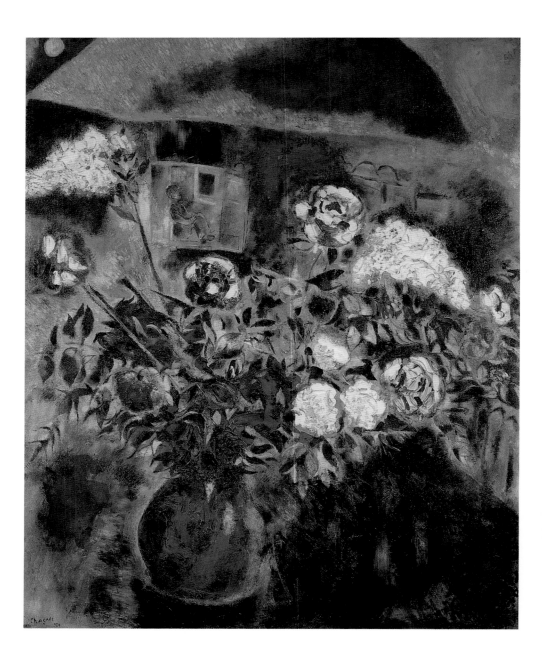

or surreality." Later Freud's theories of the subconscious and its relations to the dream became of central importance to the Surrealists.

In 1941 Breton wrote: "At the beginning of the Dadaist and Surrealist movements, which have managed to fuse poetry and the plastic arts, Chagall's position was not properly appreciated. […] Today we can make a fairer assessment of his work. His great outburst of lyricism dates from 1911. After this time, metaphor made its triumphant entry into modern painting." In the mid-20s Chagall was invited by Breton to join the Surrealist movement, but he politely refused. His decision was probably largely based on his experience of betrayal at the hands of Malevitch and Lissitzky back at the Vitebsk Art Academy, and less on any rejection of Surrealist ideas. He was wary of fanaticism in any form, and André Breton, nicknamed 'the Pope', was indeed a fanatic, to the extent that he even formally 'excommunicated' members from the movement if they – like Salvador Dalí – deviated too much from 'orthodox doctrine'.

In 1924, the year the Surrealist manifesto was published, Chagall showed 122 works at the Parisian Barbazanges-Hodebert gallery. The exhibition was a resounding success. Chagall and his family began to make excursions outside Paris. They went frequently to L'Isle Adam on the Oise, where Robert and Sonia Delaunay

Russian Village, 1926
Gouache on cardboard, 62 x 47 cm
Private collection

regularly spent weekends. Here, in 1925, Chagall painted an uncharacteristically naturalistic landscape, *Landscape near L'Isle-Adam* (ill. p. 120). During this period the Belgian art critic Florent Fels introduced the painter to the region between the Seine and the Oise. Chagall was bowled over by the countryside and its radiant light. After so many years in gloomy, melancholy Russia, the light was a revelation for him, profoundly affecting his painting. Several times during 1925 the Chagalls stayed in the small village of Montchauvet.

December 1925 saw the Chagall family leave their apartment in the Avenue d'Orleans for a house in Boulogne-sur-Seine on the outskirts of Paris. Much as the artist had been thrilled to be back in Paris, the city was not same as in 1914. The First World War had left its mark, Modigliani had been dead for three years, and Chagall's Jewish friend, the writer and painter Max Jacob, had converted to Catholicism and was now living in a Benedictine monastery. The artists he had once known were gone, to be replaced by new faces.

There was another bitter pill for Chagall to swallow. His collector, Kagan-Chabshay, who had bought several paintings from him for a few thousand francs prior to the artist's departure from Russia, permitted him to take the works to Paris for exhibition purposes. But within no time Russian relatives of Kagan-Chabshay

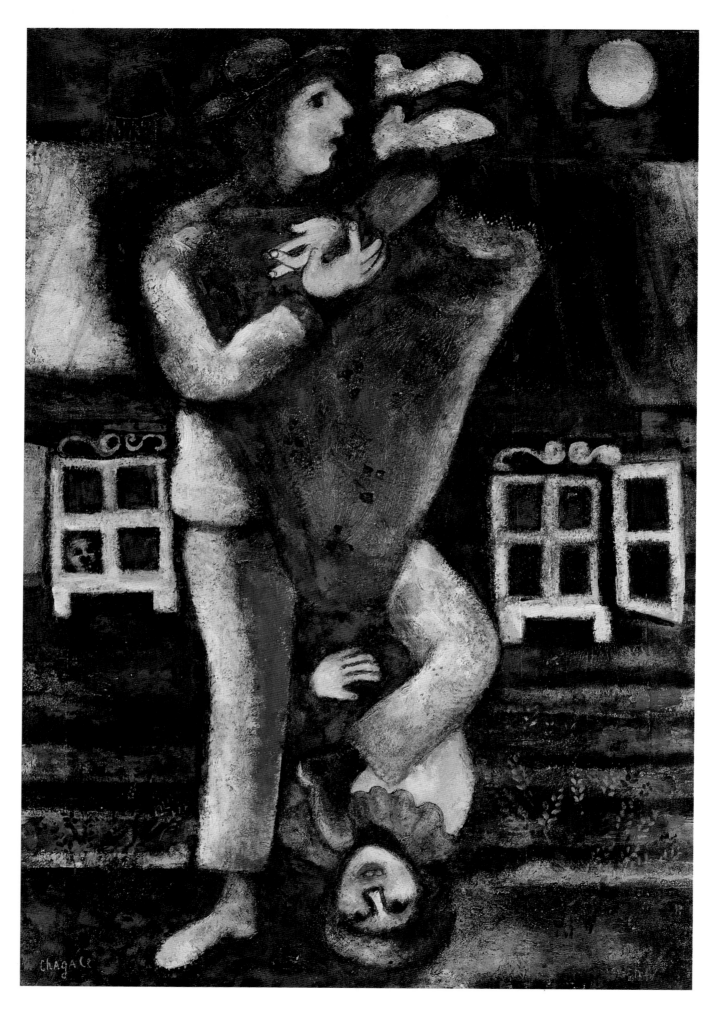

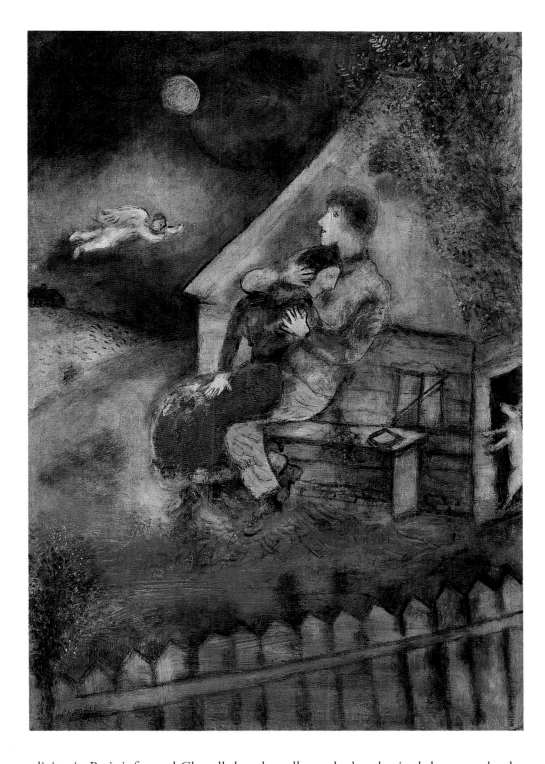

The Lovers, 1929
Oil on canvas, 55 x 38 cm
Tel Aviv, Tel Aviv Museum of Art

living in Paris informed Chagall that the collector had authorized them to take the paintings from him and sell them. Chagall had to oblige, and, as if relinquishing the pictures was not galling enough, their sale realized more than twelve million old francs.

Another collector, George Costakis, a Russian of Greek extraction who worked for the Canadian embassy in Moscow, became a specialist in Russian art and the art of the avant-garde, amassing hundreds of paintings. At the time many small-time aficionados of Russian art were forced to sell their collections for economic reasons, and Costakis exploited the situation, acquiring for a song paintings by Kandinsky, Malevitch, Rodchenko, Tatlin, Lissitsky, Popova and Chagall.

Some years before his death Costakis confessed to the author of this book that he had never paid more than 150–160 dollars for a painting. When Costakis, who had donated some of his art treasures to the Russian State, finally emigrated to the West, he was allowed to take a significant portion of his collection with him. To the

PAGE 124:
The Promenade, 1929
Oil on canvas, 55.5 x 39 cm
Private collection
Courtesy Galerie Rosengart, Luzerne

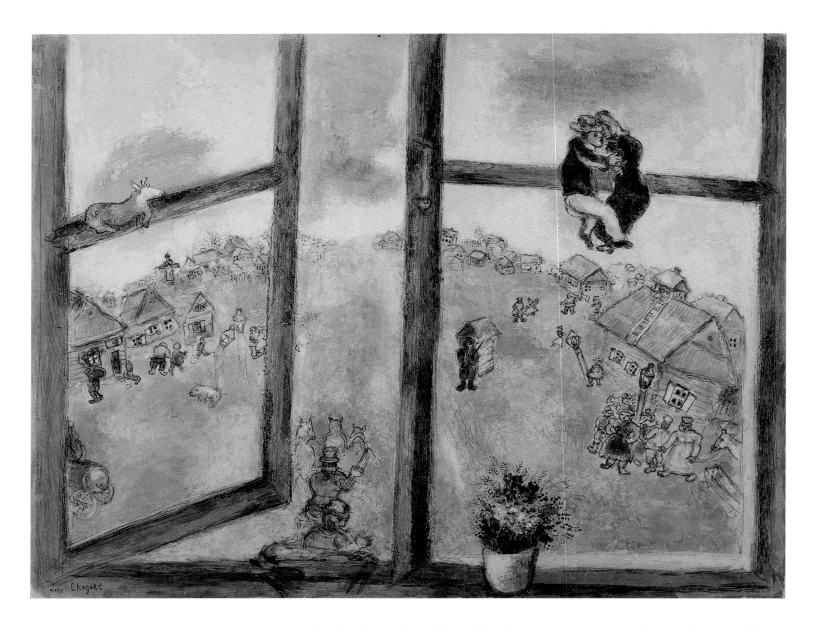

Celebration in the Village, 1929
Gouache, 50 x 65 cm
Basle, Collection Marcus Diener

author he related that a fire in his Moscow apartment had destroyed many of his pictures, although other sources have maintained that he invented this story as a way of spiriting additional paintings out of Russia by other, less legitimate routes.

In the twenties, however, it was not just minor aficionados who were having a hard time making ends meet, falling prey to exploitative big-time collectors. In those days Paris was full of Russians, many of them from aristocratic families. To earn a living, these 'White Russians' were forced to take any job that came their way, struggling along, for example, as cab drivers – the Bolsheviks themselves could not have thought up a better 're-education program'. But Chagall had little contact with his fellow countrymen, preferring, as before, the company of writers and poets.

At the beginning of 1926 Chagall had his first exhibition in the United States, with the Reinhardt gallery of New York showing about 100 works. Painting ceaselessly, the artist did not go to the opening. Most of his time he spent in Mourillon, a small fishing village on the Mediterranean coast near Toulon. The Chagalls also stayed a few months at Chambon-sur-Lac in the Auvergne, where they rented a house on the village square. Here, commissioned by art dealer and publisher Ambroise Vollard, Chagall produced about 30 gouaches based on La Fontaine's *Fables,* which were later to be engraved on copper plates for a limited book edition of etchings. Also during this period he went to Nice for the first time, falling in love with the Côte d'Azur. He delighted in the landscape, the vegetation, the blue Mediterranean, the mild weather, and above all the light. Nice was the town where

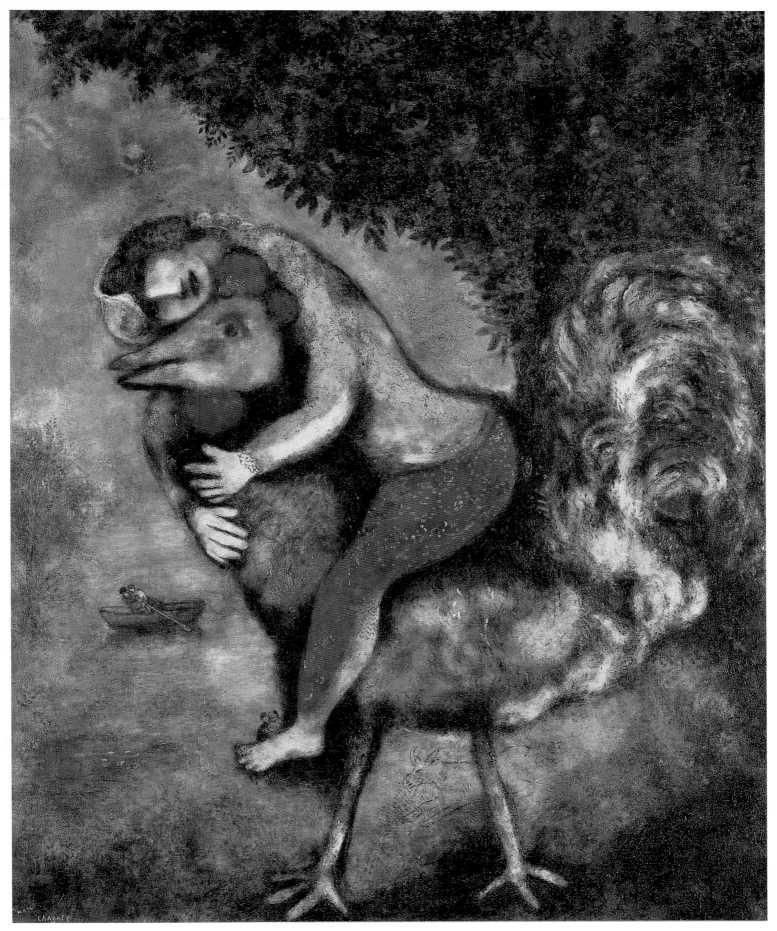

The Rooster, 1929
Oil on canvas, 81 x 65 cm
Madrid, Fundación Colección Thyssen-Bornemisza

Matisse lived and worked, and to which Picasso later moved, spending the rest of his life there. All the best ceramic, mosaic and sculpture-casting workshops lay in the vicinity of Nice, and it was Nice that was one day to house the Musée National Message Biblique Marc Chagall.

Towards the end of 1926 Katia Granoff exhibited 30 of his works in her Paris gallery, and Chagall started to illustrate books for some of his poet friends. He produced five etchings for Marcel Arland's novel *Maternité* (Motherhood) and 15 for *Les Sept Péchés Capitaux* (The Seven Deadly Sins) with texts by Jean Giraudoux, Paul Morand, Pierre MacOrlan, André Salmon, Max Jacob, Jacques de Lacretelle and Joseph Kessel. Another book he illustrated, with 92 drawings, was Gustave Coquiot's *Suite Provinciale*. Much has been said about Chagall the brilliant colourist, but very little about the superb etchings he created for his friends' books and, commissioned by Vollard, for Gogol's *Dead Souls*, the Bible, and La Fontaine's *Fables*.

Ambroise Vollard was not the only famous art dealer in Paris. Besides him there were Paul Rosenberg, Paul Guillaume and Leopold Zborovsky, who represented Modigliani. It was the period when rich American industrial magnates were coming to Paris to buy pictures for their mansions back home. Notable among such collectors was the eccentric Dr Alfred C. Barnes, of Philadelphia, who amassed a unique art collection. Dr Barnes, the inventor of 'Argyrol', a medicine for eye infections, felt himself called to promote new talent in the art world. One of his protégés was Chaim Soutine, from whom he purchased more than 100 paintings. Soutine had lived in La Ruche at the same time as Chagall, but Chagall had never had much to do with him, not least because Soutine's personal hygiene left something to be desired, and his behaviour was distinctly odd.

BOTTOM LEFT:
Man with Umbrella, 1940
Gouache on paper, 45 x 28.3 cm
Private collection

BOTTOM RIGHT:
To Charlie Chaplin, 1929
Drawing and gouache, 43.1 x 28.9
Paris, Musée national d'art moderne,
Centre Georges Pompidou

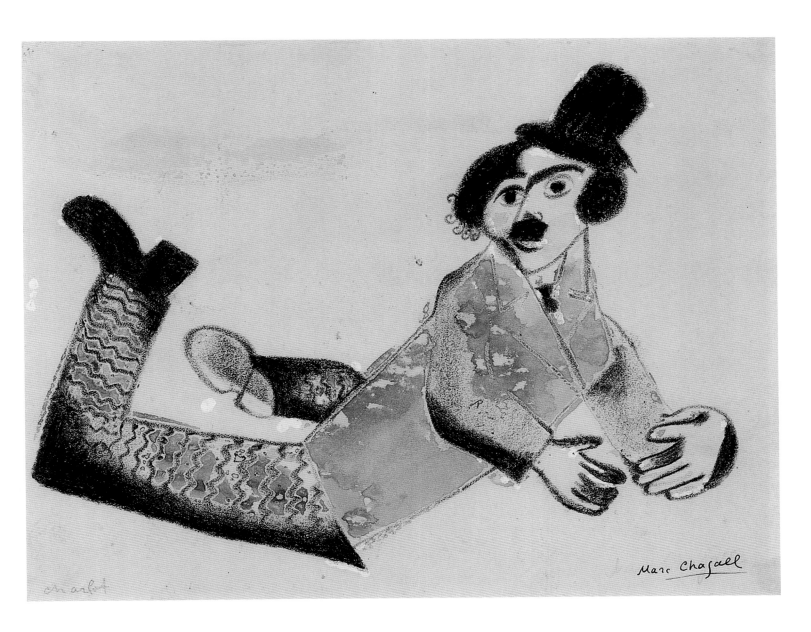

One evening Vollard invited Chagall and his little daughter Ida to join him in his box at the 'Cirque d'Hiver' (Winter Circus). Subsequently Chagall and Vollard spent many more evenings there, the performances prompting Vollard to commission the painter to do a project on the subject of the circus. In 1927 Chagall produced 19 gouaches, giving them the collective title *Cirque Vollard*. The colours of these works seem to explode as if a clown were bursting into the ring, while the backgound has a tragi-comic tinge.

In 1927 Alexander Granovsky and his Moscow 'Jewish Theatre' came to Paris to play at the Théâtre de la Porte-Saint-Martin. Chagall and Bella were thrilled to see their old friends again, especially the actor Salomon Michoels. They spent many evenings watching them perform, afterwards throwing parties at their home for the theatre group. The same year Chagall joined the Parisian 'Association of Painters and Engravers', also signing a contract with the renowned Bernheim-Jeune gallery, which provided him with a steady income. From May to September of that year the Chagalls stayed in Châtel-Guyon in the Auvergne, and in November Chagall drove with the painter Robert Delaunay to Limoux, where they called on the collector Jean Girou and the writer Joseph Delteil. Their six-day trip took them also to the Mediterranean coast, to Collioure and Banyuls-sur-Mer, where the sculptor Aristide Maillol lived. Towards the end of 1927 Chagall travelled to Chamonix in the Savoy alps, a landscape that reminded him of Russia. His painting *The Church* (1928–29), a snowscape with church seen from a window, stems from impressions gained during this trip.

Charlie (Chaplin), 1919
Watercolour, 16.7 x 21.5 cm
Private collection

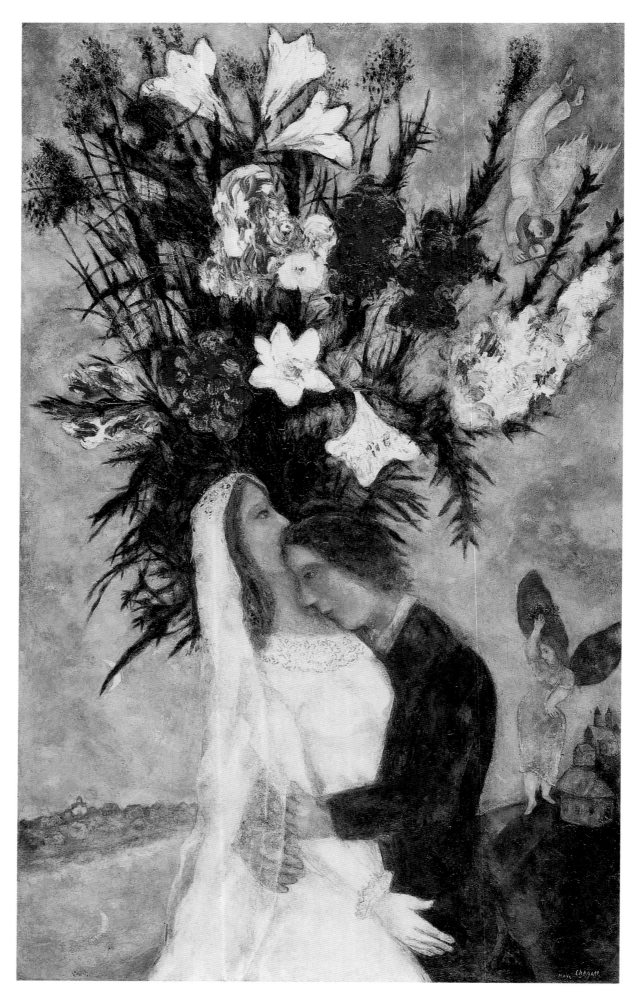

White Lilacs, 1930
Oil on canvas, 92 x 73.6 cm
Chicago (IL), Sara Lee Corporation

Lovers with Bouquet of Flowers, 1935–1938
Watercolour and gouache over pencil on paper
66 x 52 cm
Private collection

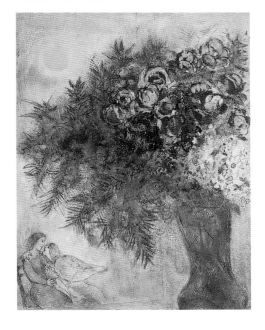

PAGE 130:
The Bridal Couple, 1927–1935
Oil on canvas, 148 x 80.8 cm
Private collection

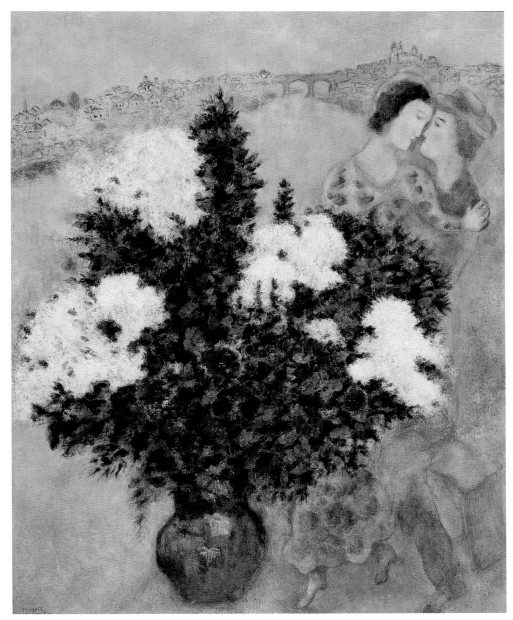

In the winter of 1927/28 Chagall continued to work on the circus gouaches and on the engravings for La Fontaine's *Fables*. Summer 1928 saw him making the acquaintance of the poets Jules Supervielle, Paul Eluard and René Schwob, as well as of the Catholic philosopher Jacques Maritain and his wife Raissa. Supervielle, who knew Picasso, admired Chagall, dedicating some poems to him. Raissa Maritain wrote a book about him, entitled *Chagall ou L'Orage Enchanté* (Chagall or the Enchanted Storm), which Chagall personally illustrated. Every Sunday at the Maritains' Meudon home a circle of writers and artists met, which for some years included Chagall and Bella.

At the end of 1929 the Chagall family moved again, this time to a house they had bought called Villa Montmorency, situated at 15 Avenue des Sycomores, near the Porte d'Auteuil. The artist continued on his circus project for Vollard, finding time also to paint lovers, nudes and sunny village landscapes. However, the Wall Street crash obliged the Bernheim-Jeune gallery to terminate their contract, leaving Chagall with only a modest income from the Vollard commissions. 1930 was marked by exhibitions of the La Fontaine *Fables* gouaches. They were shown first at the Bernheim-Jeune gallery in Paris, then at the Le Centaure gallery in Brussels, and finally at the Flechtheim gallery in Berlin (ill. pp. 222, 223). For the opening of the Flechtheim exhibition Chagall travelled to Berlin.

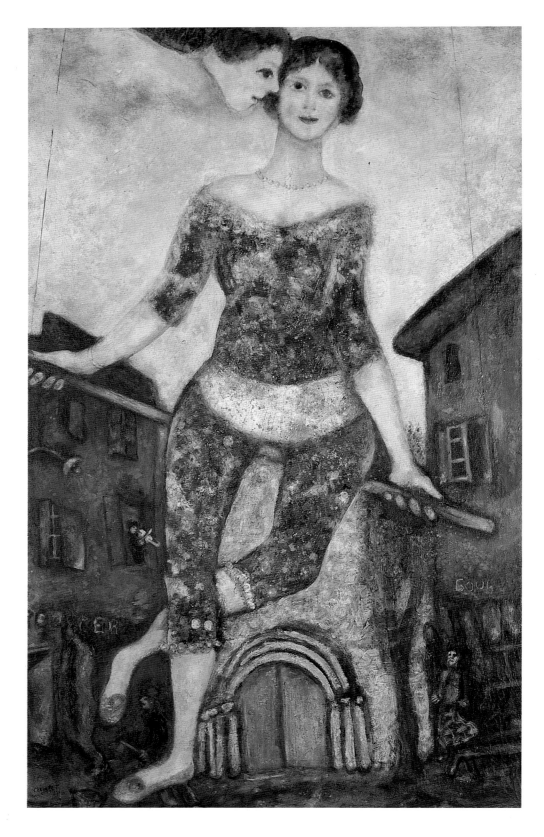

Chagall was fascinated by the French countryside, making repeated trips through it – his sketchbook always to hand. In the spring of 1930 he travelled to Neslé-la-Vallée, near L'Isle-Adam, and in the summer and autumn visited Peïra-Cava in the Alpes-Maritimes area, close to the Mediterranean coast. This landscape inspired him to paint a series of window-views.

On returning to Paris, he was commissioned by Vollard to illustrate the Bible (the Old Testament). The Bible was a subject particularly close to Chagall's heart, and the new challenge delighted him. Chagall could have fulfilled Vollard's commission without going to Palestine, but he wanted to gain inspiration by seeing

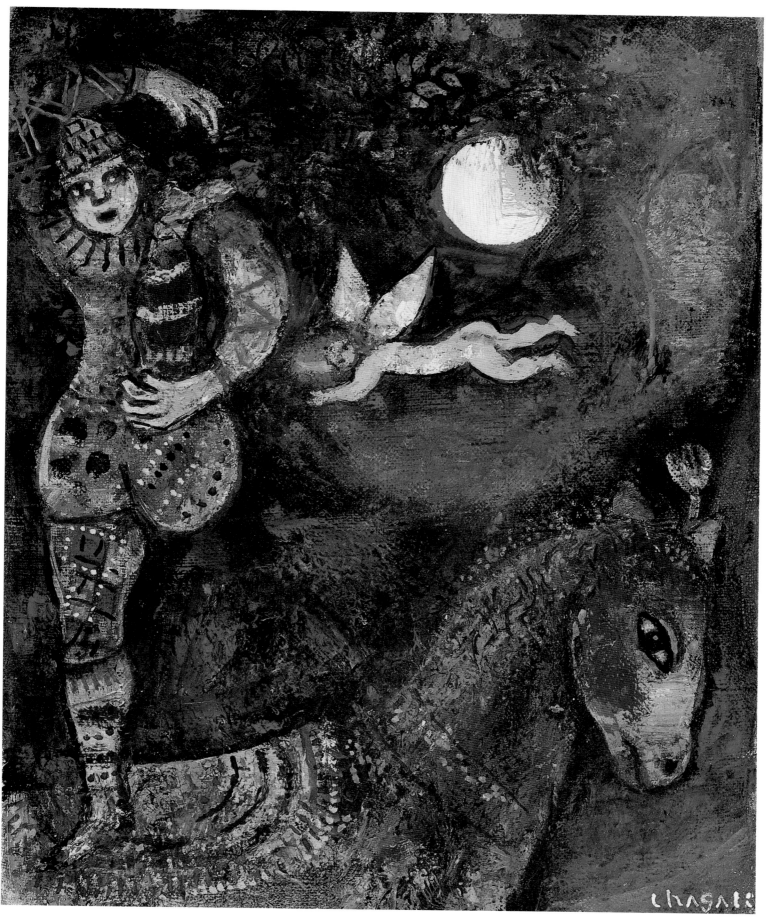

Circus Rider, 1927
Oil on canvas, 23.8 x 18.9 cm
Chicago (IL), The Art Institute of Chicago,
Gift of Mrs. Gilbert W. Chapman

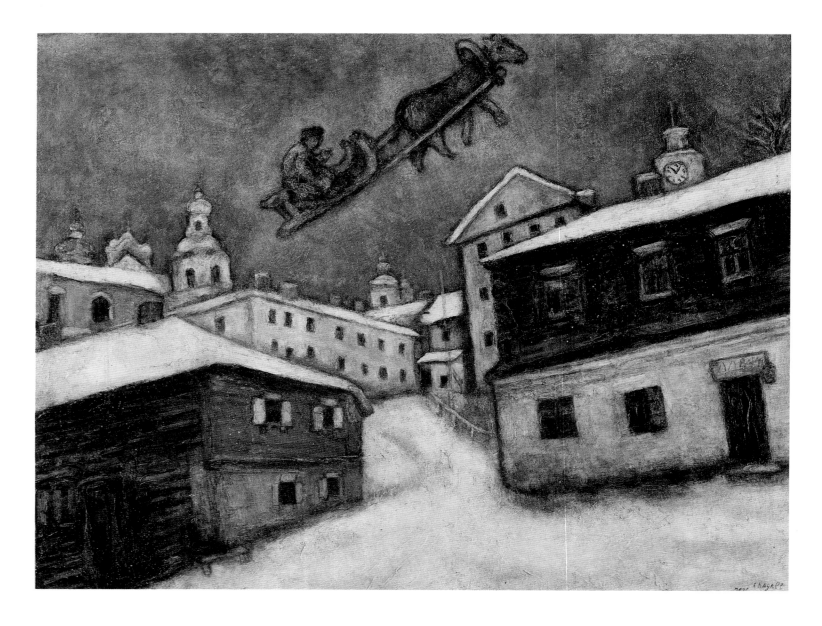

Russian Village, 1929
Oil on canvas, 73 x 92 cm
Private collection
Courtesy Galerie Beyeler, Basle

the Holy Land with his own eyes and by walking the paths once trodden by the Prophets. Chagall loved travelling, and although religion had played no great role in his life since leaving Russia, he continued to take a lively interest in Jewish literature and in everything relating to the Jewish people. With an especially keen eye he followed his people's struggle to reclaim their Biblical homeland. Every day he read Paris' Yiddish newspapers and magazines, and he corresponded with various Yiddish writers and poets.

At the invitation of the mayor of Tel Aviv, Meir Dizengoff, Chagall and his family embarked in February 1931 on a journey that would last until April. On board the steamship Champollion, their first port of call was Egypt, where they visited Alexandria, Cairo and the pyramids, to be followed by Beirut in Lebanon. From here they travelled overland to Palestine, which in those days was under British mandate. On the way from Beirut to Tel Aviv they were able to see the north of the country. They reached Tel Aviv during Purim, a particularly joyous and boisterous Jewish festival – a work by Chagall entitled *Purim,* which is a picture ablaze with vibrant reds, hangs in the Philadelphia Museum (1916–1918, ill. p. 90). Together with Meir Dizengoff, Chagall laid the foundation stone of the Tel Aviv Museum, where David Ben-Gurion, Israel's first prime minister, was to found the State of Israel on 15 May 1948.

Chagall felt at home in Palestine, where so many people spoke Yiddish, and a few even Russian. He was impressed by the pioneering spirit of the people in the kibbutzim and deeply moved by the Wailing Wall and other holy places. He visited

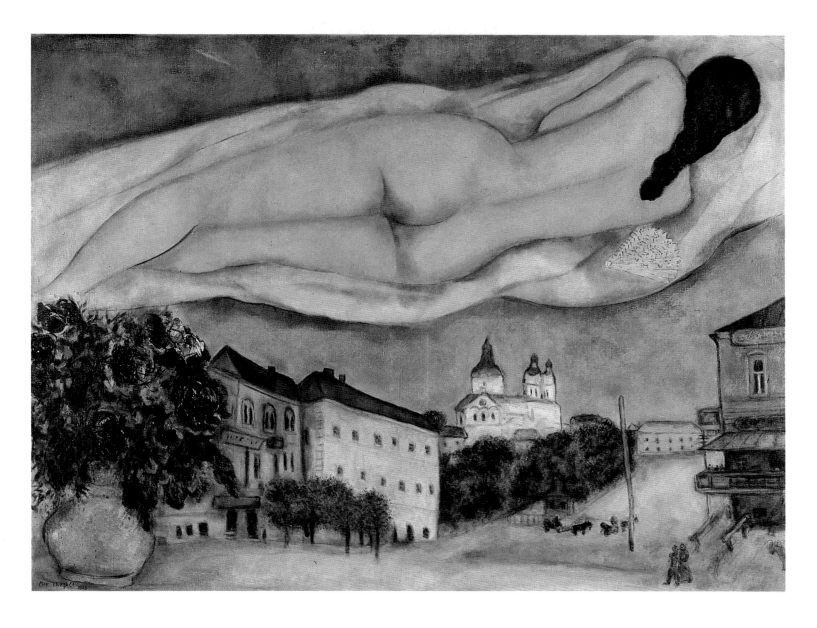

Jerusalem, the Judaean desert, Galilee, and the town of Safed, where he painted the interior of the synagogue (1931, ill. p. 136). This picture, now in the Israel Museum in Jerusalem, is a simple impressionistic rendition of the interior, featuring two figures in the background who are actually – untypically for Chagall – standing on the ground.

Elated and brimming with ideas for the Bible illustrations, Chagall returned to France. By 1932 he had completed 32 out of the total of 105 plates, and by the outbreak of the Second World War in 1939, the year of Vollard's death, he had done 66. However, when like other French artists he emigrated to the United States, he had to abandon the project, and it was not until 1952, after his return to France, that he was able to continue work on the remaining plates, finishing the series in 1956. Published by Edition Tériade, the illustrations were stunning and met with great acclaim (ill. pp. 224, 225). Once again Chagall had shown himself to be one of the 20th century's most important graphic artists.

In July 1931, through his friend Jules Supervielle, Chagall met the Andalusian poet Rafael Alberti. When in 1976 Sidney Alexander went to interview Alberti in Rome for his monograph on Chagall, Alberti recalled his first encounter with the artist: "Chagall was painting his pretty daughter Ida completely nude under a tree. […] Oh, this girl was so beautiful that it was a pleasure to see her under the trees like that. There was nothing erotic about the scene, nothing improper. She was just a model – a bit too young perhaps – posing for her father. Her father was quite unembarrassed, just as she was too." Ida was 15 years old at the time. Alberti

Nude over Vitebsk, 1933
Oil on canvas, 87 x 113 cm
Private collection

From 1933 to 1934 Chagall's artistic language changed. One notices a turning away from the spontaneous well of happiness that springs from his magical floral allegories of 1931. The worldwide economic crisis, the termination of his contract with the art dealer Bernheim-Jeune, the political coup in Germany and the first signs of discrimination against the Jews left their mark on his work. His palette became more restrained, the mood of his pictures more serious and contemplative. Although the red bouquet in the foreground still lends this picture a tentatively joyful note, the back of the reclining nude, suspended in the dark sky over a grey Vitebsk, evokes sadness and desolation.

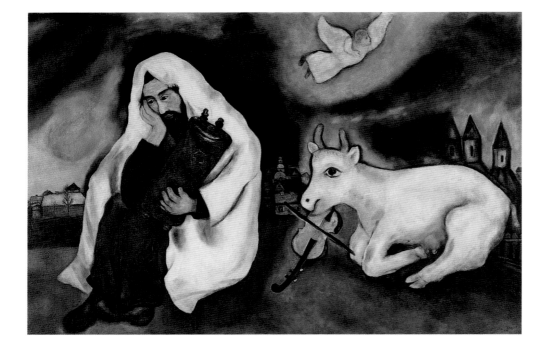

Solitude, 1933–34
Oil on canvas, 96 x 158 cm
Tel Aviv, Tel Aviv Museum of Art

Interior of a Synagogue in Safed, 1931
Oil on canvas, 58.4 x 71 cm
Jerusalem, The Israel Museum, Purchase
made possible by Janine Bernheim and Antoine
Wertheimer in memory of their Parents,
Madeleine and Paul Wertheimer and by the
Croem Family (Chicago), Edith Haas, Averell
Harriman, Loula Lasker, Edward D. Mitchell,
David Rockefeller, and Charles Ullman

visited the Chagalls on a number of occasions, and in his interview with Alexander describes the artist as follows: "He was bit pagan, […] something of a fawn, a satyr. […] He was a man truly open, free. He simply laughed. […] Chagall was a genuine Slav, ironic, very amusing, always ready to caricature himself and others. […] He loved acting up, a bit like Picasso. In fact he was better at it than Picasso."

This friendship only ended when Alberti returned to his homeland at the outbreak of the Spanish Civil War. As a parting gift Chagall gave Alberti a copy of his book *My Life*, which had been published in 1931 in French by Librairie Stock of Paris. Initially André Salmon had been entrusted with the task of translating the Russian text, but Chagall had found his rendering too French, failing to capture the atmosphere of Jewish life during the artist's childhood in Vitebsk. So Bella had a go at translating the autobiography, going through the text sentence by sentence

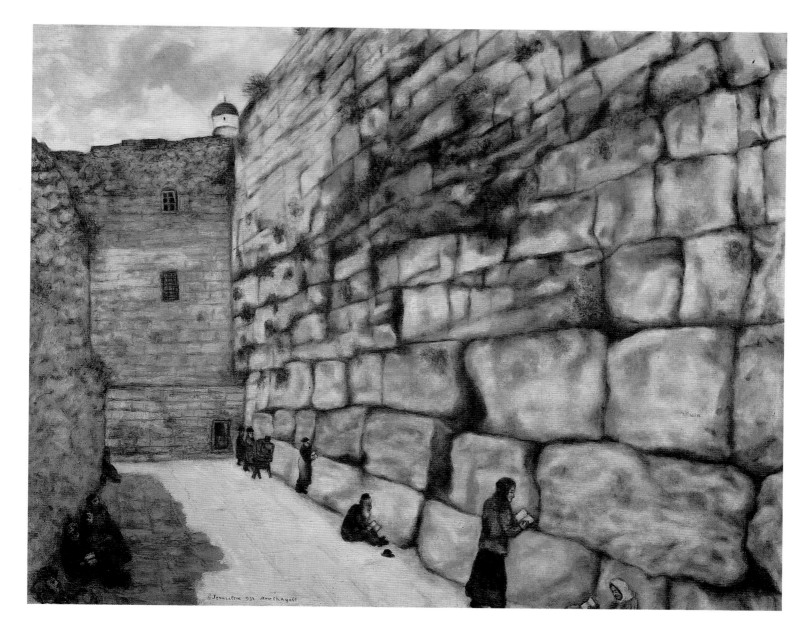

The Wailing Wall, 1932
Oil on canvas, 73 x 92 cm
Tel Aviv, Tel Aviv Museum of Art

with her husband. When the book duly appeared and Bella Chagall was cited as the translator, Salmon's pride was wounded and he claimed that Chagall's text was untranslatable. Although their relationship was soured for a while, Salmon wrote the preface to *Ma Vie* and went on to pen several texts as well as a book about Chagall. The first edition of *Ma Vie* was published in a print run of 1670 copies, and was followed in 1957 by a second edition. The book went on to be translated into other languages including Hebrew, Yiddish, German, English and Italian.

In 1932 Chagall designed the sets and costumes for a Bronislava Nijinska ballet in three parts to Beethoven variations, but the work was never performed. The same year the Chagalls went to Holland, where the 'Association of Dutch Artists' mounted an exhibition of 55 of his works in Amsterdam. In Holland, on seeing Rembrandt's paintings in the original, Chagall was deeply moved, having written in *My Life* that "I am sure Rembrandt loves me."

When in 1933 Chagall tried to become a French citizen, his application was rejected on the grounds that he had been a Soviet arts commissar. However, following the intervention of the writer, essayist and critic Jean Paulhan, one of the most influential figures in French cultural life of the day and, among other things, editor of the magazine *Nouvelle Revue Française*, he did in 1937 finally acquire French citizenship. In the summer of 1933 Chagall visited Vézelay, in Switzerland, and towards the end of that year 172 of his works were exhibited in the Kunsthalle in Basle.

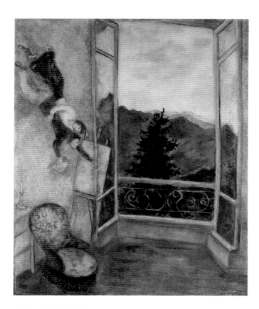

The Pink Chair, 1930
Oil on canvas, 72 x 59 cm
Private collection

In 1934, at the age of 18, Chagall's daughter Ida married Michel Gorday, a young lawyer several years older than her. To commemorate the nuptial occasion, the artist painted *The Betrothed's Chair* (ill. p. 139), which holds a special place among his many wedding pictures in that the bride and groom are missing. Further, the predominant colour is white, the bride's floral bouquet lies on the seat of a high-backed armchair, the candelabrum to the left has only one candle burning, and the wall is decorated with Chagall's picture *Birthday* (1915, ill. p. 76). This still life does not speak of joy or happiness, rather sadness.

Together with some friends, among them the poet Supervielle and painter Henri Michaux, Chagall and Bella travelled during the summer of 1934 to Spain, where the paintings of Goya and El Greco made a deep impression on him. In spring of the next year Chagall had his first London exhibition, at the Leicester Galleries, while in August, accompanied by his wife, he was guest of honour at the inauguration of the Jewish Cultural Institute in Vilna. This town just 360 kilometres from Vitebsk was once Polish but is today the Lithuanian capital Vilnius. To mark the occasion of his visit, 116 of his graphic works were exhibited. In Vilna too Chagall painted the interior of the local synagogue – a 'ritual' that he performed on journeys throughout his life, doing so perhaps in the same way that others light a candle for a loved one.

In Vilna Chagall also met the Yiddish poet Abraham Sutzkever, who later emigrated to Israel and whose book *Sybir* the artist was to illustrate in 1953. In the Poland of 1934 the Chagalls could already feel the aggression being directed at the Jewish population – the burgeoning anti-Semitism that was to culminate in the appalling events of the Holocaust. In Germany, where Chagall had been so feted and hailed as the forerunner of German Expressionism, people started ridiculing his paintings as 'decadent Jewish art'. Chagall returned to Paris. Whatever his thoughts might have been, his pictures from this period show no traces of the looming menace. As before, he painted lovers, still lifes and flowers, perhaps considering such works as talismans, whose magic charm could ward off the coming storm.

A favourite haunt of Chagall's in 1936 was the Parisian Café de Flore, where artists, writers and intellectuals congregated over an aperitif. Here he ran into Picasso, who also frequented the café. Chagall and Picasso had met several times before, at the home of Christian Zervos, the editor and publisher of the art journal *Cahiers d'Art*, but the relationship between the two artists had always remained strained. The Spanish Civil War, raging at the time, intensely preoccupied Picasso. His monumental *Guernica*, one of our century's most important paintings, was the artist's reaction to the brutal bombing on 26 April 1937 of the town of the same name by German aircraft flying in Franco's service.

About the same time Chagall produced an impressive large-format painting dealing with the Russian Revolution, which he simply called *Revolution* (ill. pp. 144–155). It was an unusual work with strong political overtones – a figure representing Lenin is doing a handstand on a table on one hand, while pointing with the other to a red Communist flag flying in the air. Between his legs flutters the French tricolour, next to the table sits a Jew holding a Torah or scroll, and on the floor stands a Russian Samovar. The left side of the picture shows a large crowd cheering and applauding, while on the right Jewish townsfolk, inhabitants of the Jewish 'shtetl', can be seen, some holding musical instruments, and one floating upside down and viewing the goings-on with astonishment. Chagall himself sits at an easel, painting. This strange work, reminiscent of the artist's circus pictures, is open to many interpretations, but is probably best seen as a gibe at the October Revolution.

Chagall was dissatisfied with the first version of this painting, and destroyed it. However a second version exists, which is now in the Pompidou Centre in Paris. The art historian Franz Meyer, Chagall's former son-in-law, believes that the first version was destroyed because it had almost said too much.

At the end of 1936 Chagall took a new studio at No. 4 Villa Eugène-Manuel, near the Trocadéro in Paris' 16th district, while the spring of 1937 he spent in Villars-Colmars in the alps of Haute-Provence, near Avignon. After that the artist

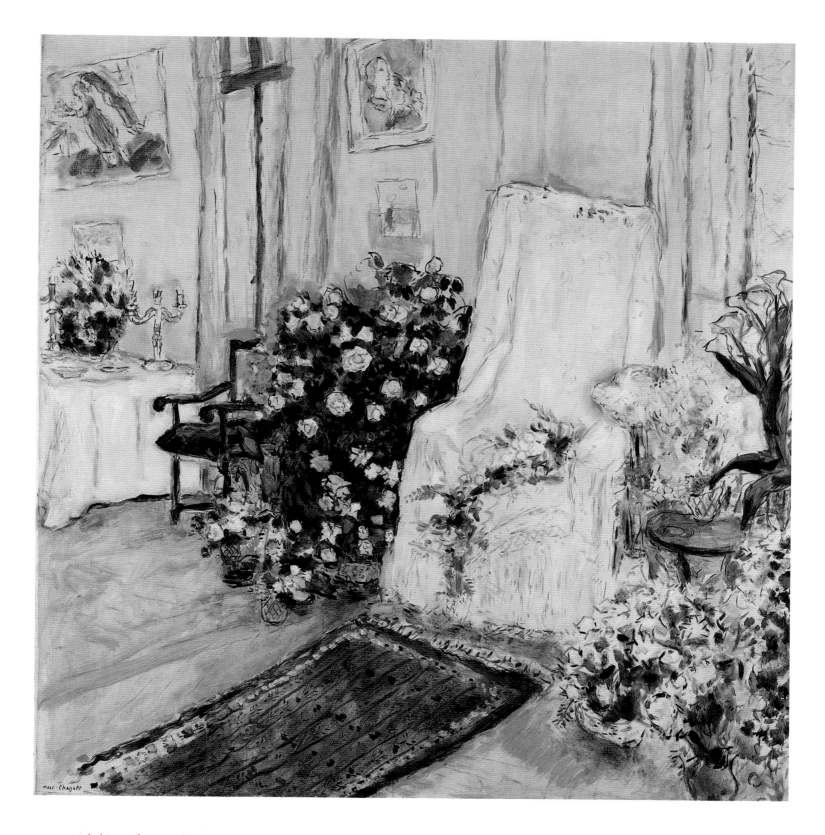

went with his wife to Italy, where in Florence he made 15 more etchings for the Bible, and in Venice he was able to marvel at the paintings of Titian, Tintoretto and Bellini. Although ever darker clouds were gathering on the political horizon, Chagall's journeys to Provence and Italy lifted his spirits.

In 1938 there were exhibitions of Chagall's work at the Palais des Beaux-Arts in Brussels and at the Lilienfeld Galleries in New York. Hardly a year after Picasso had created *Guernica*, Chagall finished one of his most important paintings: *White Crucifixion* (ill. p. 149). Christ is shown on the cross partially covered with a tallith or Jewish prayer shawl. The Hebrew inscription above his head says "Jesus of Nazareth, King of the Jews". Around the cross, a candelabrum, a Jew with a Torah,

The Betrothed's Chair, 1934
Oil on canvas, 100.5 x 95 cm
Private collection

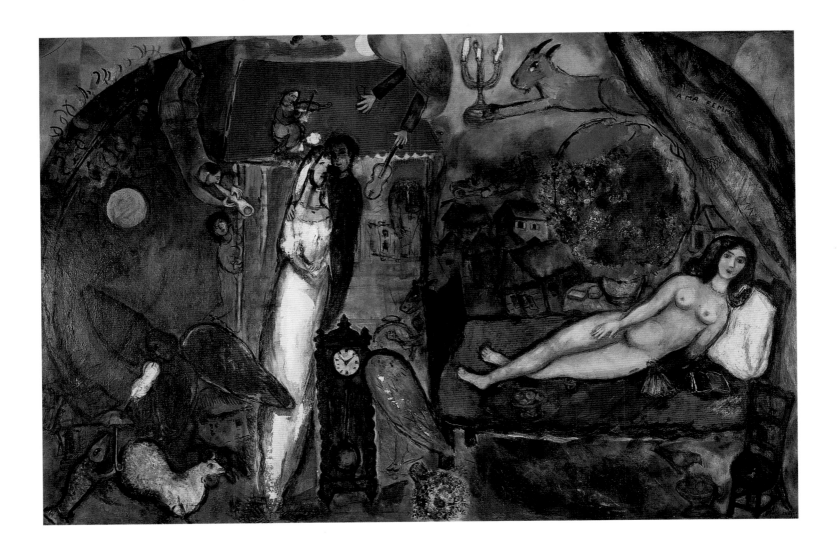

To my Wife, 1933–34
Oil on canvas, 107 x 178.8 cm
Paris, Musée national d'art moderne,
Centre Georges Pompidou

and a burning synagogue are depicted. The Ark of the Covenant is open and the Torah scrolls lie strewn on the floor. Houses are burning and everywhere there are frightened people. Later Chagall explained that the picture was his reaction to the persecution of the Jews by the National Socialists, the figure of Christ symbolizing the Jewish martyrdom. The brutal attack on a small village Chagall portrays through the entry of soldiers, brandishing red flags and weapons. Powerful as the work might be, it was nevertheless roundly criticized by some Jews, who regarded Chagall's ideas, for instance his recourse to Christian symbolism, as naive and wayward. Chagall, however, was undeterred by this, continuing to paint crucifixions in all shapes and sizes. For Sidney Alexander, Christ on the cross symbolized not only the martyrdom of the Jews, but also of Marc Chagall.

Chagall stood on the side of the Soviet Union when it joined the struggle against the Nazi dictatorship, but unlike other artists and writers – including some of his friends – he never became a member of the French Communist Party, nor did he ever sign any manifesto. Besides Fernand Léger, the poets Louis Aragon and Paul Eluard, Ivan and Claire Goll, and the composer Erik Satie, Picasso was the most famous artist to join (admittedly not until 1944) the Communist Party, and as late as 1961 he drew for the Communist Party Peace Congress his famous peace dove.

Shortly before the outbreak of the Second World War, Chagall moved to Saint-Dyé-sur-Loire, taking with him in a taxi all the paintings from his Paris studio, among them the magnificent *Bride and Groom of the Eiffel Tower* (1938–39, ill. p. 110). In October 1939, at the 'International Exhibition of Painting' of the Carnegie Institute in Pittsburgh, Chagall won third prize for his picture *Bridal Couple* (1927–35, ill. p. 130). Early 1940 Chagall and his daughter Ida brought back some paintings to Paris for an exhibition organized by Yvonne Zervos at the

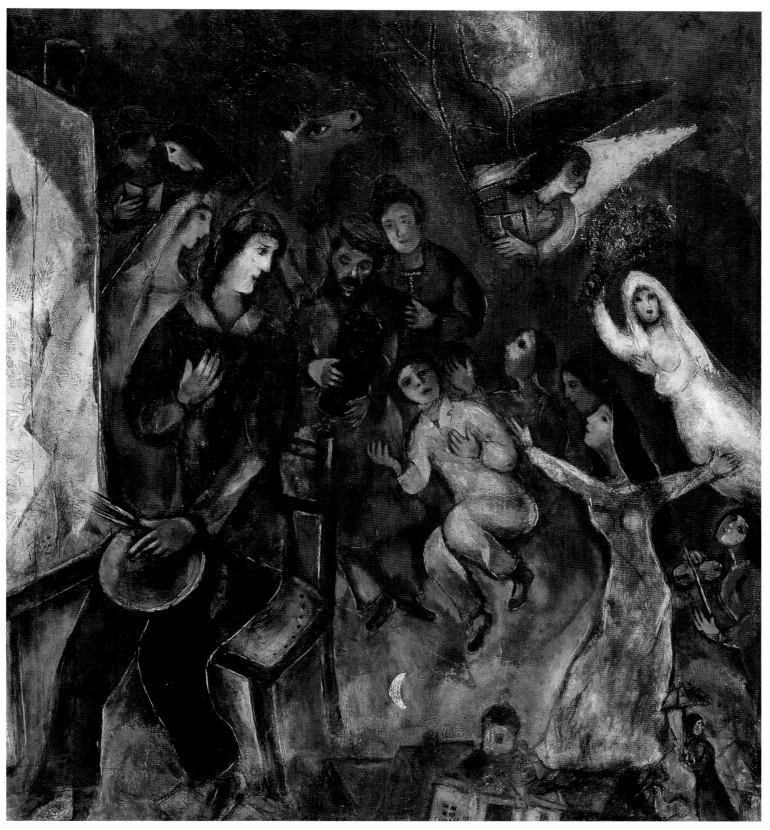

Apparition of the Artist's Family, 1947
Oil on canvas, 123 x 112 cm
Paris, Musée national d'art moderne, Centre Georges Pompidou

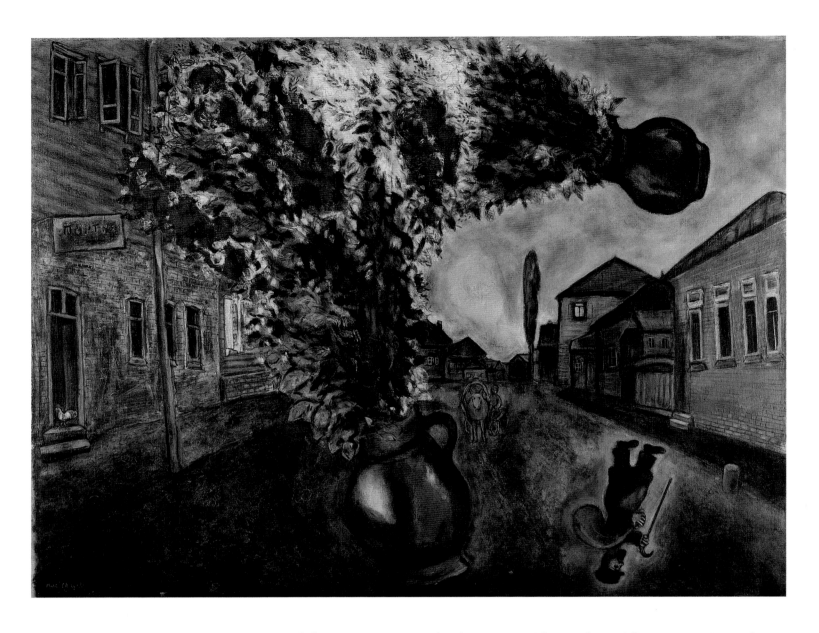

Flowers in the Street, 1935
Oil on canvas, 90.2 x 116.7 cm
Private collection

PAGE 143:
Bouquet of Flowers, 1937
Oil on canvas, 99 x 71 cm
Private collection
Courtesy Scharf Fine Arts, New York

Galerie Mai. Interestingly, the painting *The Revolution* (ill. pp. 144/145) was shown there in a back room with a new title *Composition*.

The war drew ever closer, and following the German invasion of France and their entry into Paris millions of French flocked to the unoccupied south of the country. The artist André Lhote drew Chagall's attention to the picturesque village of Gordes in the Vaucluse mountains (near the Montagne du Lubéron), 40 kilometres from Avignon, urging him to move there. In May Chagall bought the premises of a former Catholic girls' school in Gordes, where for a year he lived and worked with his family. During this time Marshall Pétain signed an armistice with Germany, becoming head of state of the 'Vichy government' in the unoccupied part of France. While French Jews and other victims of the Nazi regime were being sent to concentration camps, Chagall, unaware of the true extent of the horror, continued to paint still lifes with fruit and flowers.

Early in 1941 Varian Fry, Director of the American 'Emergency Rescue Committee', and Harry Bingham, the United States Consul General in Marseille, paid a visit to Chagall, bringing him an invitation from the Museum of Modern Art in New York to come to the United States. Other artists who received the same invitation were Picasso, Matisse, Rouault, Dufy, Max Ernst and André Masson. Both Picasso and Matisse decided to remain in France for the time being. The Chagalls, however, went in April 1941 to Marseille to prepare for their departure. They hoped to obtain a French visa there so that they could return to France at a later date without any problems. Fernand Léger, André Breton, the philosopher

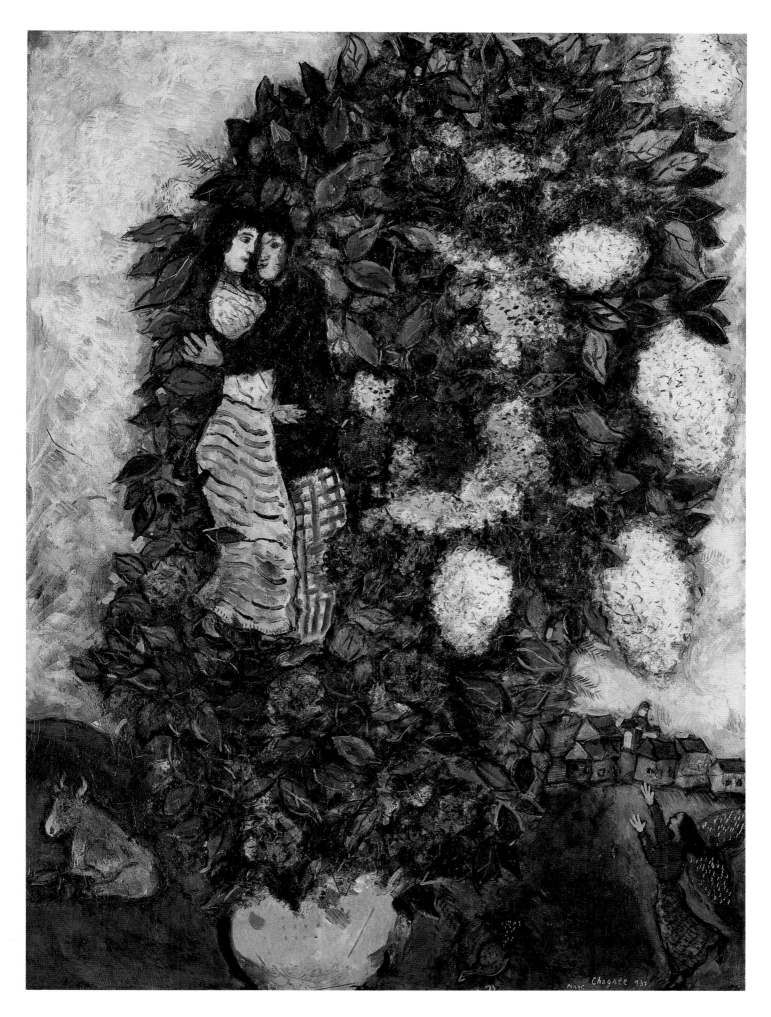

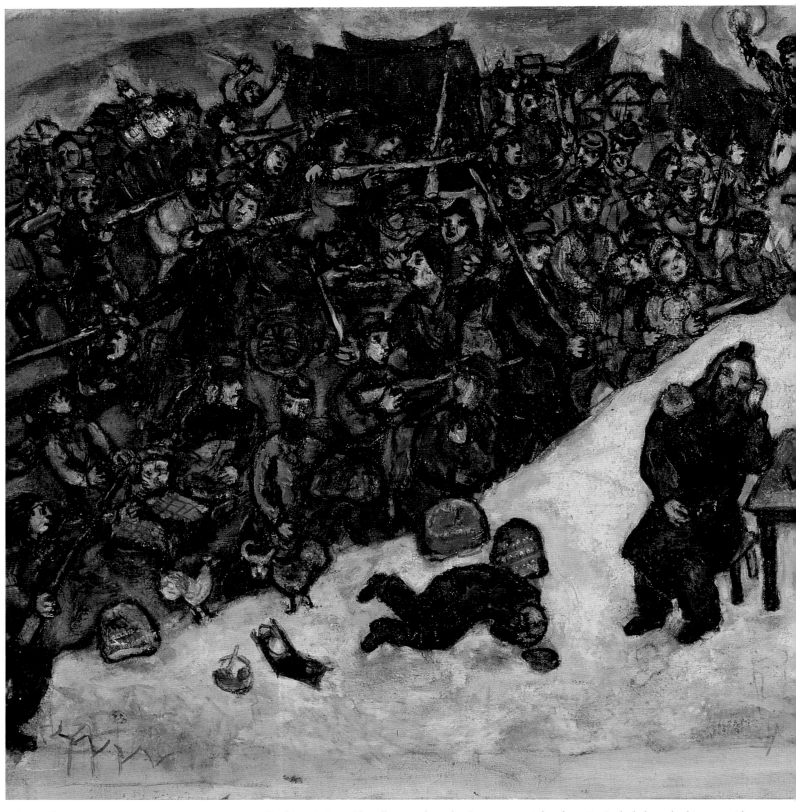

The Revolution, 1937
Oil on canvas, 49.7 x 100.2 cm
Paris, Musée national d'art moderne,
Centre Georges Pompidou

In this painting, Chagall remembers the October Revolution of 1917, as he experienced it in Russia. According to Franz Meyer, the work is part of a monumental composition that was cut into pieces in 1943. In the same year that Picasso produced his momentous anti-war painting Guernica, Chagall was parodying the Russian revolution. In the middle of the painting the "clown" Lenin is balancing on a table. With Lenin, the world is turned upside down and the red flag falls to the ground. The people to the

right, the artist included, are looking on with astonishment and fear, but celebrating life and freedom all the same. The soldiers to the left are aiming their rifles menacingly. A praying Jew is sitting at Lenin's table, hoping for the best. In 1937, as Chagall was painting this picture, many Paris intellectuals were supporting the Communists in the Spanish Civil War. Chagall obtained French citizenship in the same year, which gave him the freedom to view the revolution in his own country critically and even cynically.

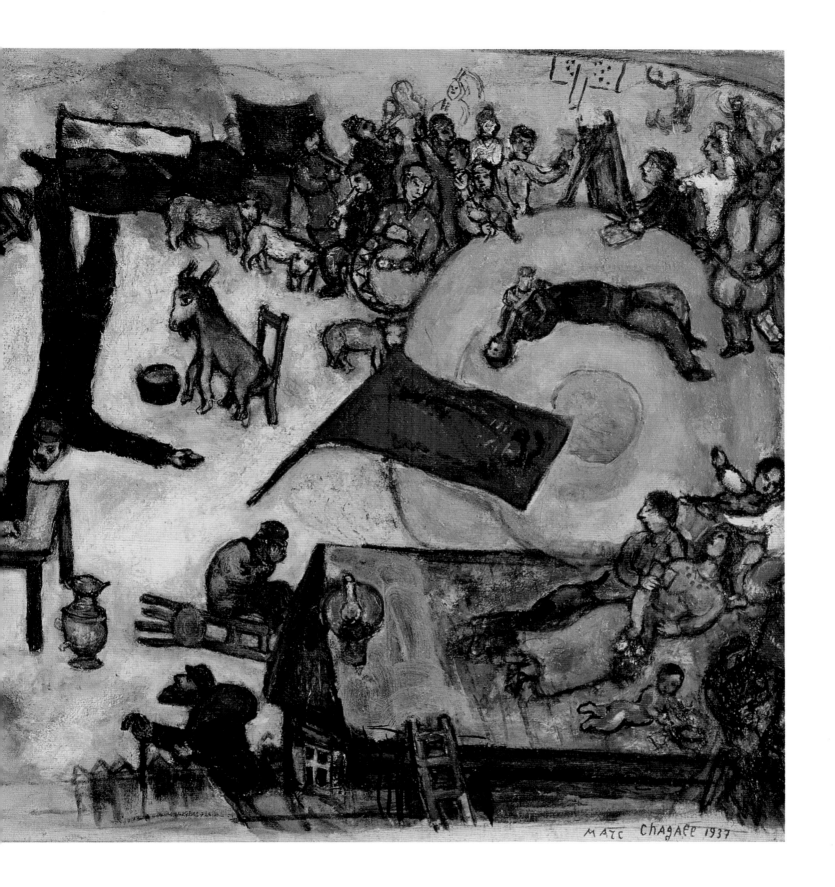

TOP LEFT:
The Pogrom, 1931
Drawing, pen and ink on paper, 22 x 15 cm
Paris, Musée national d'art moderne,
Centre Georges Pompidou

TOP RIGHT:
The Revolution, 1931
Drawing, pen and ink on paper, 22.7 x 15.7 cm
Paris, Musée national d'art moderne,
Centre Georges Pompidou

The Village and the City, 1931
Drawing and black ink, 17.7 x 13 cm
Paris, Musée national d'art moderne,
Centre Georges Pompidou

PAGE 147:
Liberation, 1937–1952
Oil on canvas, 168 x 88 cm
Paris, Musée national d'art moderne, Centre
Georges Pompidou, Loaned to the Musée
National Message Biblique Marc Chagall

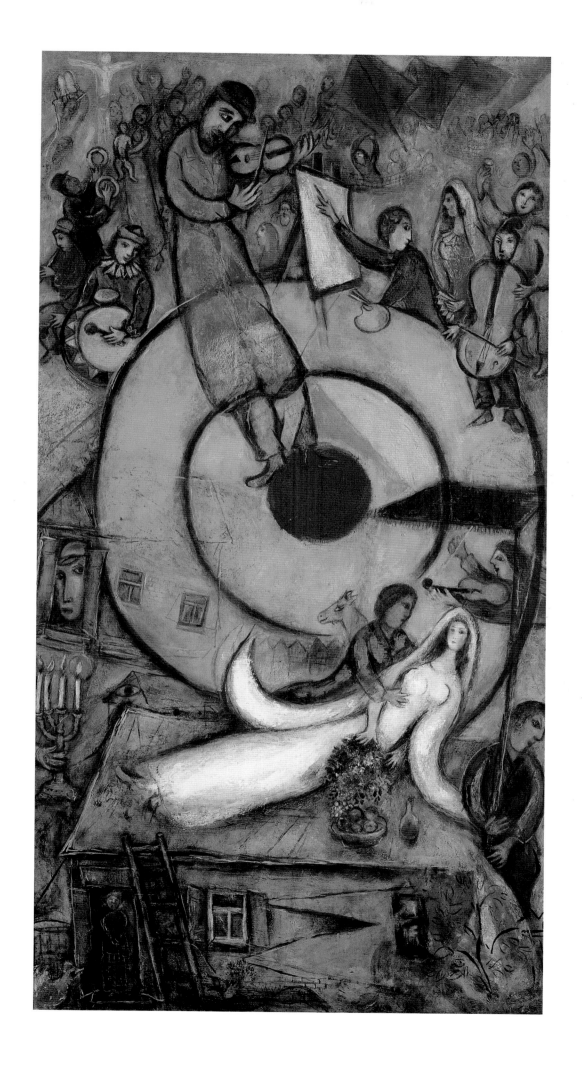

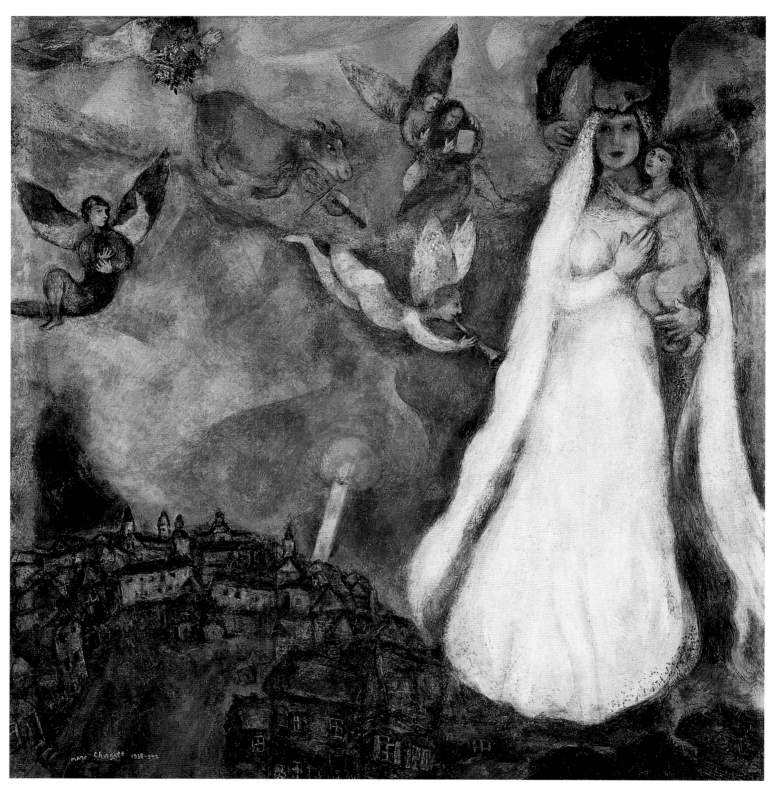

The Madonna of the Village, 1938–1942
Oil on canvas, 102.5 x 98 cm
Madrid, Fundación Colección Thyssen-Bornemisza

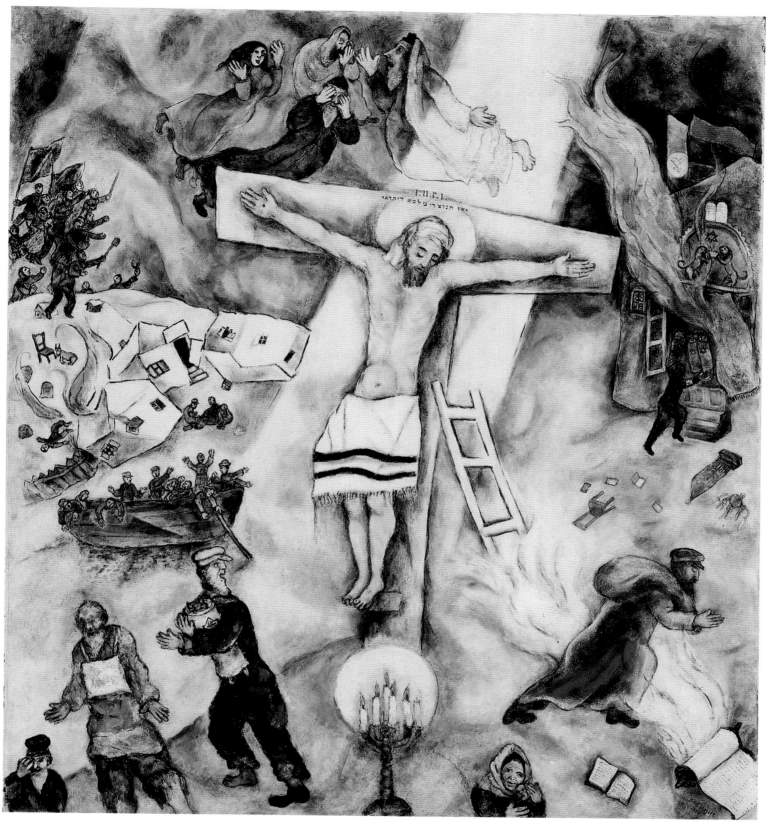

White Crucifixion, 1938
Oil on canvas, 154.3 x 139.7 cm
Chicago (IL), The Art Institute of Chicago, Gift of Alfred S. Alschuler

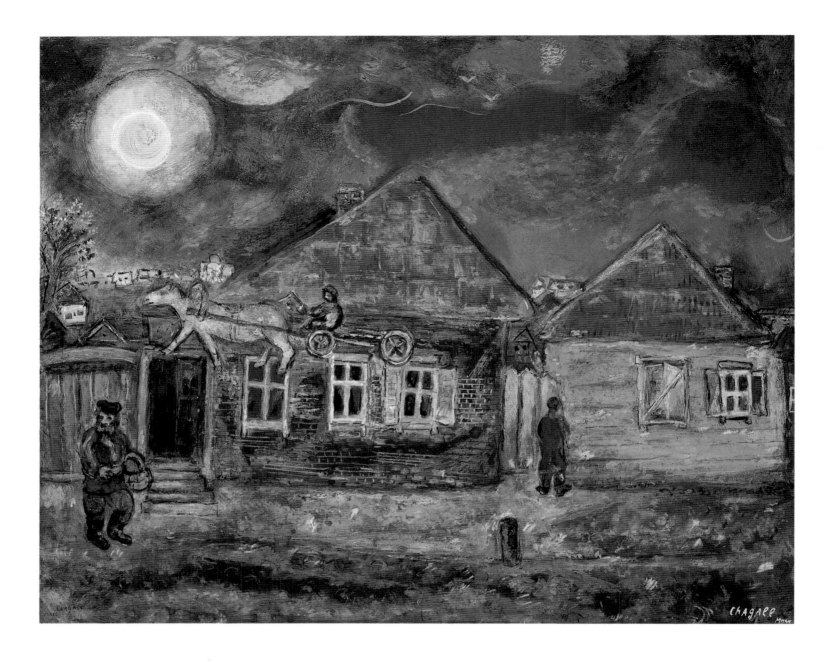

Village Street, 1940
Oil on paper, mounted on canvas
51.9 x 64.2 cm
Private collection

Jacques Maritain, and Chagall's friends Ivan and Claire Goll had already departed for the United States.

On 7 May the Chagalls left Marseille and, after a brief stop in Madrid on 11 May, arrived in Lisbon to wait for the boat that would take them to America. The artist's work, packed in crates and trunks and weighing altogether 600 kilograms, was sent to Lisbon, only to be impounded en route in Spain. It took five weeks and intense efforts on the part of Ida, Spanish, French and American friends, the American Embassy and a curator of the Prado in Madrid, to get the consignment released and loaded onto the boat bringing the Chagalls to the USA.

They were sad at having to leave France, not knowing what awaited them in their new country, whose language they could not speak. But at least they were going to be safe. On 23 June 1941, the day German troops marched into Russia, Chagall and Bella reached New York after a smooth Atlantic crossing. The first thing to greet their eyes in their new homeland was the Statue of Liberty.

PAGE 151:
Bonjour Paris, 1939–1942
Oil and pastel on cardboard, 62 x 46 cm
Private collection

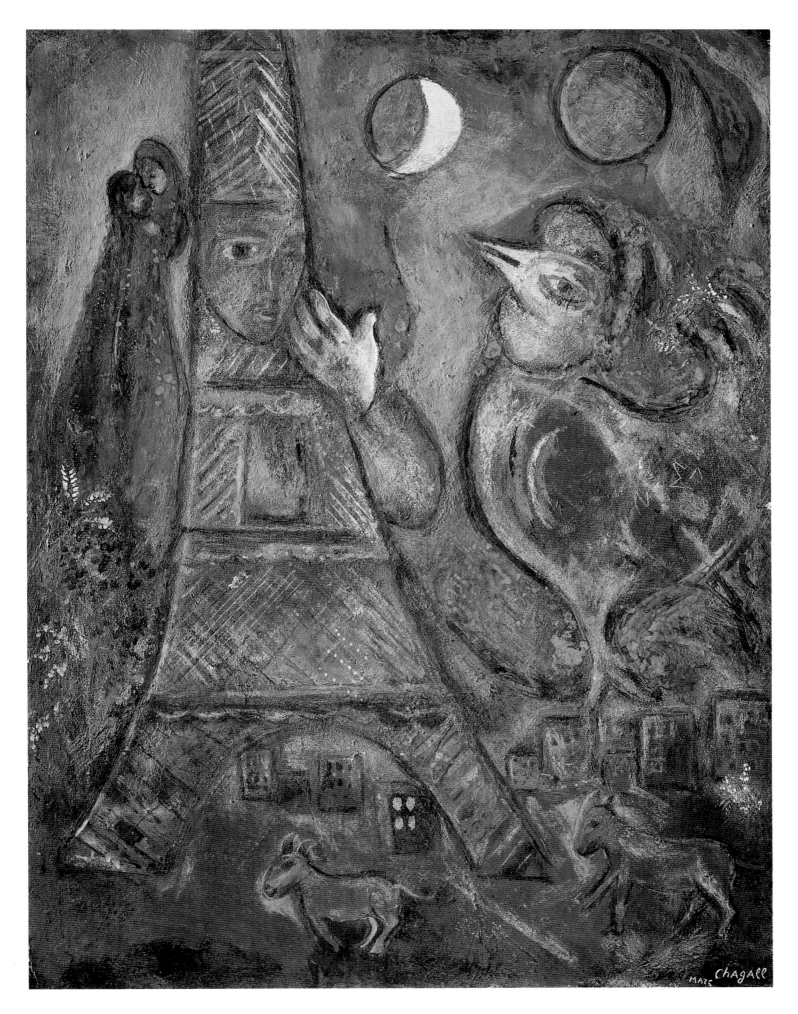

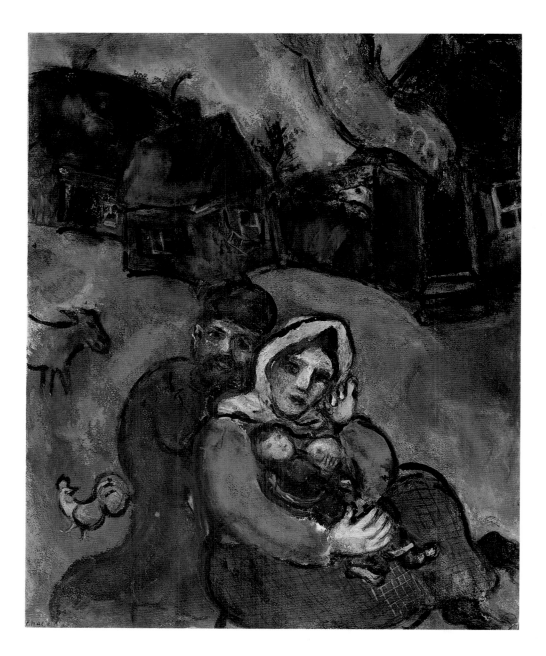

The Burning Village, 1940
Gouache on paper, 67.6 x 51.4 cm
Private collection

Since his early youth in Vitebsk, Chagall had
witnessed antisemitism, discrimination and
pogroms, all of which left deep scars and
impression he would never forget. Only after
his mother had bribed a teacher was he allowed
to attend the local school in Vitebsk, from
which Jews were officially excluded. He even
needed a special resident's permit to stay in
St Petersburg, where he wanted to study. This
dramatic picture shows a married couple, with
a small child, fleeing their burning home. The
horrors of war and the tragic fate of the Jews
are brought to life only too vividly.

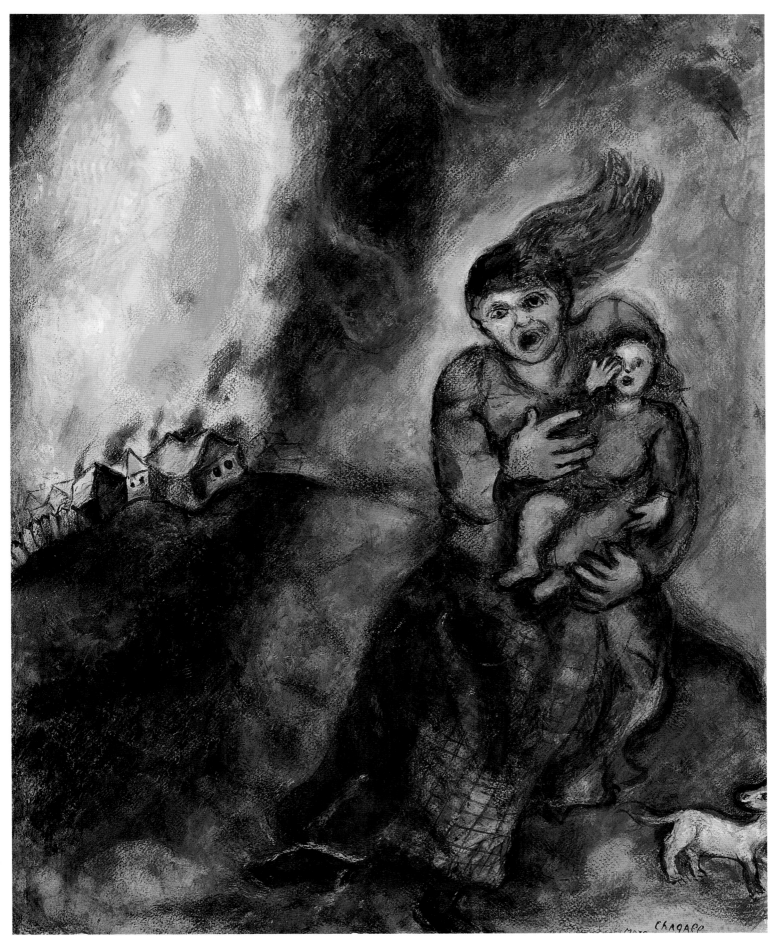

Fire in the Snow, 1940
Gouache on paper, 67 x 51.4 cm
Private collection

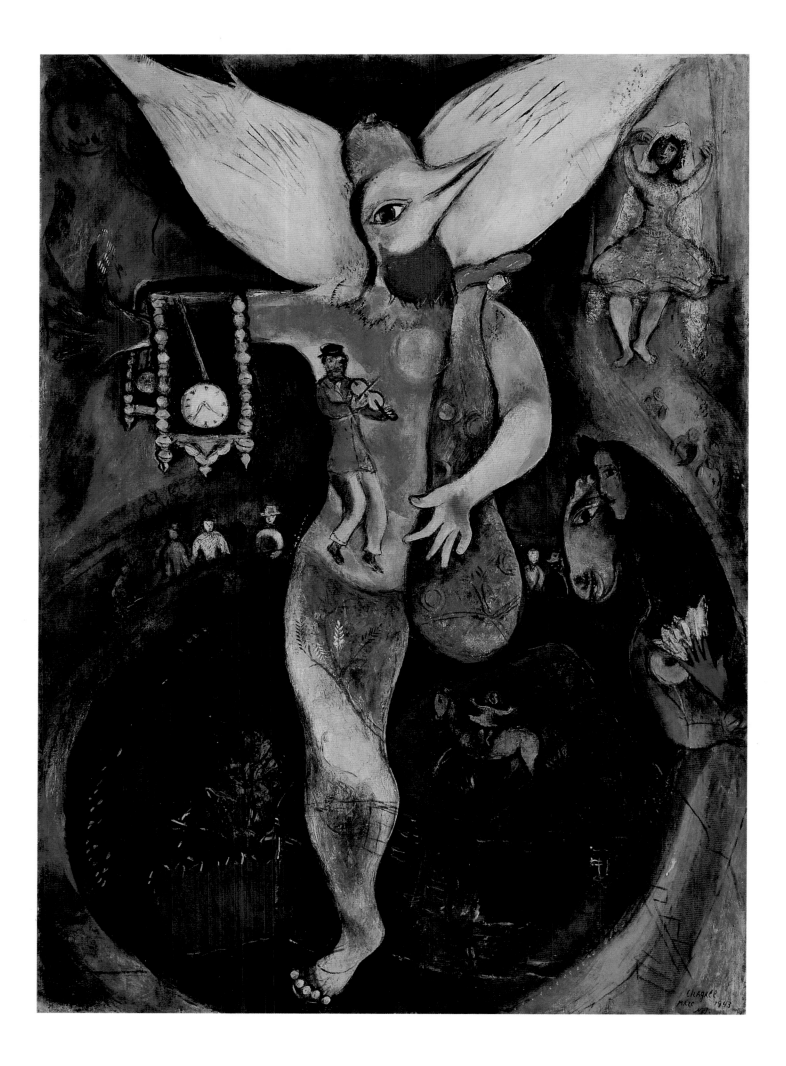

The United States 1941–1948

"I love America, I found there a feeling of youth."

Upon disembarking in New York, Marc and Bella Chagall were met by Pierre Matisse – the son of the artist and later Chagall's dealer – and a small group of friends. Chagall was both fascinated and repelled by the dimensions of the huge metropolis with its colourful mix of peoples and cultures. It seemed to him like a 'Babylon'.

After living for a few months in various hotels, the Chagalls found a small apartment at No. 4 East 74th Street, which also served as his studio. From time to time they escaped New York's summer heat by spending weeks in rural New Preston, Connecticut, near André Masson and the American sculptor Alexander Calder, with whom they made friends. Calder had lived for many years in France and shuttled back and forth between Connecticut and his main home in the South of France. After a while Chagall began to settle down in New York, which was full of writers, painters and composers who had fled from Europe. He visited galleries and museums, and met Fernand Léger, Jean Hélion, Piet Mondrian, Amédé Ozenfant, Ossip Zadkine and the high priest of Surrealism, André Breton, with whom he became reconciled after Breton wrote an essay in 1941 in New York on the importance of Chagall's painting. In America, as was their wont, Marc and Bella made contact especially with literary figures. Thus they resumed their friendship with the poet duo Claire and Ivan Goll, whom they had known since the twenties in Paris. They also became close friends with the Yiddish writer Joseph Opatoshu. Chagall loved the parts of the city where Jews lived, above all the Lower East Side, where he felt at home – as if back in Vitebsk. He also delighted in the Jewish food, for which New York was famous, and every day read the Yiddish press, which for Chagall was a vital source of information, especially since he spoke no English.

In 1942 Chagall met Professor Meyer Schapiro, a brilliant art historian on the faculty of Columbia University who was just as much at home in Christian and mediaeval art as in the art of the 20th century. At a later date, in 1959, Schapiro described Chagall in an introduction he wrote for *Harper's Bazaar* on the subject of the artist's Bible etchings: Chagall was not an intellectual artist, but a highly intelligent one, and a superb illustrator. Contemporary American artists, on the other hand, did not warm to Chagall. They had little in common with a folkloristic storyteller of Russo-Jewish extraction with a propensity for mysticism. The Paris School and what was contemptuously called 'Parisian Surrealism' meant nothing to them whatsoever.

But all that was quickly to change. On 25 November 1941 Pierre Matisse opened his first Chagall exhibition in New York, showing 21 masterpieces from the years 1910 to 1941 (ill. pp. 156, 157). The art critic Henry McBride wrote in the *New York Sun* of 28 November 1941: "Chagall is about as gypsy as they come […].

The Musician, 1941
Ink on paper, 43.1 x 25 cm
Private collection

The Juggler, 1943
Oil on canvas, 109.9 x 79.1 cm
Chicago (IL), The Art Institute of Chicago

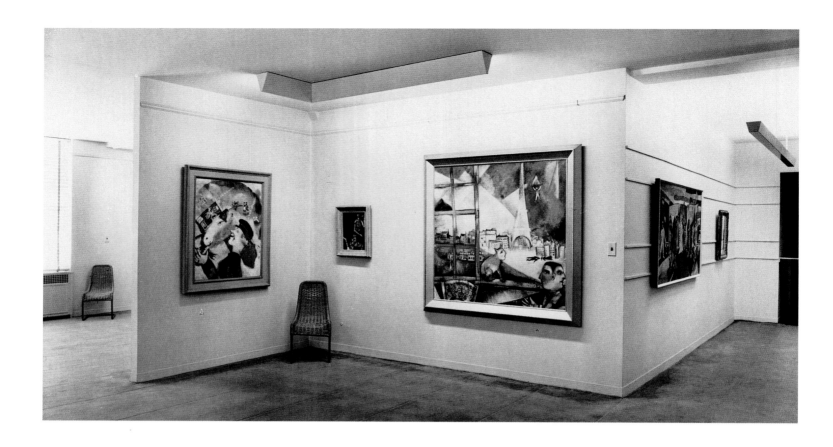

Chagall exhibition at the Pierre Matisse
Gallery, New York 1941
Courtesy Pierre Matisse Foundation, New York

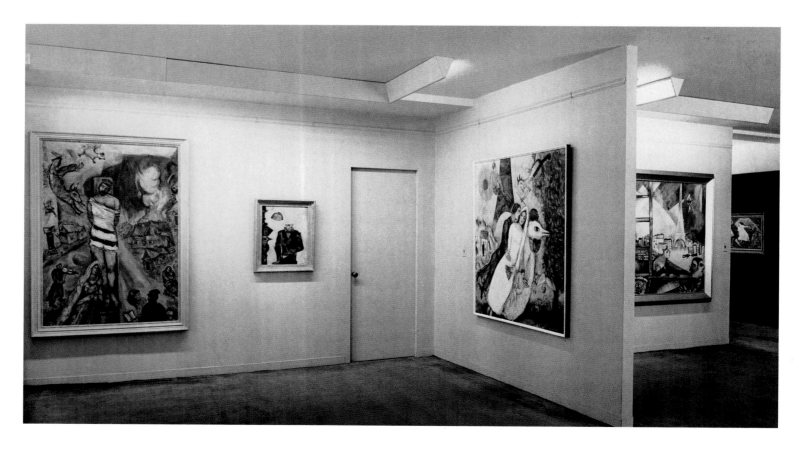

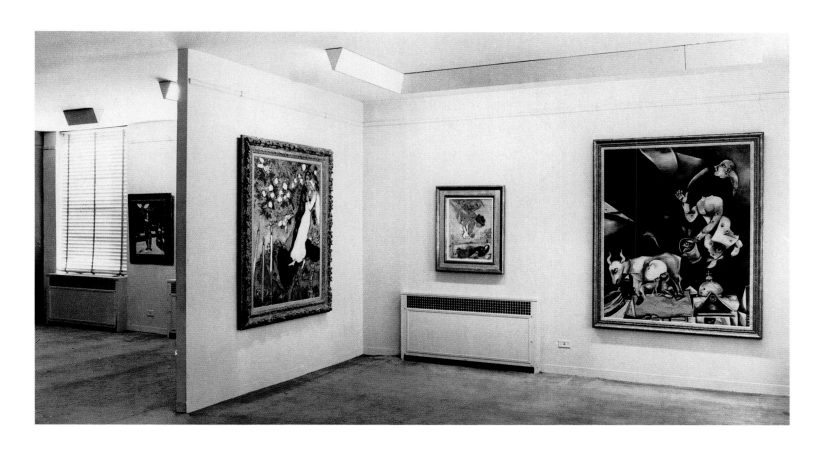

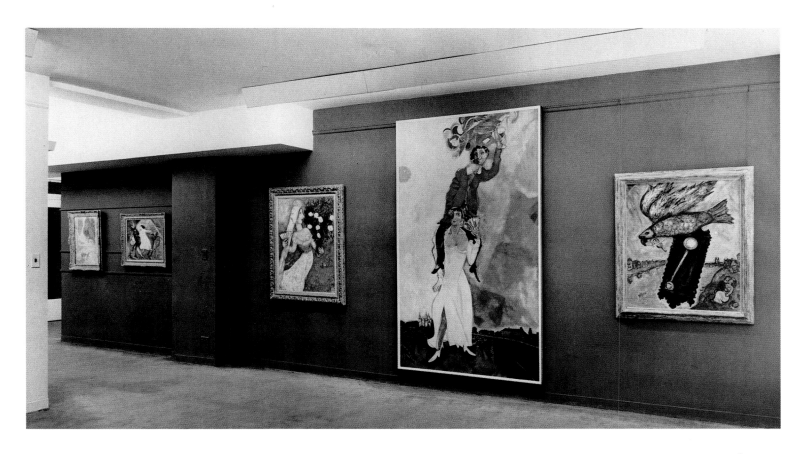

These pictures do more for his reputation than anything we have previously got to see [...]. His colours sparkle with poetry [...]. His work is as authentically Russian as a Volga boatman's song [...]." During his New York years Chagall had 11 exhibitions with Pierre Matisse, who paid handsome monthly advances to the artist for his pictures, and who continued to represent him with great success even after Chagall had returned to France.

In the summer of 1942 the New York 'Ballet Theatre' group commissioned Chagall to design the sets and costumes for the ballet *Aleko*, which the celebrated choreographer Leonid Massine wanted to stage to the words of Pushkin's verse narrative *The Gypsies* and to the music of Tchaikovsky's piano trio in A minor (ill. p. 159). For Chagall, who had already designed stage sets in the 1920s for the 'Jewish Theatre' in Moscow (ill. pp. 106/107), the assignment was nothing new. It was the first time that he had been asked to do the decor for a ballet. Nevertheless, he was very pleased that the group had placed such confidence in him and immediately set to work. What turned out to be more of a problem was that the artist did not belong to the theatre trade union. The union embargoed Chagall's involvement, enraging Massine, who transferred the whole production to Mexico City. So Chagall and Bella travelled to Mexico City, plunging with great enthusiasm into the work. While Chagall painted four large backdrops, Bella and a team of Mexican seamstresses made the ballet costumes. In their free time the Chagalls made excursions into the surrounding area, leading the painter, needless to say, to record his Mexican impressions in a number of gouaches.

The première of *Aleko* on 8 September 1942 at the Bellas Artes Theatre was a remarkable success. Sitting enthusiastically in the audience were the famous mural painters Diego Rivera and José Orozco. When the last bar of music had died away, there was tumultuous applause and 19 curtain calls, Chagall himself being called back onto the stage again and again. Four weeks later, on 6 October 1942, when *Aleko* opened in New York in the Metropolitan Opera, the triumph was repeated, and again Chagall was the hero of the evening. Edwin Denby, the critic of the

"Artists in Exile" – artists at the Pierre Matisse Gallery, New York 1941

From left to right, first row: Matta Echaurren, Ossip Zadkine, Yves Tanguy, Max Ernst, Marc Chagall, Fernet Léger; second row: André Breton, Piet Mondrian, André Masson, Amédée Ozenfant, Jacques Lipchitz, Pavel Tchelitchev, Kurt Seligmann, Eugene Berman Courtesy The Museum of Modern Art, New York
Photo: George Platt Lynes

New York Herald Tribune, wrote that his work "has turned into a dramatized exhibition of giant paintings [...]. It surpasses anything Chagall has done on the easel scale, it is a breathtaking experience [...], of a kind one hardly expects in the theatre." The curtains and many of the costume designs are now in the Museum of Modern Art in New York, along with the original decor and costumes.

When Chagall heard the news in New York about the German invasion of Russia and the destruction of his beloved Vitebsk, he was deeply upset. The sad tidings were brought to him by his son-in-law Michel Gorday, who now worked in the city for the Office of War Information and the 'Voice of America'. During this period Chagall produced several crucifixion pictures, among them the *Green Crucifixion, Crucifixion in Yellow* and and the painting *The War* (ill. p. 161). But they were accompanied by more circus scenes – in 1943 and 1944 the artist worked in the studio of Stanley W. Hayter, the renowned master engraver, producing several etchings on the theme of the circus. The summer of 1944 found Chagall and his family in Cranberry Lake, upstate New York, where among other subjects he painted several village scenes. It was here, the previous year, that they had first heard about the occupation of France and about the horror of the concentration camps. Now they received joyous news of the liberation of the French capital.

In 1943 Chagall had met up again in New York with two old friends from Russia, the actor Salomon Michoels, whom he had last seen in Paris in 1927, and the Yiddish writer Itzik Feffer. They had come to the USA as members of a Soviet cultural delegation. Chagall dedicated two pictures to them together with a letter "to his Russian friends" and his Yiddish poems, which – illustrated with drawings – appeared in New York. Shortly after they returned to Russia, both Michoels and Feffer – the one an opportunist, the other a loyal Communist – were liquidated under Stalin.

Aleko, A Wheatfield on a Summer's Afternoon, (Scene 3), 1942
Gouache, watercolour, wash, brush and pencil on paper, 38.5 x 57 cm
New York, The Museum of Modern Art, Acquired through the Lillie P. Bliss Bequest

The Night Ride, 1943
Gouache on paper, 63.5 x 48.4 cm
Private collection

Four years before his definitive return to France Chagall wrote a 'message to French painters', which in December 1944 was published in Paris in *Le Spectateur des Arts*. Chagall wrote: "I bow to those who have gone missing in action or fallen in battle […]. I bow to your struggle against the foe of art and life […]."

Unlike Chagall, who was immersed in his work, Bella was unhappy in New York and somewhat lonely – she missed Paris. When at the beginning of September the couple wanted to return from Cranberry Lake to New York, Bella suddenly fell ill with a viral infection and fever. She was taken to a poorly equipped hospital, which had no antibiotics, and died there on 2 September 1944. Her daughter Ida rushed from New York, but arrived too late. The exact circumstances of Bella's death are still not known – there are only unreliable versions of events. An obituary in the *New York Times* put her age at 48, but she may well have been 52 or 53.

Bella's sudden death was a great blow to Chagall, and his grief knew no bounds. Married to the artist for 29 years, she had stood by him through good times and bad, sharing his sorrows and his triumphs. She had been both his muse and his surest critic, his alter ego and the mother of his only daughter. Ida, who did not want her father to live alone, brought him to her New York apartment at No. 75 Riverside Drive, which overlooked the Hudson River. But even here Chagall could not work. For months he stared inconsolably out of the window. In the Jewish tradition it is customary to cover up all mirrors when a family member dies – Chagall turned all his canvases to face the wall.

In its obituary the *New York Times* stated that Bella had been her husband's only model and had strongly influenced his work. Just a few days before her death she had completed writing her memoirs in two volumes, which were later published in a German translation under the titles of *Burning Lights* and *First Encounter*. The two manuscripts were the straw that Chagall, drowning in his grief, clutched at. He tried to translate Bella's manuscript, written in Yiddish, into French. Referring to the style of her two books, he wrote in the afterword to *First Encounter*: "She wrote as she lived, as she loved, as she greeted her friends. Her words and phrases were like the breath of colour on canvas. […] Things, people, landscapes, Jewish holidays – they were her world, what she liked talking about. […] Her last words were: 'My notebooks…' Thunder pealed and the heavens opened when at six o'clock on the evening of 2 September 1944 Bella departed this world. Everything has grown dark before my eyes." The two books first appeared in New York (respectively in 1945 and 1947) in their original Yiddish form as

The War, 1943
Pen and ink on paper, 19 x 38.9 cm
Paris, Musée national d'art moderne,
Centre Georges Pompidou

The War, 1943
Oil on canvas, 105 x 76 cm
Paris, Musée national d'art moderne,
Centre Georges Pompidou

Like many other European artists, Chagall
found a safe haven in the United States during
World War II. From there he heard regular
news bulletins and followed the terrible events
taking place in Europe. During the 1940's he
produced several paintings of burning villages
and general destruction. His Crucifixion scenes,
in which Christ represents the suffering of
the Jews and humanity in general, also date
from this time, and caused much controversy
in Jewish circles. In this distressing painting,
Chagall again portrays the horrors of war.
The village people are fleeing and a dead man
is lying on the street. In the lower left hand
corner, the figure of the wandering Jew can
be seen escaping.

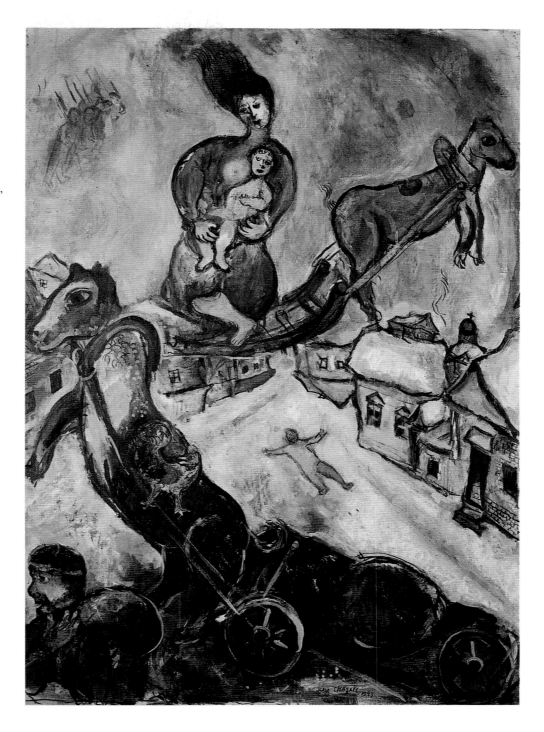

Brenendicke Licht and *Die Ershte Begegnish*. Lavishly illustrated by Chagall, they
were subsequently translated into a number of other languages.

 After painting nothing for almost nine months, Chagall moved back from
Ida's apartment to his own and slowly got back to work. But the dark cloud still
hanging over him seeped into his colours. Ida, who was very concerned about her
lonely father, decided to engage a housekeeper to cook for him and look after him.
A friend of hers recommended a young Englishwoman, Virginia Haggard McNeil,
an attractive woman, who was married to a Scottish stage designer and painter.
They had arrived in New York at the beginning of the Second World War and lived
in a shabbily furnished room with their five-year-old daughter Jean. As her hus-
band suffered from violent depressions and had abandoned his profession, it fell to
Virginia to support her family. She had grown up in Paris, where her father had
been the British consul general, and spoke French. Given that she had also studied
art and was a painter herself, she was the ideal candidate for the job of housekeeper
to the widowed artist. When she started working for him, Chagall was 58 years

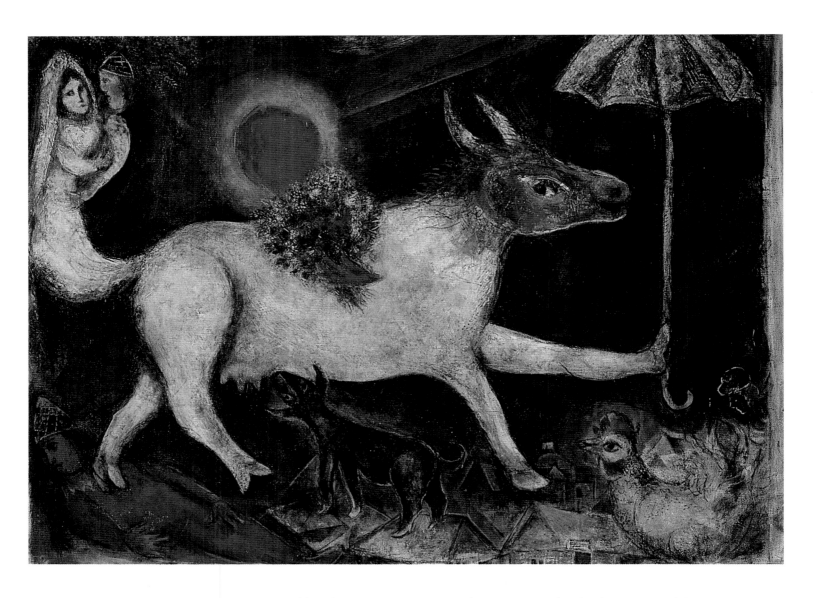

The Cow with Sunshade, 1946
Oil on canvas, 75 x 106.6 cm
New York, Collection Richard S. Zeisler

This poetic picture is a wonderful illustration of Chagall's fertile fantasy and mastery of colouristic techniques. The subject is absurd – a cow walking over the roofs of the the village, holding a parasol and stepping with one hoof on the village clown. The warmth of the sun is conveyed in a glowing orange tone. It contains references to Chagall's visit to Mexico in 1942. In *My Life* he says: "But perhaps my art is the art of a lunatic, … mere glittering quicksilver, a blue soul breaking in upon my pictures."

old and Virginia 30. Entering his apartment for the first time with her daughter, the young woman found him still affected by Bella's death. She tidied up his rooms, cooked for him and brought him fresh flowers, which he so loved to paint. In time she became Chagall's companion and lover. Slowly the dark colours in his paintings gave way to brighter ones. Listening to the music of Mozart, he painted *Nocturne, Wedding Candles, Naked Cloud (The Couple in the Cloud)* and *The Flying Sleigh*. Chagall said to his new love: "Bella sent you to me to look after me. Rembrandt had his Henrickje Stoffels to console him after Saskia's death; I have you."

The year 1945, therefore, marked the start of a new chapter in Chagall's life, one that was to last until 1952. This love story has long been hushed up. Vava Chagall, the artist's second wife, prevented any mention of Virginia in the books on Chagall that appeared in her lifetime. Even the most important monograph, the 775-page work by Franz Meyer, omits any reference to Virginia McNeil, with whom Chagall lived for seven years, and who in 1946 gave birth to their son David. In 1986 Virginia published a book entitled *Seven Years of Plenty – My Life with Chagall*, a fascinating account of Chagall's time in the United States. She writes: "We were drawn to each other instinctively by our mutual solitude and shyness, but also by a fundamental *joie de vivre* that was temporarily smothered by our sorrow. [...] When I brought him his meal, he said: 'Why don't you keep me company? I can't eat alone like this, a poor dog.'" Chagall and Virginia fell in love "almost imperceptibly": "This love did not overwhelm us all of a sudden; it grew like two plants sowed in the same soil. I felt secure in his love, and slowly yielded to it. [...] Now I felt young again, as if I was discovering love for the first time. Marc too was

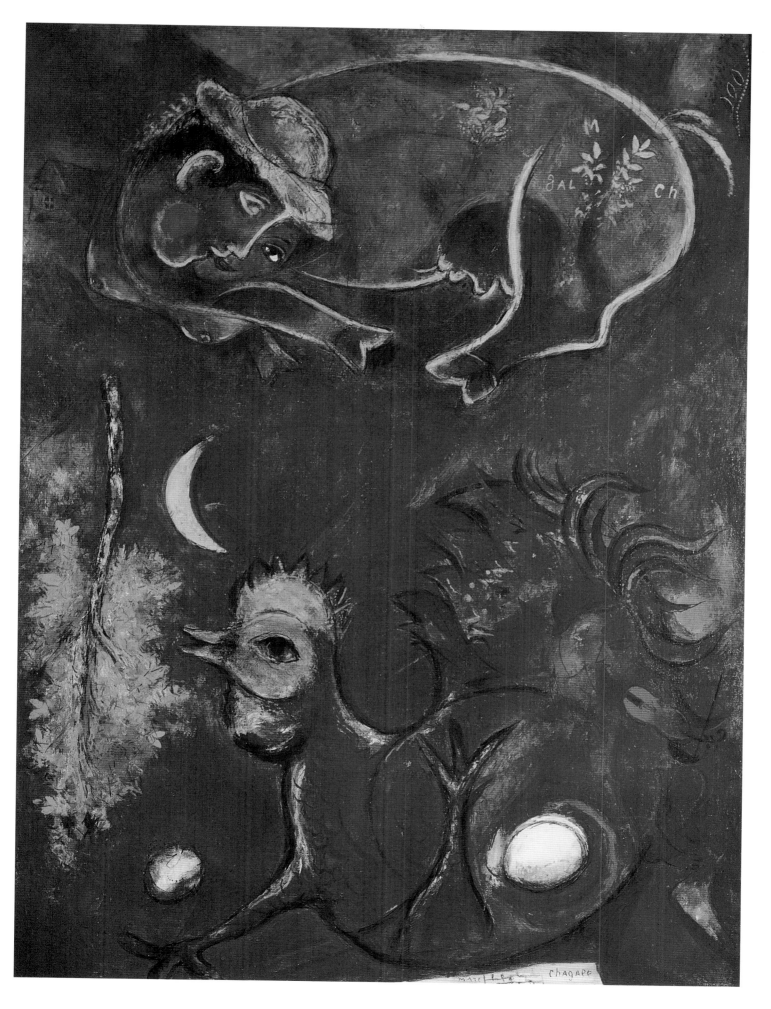

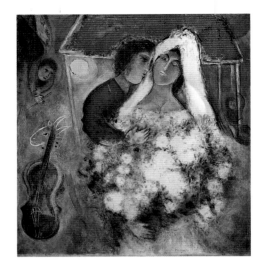

Fiancée with White Bouquet of Flowers, 1944
Oil on canvas, 66.2 x 61.8 cm
Private collection

like a shy young lover". Virginia, whose art studies in Paris had been supervised by the painters Marcel Gromaire and Charles Dufresne, loved discussing art with Chagall over lunch or dinner. "Van Gogh", said Chagall, "is like a peasant who enters a drawing room with mud on his boots, because he can't help it. Picasso also comes in with muddy boots, but on purpose, to show he doesn't care."

Chagall returned repeatedly to the topic of Picasso, whom he both criticized and envied. "I am like a mosquito buzzing around Picasso", he said once. "I sting him once, twice – and bang, he squashes me. […] Picasso is always starting new fashions. The great fashion designers put a green gown with red gloves; Picasso puts a pair of eyes in a backside, and everyone copies it. No matter what he does, the result is always a museum piece with that indisputable nimbus." On another occasion he said: "Cultivated people admire him no less than amateur philosophers and intellectual snobs. He enjoys showing all the most repulsive things in human beings – as is the fashion. People with deep feelings are not moved by his works. He is not interested in human feelings; he uses only the visible, external aspects of human nature." Diametrically opposed to Picasso, in Chagall's mind, was the sculptor Giacometti, of whom he said: "Giacometti has a moving fragility […]. I have more respect for a sculptor who inclines towards tenderness than for one who thrusts his way forward with violence, like Lipschitz."

Virginia reported that she never saw Chagall without brushes in his hands. "A day without work is not a real day for me", the artist said. One of the paintings he was working on when she met him was *Around Her* (1945, ill. p. 167), a very melancholy homage to Bella with tragic overtones. It is a reworking of a large unfinished picture entitled 'Circus People', which Chagall had cut in two. Sidney Alexander said of the work: "As in a palimpset, elements of the earlier painting were put to a new use: the topsy-turvy head became the artist at his easel, and the book became his palette. A weeping Bella leans on a large illuminated circle, reminiscent of a fortune-teller's crystal ball, which reveals the past – the wooden shacks of Vitebsk. Above this gleaming light, top right, bride and bridegroom take their nuptial flight, the long white train of the bridal veil touching the shoulder of the weeping Bella; top left are an acrobatic hermaphrodite and a cock holding a burning candle. The symbols are all familiar, part of an alphabet that Chagall has already used countless times, but the picture as a whole is now imbued with sadness: a bluish-black tone suffuses the scene and there is something lunar, remote about the elegy, a frozen dream."

In the summer of 1945 Ida Chagall rented a house for her father at Sag Harbour on Long Island. The 'New York City Ballet' had commissioned him to design the sets and costumes for Igor Stravinsky's *The Firebird*. Dating from 1910 and based on an old Russian fairytale, the ballet tells the story of a princess who finds herself in the power of an evil magician and who is rescued by a prince with the aid of a miraculous firebird. Chagall immersed himself in the work, listening for days on end to Stravinsky's music. After Joseph Opatoshu had seen a performance of the ballet, he exclaimed: "Marc, you must be in love!"

But not everything was a bed of roses. Virginia's husband, learning of his wife's affair with Chagall, threatened to commit suicide if she did not return to him, blackmail that Virginia gave in to, going back to New York. For a time Chagall was numb, showing no response, until after a short time Virginia came back to him. In the autumn the two returned to New York, where she lived during the day with him, working as his housekeeper, and spent the night in the furnished room with her husband. When, however, she discovered that she was pregnant by Chagall, she decided to leave her husband, who did not after all put an end to himself, but went back to Great Britain.

Chagall and Virginia bought a small house in High Falls, in the Catskill Mountains, near Woodstock. There they withdrew from their friends, wishing to keep their liaison secret. But another reason for the retreat was that the artist preferred life in the country to that in the 'Babylon' of New York. The only people who knew about their affair were Pierre Matisse, Chagall's dealer, and his close friends the married couple Joseph and Adele Opatoshu. These were not easy days

PAGE 163:
At Cockcrow, 1944
Oil on canvas, 92.5 x 74.5 cm
Private collection

PAGE 165:
The Wedding, 1944
Oil on canvas, 99 x 74 cm
Private collection

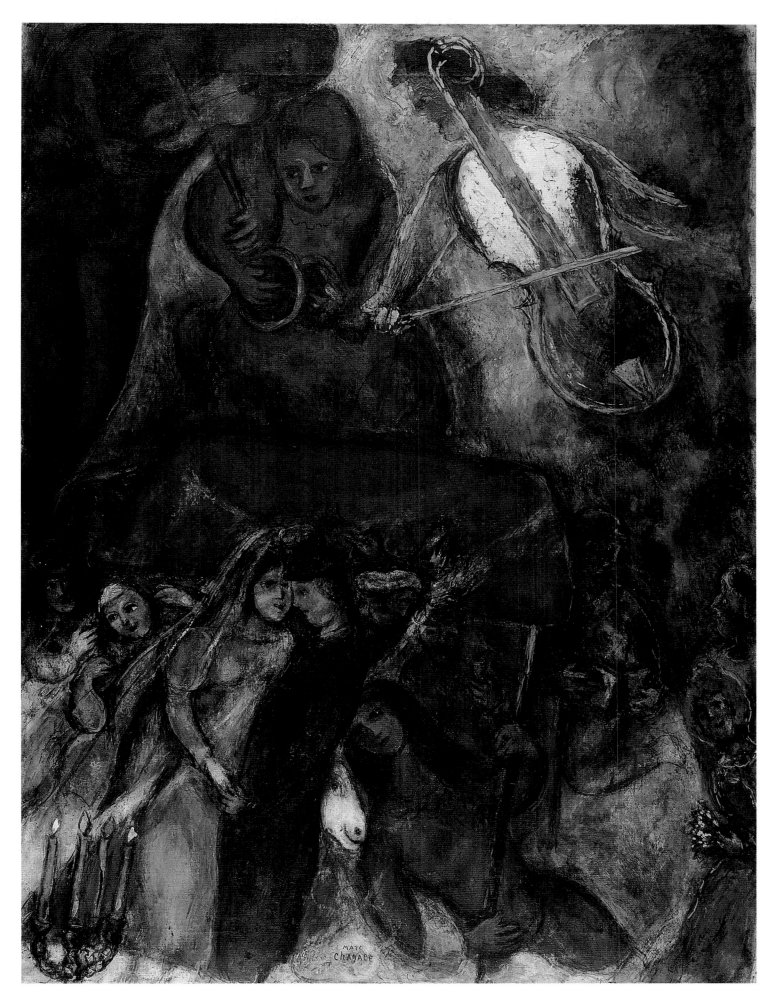

Chagall and Bella in August 1934
Photo: Lipnitzki-Viollet, Paris

for the artist, not least because his daughter Ida had mixed feelings about her father's romance with Virginia.

As Virginia wrote, her relationship with Ida "was bound to be delicate". "Sometimes Ida scrutinized me until I quite lost my composure and blushed." Ida, who was possessed of an "excellent intellect" and a marked sense of humour, was very attached to her father, with whom she conversed in Russian. Undoubtedly there was an unspoken rivalry between Ida and Virginia, since it was Ida who handled her father's business affairs, organized exhibitions, and kept in touch with art critics, publishers and journalists. During this period Chagall was commissioned by Kurt and Helen Wolff of 'Pantheon Books' to illustrate four tales from *The Arabian Nights*. The resulting 13 colour lithographs (1948, ill. pp. 218, 227), made from preliminary gouaches, are some of the artist's finest graphic works.

Chagall also continued his work for the ballet *The Firebird*, designing three backdrops, a stage curtain and more than 80 costumes, while Virginia, supervised by Ida (following in the footsteps of her mother, who had overseen the sewing of the *Aleko* costumes in Mexico), sewed the dancers' costumes. Although Adolph Bolm, the choreographer, who had previously danced for Diaghilev, disagreed with Chagall's artistic concept, the première of *The Firebird* in New York was an unqualified success. John Martin, the *New York Times* critic, wrote: "Chagall's décor dominates the ballet. [...] *The Firebird* is the triumph of a painter." The stage curtain and backdrops, especially the one depicting the wedding of the princess and the young hunter, saved from a wicked demon by the firebird's magical powers, were overwhelmingly beautiful, shimmering with seductively radiant reds and blues, the colours of the artist's new love. Chagall's work on *The Firebird* led in his oeuvre to an even more pronounced heightening of colour as a way of defining pictorial space.

On 9 April 1946, at New York's Museum of Modern Art, James Johnson

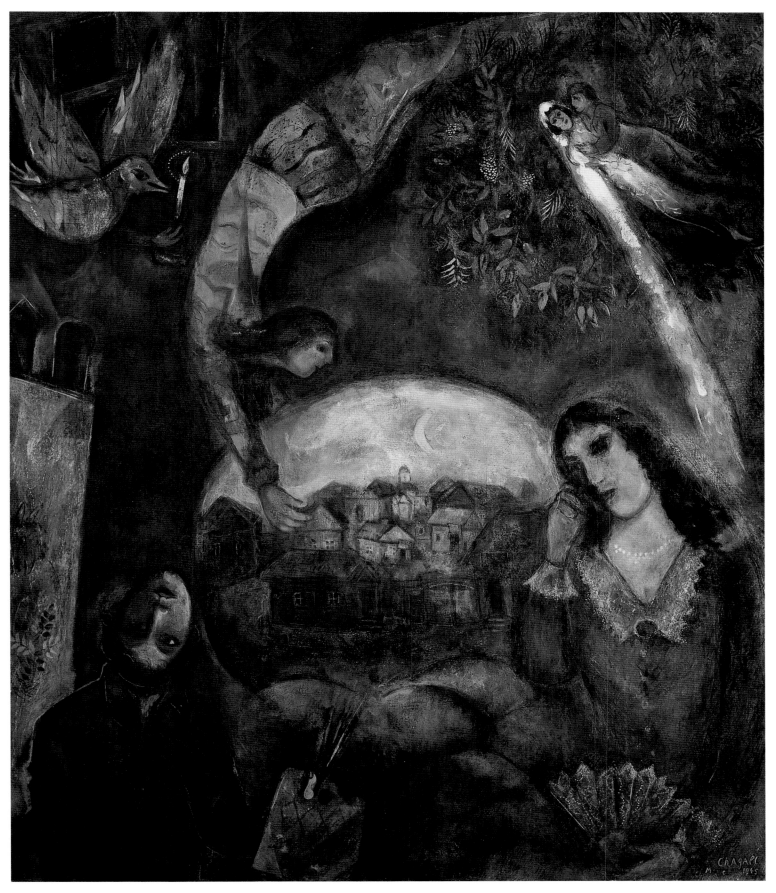

Around Her, 1945
Oil on canvas, 131 x 109.7 cm
Musée national d'art moderne, Centre Georges Pompidou

Sweeney opened a Chagall retrospective comprising 144 paintings going back 40 years. The exhibition lasted until 23 June, also being shown from 24 October to 15 November at the Art Institute in Chicago. The artist, who until then had only left solid ground in his paintings, flew for the first time in his life to the exhibition opening in Chicago. The retrospective, which largely came about through Ida's efforts, was enthusiastically received by the public. In the show's catalogue Sweeney hailed it as "Chagall's contribution to contemporary art: the reawakening of a poetry of representation, avoiding factual illustration on the one hand, and non-figurative abstractions on the other [...]. Chagall is a conscious artist [...], there is nothing automatic in his work [...], he is an artist with an incomparable sense of colour [...]. Chagall has brought poetry back into painting."

Following the success of the New York retrospective, Ida travelled to Paris to prepare for further exhibitions. Supported by Jean Cassou, director of the Musée nationale d'art moderne in Paris, she wanted to organize an exhibition at that institution on the occasion of its reopening. Another of her goals was to reactivate contacts that had become quiescent during Chagall's long absence. Late May Chagall himself went to Paris for a three-month stay. He did not want to be present at the birth of his son on 22 June. Virginia, who was eight months pregnant, did not hold this against him, knowing how the birth process had an unsettling effect on him. For Chagall, his paintings were his true children. He felt that an artist was entitled to be an egoist and that the act of artistic creation had to take precedence over everything else, including other people's feelings. He could not stand crying children and other noises that distracted him from his work. Chagall even prevailed upon Virginia to send her daughter Jean to a boarding school in New Jersey, which was to create a rift between mother and daughter that never completely healed. Virginia admits in her memoirs that she sacrificed Jean for the sake of peace with Chagall and that she closed her eyes to Jean's suffering. After the birth of their son, who was given the name David after Chagall's younger brother, "Marc was", so Virginia wrote, "dreadfully upset by this undeniable evidence of our young love." Virginia for her part felt terribly isolated and was "distraught with Marc's reluctance to accept the child". After David's birth it was two months before Chagall finally returned from Paris, but by all accounts he became a good and loving father despite everything. Certainly his letters from Paris were affectionate enough. Because Virginia was still officially married, their son took the name surname 'McNeil'.

In Paris Chagall re-established contact with the painters and poets of his old circle of friends, above all with Paul Eluard, for whom he illustrated a volume of poetry with old and new drawings. In addition he made numerous sketches from which he painted, between 1953 and 1954, his Paris series *Pont Neuf* (1953–54, ill. p. 264), *The Opera, Notre Dame* and other Parisian monuments. Inspired by David's birth, *Pont Neuf* shows a delivery: the mother is lying down, her newborn babe in her arms, while in the foreground, above her, hover the painter with palette and easel, and Bella in a wedding dress. Chagall was in high spirits. He painted a bouquet with flying lovers, and major pictures such as *Flayed Ox* and *Self-Portrait with a Wall Clock*. In 1947 several retrospectives were held in museums in Paris, Amsterdam, London, Zurich and Berne, and Chagall travelled to Europe to attend the openings.

A typical example of the magnificent work that Chagall produced in New York is *The Rooster* (1947, ill. p. 171). The bird takes up almost the whole pictorial space. This depiction is more impassioned, tense and aggressive than earlier portrayals. The same is true of its colouration. Both the white plumage, in which the lovers nestle, and the bride's red gown stand out vividly from the dark background. The artist's love for Virginia lent his work a luminous exuberant quality, marking the last stage of Chagall's artistic development, which André Malraux characterized as "the great play of colours".

In the spring of 1948 a Belgian photographer, Charles Leirens, visited Chagall in High Falls to take portrait photographs of him. About the same age as the artist, he had already photographed André Gide, Paul Valéry, Colette, Mauriac, Malraux,

Marc Chagall, Virginia Haggard and their son David in April 1951
Photo: Lipnitzki-Viollet, Paris

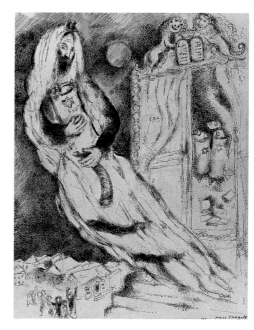

Illustration for the Book *The Last Resistance* by Joseph Opatoshu, 1947
Pen, 22 x 33 cm
Private collection

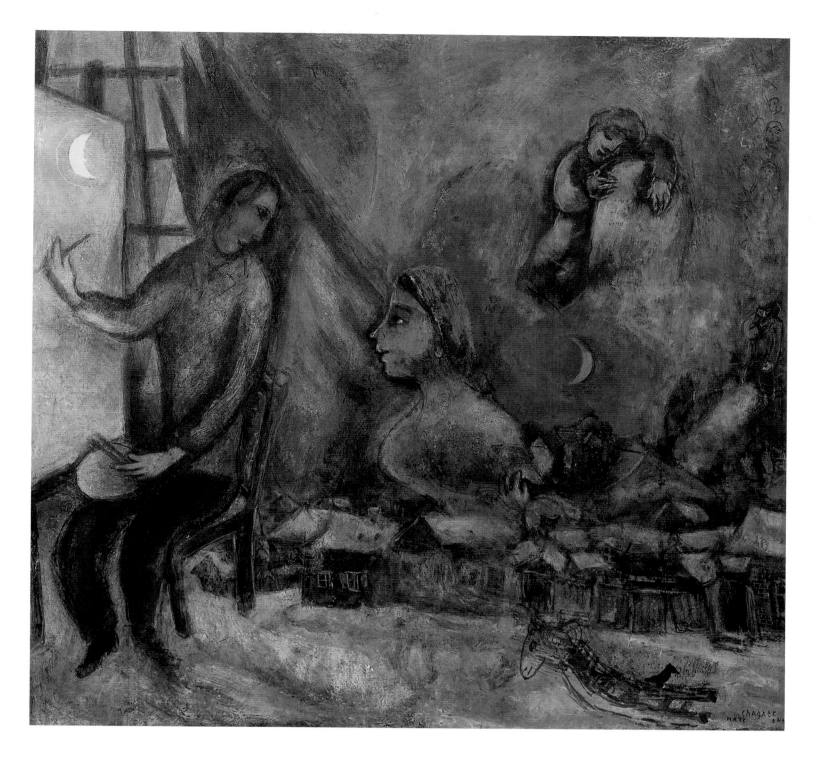

Homage to the Past, 1944
Oil on canvas, 71 x 75.5 cm
Private collection

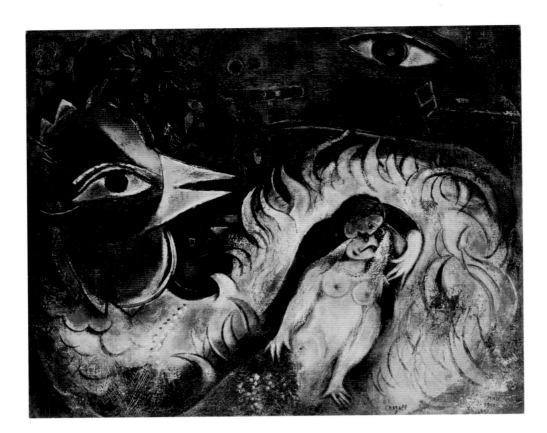

The Rooster in Love, 1947–1950
Oil on canvas, 71 x 87 cm
Private collection

Maillol and the composer Béla Bartók. Leirans was also a musicologist, and taught both musicology and photography in New York during the war at the New School for Social Research. He was a witty and charming man, who was to re-enter their lives just a few years later with dramatic consequences.

In August 1948 Chagall and Virginia boarded the steamer 'Le Grasse' in New York for the Atlantic crossing to France. After seven years in the United States the painter wanted to settle in Europe again. Chagall summed up his stay in America thus: "I lived here in America during the inhuman war in which humanity deserted itself [...]. I have seen the rhythm of life. I have seen America fighting with the Allies [...] the wealth that she has distributed to bring relief to the people who had to suffer the consequences of the war [...]. I like America and the Americans [...], people there are frank. It is a young country with the qualities and faults of youth. It is a delight to love people like that [...]. Above all I am impressed by the greatness of this country and the feeling of freedom that it gives me." However, Chagall was not deserting the United States – after his relocation to France he returned there many times to complete commissions for monumental works: stained glass windows, mosaics, sculptures, ceramics, tapestries and important paintings.

PAGE 171:
The Rooster, 1947
Oil on canvas, 100 x 88.5 cm
Paris, Musée national d'art moderne, Centre Georges Pompidou

PAGE 172:
The Blue Violinist, 1947
Oil on canvas, 84 x 63 cm
Private collection

PAGE 173:
Blue Concert, 1945
Oil on canvas, 124.5 x 99.1 cm
Private collection
Courtesy Acquavella Galleries, New York

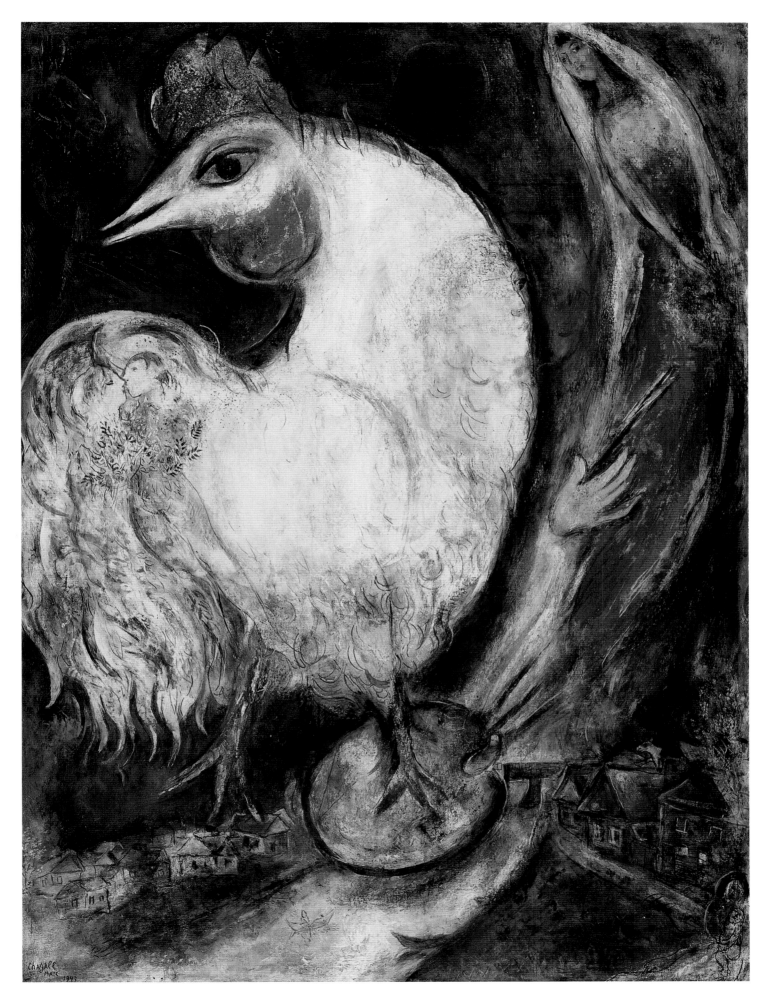

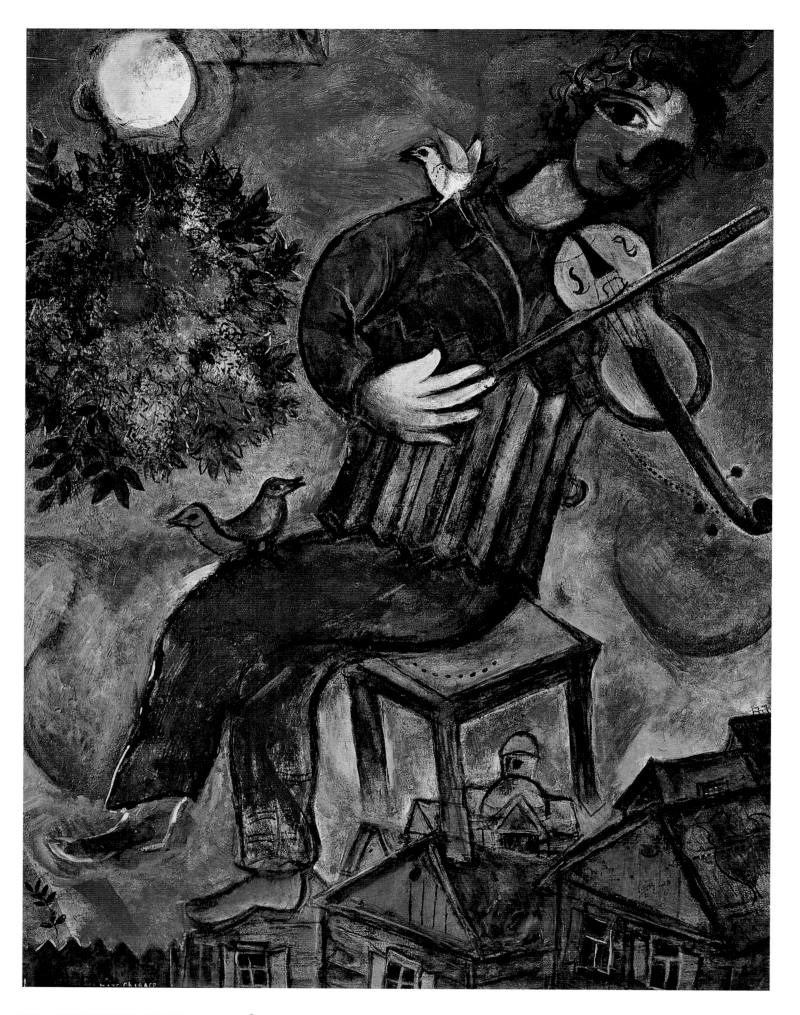

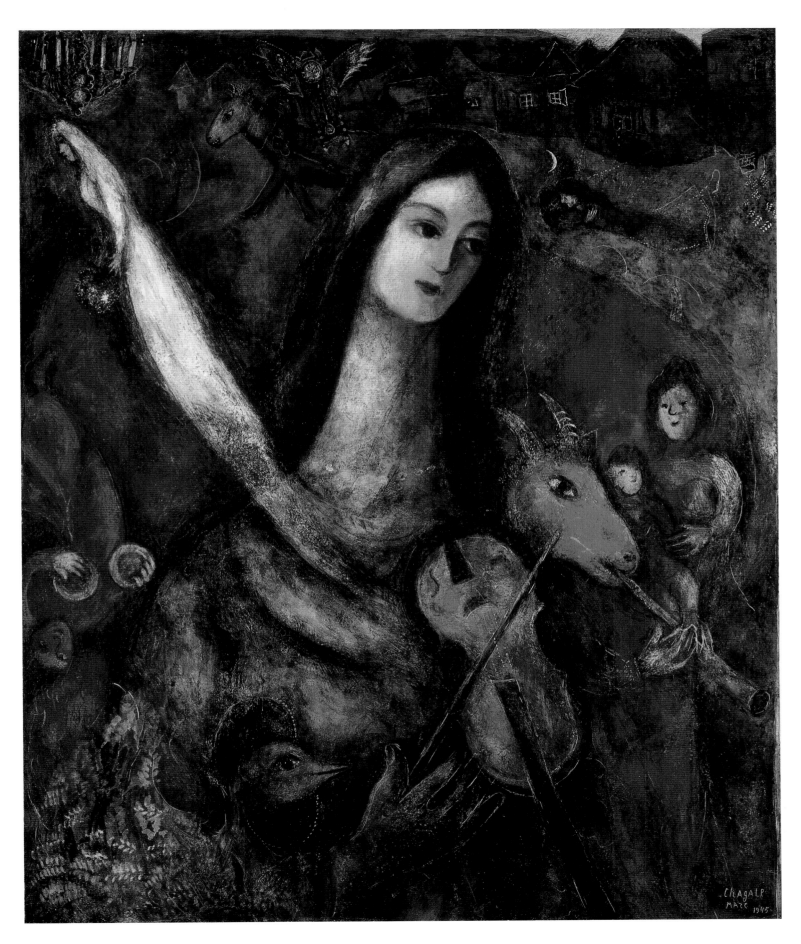

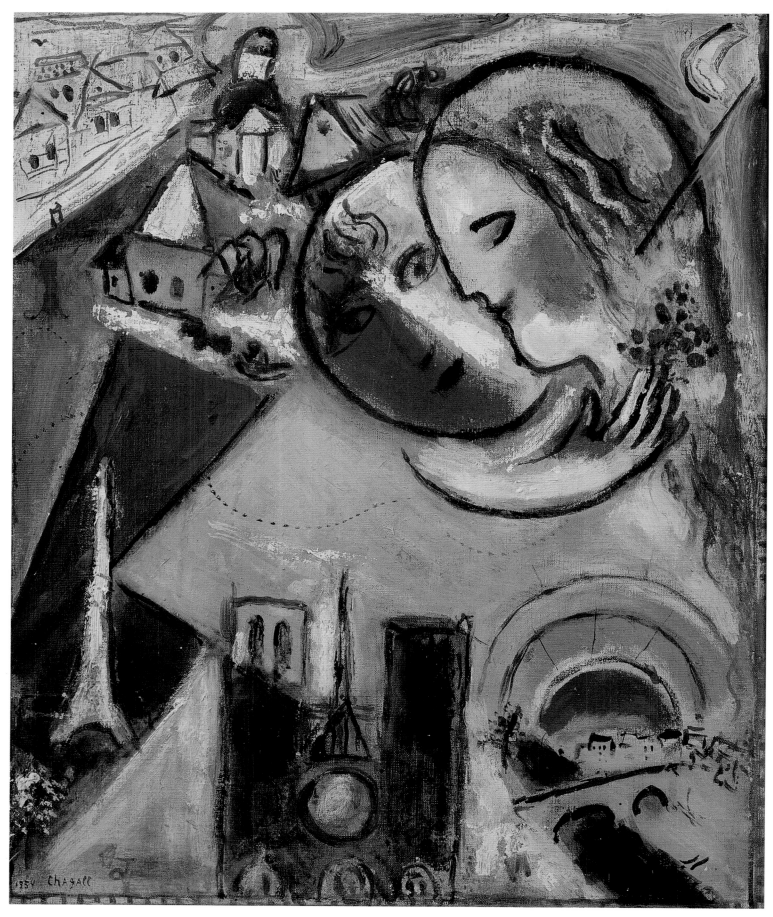

Sunday, 1954
Oil on canvas, 173 x 149 cm
Private collection
Courtesy Gallery Daniel Malingue, Paris

Back in France 1948–1985

"I have always done without theory or method."

At Le Havre Chagall, Virginia and their son David were met by Ida. She drove the three to Orgeval, near Saint-Germain-en-Laye just outside Paris, where she had rented a house with an overgrown garden, surrounded by tall trees. The walls of this house she had hung with masterpieces such as *The Wedding* (ill. p. 93), *The Studio* (ill. p. 34), *The Cattle Dealer* (ill. p. 60), *The Small Drawing Room* (ill. p. 26), *The Dead Man* (ill. p. 25), *The Red Horse* and *The Rooster* (ill. p. 127), one of his 'American' pictures.

A frequent guest in the house was the Greek-born Tériade, who as an art critic had written about Chagall before the war, subsequently becoming famous for his magazine *Verve*. He had acquired from Vollard's estate the printing plates for Chagall's illustrations to *Dead Souls*, La Fontaine's *Fables* and the Bible. Another frequent visitor in Orgeval was Christian Zervos, the publisher of the art magazine *Minotaure* and of Picasso's catalogue raisonné. Other regular guests included writers such as Paul Eluard, Claire Goll, and Jacques and Raissa Maritain, as well as the art dealers Louis Carré and Aimé Maeght, who henceforth represented Chagall in France. Michel Gorday, Ida's ex-husband, also often called by with his new wife.

In September 1948 Chagall and Virginia went for the first time to Italy for the Venice Biennale, where the artist was awarded a graphic arts prize. There they frequently met up with the Italian painter Giorgio Morandi, of whom Chagall was very fond. From Venice they travelled to Padua to look at Giotto's frescoes. In Venice's churches and museums it was the work of Titian and, above all, of Tintoretto that most deeply impressed Chagall. He visited the Jewish ghetto, and was altogether enchanted by the city of waterways, which he explored from the privileged vantage point of Peggy Guggenheim's private gondola. Chagall commented to Virginia: "One likes France, but falls in love with Italy." On his return to Orgeval he was asked if he could loan two works for the foyer of the Watergate Theatre in London for a period of two years. The two pictures, *The Dance* (ill. p. 176) and *Blue Circus*, which were completed in 1950, were taken to London by Virginia, who stood in for Chagall at the inauguration.

In 1949 Chagall spent four months in Saint-Jean-Cap-Ferrat, the narrow Mediterranean peninsula between Nice and Monte Carlo, where his friend Tériade lived half the year. The artist's first re-encounter with the Mediterranean led to significant new artistic forms. In Saint-Jean he painted almost exclusively gouaches. They show the sea with foothills, above which the sky rises as a giant space, bathed in the sun's light or softly illuminated by the moon. The fiery orb and the lunar disc hang over the water, on which barques ply and fish leap (*Green Landscape*, 1949, ill. p. 189). The pictorial space now lives entirely from the colour, which has become even more radiant and intense. Chagall also produced some first ink draw-

Self-Portrait, 1955
Brush and black ink on paper, 39.3 x 25.4 cm
Private collection

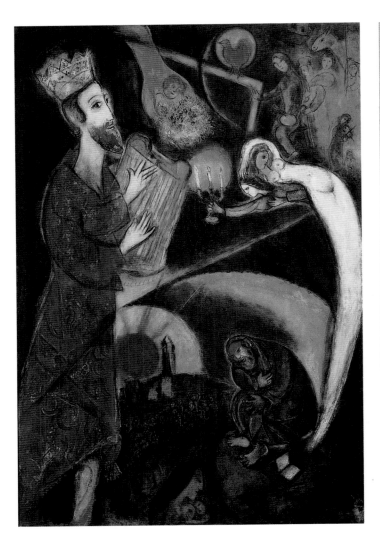

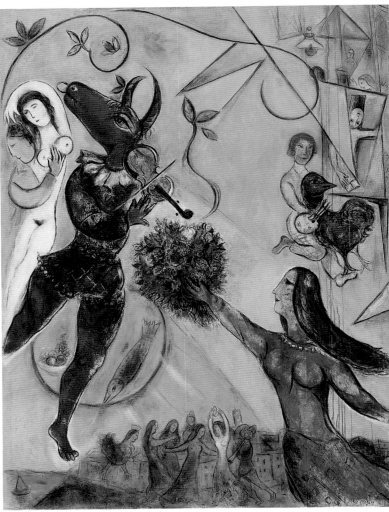

ings as illustrations for Boccaccio's *Decameron*, which appeared the following year in the magazine *Verve*.

After the war the Côte d'Azur became an artistic centre. Matisse, who between 1943 and 1948 had lived in Vence, now lived in Cimiez above Nice, while Picasso was at Vallauris. One day on the beach Chagall bumped into Picasso, who had had himself driven there by his liveried chauffeur in a big car. In those days petrol was strictly rationed, leading Chagall to enquire: "How do you manage to get so much petrol for that great car?" Picasso replied: "There are oceans of petrol for those who can afford it." According to Virginia, Chagall's jealousy of Picasso and Matisse was a "standing joke; everybody teased him about it [...]. Picasso and Matisse (in that order) were the undisputed masters, and Chagall felt he would never attain their tremendous prestige."

In 1950, at her father's request, Ida went to the United States to bring back to France the paintings he had left in New York and sell his house in High Falls. Meanwhile the artist's passion for the South of France and the Mediterranean light had led him to buy the villa 'La Colline' in Vence, to which he and Virginia moved in the spring of 1950. The previous winter he had attempted his first ceramic works there, in Mme Bonneau's studio, and it was in Vence that from 1950 onwards he started work on his monumental pictures on Biblical themes. From his new villa Chagall regularly went by train to Paris to work on his lithographs in Fernand Mourlot's studio, where he also produced his first poster design.

On the occasion of a retrospective shown in Jerusalem, Haifa and Tel Aviv, Chagall and Virginia travelled to Israel in 1951 – the artist's first visit to the now independent State of Israel since his journey to Palestine in 1931. It was at this time that the author of this book first met Chagall, initiating a friendship that was to

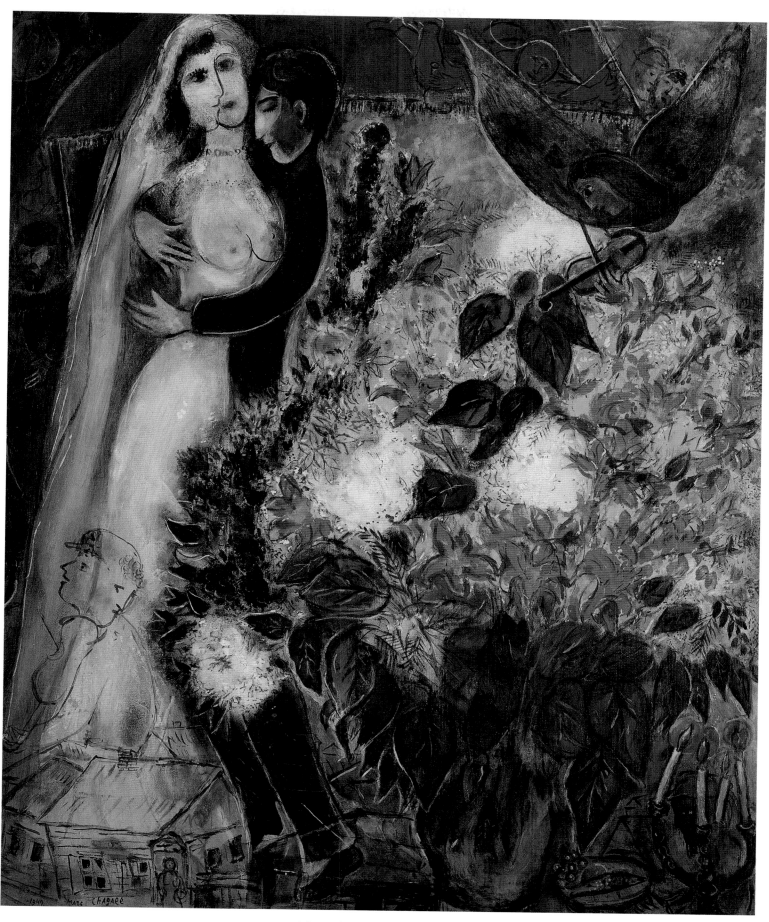

The Bride under the Canopy, 1949
Oil on canvas, 115 x 95 cm
Private collection

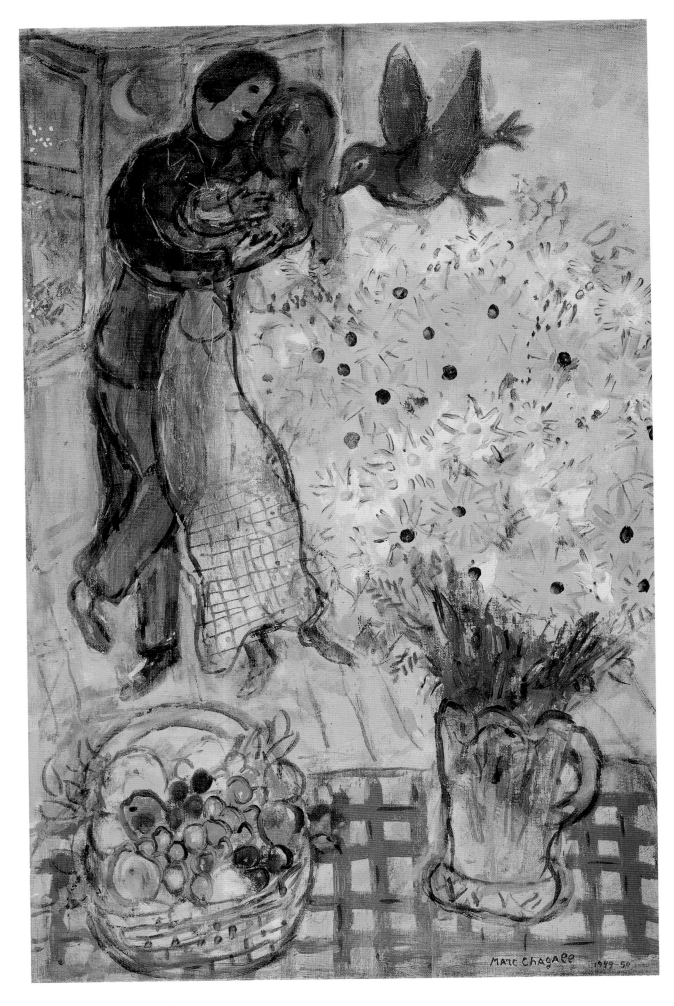

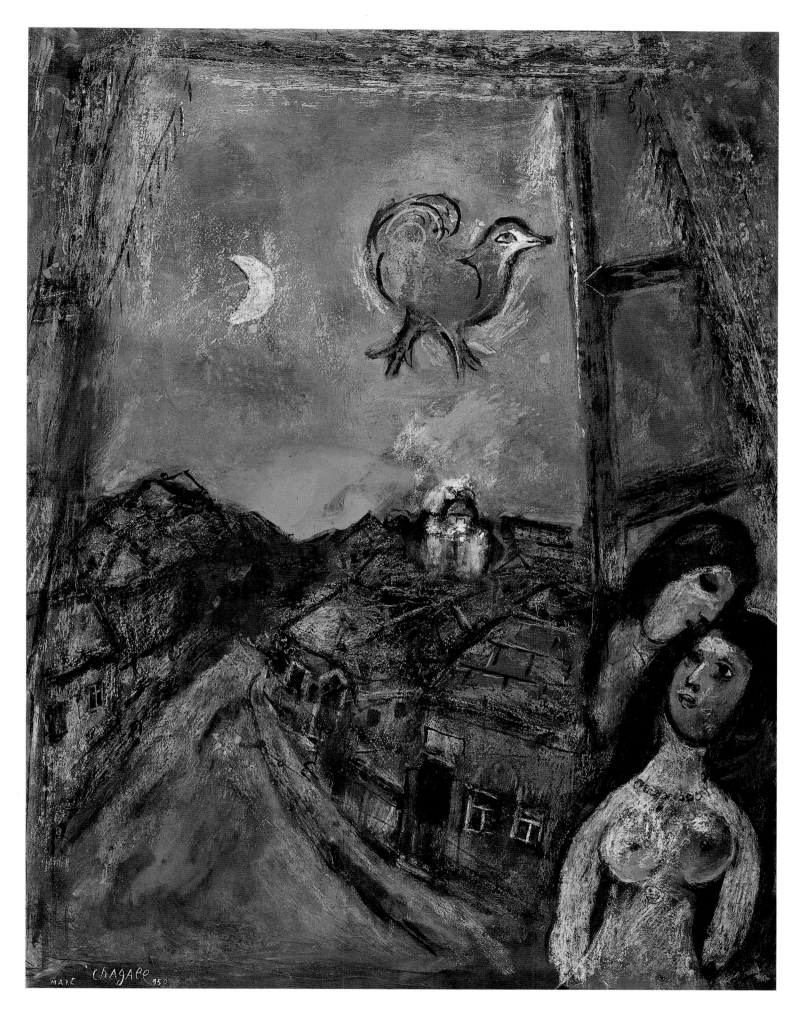

Grandfather Clock with Blue Wing, 1949
Oil on canvas, 92 x 79 cm
Private collection

last the rest of the painter's life. As a young journalist working for an Israeli newspaper, I covered a press conference held in connection with the exhibition and was afterwards granted a private interview because I spoke Yiddish, which Chagall also liked to speak. When I subsequently went to the USA to study and continue my journalistic work, I started up a correspondence with the artist, who had taken a liking to me and enjoyed receiving press clippings about the American art scene and especially about his reputation in the States. When he came to the US, we always met at his hotel for an interview. He mailed me signed copies of his books and exhibition catalogues, and even original lithographs as New Year cards. We also met in Paris, Reims (when he was working on his stained-glass windows), in Vence, and later in Saint-Paul-de-Vence, his last home. In 1969 I was present at the laying of the foundation stone of his museum in Nice ('Musée National Message Biblique Marc Chagall'), later attending the opening ceremony.

In Israel, where Chagall was considered the greatest living Jewish artist, he was always welcomed with great enthusiasm. One of his best friends there was the poet Abraham Sutzcever, whom he had met in Vilna (Vilnius) in 1935, and whose book *Sybir* he illustrated in 1953. That same year – 1951 – Virginia got a divorce from her husband John McNeil, but life with Chagall was no longer without its stresses and strains. She had made friends with a group of young people who practised nature healing, and Chagall accused her of spending too much time with them. Their problematic relationship finally broke down when Charles Leirens, the Belgian photographer who had visited the couple in New York, reappeared. He had

PAGE 178:
Lovers with Daisies, 1949–1959
Oil on canvas, 73 x 47 cm
Private collection

PAGE 179:
Evening at the Window, 1950
Gouache on paper, 65 x 50 cm
Luzerne, Galerie Rosengart

PAGE 181:
New Year's Eve, 1950–51
Oil on canvas, 64.7 x 40.6 cm
Private collection
Courtesy Acquavella Galleries, New York

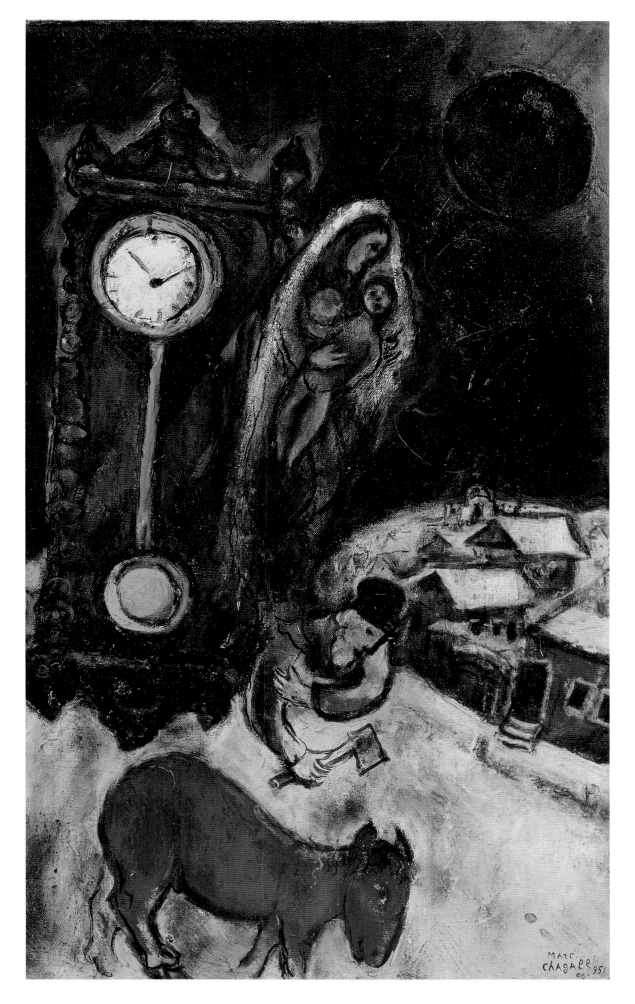

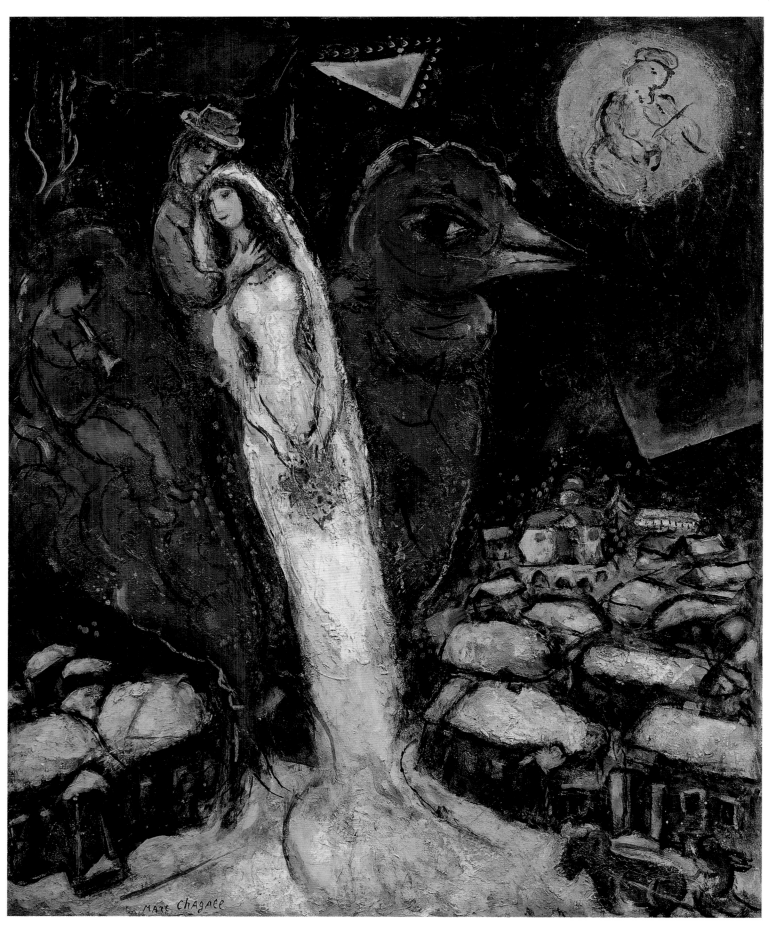

Lovers with Red Rooster, 1950–1965
Oil on canvas, 81 x 66 cm
Private collection
Courtesy Galerie Maeght, Paris

come to Vence to photograph Chagall, and while the artist was away again in Paris working on his lithographs, Virginia and Leirens became lovers. Virginia decided once and for all to leave Chagall, who in his implacable rage about her affair with Leirens had completely withdrawn into his work. She took their son David with her, but left behind the 17 gouaches and oil paintings that Chagall had given to her during their seven-year-long relationship. For Virginia breaking up with Chagall was the "logical conclusion to an unhappy situation [...]. Looking back on our seven years together, I have nothing but loving and grateful memories [...]. But I had to leave. I had to find out who I was, not go on simply as the wife of a famous artist, the charming hostess to important people."

In January 1952 Ida Chagall married the art historian Dr Franz Meyer in Vence. Meyer, who came from a wealthy family, was the director of the Kunsthalle in Berne and later went on to become director of the Kunstmuseum in Basle. The wedding reception was attended by 30 guests. Soon afterwards Ida, ever the matchmaker, who knew very well that her father could not live on his own, introduced him to Valentina (Vava) Brodsky, a woman from a Russo-Jewish family who ran a successful fashion business in London. She became his secretary, and it was not long before Chagall fell in love with this dark-haired woman, who was 25 years younger than himself. On 12 July 1952 they got married in Clairfontaine near Rambouillet – once again the artist had found a companion who relieved him of all life's practical everyday worries. His new wife and renewed happiness gave him fresh energy and inspiration for his work. In the many years that lay ahead of him at Vava's side, he produced not just paintings and graphic work, but also numerous sculptures and ceramics, including wall tiles, painted vases, plates and jugs. From the fifties onwards he turned more and more to working in a large-scale format, producing monumental murals, stained-glass windows, mosaics and tapestries.

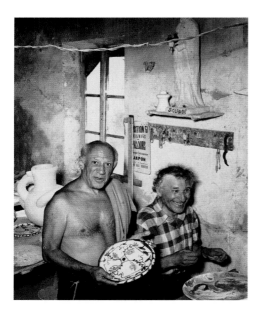

Pablo Picasso and Marc Chagall working on ceramics at Madoura in Vallauris, c. 1952

Encounters with Picasso, Matisse and Miró

After moving to the South of France, Chagall repeatedly met Picasso and Matisse. His relationship with the Spanish maestro was complex and at times strained, as some of his acerbic comments show. When Chagall arrived in Paris in 1910 at the age of 23, Picasso was on everyone's lips, and the young Russian painter asked Apollinaire to introduce him to Picasso, which Apollinaire advised him against. He met the Spaniard casually on several occasions, but no friendship developed. A marked difference of temperament between the two artists was that Picasso was a ladies' man while Chagall thought only of his great love, Bella Rosenfeld, who was waiting in Vitebsk for his return. Just how much the young Russian initially admired Picasso can be seen in his remarkable small-scale (19.1 x 21.6 cm) drawing of 1914, entitled *Thinking Of Picasso* (ill. p. 184). The title appears on the work, written in Russian.

Françoise Gilot, Picasso's companion and the mother of his two children Paloma and Claude, writes in her book *Life with Picasso* that Chagall sent a letter to Picasso from the United States telling him that after his return to France he would like to meet up with him. Chagall also enclosed a photo of himself and his son David, to whom his companion, Virginia, had given birth in America. According to Françoise Gilot, Picasso was touched by the photo, even pinning it up in his studio. Picasso mentioned this letter to Tériade, who had come to ask Picasso to illustrate Pierre Reverdy's *Chant des Morts*. "I would be pleased to see him", Picasso said. "It is ages since I last saw the chap." Françoise Gilot also recounts that Chagall's daughter Ida, who was Tériade's house guest at the time, expressed a wish to arrange a meeting between Picasso and her father.

A week later Ida, Picasso and Françoise Gilot, together with the critic Michel Leiris and his wife, met for lunch at Tériade's house in Saint-Jean-Cap-Ferrat. Ida had prepared a sumptuous Russian meal for them. Knowing that Picasso's first wife, Olga, had been Russian, she thought that Picasso might still have a taste for Russian food. Gilot says: "(Ida) turned on all her charm for Pablo, telling him

Thinking of Picasso, 1914
Ink on paper, 19.1 x 21.6 cm
Paris, Musée national d'art moderne,
Centre Georges Pompidou

"When Chagall paints you do not know if he is asleep or awake. Somewhere or other inside his head there must be an angel" – said Picasso, commenting on Chagall's work. The relationship between Picasso and Chagall was very complex. Since his arrival in Paris, the Russian had been eager to meet the Spaniard. But when the poet Apollinaire offered to introduce Chagall to Picasso, he retorted: "Picasso? Are you feeling suicidal?" The two artists met on occasion all the same. In 1914, just before his return to Russia, Chagall drew *"Thinking of Picasso"* and later produced another work, this time entitled: *"Tired of Picasso"*
After the Second World War, when Chagall had returned to France, they met frequently at the Madoura ceramic workshops in Vallauris. The big break up came at a dinner party where they had a fierce argument and Chagall left in a fury. Thereafter they never met or spoke to each other again, and Chagall only referred to Picasso as "The Spaniard".

how much his work meant to her. That was music to his ears, of course. She had
a superb figure, with curves everywhere, and she constantly bent over him,
adoringly. By the time she had finished, Picasso was in the palm of her hand, and
he began telling her how much he liked Chagall. This was how Ida completed
what her father had begun – she made Picasso want to see Chagall, even before he
had returned." Some months later Chagall came back from America, settling in
the South of France, where many fellow artists lived. That was when he started
to model ceramics in the famous Madoura potter's workshop in Vallauris, where
Picasso also worked. Françoise Gilot maintains that this "was too much for Picasso.
Much as he liked Chagall, he could not put up with that, and he made no secret
of his feelings." There was even a rumour that in the workshop, in Chagall's
absence, Picasso completed a half-finished clay plate by adding a few quick brush
strokes, the result being a remarkably authentic-looking 'Chagall'. Following the
incident Chagall was not seen any more in that particular workshop. In Gilot's
assessment: "There was no quarrelling; it was just that Picasso was much less
enthusiastic about Chagall once he was back. Outwardly, however, they remained
good friends."

Chagall, tired of Picasso, 1921
Watercolour and ink on paper, 22.8 x 33 cm
Private collection
Courtesy Pucker Gallery, Boston

PAGE 186:
The Yellow Face, c. 1950
Oil on paper, mounted on canvas, 63.7 x 46 cm
Private collection
Courtesy Galerie Rosengart, Luzerne

PAGE 187:
The Joy of the Village, c. 1957
Watercolour and gouache on paper, 75 x 45 cm
Private collection

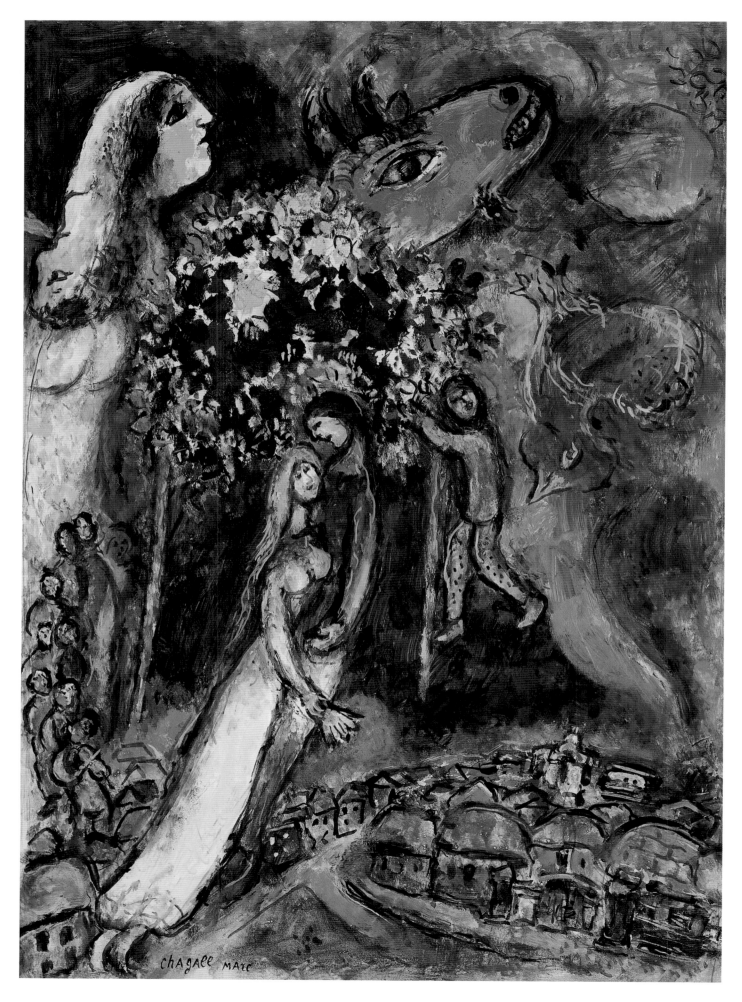

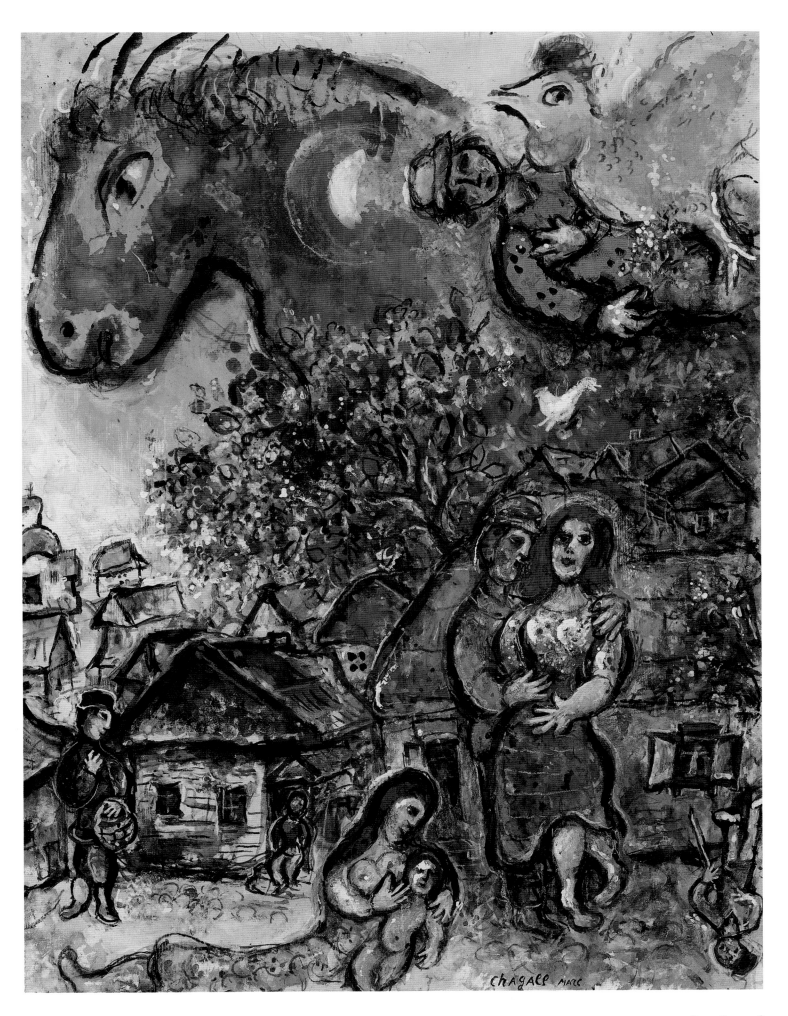

Marc Chagall in his studio, 1945
Courtesy Virginia Haggard, Brussels

About a year later, probably at Ida's instigation, the publisher Tériade again invited Picasso and Françoise for a lunch, which Chagall and his companion Virginia were also to attend. Françoise tells us how Picasso was put out from the start when he saw that Virginia, who was very thin, hardly touched the food. "Picasso found it so repugnant that he could scarcely bear to eat either. […] Surrounded by skinny women, he was in a bad mood, and decided to take out his pique on the others. He started sniping sarcastically at Chagall: 'My dear friend, I can't understand why, as a loyal, even passionate Russian, you never set foot in your own country anymore. You go everywhere else, even to America. But now that you're back again, and since you've come this far, why not go a little farther and see what your own country is like after all these years?'" Chagall, who had not been to Russia since 1922, "gave Picasso a broad smile and said: 'My dear Picasso, after you, but you must go first. According to all I hear, you are greatly loved in Russia, even if your paintings are not. Maybe once you get there and test the waters, I could follow along after. I don't know; let's see how you get on.'" Picasso grew very irritated, snapping: 'With you I suppose it's a question of business. There's no money to be made there.'" According to Françoise, that finished their friendship then and there: "The artificial smiles remained for a while, but the innuendos became clearer and clearer, and by the time we left, there were just two corpses under the table. From that day on Picasso and Chagall never set eyes on each other again."

When Françoise saw Chagall a while later, "he was still smarting over the luncheon – 'a bloody affair', he called it." Not long after the meal Virginia Haggard (as she had then become again, having divorced her husband McNeil) left Chagall, and soon afterwards Picasso and Françoise Gilot met Ida Chagall at the ballet. Françoise recalls: "Ida was incensed about Virginia deserting her father. 'Papa is so miserable', she said. Picasso began to laugh. 'Don't laugh', said Ida, 'it could happen to you.' Picasso laughed even louder. 'That's the most ridiculous thing I've ever heard', he said." It did not take long for Ida's prophecy to come true. Françoise Gilot finally took her two children and walked out on Picasso – a great blow to the macho Spaniard.

Chagall never discussed the incident, but his attitude towards Picasso became very cynical, and from then on he always referred to Picasso merely as "the Spaniard". His new wife Vava reproached Picasso with having "more head than heart" and being "sly and dangerous". In spite of everything Picasso retained, according to Françoise Gilot, a great deal of respect for Chagall as a painter: "Once, when we were discussing him, Picasso said: 'When Matisse dies, Chagall will be the only painter left who understands what colour is. I'm not exactly crazy about those cocks and asses and flying fiddlers and all the folklore, but his canvases are really painted, not just tossed together. Some of the last things he's done in Vence convince me that there's never been anybody since Renoir who has the feeling for light that Chagall has.'" Much later Chagall told Françoise Gilot his opinion of Picasso, proving that he could be as sarcastic as ever: "What a genius Picasso is! It's a pity he doesn't paint."

There is a story that the Jewish painter Mané-Katz, an associate of the 'School of Paris' whom Chagall could not abide, when asked for his opinion of Chagall, replied: "A great artist and a wonderful human being." When Chagall was asked what he thought of Mané-Katz, he answered: "A terrible artist and an awful man." Mané-Katz, when asked how he could praise a man who clearly damned him, responded: "All artists are liars […]." The author well remembers how Chagall once flew into a rage when he found out that Mané-Katz was travelling on the same boat, the 'S.S. France', from New York to France. "What does he want from me?", he shouted out. "Why does he keep following me around?"

One day I accompanied Chagall on one of his daily walks in Vence. He reacted very testily when tourists, who did not know who he was, asked him the way to the famous Matisse Chapel, which lay not far from his home. This jealousy, however, did not stop him from admiring Matisse and his work. With his daughter Ida, whom Matisse sketched several times, he even visited the artist in Nice. Besides a small version of Renoir's *Washerwoman* and a sculpture by Henri Laurens, these

Marc Chagall painting his daughter Ida, c. 1945
Courtesy Virginia Haggard, Brussels

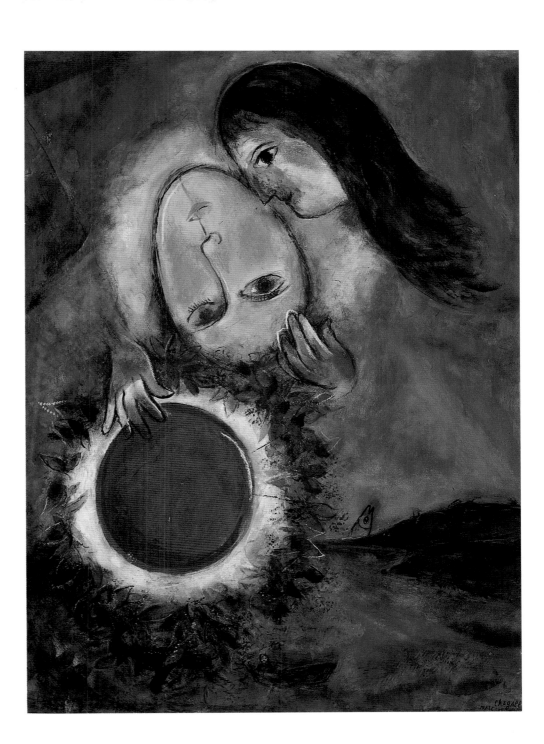

Green Landscape, 1949
Gouache on paper, 77 x 56 cm
Basle, Collection Marcus Diener

drawings were the only works by another artist that Chagall allowed alongside his own paintings in his living room.

Chagall had nothing good to say about Joan Miró either. The author still vividly recalls a summer's afternoon in the early 1970s when a Miró retrospective was being held in the Maeght Foundation in Saint-Paul-de-Vence. At the opening, Chagall, who lived next door, was conspicuous by his absence, even though Aimé Maeght was not only Miró's dealer but his own. He just could not stand playing second fiddle. I had an appointment to see Chagall at 5 p.m. on that day. My wife Aviva and I had arrived two hours early to see the Miró exhibition. While strolling through the show, we noticed Chagall 'disguised' in a hat and dark glasses. On spotting us, he said only "See you later."

At the appointed hour we were welcomed to his villa 'La Colline' by the barking of his dog Pasha. I greeted Chagall as I always did with "Bonjour, Maître", a suitable form of address for such a master. The word 'maître' sounds like 'mètre'. Chagall countered as usual: "I am only a centimetre" or, acting modest, "I am only a millimetre", to which I, playing along with his game, would reply: "No, you are a

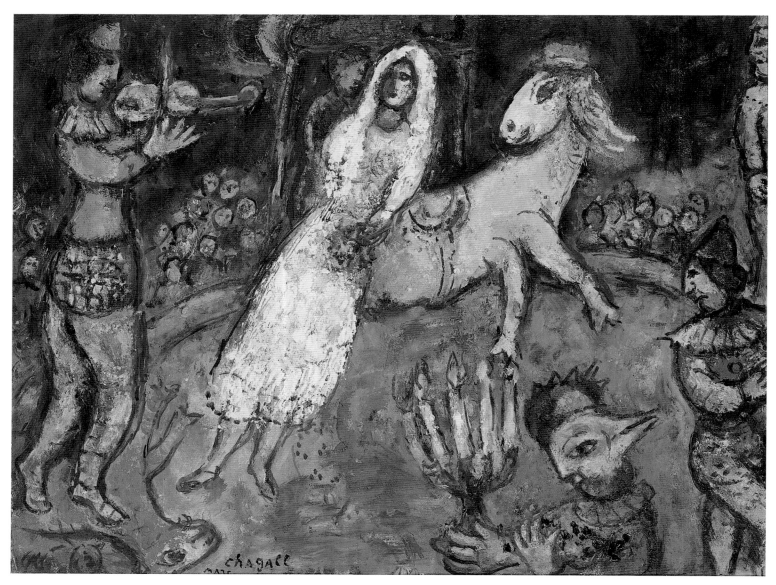

The Circus, 1962
Oil on wood panel, 41 x 53 cm
Private collection
Courtesy Hammer Galleries, New York

Like many fellow artists of this generation, Chagall loved the circus. He had been fascinated by travelling entertainers and acrobats in his youth. His first circus picture, *The Three Acrobats* was painted in 1926. In the following year, the art dealer and publisher Ambroise Vollard invited him frequently to his private box at the Cirque d'Hiver (The Winter Circus) in Paris, so that Chagall could make sketches for an album of prints on this theme. Although nineteen circus gouaches were produced at that time, they were not made into lithographs until after the Second World War. This painting was done many years later. The circus kept its hold on Chagall's imagination to the end of this life. For him, it was a world of colour and drama in which tragedy and comedy were continually intermingled. Many of his circus motifs are to be found in the murals he painted for the Jewish Theatre in Moscow in the early 1920s.

PAGE 191:
TOP LEFT:
The Three Acrobats, 1926
Oil on canvas, 116.5 x 89 cm
Private collection

TOP RIGHT:
The Clown on the White Horse, 1926–27
Gouache on grey paper, 63 x 48 cm
Private collection

BOTTOM LEFT:
The Circus, 1937
Watercolour, pastel and pencil on paper
65.1 x 51.1 cm
Private collection

BOTTOM RIGHT:
The Violet Rooster, 1966–1972
Oil on canvas, 88.5 x 77.5 cm
Private collection
Courtesy Galerie Daniel Malingue, Paris

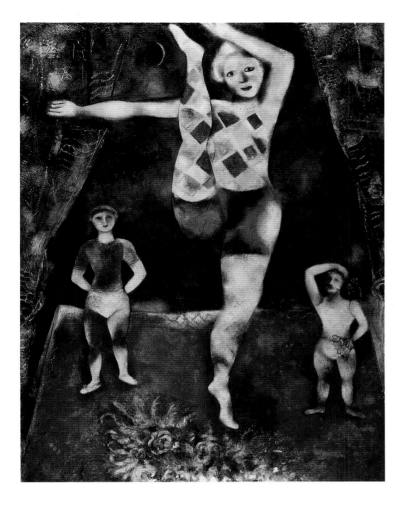

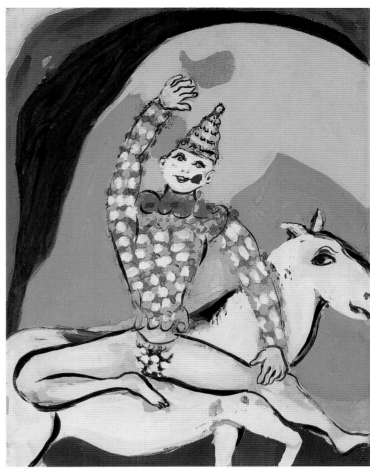

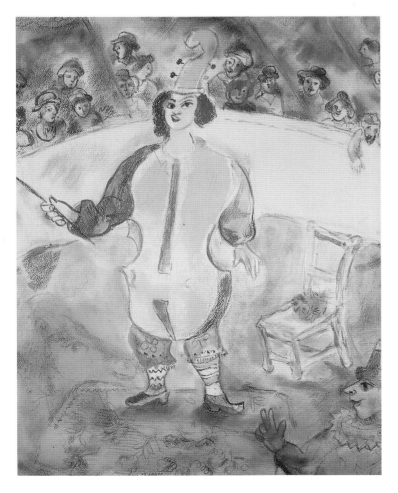

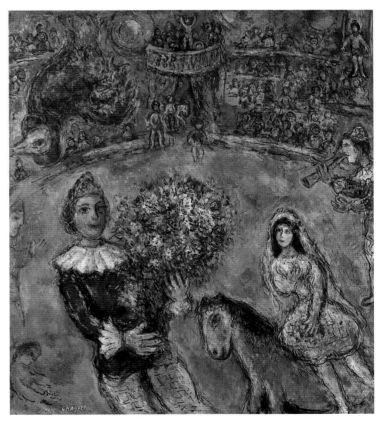

Confidences at the Circus, 1969
Gouache on cardboard, 59.5 x 57 cm
Private collection

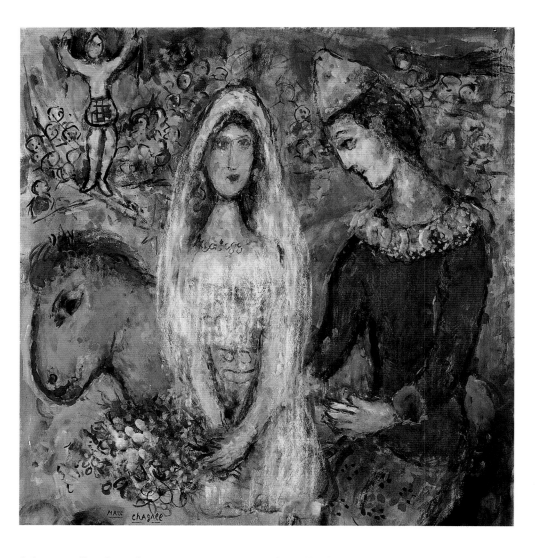

Circus with Red Horse, 1968
Oil on canvas, 55 x 46 cm
Private collection

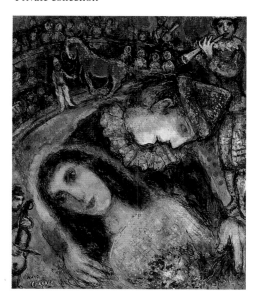

kilometre." When the niceties were over, Chagall's first question was: "How did you like the Miró exhibition?" Putting the ball back in his court, I said only: "What I think, Maître, is not important, what do you think?" Pausing for only a moment's thought, Chagall said: "If you are ill, you go to the doctor. What is the first thing the doctor does? He takes your pulse. If you have no pulse, you are dead! Miró has no pulse..." Knowing his opinions, Aviva and I were not put out. We simply looked at each other and quickly changed the subject.

Another anecdote also shows Chagall's abrasiveness with regard to Miró. On 30 June 1984, in honour of Chagall's 90th birthday, the Pompidou Centre in Paris mounted an exhibition of 200 of his works on paper, including many rarely seen drawings from the artist's early Russian period, the show later going to Hanover, Zurich and Rome. Chagall attended the opening, which was to be his last visit to Paris. At a press conference held at the opening he appeared in a wheel-chair, looking frail, although his mind was as sharp as ever. He was accompanied by his wife and Nicole Duault, a woman journalist from the widely read French newspaper *France Soir*, who had prepared a full-page article on Chagall at 90. Entering the museum, the three passed a large Miró picture, and Chagall asked the lady journalist: "How do you like this painting?" She replied: "It is very beautiful." "No!" Chagall retorted, "It's shit!" The lady was dumbfounded, scarcely able to hide her amazement behind a smile. She opened her article by quoting his remark verbatim.

An incident in New York during the Second World War further illustrates how caustic Chagall could be. On the way to his American dealer, Pierre Matisse, he got out of the lift on the wrong floor, inadvertently stumbling into another gallery where a young artist was exhibiting his paintings. While Chagall was looking around, he was recognized by the young artist, who could hardly contain his joy at

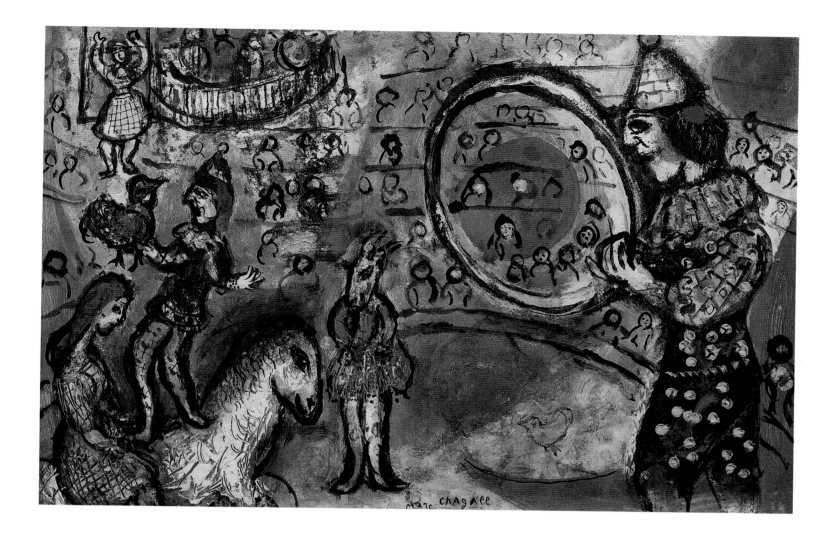

The Circus, 1967
Oil and gouache on paper, mounted on canvas
38.1 x 57 cm
Private collection
Courtesy Hammer Galleries, New York

having the great master visit his show. "What do you think of my paintings?" the young man asked, to which Chagall replied abruptly: "Art is very difficult", and walked out of the gallery.

Chagall disliked abstract art and used harsh words to describe it. It was for him "like something spat out". Once, reviewing his tendency to invective and turning it against himself, he declared: "The poet Mayakovsky used to say to me in Moscow: 'My dear Chagall, you are a good fellow, but you talk too much.' I see that I have not improved with age!"

Chagall and the circus

Artists throughout the 20th century have drawn inspiration from the circus. Its drama, tension, tragi-comedy, magic, joys and sorrows, and above all its vivid colours captivated many painters, notably Seurat, who rendered the world of the circus in his own pointillist technique. The circus portrayals of Toulouse-Lautrec, Picasso, Rouault and Léger are admired by art lovers the world over. Chagall's fascination with the circus goes back to his early childhood. A man with a little boy and girl used to come to his home town of Vitebsk to perform to half a dozen spectators in the street. Before starting their act, the man would lay a dirty rug on the ground. He attached to his belt a pole ten or twelve feet long, which the boy would climb up, anxiously clinging on while his father hoisted the pole to hold it in his mouth. When the lad came down, it was the girl's turn to go up.

Chagall wrote: "These clowns, bareback riders and acrobats have made themselves at home in my visions. Why? Why am I so touched by their masks and grimaces? With them I can move towards new horizons, lured by their colours and

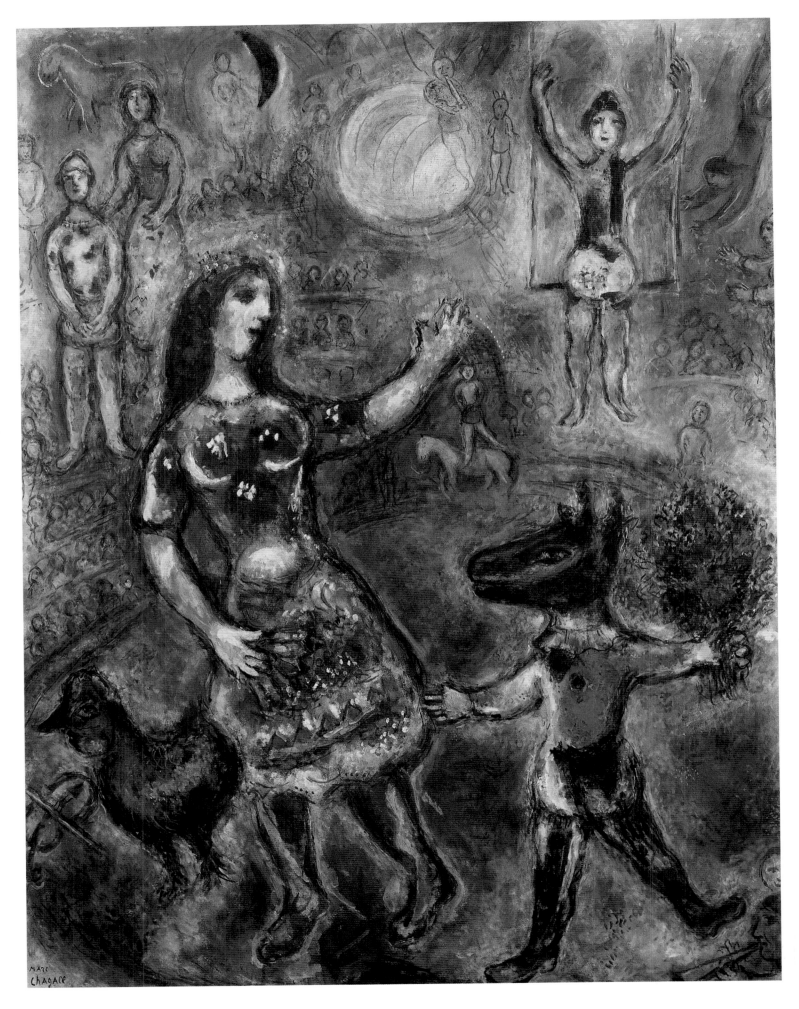

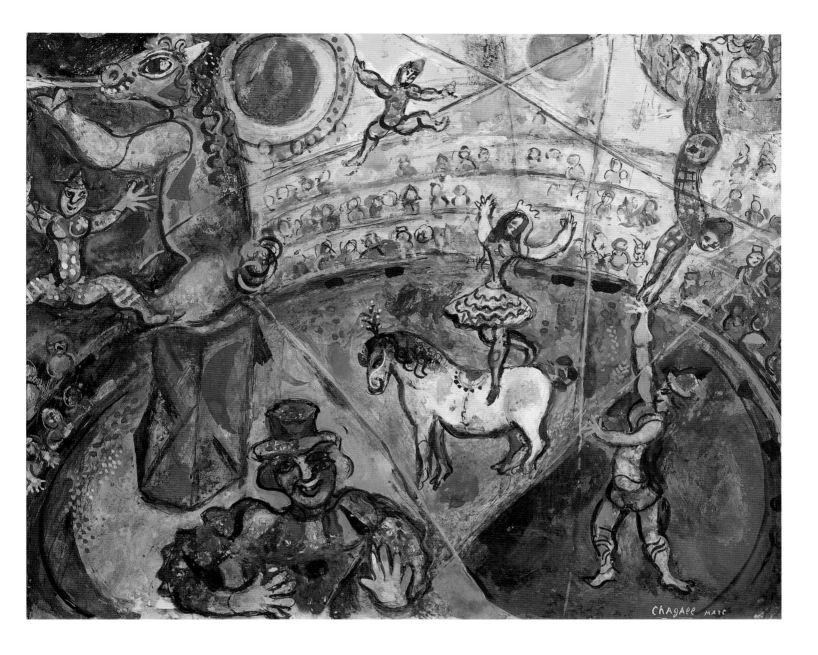

masks to other psychic distortions, which I would really like to paint." Two of
the artist's early pictures, *The Violinist* (1912–13, ill. p. 56) and the *Green Jew* (1914),
clearly reflect the garish, thickly applied colours of the circus clown's make-up.
Chagall said: "A revolution that does not achieve its ideal is perhaps also a circus.
[…] 'Circus' is a magic word, a timeless dancing game, whose tears and smiles,
and play of arms and legs take the form of a great art. […] The circus seems to me
the most tragic show on earth, man's most poignant cry across the centuries in his
search for amusement and joy. It often takes the form of great poetry." Chagall's
many circus paintings are exceptional, their riot of warm colours and their sense of
drama setting them apart from those of other artists. They are full of poetry and
empathy, leaving no viewer untouched. One senses how much Chagall loved this
world, its atmosphere, tension and colours.

The French writer Louis Aragon, a great admirer and friend of Chagall's, once
said that he would like to see the circus paintings of Chagall, Seurat, Toulouse-
Lautrec, Rouault and Léger all together to find out just how much each is really
influenced by the circus. "One would perhaps be somewhat surprised to find that
only in Chagall do all the senses play a prominent role. Only with him is the smell
of the horses and the riding women, wafting from the glittering ring to the spectat-
ors on their benches, as beguiling as the radiant light. In Chagall's circus pictures
the spectators in the galleries represent us, the viewer. What makes the works

The Circus Horse, c. 1964
Gouache on paper, 49.4 x 61. 8 cm
Private collection
Courtesy Hammer Galleries, New York

PAGE 194:
The Queen of the Circus, c. 1958
Oil on canvas, 116 x 84 cm
Private collection

incomparable is that we are caught up with the woman rider circling the ring, whose beauty is the beauty of danger, waiting for her to come round again, until all the men watching with bated breath reach the point where they envy the horse." Not just dramatic, Chagall's circus paintings are poetic and gloriously colourful in a way that only he can achieve.

Chagall himself said: "I have always thought of clowns, acrobats and actors as tragically human beings, who for me resemble figures in certain religious paintings. Even today, when I paint a crucifixion or some other religious scene, I still experience the same emotions that I feel when painting circus folk. Yet there is nothing literary about these paintings, and it is hard to see why I should feel a psycho-plastic similarity between such different kinds of subject."

Chagall painted his first circus pictures in the twenties, when the art dealer and publisher Ambroise Vollard invited him to his box at the 'Cirque d'Hiver' in Paris – with an eye to commissioning Chagall to produce a series of lithographs on the circus theme. In 1955 the painter's interest in the subject was rekindled during the shooting of a film at the 'Cirque d'Hiver'. The sketches he made while watching this went into the 1956 picture *Large Circus*. The circus theme occupies a prominent position in Chagall's œuvre because, as Franz Meyer puts it, "the circus act, as a direct representation of life in all its magical mystery, corresponds to a Chagallian archetype of art."

The year 1955 saw Chagall begin the large-scale paintings for his *Biblical Message* series. In 1957 he visited Israel for the third time, and in the same year there was a retrospective exhibition of his graphic works in the Bibliothèque National in Paris. The following year, 1958, he went to Chicago to give a lecture at the university there. Upon his return he was commissioned by the Paris Opera to design the sets and costumes for Maurice Ravel's ballet *Daphnis and Chloë* with a libretto by Michel Fokine and choreographed by Georges Skibine (ill. p. 229). The première took place in 1958 in Brussels at the World Fair, where Chagall met Charles Marq, the glass window master craftsman and director of the famous Simon studio in Reims. In the years ahead Marq was to help the artist realize numerous stained-glass window projects.

The ceiling of the Paris opera

In 1963 André Malraux, one of France's greatest culture ministers, commissioned Chagall to paint a new ceiling for the Paris Opera, a majestic 19th-century building also known as the 'Palais Garnier' after its architect. When the press reported the commission, Malraux was violently attacked. Various conservative voices, unmistakably anti-Semitic in tone, strongly objected to the idea of having a French national monument decorated by a Russian Jew. Others took exception to the ceiling of the historic building being painted by a modern artist. In their view the cherubs and rosy clouds of Jules-Eugène Lenepveu's academic frescoes were far more in keeping with this symbol of the Second Empire. The newspaper *France Observateur* and the magazine *Art* ran outraged articles, which led Chagall to remark to the writer Carlton Lake: "They called me Bernardin de Saint-Pierre of the Ghetto and so on […]. Malraux was abused that he should not 'insult the future' […]. They really had it in for me […]. It is amazing the way the French resent foreigners. You live here most of your life. You become a naturalized French citizen, give them twenty paintings for their museum of modern art, work for nothing decorating their cathedrals, and still they despise you. You are not one of them. It was always like that." (There was a similar outcry a few years ago when I. M. Pei, the American architect of Chinese extraction, erected a controversial glass pyramid in the courtyard of the Louvre.)

André Malraux was not a man to be swayed or intimidated by narrow-minded conservatives and anti-Semites, and therefore went ahead with the project. The controversy troubled Chagall, and he had difficulty deciding whether to accept the commission or not. He was a dreamer and did not want to be beholden to anyone.

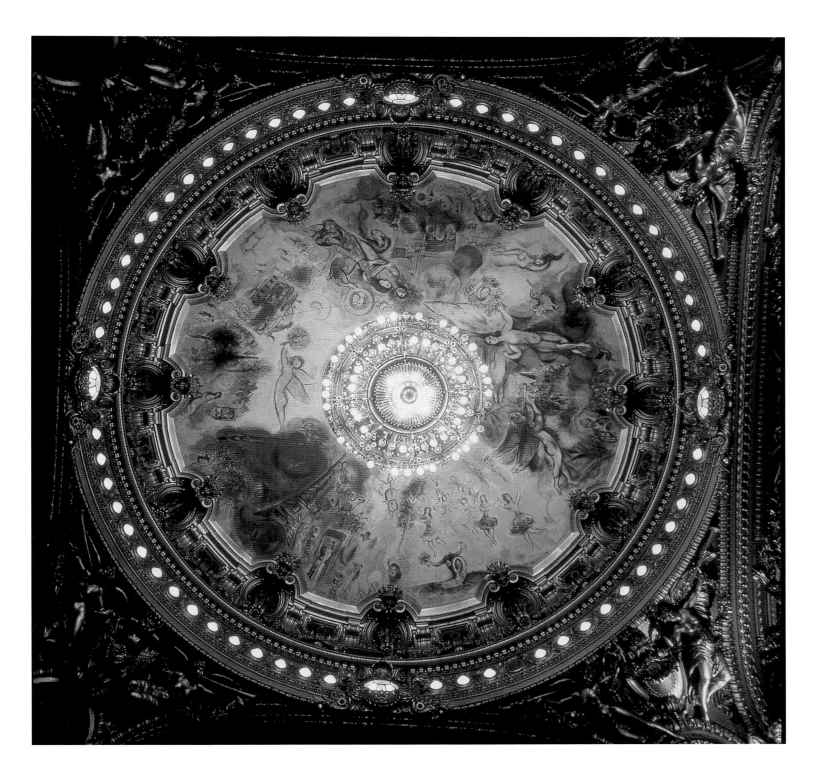

The Ceiling of the Paris Opera, 1964
Oil on canvas, c. 220 sq. m.

Nevertheless, monumental works attracted him, and he felt honoured by the confidence placed in him by Malraux, whose "shrewd vision" impressed him. All the same, he continued to be plagued by doubts until one day Vava said to him: "Why don't you try a couple of sketches, then you'll see." Chagall thought about the "Paris Opera as a total work of art": "I sensed how brilliant Garnier's architecture was and how inspired Carpeaux's sculptures." Finally he resolved to accept this important commission and set to work. "I don't consider André Malraux a minister but a visionary," said Chagall. The vast expanse of the ceiling and its shape and setting was a great challenge for Chagall, throwing up formidable technical problems.

The idea of commissioning Chagall to do the ceiling painting had come spontaneously to Malraux when two years earlier he had spent an evening at the opera in the company of President Charles de Gaulle. It was one of his most important

The Ceiling of the Paris Opera, 1964
Oil on canvas, c. 220 sq. m.

decisions as Culture Minister. He is to be thanked not only for sprucing up famous sights such as the Louvre and the Invalides, or the palaces and chateaus of Versailles, Fontainebleau and Chambord, but also for revamping entire districts of Paris – all in all he had the façades of some 40,000 buildings cleaned up.

Chagall felt his way forward with numerous dish-sized pastel sketches, which he later enlarged. His final designs were then transferred to canvas at the Gobelin tapestry workshops. 440 pounds of paint were needed to cover the 220 square metres of canvas, which was then glued to polyester panels lying on the floor to be hoisted into position just a few centimetres beneath Lenepveu's ceiling frescoes. The work consists of five segments (1964, ill. pp. 197, 198), the dominant colours being red, green, blue, yellow, and white. The images pay tribute to the composers Mozart, Wagner, Mussorgsky, Berlioz and Ravel, as well as to famous actors and dancers. Chagall, who worked on the project for a year and was 77 years old at the time, clambered up the scaffolding 70 feet above the ground to add the finishing touches.

On 23 September 1964 the monumental work was handed over to the public in the presence of André Malraux and 2100 invited guests. The Paris correspondent of the *New York Times* reported: "For once the best seats in the house were in the uppermost circle." To begin with, the big crystal chandelier hanging from the centre of the ceiling was unlit. As Hector Berlioz' *Trojan March* played, the entire *corps de ballet* came onto the stage, after which, in Chagall's honour, the opera's orchestra, conducted by Manuel Rosenthal, played the finale of the *Jupiter Symphony* by Mozart, Chagall's favorite composer. During the last bars of the music, the chandelier lit up, bringing the artist's ceiling painting to life in all its glory, and drawing rapturous applause from the audience. The gala evening was concluded with a performance of Michel Fokine's *Daphnis and Chloë*.

Once the new ceiling had been unveiled, even the bitterest opponents of the commission seemed to fall silent. In a speech to the invited guests Chagall said: "Up there in my painting I wanted to reflect, like a mirror in a bouquet, the dreams and creations of the singers and musicians, to recall the movement of the colourfully attired audience below, and to honour the great opera and ballet composers. Sometimes what one thinks to be inconceivable is possible, what seems strange is comprehensible. Our secret dreams thirst only for love. I wanted to pay homage to Garnier [...] and have here laboured with all my heart. Now I offer this work as a gift of gratitude to France and her École de Paris, without which there would be no colour and no freedom." When I first saw the new ceiling painting shortly after its unveiling, I was simply overwhelmed. I found it hard to concentrate on what was happening on the stage because my eyes kept straying up to the work above, which filled the classical theatre auditorium with life. It was a great triumph. Unanimously the press declared Chagall's new work to be a great contribution to French culture.

In his book *Voices of Silence* André Malraux wrote: "A masterpiece by accident cannot be more than just a happy accident, for genius does not create style in passing, but through tenacious work, thriving not on what it encounters by chance, but on what it appropriates." This observation could be said to apply to Chagall's whole œuvre and in particular to his ceiling painting for the Paris Opera. The artist did not disappoint the trust that Malraux had placed in him. Malraux himself said of his decision: "What other living artist could have painted the ceiling of the Paris Opera in the way Chagall did? [...] He is above all one of the great colourists of our time [...], many of his canvases and the Opera ceiling represent sublime images that rank among the finest poetry of our time, just as Titian produced the finest poetry of his day."

In 1964 Chagall and his wife went to New York for the inauguration of his stained-glass window, entitled *Peace* (ill. p. 245), at the United Nations in honour of Dag Hammarskjöld, the UN's second secretary general who was killed in a plane crash in Africa in 1961. It was then that Rudolph Bing, director of the New York Metropolitan Opera commissioned him to paint two monumental murals for the outside of the building. Titled *The Sources of Music* (ill. p. 205) and *The Triumph*

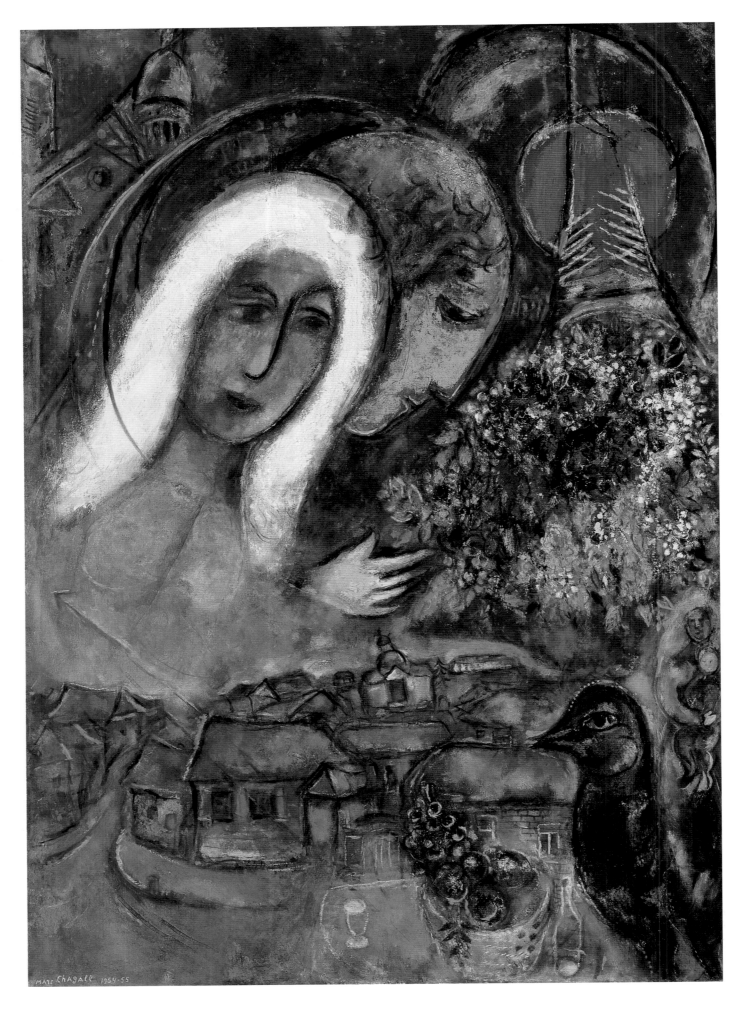

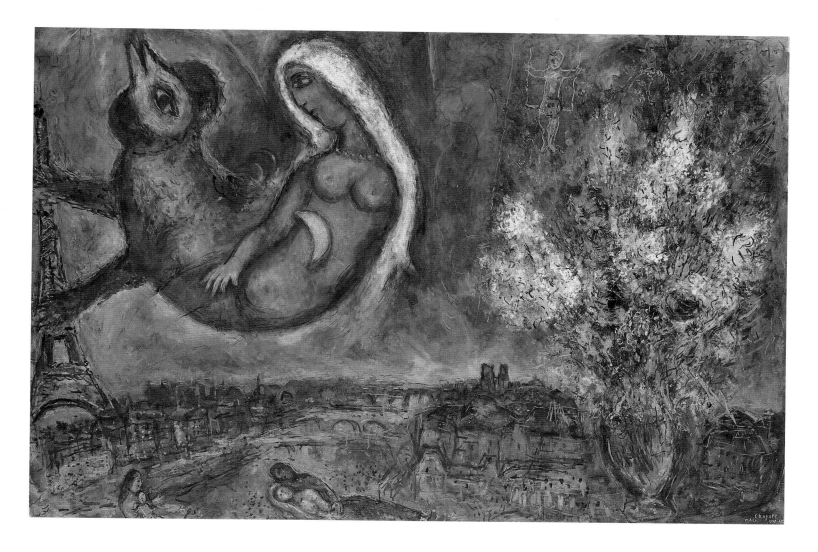

of Music (ill. p. 204), the two works were completed and shipped to New York in 1966. The artist continued to produce many lithographs and stained-glass windows, among them a cycle dedicated to John D. and Michael C. Rockefeller in the Union Church of Pocantico Hills, New York State (1967, ill. pp. 250, 251). From June to October 1967, under the title of *Message Biblique*, the Louvre exhibited 17 large-scale paintings and 38 gouaches, which Chagall donated to the French nation on condition that a museum was built for them in Nice.

Reflections on art and artists

In 1967 Chagall was interviewed by the art historian and critic Pierre Schneider for the book *The Louvre Dialogues*. It was now 57 years since he had first visited that treasure house. When asked why he had gone there immediately on arriving in Paris, Chagall answered: "I felt that the truth was there. The Modernists hadn't yet passed the test of time. There it was serious. [...] I went to the Louvre to examine myself, improve myself, hoping to learn something. But it was useless. [...] Painting cannot be learned. I am against the well-drawn, the well-painted. Cézanne had no draftsmanship, nothing." For Chagall, the Louvre had a magical significance: "Going into the Louvre is like opening the Bible or Shakespeare." He visited the museum over and over again: "It is the cemetery of geniuses. [...] Death can really help you to see." Pierre Schneider once characterized Chagall with the words: "Perpetual childhood, because he lives exclusively on dreams. [...] Angels do not age".

Interesting are Chagall's observations on other artists. Monet, he claims, he discovered "only after the war [...] on the ship bringing me back from America. At

The Bird Woman, 1958–1961
Oil on canvas, 108 x 159 cm
Private collection

PAGE 200:
Le Champ de Mars, 1954–55
Oil on canvas, 149.5 x 105 cm
Essen, Museum Folkwang
Courtesy Essen, Museum Folkwang

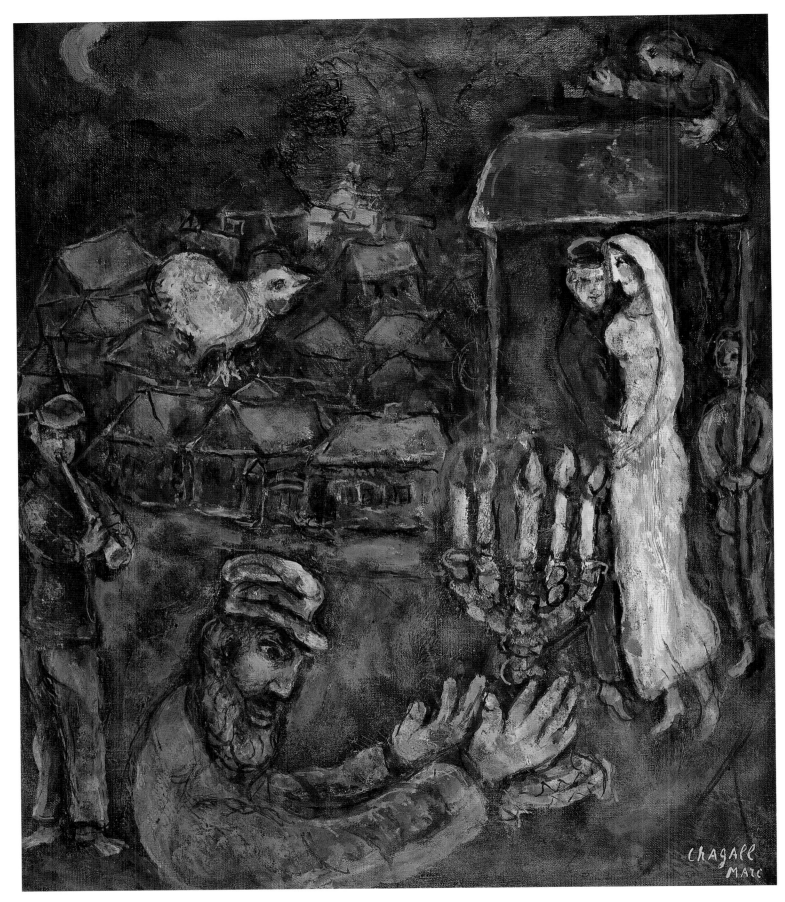

The Night Mariage, c. 1960–61
Oil on canvas, 55 x 46 cm
Private collection
Courtesy Galerie Rosengart, Luzerne

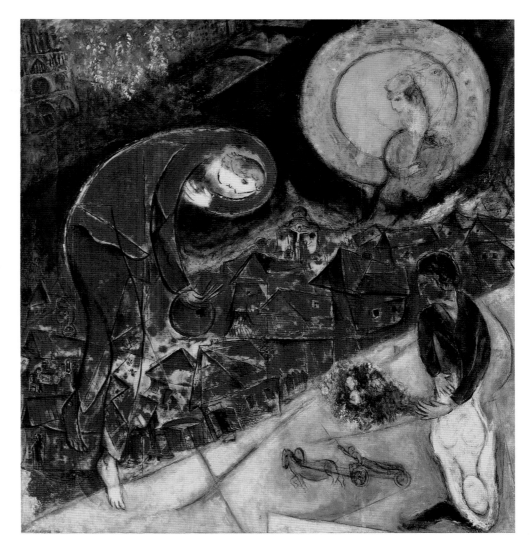

the time, on the ocean, I asked myself: 'Whose colour flows freely and naturally?'
And I answered myself: 'Monet's'. From the 'chemical' point of view, Monet is
for me the Michelangelo of our time.'" Again, according to Chagall, Watteau has
endured "not because of his figures, but because of chemistry. […] Everything else
– realistic or anti-realistic, figurative or abstract – no longer matters." Chagall com-
mented frankly on other artists: "Rouault: he bored me." "Bonnard? A beefsteak
that has been handled too much. […] Rather bourgeois. A man who does not look
you in the eye. Matisse? Yes! That rousing anarchy, that dash!" "Gleizes I rated too
highly, seeing in him a kind of Courbet of Cubism. As for Delaunay, today I have
a higher opinion of his early modest work than of the later work, where he is 'con-
sciously striving' for something." "La Fresnaye is a nice painter now that he has
gained depth and variety." "Dadaism is no great shakes, but Schwitters had done
some marvellous stuff." Schwitters, we recall, dedicated a poem to Chagall in 1914
(see p. 111). "(Courbet) is an artist I like very much. Of the same breed as Masaccio,
as Titian. […] He moves me, almost to tears. A painter of life. […] Courbet is a
naturalist and yet a great poet […]." Rubens "is a pig, but a great artist." "Ingres
irritates me. There is something overstuffed about him. There is a sort of impo-
tence in his portraits. They seem stilted, chiaroscuro." Delacroix: "You can really
feel that Manet is in the wings. What intelligence!" As to Spanish painting: "You
could weep before Courbet and Watteau, but not before Velásquez or Goya. They
are gods, but foreign gods. Zurbarán perhaps – such freshness! And Greco – but
he was Greek. There is always something of the bullfight about him." Corot:
"Now there you have an artist! […] He leaves you speechless. A god. He transcends
everything. […] What was left for the Impressionists to do after him? He had
already done everything. A real painter. He has chemistry, 'chimie'. He is a prince.

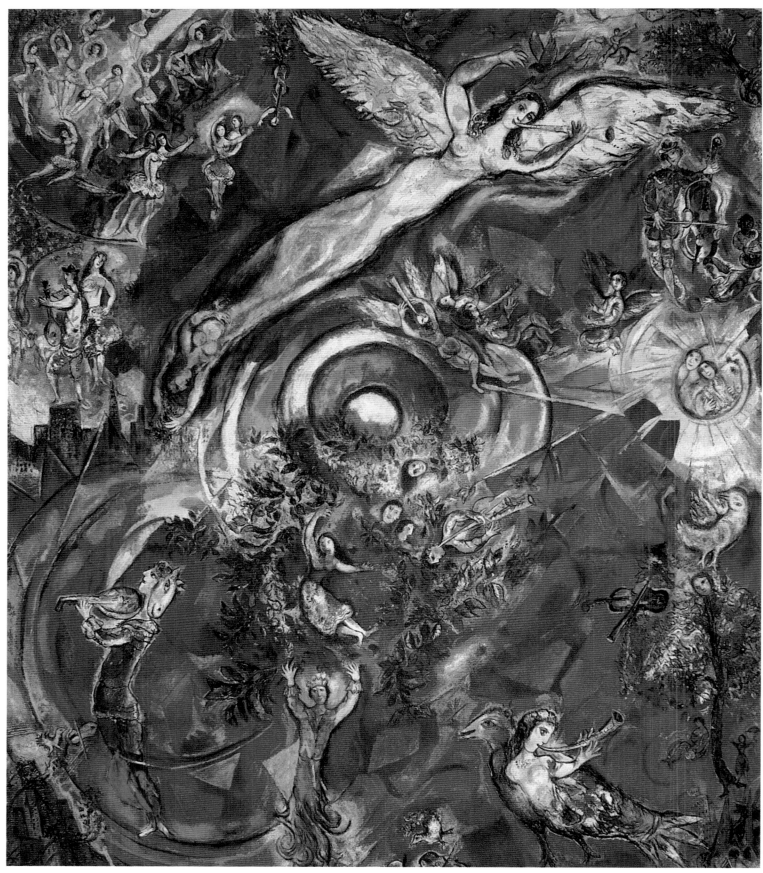

The Triumph of Music, 1967
Mural painting, oil on canvas, c. 11 x 9 m
New York, The Metropolitan Opera, Lincoln Centre

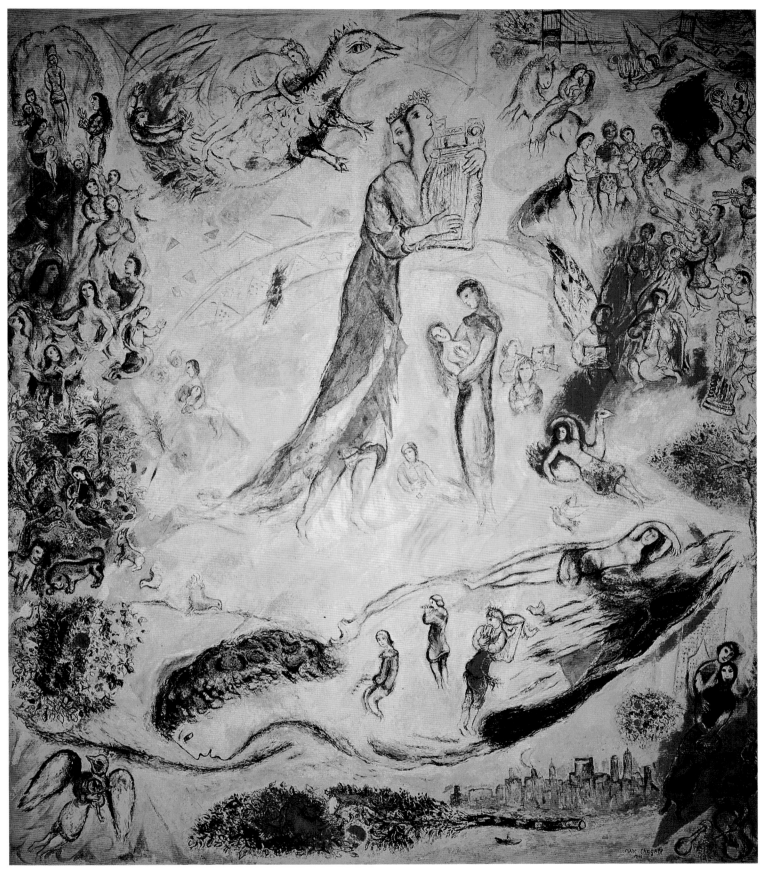

The Sources of Music, 1967
Mural painting, oil on canvas, c. 11 x 9 m
New York, The Metropolitan Opera, Lincoln Centre

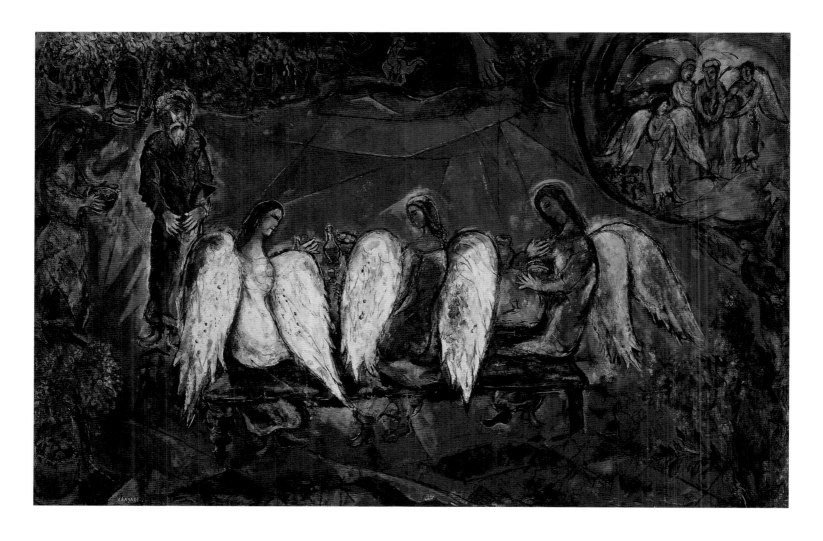

Abraham and the Three Angels, 1960–1966
Oil on canvas, 190 x 292 cm
Nice, Musée National Message Biblique
Marc Chagall

He can do anything. A Mozart." Salvador Dalí Chagall referred to as 'Monsieur Meschugge' – Yiddish for 'Mr Madcap'.

Chagall said that he came to Paris because of the light. "I hate Russian or Central European colour: it is like the footwear there. Soutine, me, all of us left because of the colour. I was very dark when I arrived in Paris. I was potato-coloured, like van Gogh. Paris is light and bright."

'Chimie' was a word Chagall especially liked using from the early 50s onwards and which, to preserve the special coloration of his language, is better left untranslated. With this word he meant everything that happens to the material with the forming hand of the artist – almost a process of alchemical transmutation. "The 'great chimie' leads one to community with nature, the 'lesser chimie' to community with man."

Chagall disputed the claim of André Breton and the Surrealists that as early as 1912 he had already been practising the 'automatism' they had advocated in their 1924 Surrealist Manifesto, thus anticipating their movement. The contrary was true, Chagall maintained: "I consciously seek [...] to construct a world where a tree can be different, where I myself can suddenly discover that I have seven fingers on my right hand [cf. *Self-Portrait with Seven Fingers*, 1913–14, ill. p. 73], but only five on my left – basically a world where everything is possible [...]."

In another context Chagall said: "In those days the sun of art shone only in Paris, and it seems to me even today that there has never been a greater revolution of the eye than the one I encountered in 1910 on my arrival there. The landscapes, the figures of Cézanne, Manet, Monet, Seurat, Renoir, van Gogh, the Fauvism of Matisse, this and so many other things astounded me! They attracted me like some natural phenomenon. My homeland lay far off, in my imagination its fences standing out against the background of houses. There was no sign there of the colours of Renoir. Two or three dark spots, and one would have had to live alongside them,

The Creation of Man, 1956–1958
Oil on canvas, 300 x 200 cm
Nice, Musée National Message Biblique
Marc Chagall

This painting is one of a series entitled *Message Biblique*, that Chagall donated to the French nation. They were first exhibited in the Louvre in Paris before being permanently installed in the Musée National Message Biblique Marc Chagall in Nice.

"Ever since early childhood, I have been captivated by the Bible. It has always seemed to me, and still seems today, the greatest source of poetry of all time. Ever since then, I have searched for its reflection in life and in art. The Bible is like an echo of nature and this is the secret I have tried to convey [...]. To my way of thinking, these paintings do not illustrate the dream of a single people, but that of mankind. They are the result of my meeting the French publisher, Ambroise Vollard, and of my trip to Palestine. I thought I would leave them to France, a kind of second birthplace for me. It is not up to me to comment on them. Works of art should be able to speak for themselves."

MARC CHAGALL

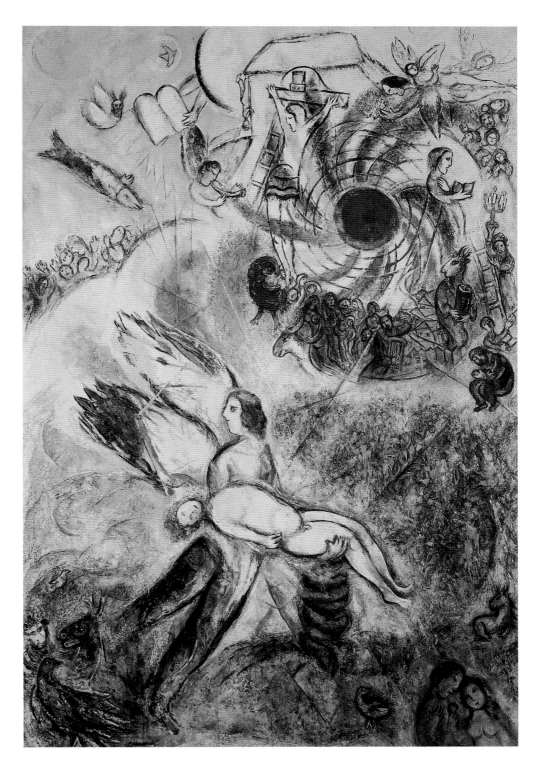

with no hope of finding this liberated artistic language, which, like man, breathes of its own accord [...] Having read, marked, learned and inwardly digested this unique technical revolution in art in France, I went back to my native country and lived there as if turned upside down".

Jacob Tugendhold, who in 1918 together with Abraham Efross published the first monograph on Chagall, described Chagall's early work in another article 'A New Talent' (published in Moscow in 1915) as follows: "(His) works seem intimate, humble, almost retrograde. But this is characteristic of all true art, of art which does not follow the dictates of fashion, but responds to the intrinsic call of inspiration [...], and his work, blending Parisian formalism with almost provincial childlike naivety, is full of emotion, depth and spirituality. We find here both the 'sacred simplicity' of a true primitive and the cruelty of the descendants of Dostoyevsky.

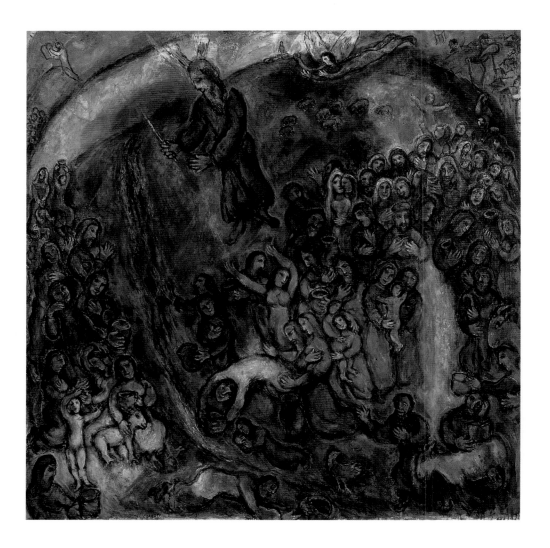

Moses Striking the Rock, 1960–1966
Oil on canvas, 237 x 232 cm
Nice, Musée National Message Biblique
Marc Chagall

[…] Chagall captures the barely perceptible, yet awe-inspiring mystical essence of Russian life […], eliciting from this drab sleepy life a marvellous legend […]. Chagall is one of the great hopes of Russian Art".

The 'Bible museum' in Nice and the major exhibitions of the later years

In 1969 the foundation stone was laid for the Musée National Message Biblique Marc Chagall in Nice. After four years of construction work the museum was inaugurated on 7 July 1973, Chagall's birthday, by André Malraux. It contains monumental paintings on biblical themes, three stained-glass windows, tapestries, a large mosaic and numerous gouaches for the Bible series. Each year the museum mounts a special exhibition relating to some particular aspect of the artist's work. It was at a celebration there marking Chagall's 97th birthday in 1984 that the author saw the artist for the last time.

From December 1969 to March 1970 the largest Chagall exhibition yet, of 474 works, was mounted at the Grand Palais in Paris. Called 'Hommage à Marc Chagall', the show was opened by the French President and proved an enormous success with the public and critics alike.

At the invitation of the Soviet Culture Minister Yekaterina Furtseva, Chagall and his wife Vava travelled in 1973 to Russia – the artist's first visit to his homeland since 1922 and an emotional occasion for him. In the Tretiakov gallery in Moscow an exhibition of gouaches, oils and graphics was organized to mark the occasion. Here the artist, unable to hold back his tears, was asked to sign the murals for the 'Jewish Theatre'. In Leningrad – now St. Petersburg again – Chagall was reunited with two of his sisters, whom he had not seen for more than 50 years. Two years

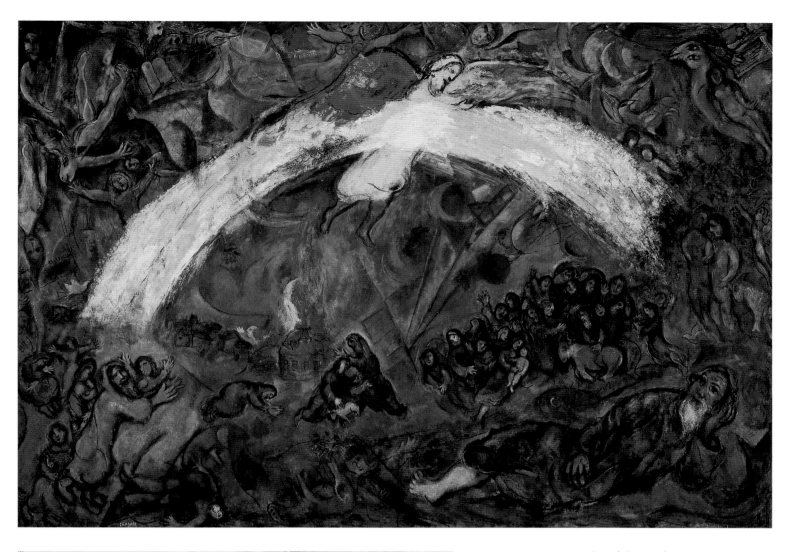

Noah and the Rainbow, 1961–1966
Oil on canvas, 205 x 292.5 cm
Nice, Musée National Message Biblique
Marc Chagall

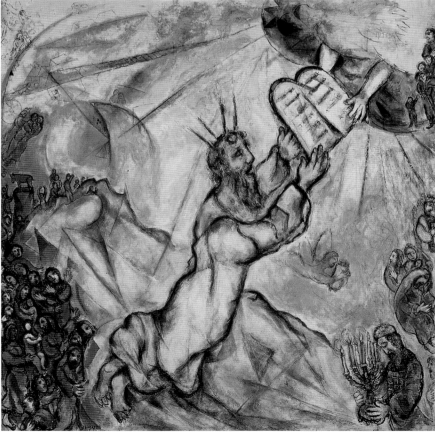

Moses Receiving the Tablets of the Law,
1960–1966
Oil on canvas, 238 x 234 cm
Nice, Musée National Message Biblique
Marc Chagall

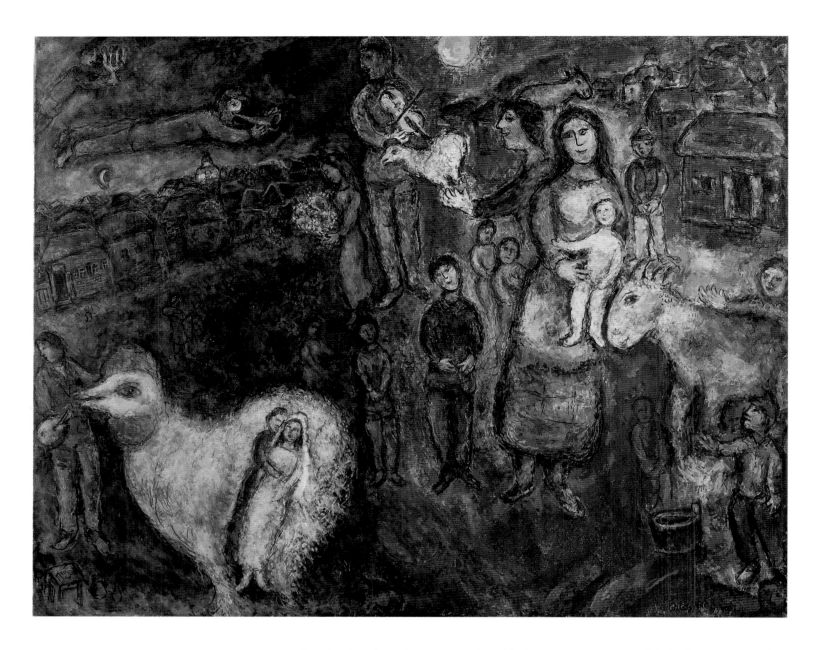

The Event, 1978
Oil on canvas, 130 x 162 cm
Private collection

PAGE 211:
The Sky of Paris, 1973
Oil on canvas, 100 x 73 cm
Private collection

PAGE 212:
Don Quixote, 1975
Oil on canvas, 196 x 130 cm
Private collection

PAGE 213:
The Prodigal Son, 1975–76
Oil on canvas, 162 x 122 cm
Private collection

after the Russian trip, in 1975, Gérald Cramer in Geneva published a selection of Chagall's poems, written between 1930 and 1964 (ill. p. 271).

In 1982 the Moderna Museet in Stockholm organized a retrospective, which went on to be shown the next year in the Louisiana Museum in Humlebaek, Denmark. 1984 was marked by two events: the Musée National d'Art Moderne in Paris mounted a large exhibition of the artist's works on paper, and the Maeght Foundation in Saint-Paul-de-Vence arranged a retrospective of his paintings. In January 1985 the Royal Academy in London presented a major retrospective, which later moved to the Philadelphia Museum of Art. Chagall was now too old and frail to attend the London opening, and on 28 March, after working all day on a lithograph with Charles Sorlier, he died peacefully of old age. On 1 April, at Saint-Paul-de-Vence cemetery, a simple funeral took place, attended by Chagall's closest friends, numerous representatives from public life, and also Picasso's widow Jacqueline. An old friend of the artist's, the Yiddish journalist Leneman, said the kaddish, the Jewish prayer for the dead. Chagall's passing marked the end of an important era in 20th-century art.

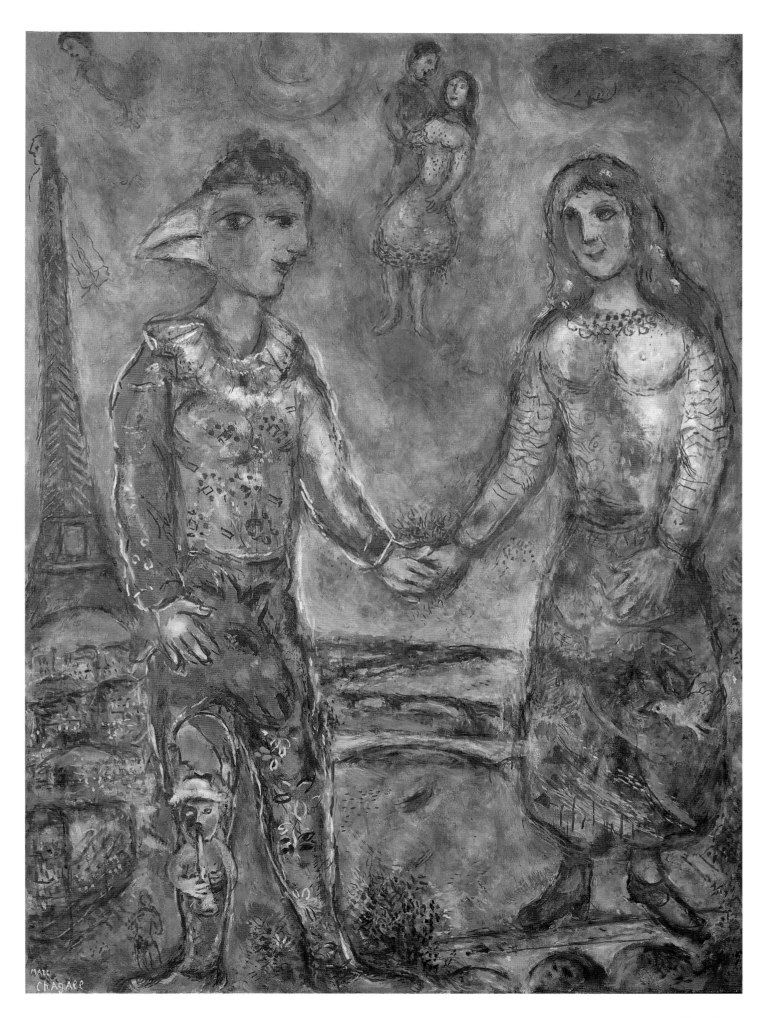

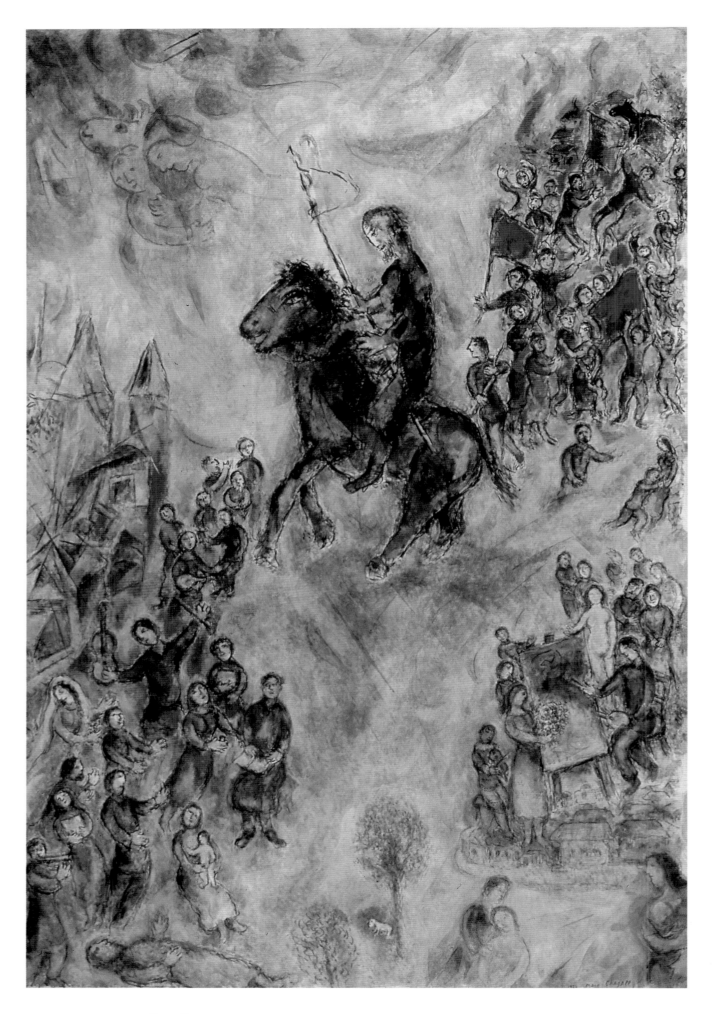

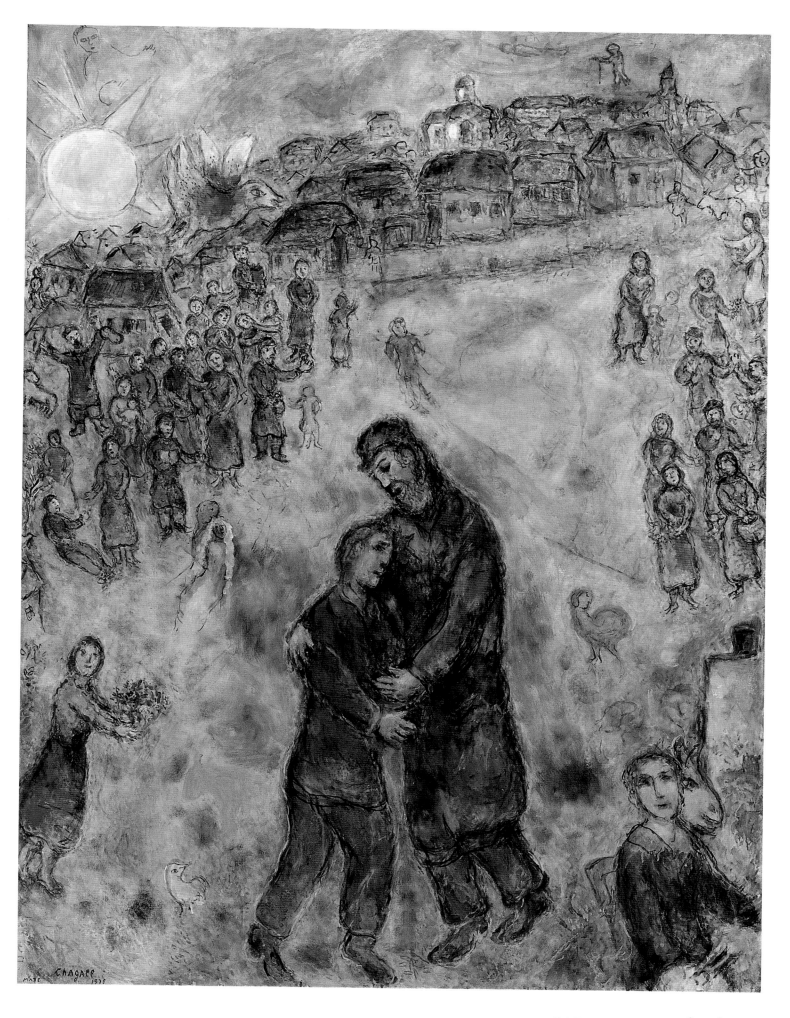

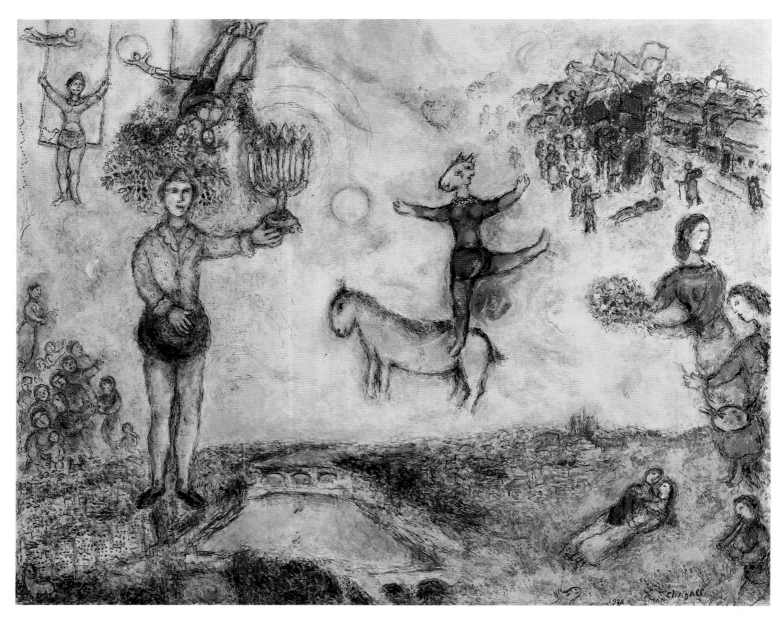

Paris Landscape, 1978
Oil on canvas, 130 x 162 cm
Private collection

"The habit of ignoring nature is deeply im-
planted in our times. This attitude reminds
me of people who never look you in the eye;
I find them disturbing and always have to look
away [...]"

 "If ever there was a moral crisis, it was that
of paint, matter, blood, and all their con-
stituents – the words and tones, all the things
out of which one makes a life or creates art. For
even if you cover a canvas with thick masses of
paint, irrespective of whether the outlines of
shapes can be made out or not, and even if you
enlist the help of words, it does not necessarily
follow that an authentic work of art will
emerge."

 MARC CHAGALL

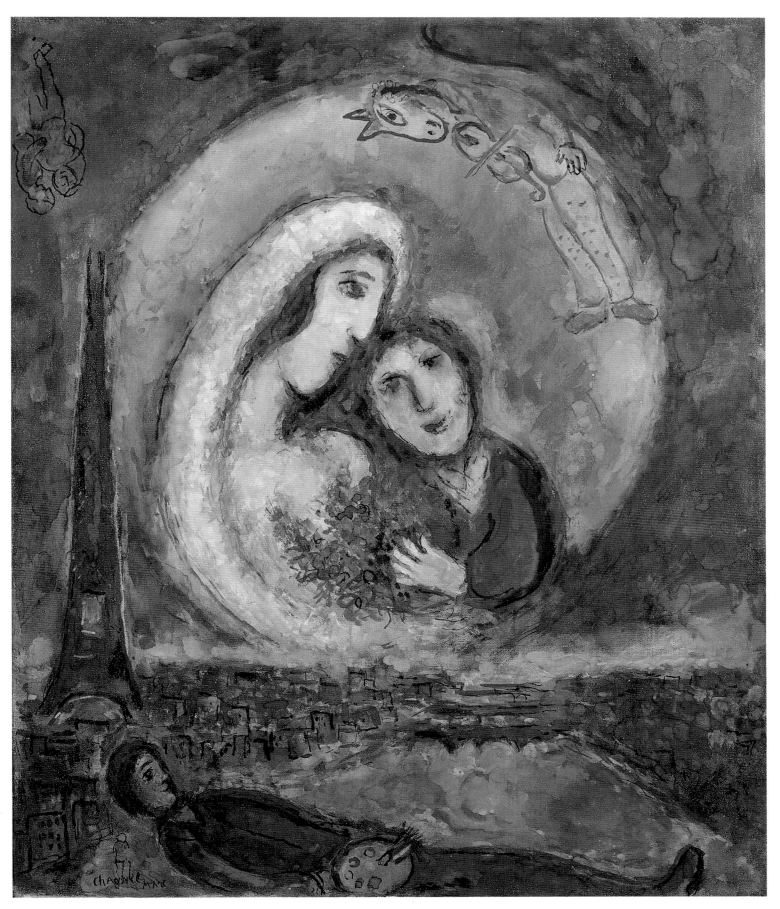

The Dream, 1978
Tempera on canvas, 65 x 54 cm
Private collection

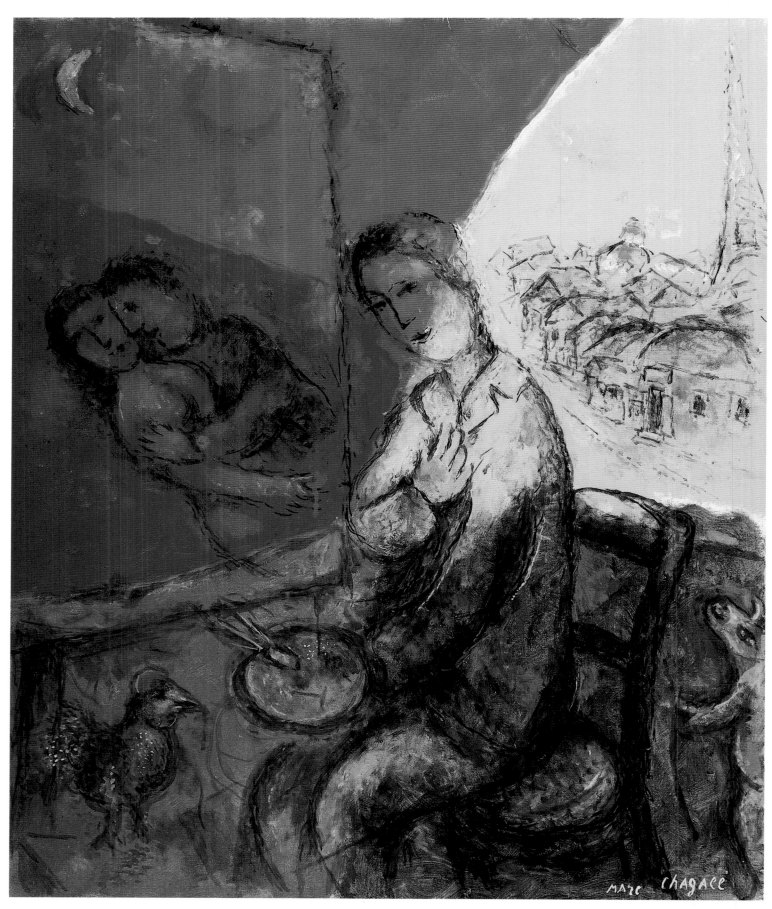

The Painter, 1976
Oil on canvas, 65 x 54 cm
Private collection

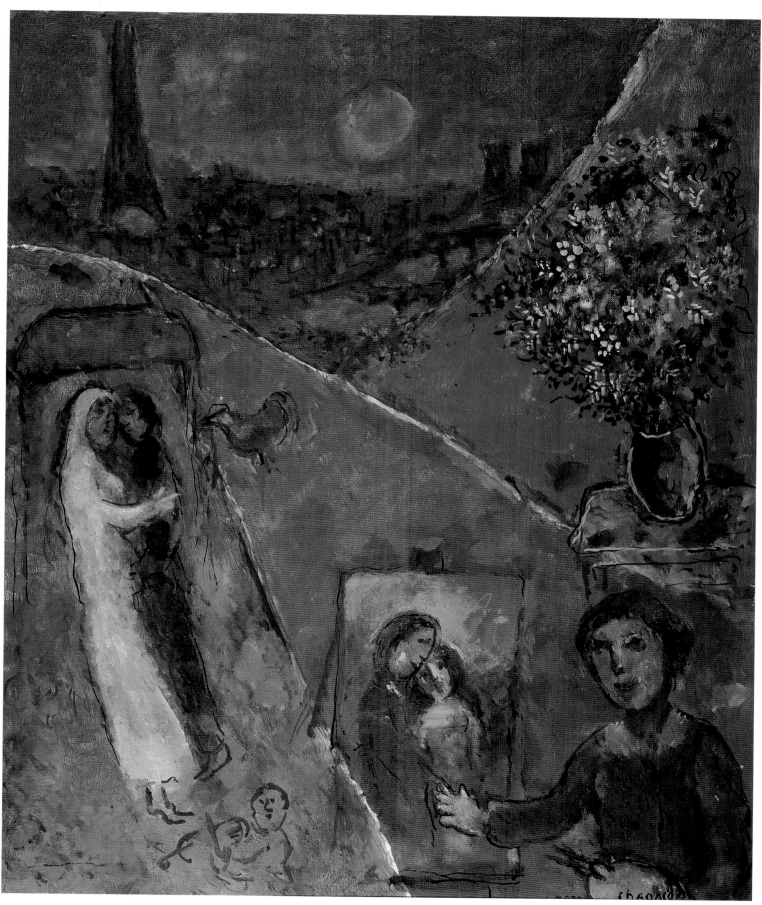

The Painter and the Bridal Couple, 1978
Acrylic on canvas, 60 x 50 cm
Private collection

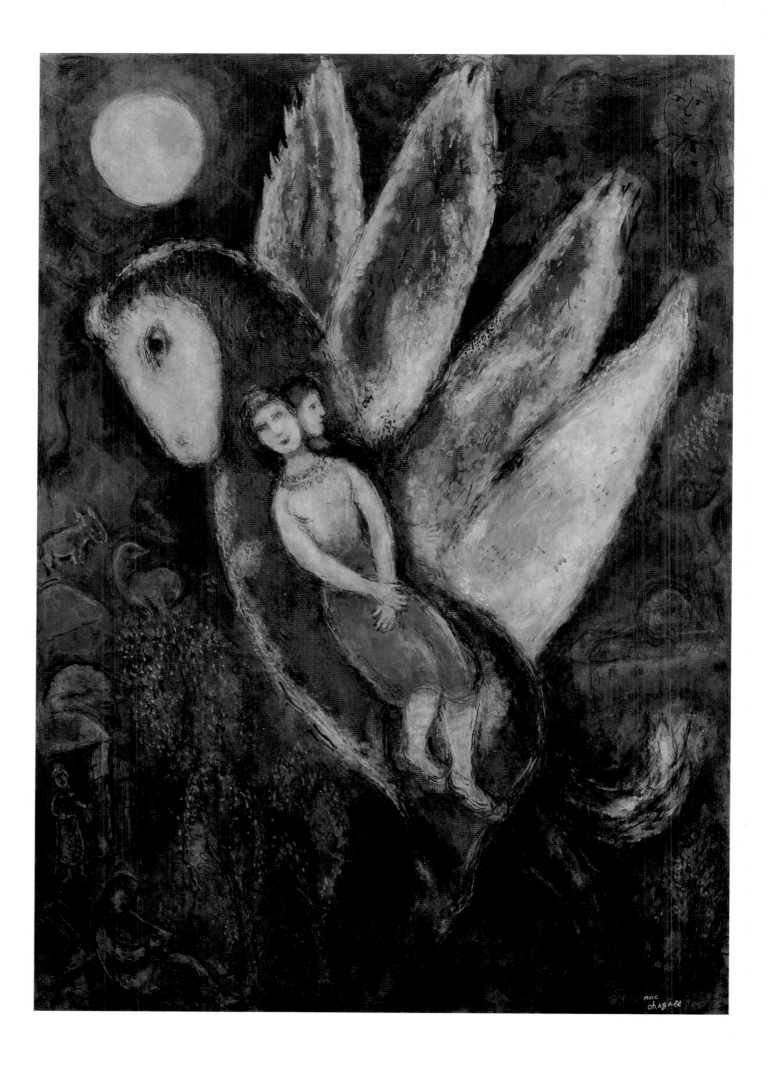

Graphic art, tapestries, mosaics

"Loving art is life itself."

Chagall's long and distinguished career as a graphic artist began in 1922 in Berlin, where he stopped off on his way from Russia to Paris. He was warmly welcomed there, because in Berlin his paintings were already known and admired. It was through meeting the German dealer and publisher Paul Cassirer that the artist first came to the world of graphics. Cassirer wanted to publish Chagall's autobiography *My Life* with illustrations by the artist, and he commissioned Chagall to produce a portfolio of 20 engravings (1922, ill. pp. 219-220). Having no experience in this field, Chagall sought the aid of Hermann Struck, a brilliant German engraver of Jewish origins, who introduced him to the technique.

Engraving – the term refers to both the technique as well as the finished printed product – involves cutting a design into metal or wood. The intaglio metal engraving and printing technique used by Chagall was the most common reproductive printing medium used in Germany from the 16th to the 19th centuries. For Chagall, who until then had only worked with the mediums of painting and drawing, engraving was a revelation. In no time, combining the etching and drypoint processes, he produced 20 engravings, which depicted scenes and figures from his youth in Vitebsk – his father and mother, his uncle sitting on the roof, his father's grave, and his home. The works were printed in 1923 in an edition of 110 copies. At about the same time he created an engraving based on his painting *The Promenade*, in which he is holding his wife Bella floating in the air with one arm. This work was published by the State Bauhaus in Weimar. From the outset Chagall, who was known for his rich colours, showed astonishing skill in this black and white medium, quickly becoming a master engraver. He had written in *My Life*: "I am sure that Rembrandt loves me", and undoubtedly he wanted to emulate this great engraver.

Cassirer's original plan, to publish an edition of *My Life* illustrated with engravings, could not be realized because translating the nostalgic, poetic and humorous text from the Russian proved problematic. Chagall had finished writing the book in Moscow in 1922, but it was not until 1931 that it finally appeared. It was published in Paris by Librairie Stock in a French translation by Bella and included 32 drawings from the artist's youth. A later edition was expanded to include 14 reproductions of engravings. Subsequently translated into many languages, the book is dedicated to his parents, his wife (Bella) and his native town.

In Berlin Chagall also met the Jewish artist Joseph Budko, who was known for his woodcuts and lithographs. Through him Chagall discovered the art of lithography, which he later in Paris brought to new heights. Invented in 1798 in Munich by Aloys Senefelder (1771–1834), lithography is a method of surface printing in which the artist draws directly on a stone or zinc plate with an oily lithographic crayon, not engraving or etching the surface as in intaglio printing. Some early

Father (Plate 1 from the Portfolio of Chagall's autobiography *My Life*), 1922
Etching and dry point, 27.8 x 21.8 cm
Private collection

PAGE 218:
Julnar the Sea-Born and her Son King Badr Bâsim of Persia (Illustration for the *Arabian Nights*), 1945–46 (1948)
Lithograph, 92 x 73 cm
New York, Collection Jacob Baal-Teshuva

Grandmother (Plate 4 from the Portfolio of Chagall's autobiography *My Life*), 1922
Etching and dry point, 20.9 x 16 cm
Private collection

The Talmud Teacher (Plate 9 from the Portfolio of Chagall's autobiography *My Life*), 1922
Etching and dry point, 24.6 x 18.8 cm
Private Collection

masters of lithography were Delacroix, Daumier and Géricault, followed by Manet, Degas, Redon, Bonnard, Picasso and Whistler. After he had settled in Paris in 1923 and had mastered a variety of graphic techniques, Chagall produced until the end of his life innumerable engravings, drypoints, aquatints, lithographs and printed graphics in other mediums.

Book illustrations

Chagall, who as a Jew belonged to the 'people of the book', loved books and had a great respect for learning. He grew up with the Bible and prayer book. Later he incorporated Hebrew words into his drawings, gouaches and oil paintings. His love of literature brought him various important commissions. Altogether he illustrated for writers, poets, art historians and critics with whom he was befriended 114 books and catalogues, using diverse graphic techniques. The first book illustrated by Chagall with original graphics was Marcel Arland's *Maternité* (Maternity), published in 1926 in an edition of 960 copies and containing five etchings by Chagall. The same year *Les sept péchés capitaux* ('The Seven Deadly Sins') appeared in an edition of 300 copies, with texts by among others Jean Giraudoux, Paul Morand, Max Jacob and André Salmon, and 15 etchings by Chagall. All the subjects of the artist's canvases crop up in the graphic work of this period.

Chagall's first major commission in this field came from Ambroise Vollard, the renowned publisher and art dealer, who handled Cézanne, Gauguin and Renoir. Vollard asked him to illustrate Nikolai Gogol's *Dead Souls*. The publisher, who in 1937 brought out Picasso's *Suite Vollard*, could not have made a better choice than the Russian artist for the job. Chagall knew how to recreate the world of rural Russia with sensitivity and wit, originality and mordant humour. His etchings capture the spirit of Gogol's text, enriching it with elements from his own world of poetry, imagination and Russian folklore. The etchings are based on gouaches, which delighted Vollard. However, the publisher did not live to see the completion of the project, as he died in 1939. The etchings were finally brought out in 1948 in Paris by the publisher Tériade, after Chagall had completed all eleven for the vignettes. The two-volume work appeared in an edition of 368 copies, 40 of which were hand-coloured by the artist.

La Fontaine's fables

In 1927 Vollard entrusted Chagall with a second, much more ambitious commission, to illustrate the *Fables* of Jean de la Fontaine (ill. pp. 222, 223). The fables, with their fantasy, poetry and irony, embodied the French 'esprit' and were considered *the* classic work of French literature, a national treasure *par excellence*. They had already in the past been illustrated by a number of French artists, but in Vollard's opinion none of these illustrators had adequately captured the spirit of the fables.

Between 1924 and 1928 Chagall discovered Brittany, L'Isle-Adam on the Oise (ill. p. 120), the Côte d'Azur, the Auvergne, the Alps, and the Pyrenees, incorporating impressions of all these landscapes into his art. In Chambon-sur-Lac in the Auvergne in 1926 he produced in rapid succession 31 gouaches for the *Fables*, following this up the year after with another 69. The attempt to translate the gouaches into colour illustrations proved unsatisfactory, and so in the end Chagall made the etchings for La Fontaine himself, concentrating on the work in Céret in the Pyrenees in 1928. In 1930 Bernheim-Jeune, one of the most prestigious galleries in Paris, exhibited the gouaches, after which they were also shown in Brussels and Berlin, the artist himself attending the Berlin vernissage. After this tour the gouaches became famous, but were scattered all over the world, never more to be seen as a coherent group. The gallery bought them for 4000 francs a piece and sold them all. When the Céret Museum of Modern Art wanted to mount an exhibition

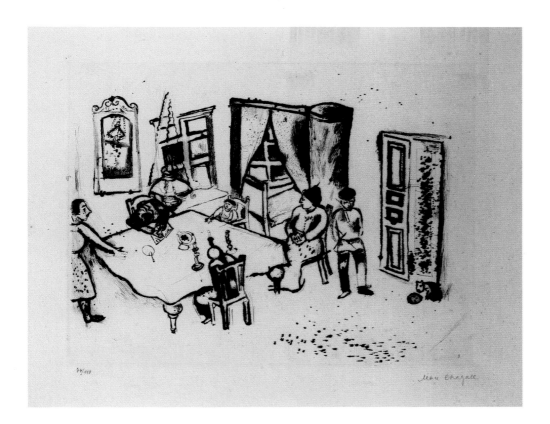

Dining Room (Plate 10 from the Portfolio of Chagall's autobiographie *My Life*), 1922
Etching and dry point, 27.6 x 21.7 cm
Private collection

of the gouaches to commemorate the 300th anniversary of La Fontaine's death, only 29 of them could be shown because the whereabouts of the other 71 was unknown. The exhibition, which the French newspaper *Le Figaro* described as a "ballet of colours", was also presented in 1966 at the Musée National Message Biblique Marc Chagall in Nice.

Vollard had wanted to bring out an illustrated edition of La Fontaine's *Fables* ever since he had started publishing. Explaining his choice of Chagall as the illustrator, he said: "[…] in my opinion the only person who could do such work is a painter with vitality, with creative talent, and brimming with ideas. […] Chagall enabled me finally to achieve this long-cherished aim. […] Precisely him because his aesthetic seems to me to be close, in a sense related, to La Fontaine's – at once sturdy and subtle, realistic and fantastic." Vollard's choice of Chagall ran into bitter opposition. In letters to the editors of in several newspapers and art magazines reactionary voices expressed outrage that La Fontaine, "part of our national heritage", should be illustrated by a Russian, a Jew and a foreigner. The matter even came to be hotly debated in the National Assembly. Deputies made protest speeches, one even calling Chagall "the sign painter from Vitebsk". The attacks on the artist were sarcastic, vicious and anti-Semitic. On 15 December 1927 the art critic Jacques Genne wrote in *L'Art Vivant*: "To have a quintessentially French poet illustrated by a Russian, by Chagall, what a sacrilege!" Even the French painter Georges Rouault laid into him vociferously and maliciously.

At the Easel, 1922
Etching and dry point, 24.7 x 19 cm
Private collection

Vollard, however, was not to be intimidated, defending his decision in an article published on 8 January 1929 in *L'Intrasigeant*, a liberal evening paper. Entitling his counterblast 'I publish La Fontaine's fables and I choose Chagall as illustrator', he said: "The specifically oriental quality of the sources of this fabulist – Aesop and the storytellers of India, Persia, Arabia, even China, from whom he borrowed not just the themes, but also sometimes the names and the atmosphere of his recreations – made me think that an artist whose providence has made him familiar with the magic of the Orient would be the very person to produce sensitive illustrations."

It was only in 1952 that the large-format two-volume book was published – again by Tériade – in a limited edition of 200 copies, of which 85 contain hand-coloured etchings. Again, the etchings for La Fontaine's *Fables* demonstrated

Frontispiece to the *Fables* of La Fontaine, 1952
Etching and dry point, 38.5 x 28.3 cm
Private collection

Chagall's vision and mastery, and were a resounding success. In his Chagall monograph Franz Meyer, the artist's former son-in-law and one of the most respected authorities on Chagall's life and work, writes about the gouaches for the *Fables:* "The vibrations of the painterly medium translate both the insistent power of the plant world and the great quiet strength of the animal world."

Bible illustrations

Even before the final etchings for La Fontaine's *Fables* were finished, Vollard asked Chagall to carry out his third, last and most demanding commission: illustrations for the Bible (ill. pp. 224–225). Chagall accepted the commission enthusiastically and resolved to this end to visit the Holy Land. When he informed Vollard about his plan, Vollard responded laconically: "Go to the Place Pigalle", an irreverent remark that took the artist aback.

Chagall sums up his profound love for the Bible as follows: "Since my earliest childhood I have been captivated by the Bible. It has always seemed to me the greatest source of poetry of all time. Ever since then I have sought its reflection in

life and art. The Bible is like an echo of nature, and this is the secret I have tried to convey."

This decision of Vollard's also met with widespread opposition. Maurice Raynal, who was in charge of the arts section of the French newspaper *L'Intransigeant*, solicited and published opinions on the project. Rouault, who was well-known for his rendition of Biblical subjects in his paintings and engravings, and who had vehemently opposed the idea of Chagall illustrating La Fontaine's *Fables*, commented spitefully: "Chagall is going to do his dance in front of the Wailing Wall." Years later, in 1962, Chagall reacted to Rouault's remark in an interview with Carlton Lake for the *Atlantic Magazine*: "That's typical of Rouault, a great artist perhaps, but a pain in the neck. [...] In our bodies there are good microbes and bad ones. The good ones fight against the bad, defending our bodies against them. And it is no different in life. There are people who are against you, jealous of you, who struggle by every means, sometimes in an underhand way, sometimes openly. Rouault was just one of many microbes who have wanted to harm me. Such microbes can knock you flat if you don't have any good microbes to protect you." Chagall never forgot or forgave the obnoxious machinations of artists such as Malevitch, Lissitzky and Rouault, but, as the saying goes, 'the dogs bark and the caravan moves on'. His whole life long Chagall unwaveringly pursued his goal no matter what obstacles were put in his path.

From February to April 1931 Chagall travelled with his wife Bella and his young daughter Ida to the Holy Land. Early in 1932 he produced 32 printing plates, and by 1939, when Vollard died, he had completed 66. Meanwhile the war and his stay in America intervened, and it was not until 1952 that he resumed work on the etchings. By 1956 he had completed altogether 105 etchings, which were published the same year by Tériade (ill. pp. 224, 225). They appeared in a two-volume edition of 275 copies. The 105 sheets were also published hand-coloured in a portfolio limited to 100 copies. To celebrate the appearance of the Bible etchings, Tériade devoted to Chagall a special double issue of his art magazine *Verve*, one part for the Bible etchings, and the other for the Bible drawings. Besides reproductions of all 105 etchings, this double issue contained altogether 30 lithographs specially created for the publication.

Throughout his long and productive life Chagall produced hundreds of etch-

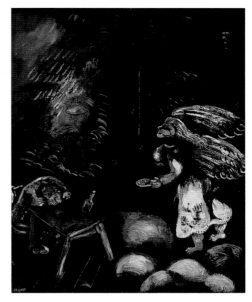

The Drunkard with his Wife
(Illustration for the *Fables* of La Fontaine),
1926–27
Gouache on black paper, 51.3 x 40.8 cm
Private collection
Courtesy Galerie Rosengart, Luzerne

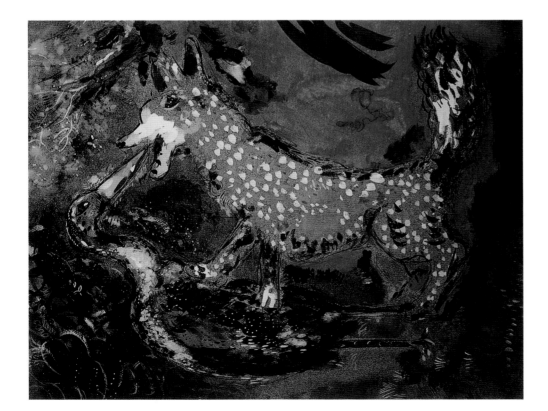

The Fox and the Stork
(Illustration for the *Fables* of La Fontaine),
1916–1927
Gouache on paper, 50.5 x 39 cm
Private collection

Rachel's Tomb (Plate 17 from the Bible Series, published in 1956 [Genesis 35, 19–20])
Etching and dry point, 30.7 x 22.8 cm
Private collection

ings. Besides the series already discussed, the following also deserve a mention: 24 aquatints for Louis Aragon's book of poems *Celui qui dit les choses sans rien dire*, published in 1976 by Adrien Maeght; 15 etchings for André Malraux's text *Et sur la terre*, which appeared a year later with the same publishing house; and 30 aquatints, dating from 1979, illustrating the psalms of David. In 1970 the art dealer and Chagall collector Eberhard W. Kornfeld in Berne brought out the first volume of a projected three-volume catalogue raisonné of the artist's etchings, covering the important early period from 1922 to 1966. The second volume was planned to cover the etchings for Gogol's *Dead Souls*, La Fontaine's *Fables* and the Bible, and the third was to be devoted to Chagall's copper engravings and wood cuts. Unfortunately, the latter two volumes never appeared.

Lithographs

Another great body of Chagall's graphic works comprising 1100 or so lithographs, were listed and for the most part reproduced in colour in a six-volume catalogue raisonné, the first volume being published in 1960 by the famous Parisian printers Fernand Mourlot and Julien Cain. The artist said of his lithographs:"It seems to me that something would have been lacking in my art if, besides my painting, I had not also produced etchings and lithographs. […] When I held in my hand a lithographic stone or copper plate, I believed I was touching a talisman. It seemed to me that I could entrust them with all my joys, all my sorrows, […] everything that over the years passed through my life, births, deaths, marriages, flowers, animals, birds, poor working people, my parents, lovers at night, the prophets from the Bible […]." And elsewhere: "I feel the difference between lithography, engraving and drawing when I work with the different tools and materials. It is possible to draw well, and yet not possess in one's fingers the lithographic touch, […] each line should emanate a particular spiritual quality that has nothing in common with either know-how or knack." Most of Chagall's lithographs repeat the subjects of his paintings, gouaches and drawings. Among his lithographic masterpieces are the 13 colour lithographs based on *Tales from the Arabian Nights*, which were commissioned by the publisher Kurt Wolff (a friends of Claire Goll) and published in 1948

Abraham Weeping for Sarah
(Plate 11 from the Bible Series, published in 1956 [Genesis 23, 1–2])
Etching and dry point, c. 30.4 x 22.8 cm
New York, The Museum of Modern Art

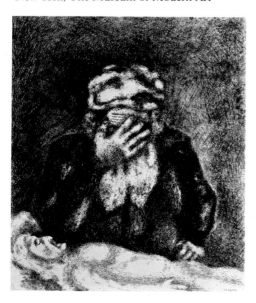

The Crossing of the Red Sea
(Plate 34 from the Bible Series,
published in 1956 [Exodus 14, 19–25])
Lithograph, c. 30.4 x 22. 8 cm
Private collection

LEFT:
Rebecca at the Well
(Plate 12 from the Bible Series,
published in 1956 [Genesis 24, 10–14])
Etching and dry point, 30.4 x 22.8 cm
Private collection

RIGHT:
Moses and Aaron Confronting Pharaoh
(Plate 30 from the Bible Series,
published in 1956, Exodus 5, 1–4)
Lithograph, c. 45.7 x 33 cm
Private collection

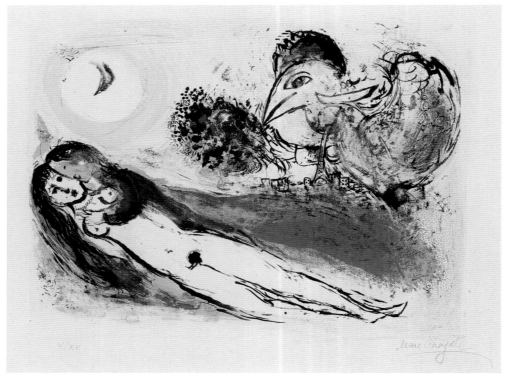

TOP:
The Rider, 1956
Colour lithograph, 35 x 53 cm
Private collection

LEFT:
Bonjour over Paris, 1952
Colour Lithograph, 47 x 54.5 cm
Private collection

in New York by Pantheon Books in an edition of 111 copies (ill. pp. 218, 227). The essence and spirit of the oriental stories is successfully captured by the richness of Chagall's colours and his fertile imagination.

Chagall made many beautiful lithographs for *Derrière le Miroir* (Behind the Mirror), a magazine published by his dealer Aimé Maeght. In 1954 a special issue of the magazine served as a catalogue for an exhibition of the artist's *Paris* series.

One of Chagall's brilliant achievements in the field of printed graphics is his set of 42 colour lithographs for *Daphnis and Chloë*, a work commissioned by Tériade (1959-61, ill. p. 229). Before producing them, Chagall wanted to see Greece with his own eyes, and so in 1952, soon after his marriage to his second wife Vava, he went with her to Athens and Delphi, staying briefly on the island of Poros. The journey provided him with the inspiration he needed, and upon returning he made the first drafts for the lithographs, which were finally published by Tériade in 1961 in a limited edition of 270 copies, of which only 60 were signed by the artist. Sixteen of the 42 lithographs were double-page (42 x 64 cm). The *Daphnis and Chloë* lithographs are especially prized by Chagall collectors and, accordingly, are very expensive.

Working on an Ambroise Vollard commission, Chagall had produced 19 *Circus* gouaches as early as 1927, but it was to be another 30 years before Tériade published the portfolio *The Circus*, containing 23 colour and 15 black and white lithographs, in an edition of 250 signed copies. The works express Chagall's love of the circus in all its glorious colour and drama.

In 1966 Léon Amiel published *The Story of Exodus* with 24 colour lithographs (ill. p. 225). With these illustrations of the second Book of Moses Chagall returned to a favourite subject of his, the Bible. A year later, in 1967, the publisher A. C. Mazo brought out *Sur la terre des Dieux* ('Land of the Gods'), containing 12 coloured lithographs based on Greek mythological subjects. The indefatigable

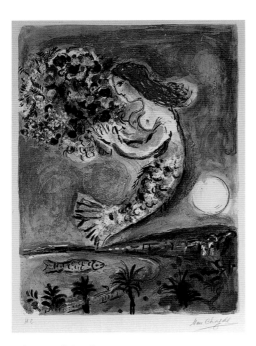

The Bay of Angels, 1962
Colour lithograph, 57 x 78 cm
Private collection

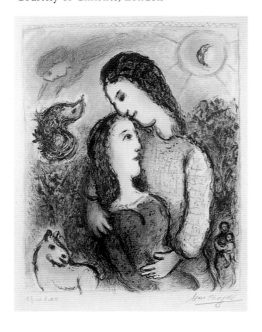

The Offering, 1945
Hand-coloured etching, 25 x 18.6 cm
Courtesy of Christies, London

Chagall also illustrated Homer's *Odyssey* with a total of 82 colour and black-and-white lithographs. The first of the two *Odyssey* volumes, both of which were published by Fernand Mourlot in a limited edition of 270 copies, appeared in 1974, the second coming out in 1975. Even Shakespeare was illustrated by Chagall. On the subject of *The Tempest* he produced 50 black-and-white lithographs, which were also published in a limited edition of 270 copies, this time by Sauret in 1976. A delightful custom of the artist's was to send New Year's cards to his friends and associates in the form of small colour lithographs.

It is not possible to speak about Chagall's lithographic output without mentioning his collaborator Charles Sorlier (ill. p. 227). The artist got to know Sorlier in 1950, when he was working in the studio of the famous printer Fernand Mourlot in Paris. From that time on Sorlier was involved in the production of all Chagall's lithographs, even working with him on a lithograph in Saint-Paul-de-Vence on the day the artist died. Symbolically, the subject of this last work is a painter at his easel who has laid down his palette (ill. p. 270). Because Chagall died on the evening of that day, the edition of the lithograph was never signed, and bears only the artist's stamp.

Sorlier was an expert in the field of lithography, who knew how to solve every kind of technical problem. Chagall was very fond of him, treating him like a son. Before he met Sorlier, Chagall – whose 'trademark' was colour – had confined himself to linear, very precisely drawn, black-and-white lithographs and etchings. The colour that characterizes his graphic work from 1950 could not have been achieved without the expertise of Charles Sorlier, who prepared the stones, later replacing the limestone plates with copper ones and developing new techniques. Some art historians believe that Chagall's work on his colour lithographs had an influence on his oils, gouaches and even his famous stained-glass windows with their luminous and striking colours. The lasting success of his 42 lithographs on *Daphnis and Chloë* is in great part due to the unrivalled skills of Charles Sorlier. Chagall rewarded him with paintings, gouaches and a multitude of colour drawings in the many books and albums which they had worked on together.

In 1989 *Chagall, Le Patron*, Charles Sorlier's biography of the artist, appeared, and in his recollections *Mémoirs d'un homme de couleurs* many pages are devoted to Chagall. After Sorlier's death in 1989 a Parisian gallery exhibited 124 items from his estate under the title *Chagall et le livre* (Chagall and the Book). Most of these books were illustrated with colour drawings retrospectively. Franz Meyer has also emphasized the fruitful collaboration of Chagall and Sorlier in his major study of the artist, published in 1961. For him Chagall's lithographs are a "stream carrying the message of his paintings to the world at large".

Since Chagall lithographs were in great demand, commanding high prices at galleries and auctions, the art market became inundated with fakes. The catalogue raisonné of his original lithographs contains black-and-white reproductions of some 100 fake lithographs with fake signatures.

The tapestries

Chagall's venture into tapestries, another aspect of his all-round œuvre, began in the early 60s. When he visited Jerusalem in February 1962 to attend the inauguration of his twelve stained-glass windows for the synagogue of the Hadassah University Medical Centre (ill. pp. 246, 247), he was asked by Kadish Luz, speaker of the Israeli parliament, to decorate the state reception hall of the new Knesset or Israeli Parliament, which was then under construction. Initially stained-glass windows and then a large mural were proposed, but in the summer of 1963 Chagall decided that tapestries would best suit the large well-lit hall. The subject suggested to him was the history of the Jewish people, from their return to Zion up to the creation of the state of Israel (ill. pp. 232, 233). Chagall accepted the idea with enthusiasm and started work on the cartoon (the preparatory drawing – in this case gouache – which serves as the model for the tapestry weavers). This cartoon was given late

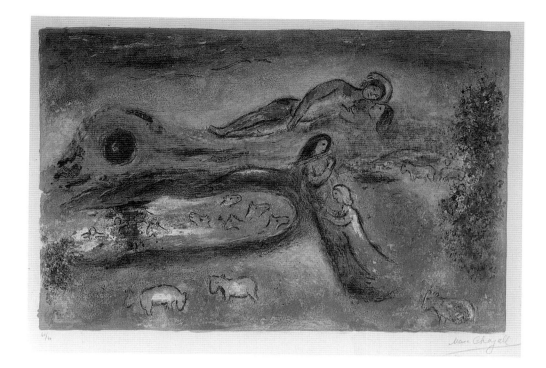

Death of Dorcon (Daphnis and Chloë),
1959–1961
Colour lithograph, 31.9 x 46.8 cm
Private collection

"It seems to me that something would have been lacking if, in addition to colour, I had not, at some stage in my life, worked at engravings and lithography [...]. Holding a lithographic stone or a copper plate in my hand, I believed I was touching a talisman. It seemed to me that I could entrust them with all my joys, all my sorrows. [...] everything that has crossed my path, throughout the years: births, deaths, marriages, flowers, animals, birds, poor working people, my parents, lovers at night, the prophets from the Bible – on the street, in my home, in the temple or in the sky – and, as I grow older, the tragedy of life that is inside us and all about us."

MARC CHAGALL

Daphnis and Gnathon (Daphnis and Chloë), 1959–1961
Colour lithograph, 42.4 x 32.2 cm
Private collection

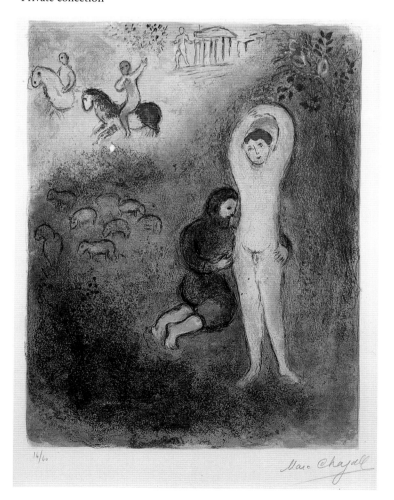

Summer's Season (Daphnis and Chloë), 1959–1961
Colour lithograph, 42.4 x 32.2 cm
Private collection

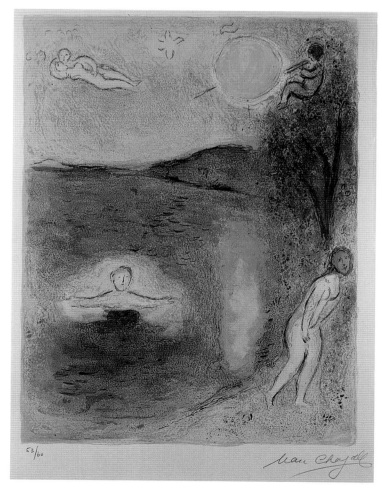

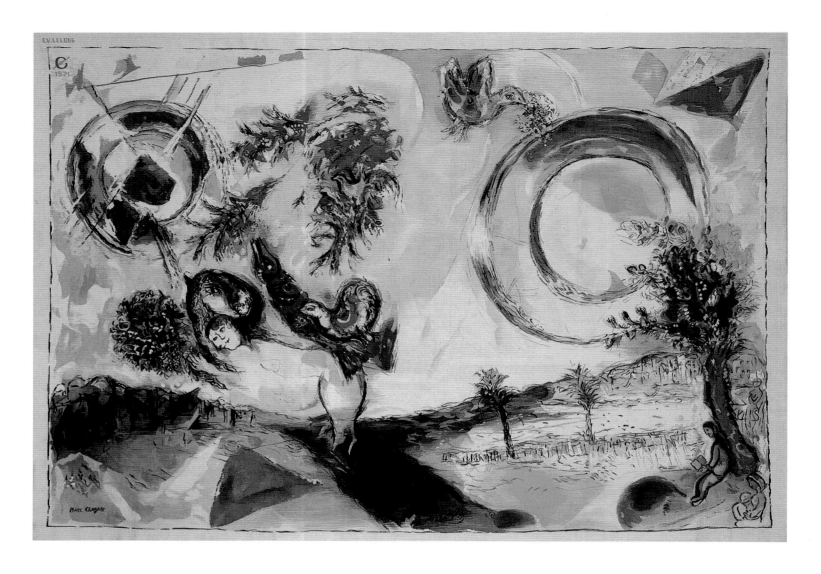

Tapestry in the entrance of the Musée National
Message Biblique Marc Chagall, Nice, c. 1974
Wool, manufactured at the Gobelin Tapestry
Factory, Paris, 226 x 322 cm
Nice, Musée National Message Biblique
Marc Chagall

November 1963 to the famous Parisian tapestry firm Manufacture Nationale des
Gobelins, founded by Louis XIV in 1667. After a further trip to Israel in the
summer of 1964 Chagall finished two more cartoons.

It was estimated that it would take four years to complete the tapestries. 160
different colour shades were needed to translate Chagall's gouaches into tapestries,
and 68 kilometres of thread were used to weave the three tapestries. The 120 cm-
high cartoons had to be enlarged almost four times in order to reach the height of
the tapestries – 475 centimetres. Chagall, who at the time was living in Vence in
the South of France, came frequently to Paris to watch the work in progress and to
discuss with the weavers problems as they arose. Begun in 1965, work on the three
tapestries was completed early 1968, a year ahead of schedule. The triptych consists
of one large and two smaller tapestries, all of the same height which hang in a row.
The large tapestry is 9.5 metres wide, the two smaller ones 5.5 metres wide each.
The subject of the large, centrally placed tapestry is the *Exodus* (ill. p. 232), that of
the smaller one to the right-hand side *Isaiah's Prophecy* (ill. p. 233), and that of
the smaller one to the left *Entry into Jerusalem* (ill. p. 232). *Isaiah's Prophecy* deals
with the national and historic vision. *Exodus* depicts the handing over of the tablets
of the Law to Moses and the suffering throughout history of the Jewish people.
Entry into Jerusalem shows the triumphal entry of King David into the holy Zion
and the return of the Jewish people to their ancestral homeland. With its power-
ful imagery, the triptych represents a great triumph, proof of the successful
collaboration between the painter and the weavers, who knew how to render faith-
fully the blues, greens, reds, golden yellows, browns, purples and whites of the
cartoons.

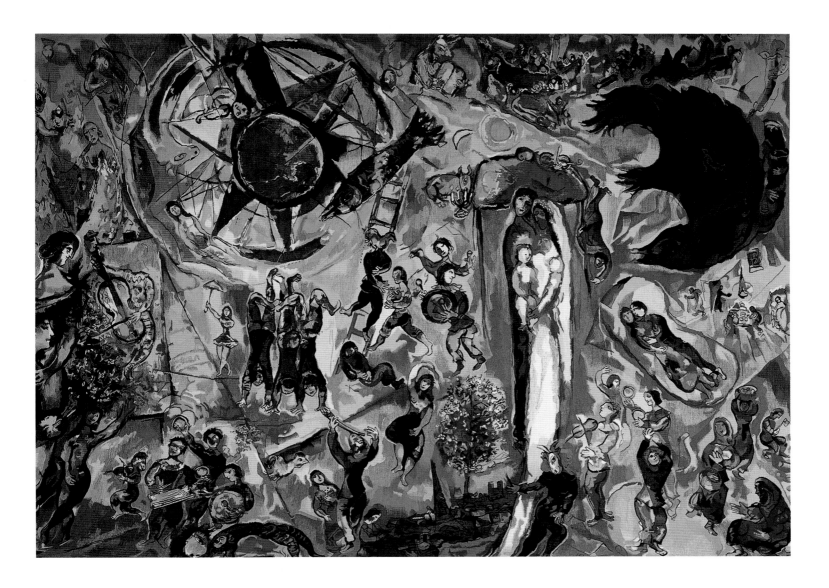

Life, c. 1990
Tapestry, manufactured by master-craftswoman
Yvette Cauquil-Prince, 361 x 485 cm
Private collection
Courtesy Yvette Cauquil-Prince, Paris

The three tapestries are marked with the date of their completion and are signed by the artist and the weavers involved. They were unveiled on 18 June 1969 in the presence of the artist at a ceremony attended by the then Israeli president, Salman Shazar, prime minister Golda Meir, and the Knesset speaker (ill. p. 233). In a speech Chagall said of his work, which was inspired by the founding of the state of Israel, that it represented a kindling of "new hope" and that into it had gone "the experience, suffering and joy of an entire life". "That which is found on every page of the Bible is also found here, floating in the air, above the fields and in the hearts and souls of the people who inhabit the country." Once again Chagall had demonstrated that at a first attempt he could master an art he had never tried before. The acclaim with which his first three tapestries were greeted encouraged him to produce more.

In 1964 Chagall met Yvette Cauquil-Prince, a Belgian-born master craftswoman of tapestry weaving who had realized the tapestry designs of a number of important 20th-century artists. She was herself a painter and had studied 1st and 2nd-century Coptic tapestry art as well as French and Flemish gobelins from the 13th to 15th centuries. She had opened her first weaving studio in 1959, and since 1967 had been producing tapestries from watercolours and other models supplied by Picasso, Braque, Léger, Max Ernst, Calder, Kandinsky, Klee, Matta and Henry Miller. She hired highly specialized weavers, and created a new technique whereby, on the basis of the cartoons, submitted designs could be worked out that were the same size as the projected tapestry.

Chagall was very taken by the quality of her work, and from then on had his tapestry designs executed in her studio. From existing lithographs, gouaches and

In the early 1960s Chagall met an expert in tapestry weaving, Yvette Cauquil-Prince, and ventured into the field of tapestries. He was deeply impressed by her work and so they began to collaborate. Over the course of the years, Yvette Cauquil-Prince created a number of tapestries in various sizes from Chagall's designs, many first appearing after his death. Chagall normally selected subjects he had already used in lithographs and gouaches. Some of his tapestries, including the one for his museum in Nice (ill. p. 230) and the three splendid designs for the Knesset (the Israeli parliament) (ill. pp. 232, 233) were produced at the famous "Manufacture Nationale des Gobelins" in Paris.

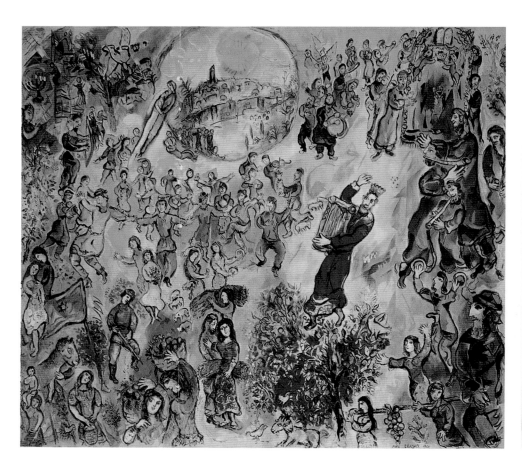

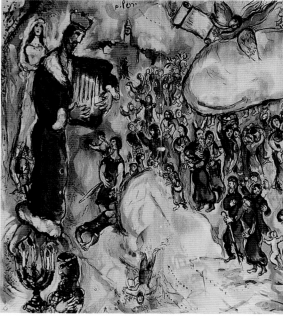

other media she made 24 highly acclaimed tapestries on Biblical themes, the circus, and other Chagall subjects. Her 25th Chagall tapestry is currently nearing completion. Her largest tapestry for the artist, *Peace*, which measures almost 33 square metres, was made for the Chapelle des Cordeliers in the Lorraine town of Sarrebourg in France, where it was unveiled on 22 June 1993. The subject of the tapestry is the same as the stained-glass window that Chagall did for the United Nations in New York (ill. p. 245). The large tapestry produced by Yvette Cauquil-Prince is a masterly and stunningly effective translation of Chagall's work into the demanding medium of tapestry. Her tapestry *Job* can be seen in Chicago, while that depicting the prophet Jeremiah now hangs in Milwaukee, Wisconsin.

Yvette Cauquil-Prince's tapestries to designs by Chagall and other artists have been exhibited all over the world, from Finland to Japan, from the USA to Latin America. As François Mathey, the curator of the Musée des Arts Décoratifs in Paris, once said: "The true validity of a work of art is demonstrated when it is translated into a tapestry. Its projection and magnification to startling dimensions proves its physical existence, while at the same time not denying the textural or spiritual form of the artwork." And Jean-Louis Prat, the director of the Maeght Foundation in Saint-Paul-de-Vence observed that: "The tapestry universe conveyed by Yvette Cauquil-Prince takes on another meaning; it is a new creation, another aspect of the work, its natural continuation. Nothing is identical with the original; everything is different and complementary, for tapestry demands different lines of force, necessitating a creative autonomy: the autonomy of the tapestry master-craftswoman."

The mosaics

Mosaics, the art of making designs and patterns out of small fragments of glass, marble set in cement or plaster, was developed by the Greeks and Romans to decorate floors and walls. The colour fragments used were irregular and uneven in

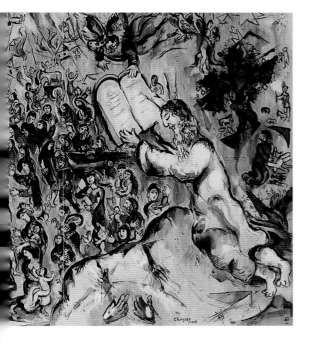

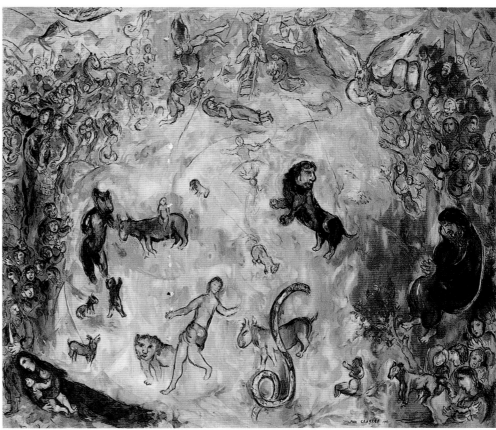

shape. In Byzantine and mediaeval art, mosaics are found not only on floors and internal walls, but also on church façades. Mosaics have been used to decorate churches right into the 20th century.

Chagall loved mosaics, taking a keen interest in mediaeval and Byzantine art. After getting to know the renowned mosaicist Lino Melano and his work in the early sixties, he decided to try to translate his pictorial ideas into this medium with the aid of Melano and his wife. Since that time over 20 mosaics based on Chagall designs have been produced for public and private patrons in Europe, Israel and the United States. Supplementing the three tapestries mentioned earlier, a wall mosaic measuring 3 x 2.85 metres and twelve floor mosaics also adorn the reception hall (known as the 'Chagall Hall') of the Knesset, the Israeli parliament in Jerusalem (ill. p. 240). Chagall took the decision to harmoniously incorporate twelve mosaic segments with brown, orange, beige and warm grey earth tones in the hall's brown and grey marble floor in July 1964. In his preparatory drawings he depicted a menorah, birds, animals, flowers and musical instruments. When the cartoon was finally worked out, it was entrusted to Lino Melano, his wife and their assistants, who went on to create a floor mosaic of the highest order – every bit as good as the mosaics of bygone centuries.

Revisiting Israel in December 1965, Chagall decided to create a wall mosaic that would both make the most of the strong Jerusalem sun and link up with his twelve floor mosaics and three huge tapestries. For the wall mosaic's subject he chose the image of the Wailing Wall, a menorah with burning candles, and an angel blowing a horn (ill. p. 240). When the Knesset building was inaugurated in August 1966, the mosaics were complete, but the tapestries were not ready to be unveiled until 18 June 1969.

Chagall's largest mosaic, *The Message of Ulysses* (1968, ill. p. 239), a colourful and truly monumental work measuring 3 x 11 metres, was commissioned by the law faculty of Nice University, where it was installed in 1968 in a wall 6 metres high and 24 metres long. Its dedicatory plaque reads: "I dedicate this mosaic to all students in the hope that their hearts are touched by the beauty of Homer's poem,

TOP RIGHT:
Isaiah's Prophecy, 1964–1967
Tapestry, manufactured by master-craftsman M.E. Meot at the Gobelin Tapestry Factory in Paris, 475 x 533 cm
Jerusalem, The Knesset

President Z. Shazar, Marc Chagall, Prime Minister Golda Meir at the inauguration of the Knesset Tapestries, June 1969

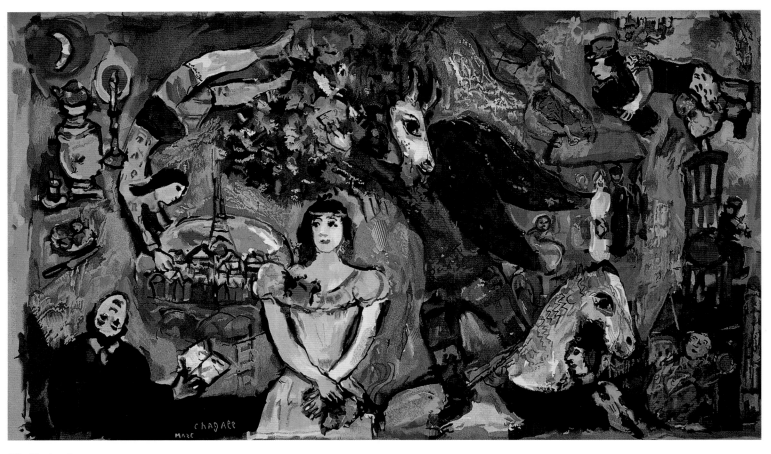

The Harlequins, 1993
Tapestry, manufactured by master-craftswoman
Yvette Cauquil-Prince, 317 x 527 cm
Private collection

The Big Circus, ca. 1993
Tapestry, manufactured by master-craftswoman
Yvette Cauquil-Prince, c. 300 x 600 cm
Private collection

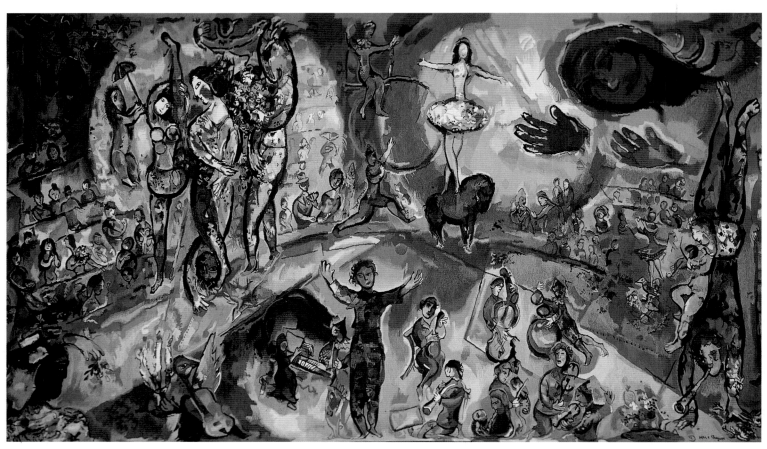

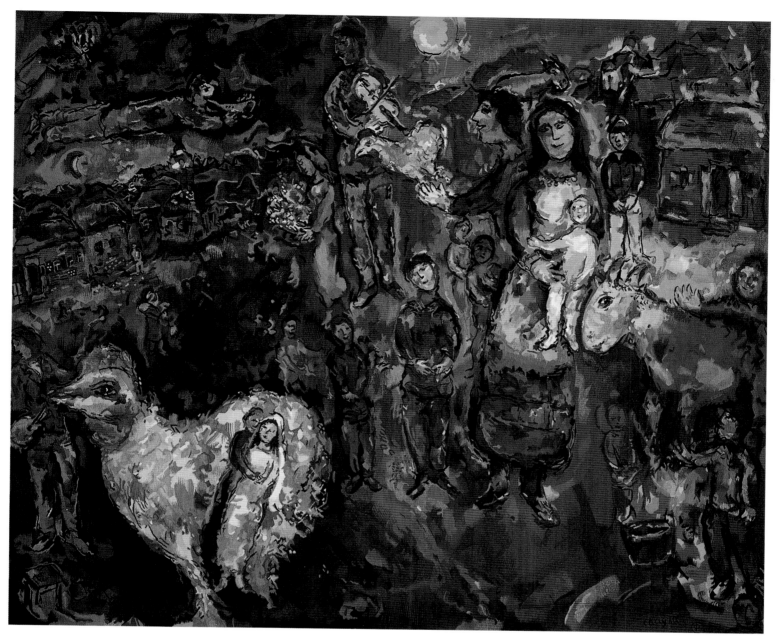

The Event, 1990
Tapestry, manufactured by master-craftswoman
Yvette Cauquil-Prince, 293 x 355 cm
Private collection

Chagall with Yvette Cauquil-Prince, c. 1966

Chagall in front of his mosaic
The Prophet Elijah, 1971
(Musée National Message Biblique
Marc Chagall, Nice) Cover of the magazine
XXᵉ Siècle (c. 1975)

the friendship which inspires this mosaic, and the sublime splendour of the Bible." The mosaic depicts ten mythological scenes reminiscent of Chagall's lithographs and *Daphnis and Chloë* ballet designs. As with all his other mosaics, Chagall first produced preparatory studies, which were then developed into a final colour cartoon, measuring 85 x 245 centimetres. This mosaic too was also executed by Lino Melano and his wife.

Chagall's first mosaic, *Les Amoureux* (The Lovers), was produced between 1964 and 1965 for the exterior wall of the Maeght Foundation library in Saint-Paul-de-Vence, the small town where Chagall lived from 1966 onwards and where he died in 1985. In 1967 Melano executed another mosaic there, outdoors at 'La Colline', Chagall's private villa (ill. p. 236). Saint-Paul-de-Vence boasts a further Chagall mosaic, on an interior wall of the local school. Two further Chagall mosaics are privately owned and not accessible to the public. One was done for a winter garden in Paris, while the other is in Washington D.C., in the home of Chagall's friend Professor Neff, who had organized lectures and an exhibition for the artist when the artist was in the United States during the Second World War. This latter mosaic is entitled *Orpheus.*

For the Musée National Message Biblique Marc Chagall in Nice Chagall designed a mosaic called *The Prophet Elijah* (1971, ill. pp. 236, 237). The only mosaic he did for a church was installed in 1976 in the Chapelle de Sainte Roseline at Les Arcs, in the department of Var. It is entitled *The Offering* and measures 6.65 x 5.70 metres. The only mosaic in the United States accessible to the public is *The Four Seasons* (1974, ill. p. 238), which was commissioned by the First National Bank of Chicago. The large mosaic was installed to much acclaim in the plaza in front of the bank building and handed over to the public in 1974 in the presence of the artist and his wife.

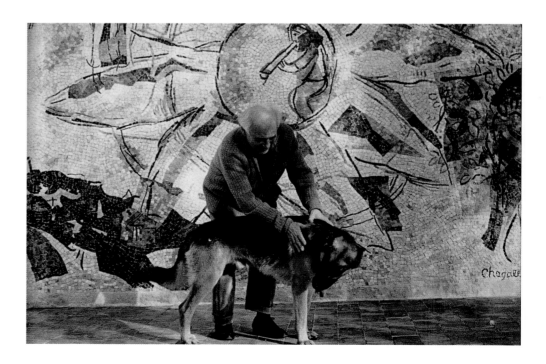

Chagall in front of the mosaic in his home
at Saint-Paul-de-Vence, c. 1975

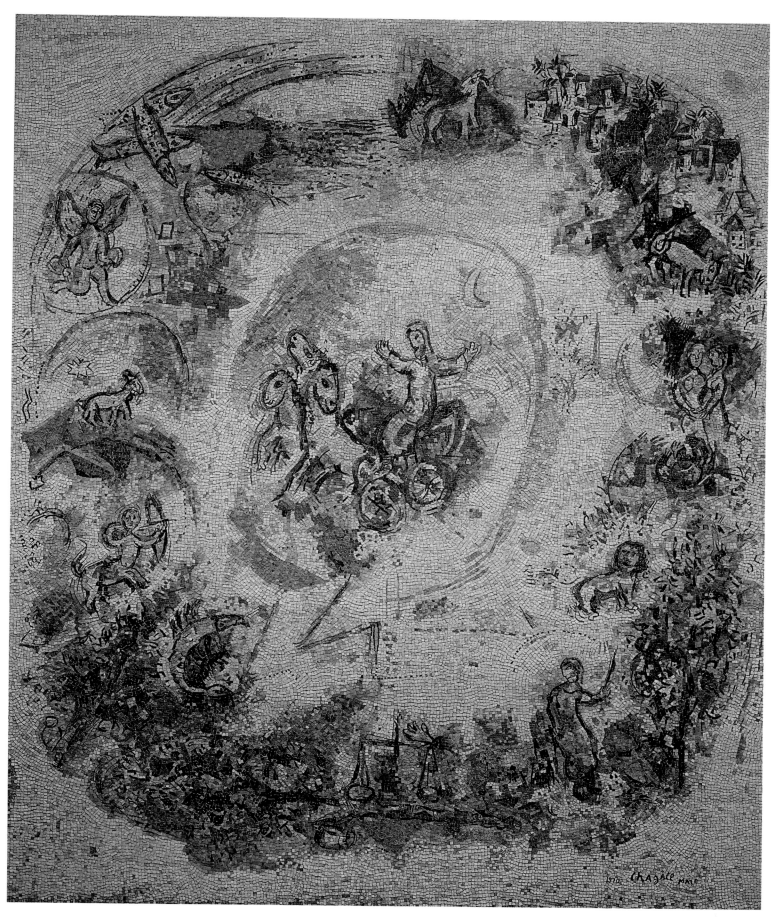

The Prophet Elijah, 1971
Mosaic, 715 x 570 cm
Nice, Musée National Message Biblique Marc Chagall

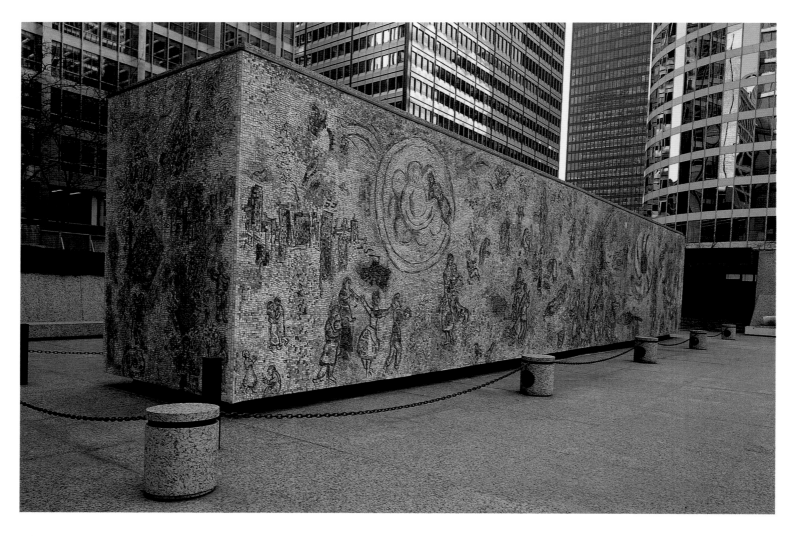

The Four Seasons, 1974
Ceramic Mosaic, 21 x 4.5 m
Chicago (IL), First National Bank of
Chicago Plaza

There was hardly any field of the plastic arts
at which Chagall did not try his hand and go
on to become a true master. One such field
was the century-old art of mosaics, which had
flourished in Roman times. Working with
specialised craftsmen, he produced more than
twenty mosaics for both public and private
patrons in Europe, Israel and the United States.
He also designed one for the Musée National
Message Biblique Marc Chagall in Nice.
Another three mosaics are in St Paul de Vence.
One in the Maeght Foundation, one in the
local school and one in his villa "La Colline".
He produced thirteen mosaics for the Knesset
in Jerusalem. His largest, *The Message of Ulysees*
(ill. p. 239), was made for the law faculty of the
University of Nice. This monumental work is
3 metres high and 11 metres long. *The Four
Seasons* is one of his last and most beautiful
mosaics. It was installed in the plaza in front of
the National City Bank of Chicago in 1974 to
great acclaim, in the presence of the artist.

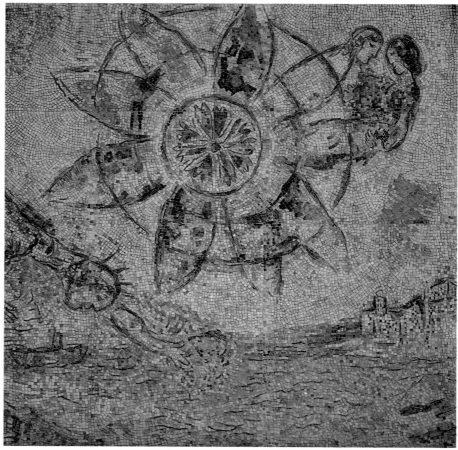

Detail of the Mosaic *The Four Seasons*, 1974

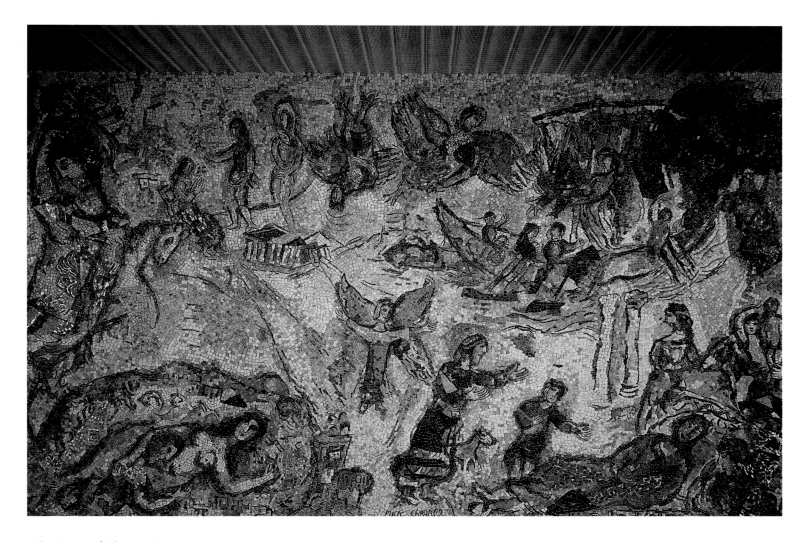

The Message of Ulysses, 1968
Mosaic, 300 x 1100 cm
Nice, Law Faculty of the Nice University

PAGE 240:
From Exile to Return, 1966
Detail of the wall mosaic depicting the
Wailing Wall and the menorah, designed for
the Israeli Knesset, 300 x 285 cm
Jerusalem, The Knesset

PAGE 241:
Moses saved from the Waters, 1979
Mosaic
Vence, Cathedral

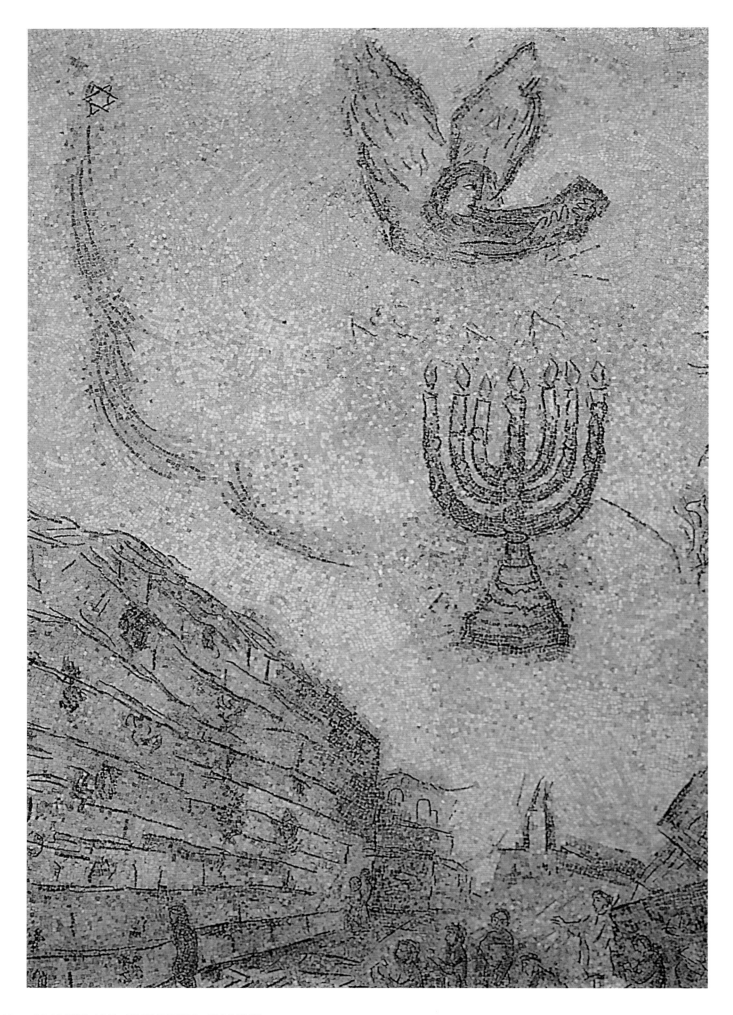

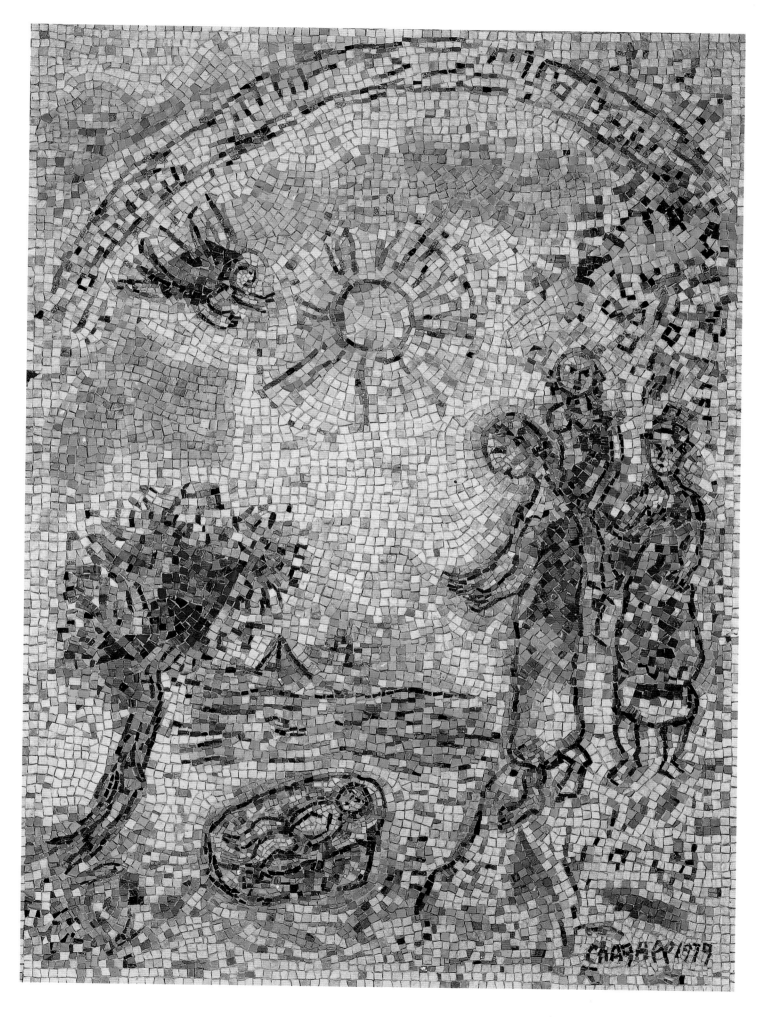

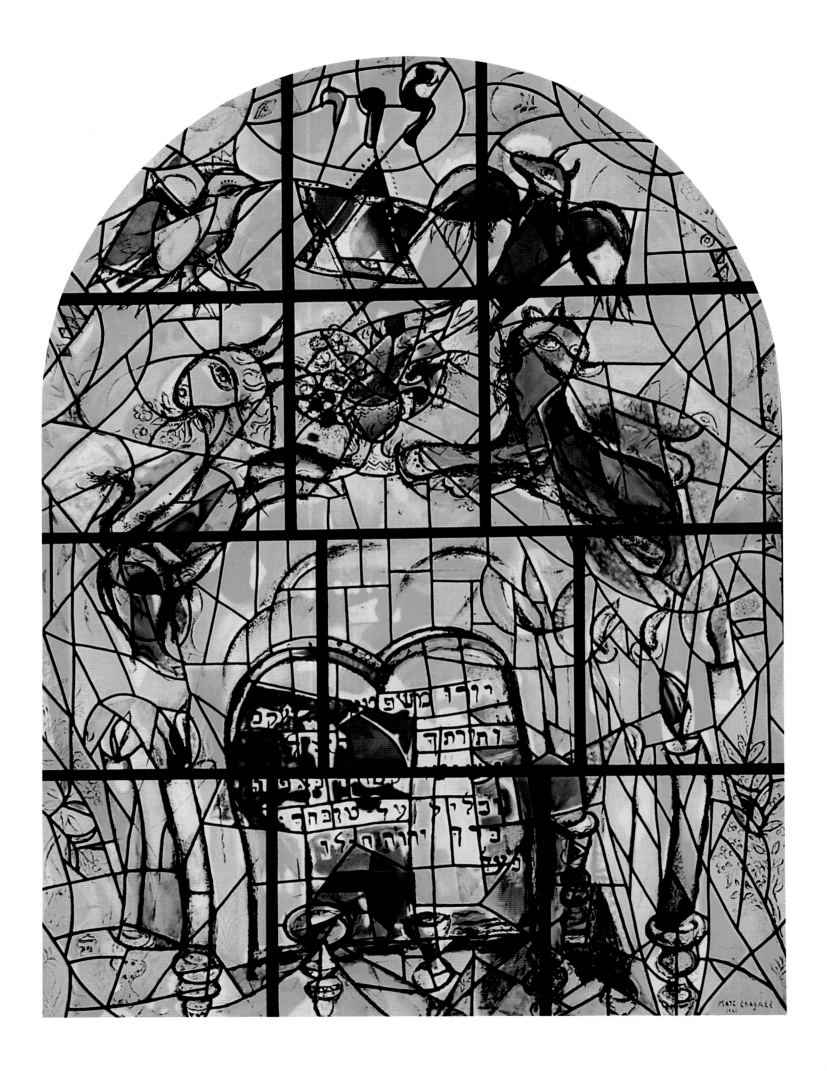

Stained glass, sculptures, ceramics

"If I create from the heart, nearly everything works."

The stained-glass windows

The art of creating stained-glass windows, which Chagall came to only late in his career, when he was almost 70, was to contribute greatly to his popularity. The scale of commissions is vast, his windows can be found in churches and public buildings all over the world. Stained-glass window painting originated in Byzantium, but reached its heyday with Gothic architecture in Western Europe. The oldest, completely intact stained-glass windows are those in Augsburg Cathedral, which date back to about 1050–1150 AD. Stained glass is an art that makes exceptional demands both on the artist creating the design and on the craftsman executing that design.

Among the magnificent Gothic cathedrals Chagall was able to admire in France were Chartres, which he visited in 1952, and Notre-Dame in Paris. The richness of the colours and composition of stained-glass windows attracted him enormously, leading him to want – like Braque, Villon, Léger and other artists of his time – to delve into the art of stained glass. Matisse in particular deserves mentioning here because he decorated the Notre-Dame du Rosaire chapel (consecrated 1951) in Vence, where Chagall settled in 1950.

Chagall said of the medium: "There is something very simple about a stained-glass window: just materials and light. Whether it is in a cathedral or a synagogue, it is all the same – something mystical passes through the window." And in a conversation with André Verdet he observed: "For me a church window represents the transparent partition between my heart and the heart of the world." Chagall's poetic mode of representation and typically glorious colours brought stained glass to new heights. For the artist personally, stained-glass windows, which he always designed so that they would fit in with the architecture, were much more than just decorative assignments; they opened up his whole oeuvre to new horizons. Today Chagall's superb windows can be found in France, Israel, the United States, Germany, England and Switzerland, mostly in churches (only in one synagogue), but also in a few museums.

The artist designed his first two stained-glass windows in 1957 for the church of Notre-Dame de Toute Grâce on the Assy plateau in Haute-Savoie. This was a building which the Dominican Father Marie-Alain Couturier, who in articles for the review *L'Art Sacré* advocated a renewal of sacred art in France and who knew many leading contemporary artists and writers, commissioned to be decorated by outstanding representatives of modern art. Chagall's two windows were executed by the stained-glass craftsman Paul Bony.

In 1958 Chagall met Charles Marq, a great stained-glass mastercraftsman who directed the well-known Simon workshops in Reims, and who from now on, in

Marc Chagall with Charles Marq, mastercraftsman of the Simon Workshop in Reims who made the Jerusalem Windows for the Synagogue of the Medical Centre of the Hadassah-Hebrew University, c. 1960
Courtesy Charles Marq

PAGE 242:
The Tribe of Levi
(The Twelve Tribes of Israel) 1960–1963
Stained-glass windows, 338 x 251 cm
Jerusalem, Synagogue at the Medical Centre of the Hadassah-Hebrew University

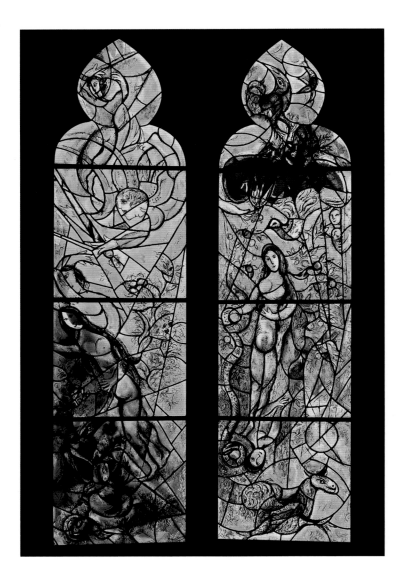

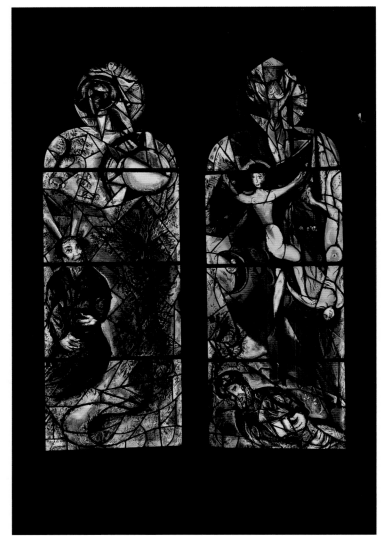

collaboration with the Saint-Just-sur-Loire glassworks, realized all the artist's windows in a multitude of colours and shades. The first fruits of this close and long cooperation with Charles Marq and his wife Brigitte were the windows for the Saint-Etienne Cathedral in Metz, which depicted biblical themes such as *The Creation, Abraham's Sacrifice, Moses receiving the Tablets of the Law, King David, The Prophets* and *Adam and Eve's Expulsion from Paradise* (ill. p. 244). At the time Chagall pointed out that it was not the Catholic Church that had commissioned him to do these windows, but the French government. He accepted the task because he considered it a great honour to be invited as a Jew to present biblical themes in a 13th-century cathedral. As with his other church windows, he declined to take any payment for this work.

One of Chagall's greatest achievements in stained glass were the twelve windows commissioned in 1960 by Dr Myriam Freund, president of the Hadassah (an American Zionist women's organization), for the synagogue of the medical centre in the Hebrew University just outside Jerusalem which is supported by that organization. The subjects of the windows are the twelve tribes of Israel (ill. pp. 246–248) as described in the Book of Genesis. In accordance with Jewish religious precepts, the windows show no human images, but only the names of tribes and biblical quotations in Hebrew, as well as candelabra, flowers, birds, fish and other animals. Once the designs were completed, Chagall travelled repeatedly to Reims to supervise the progress of the works. After two years the windows, measuring over 3 metres high by 2.5 metres wide, were finished. Made especially luminous by the strong Jerusalem light, they are a moving symphony of colour, poetry and imagination. *The Christian Science Monitor* described the windows, which are based on the

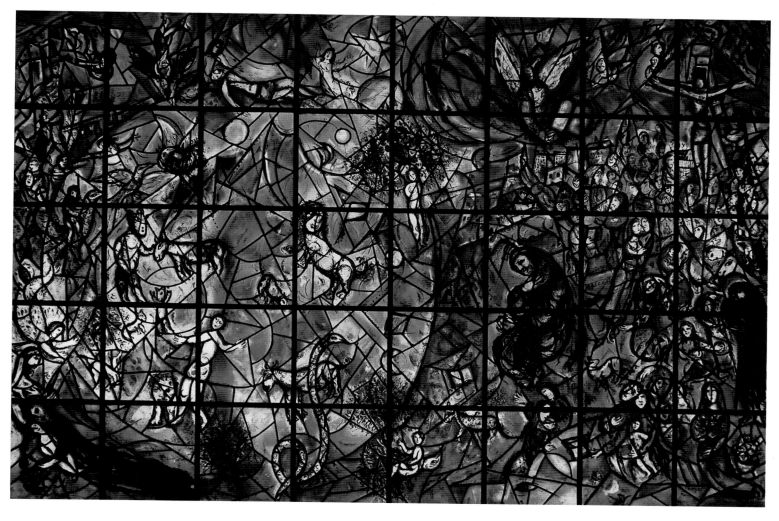

Peace (Staff Memorial to Dag Hammarskjöld
and the 15 people who died with him), 1964
Stained-glass window, c. 450 x 340 cm
New York, The United Nations

Marc Chagall with Basile Yakovlev in
front of the stained-glass window to Dag
Hammarskjöld (detail), 1964

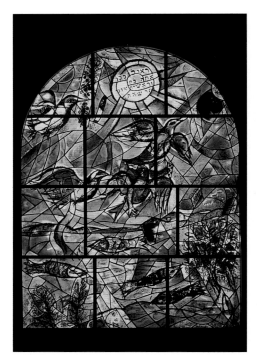

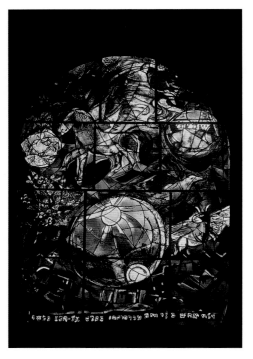

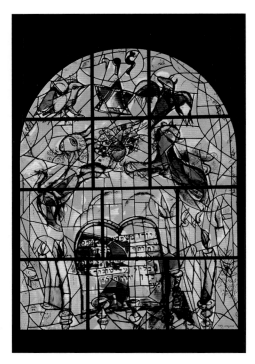

The Tribe of Reuben
(The Twelve Tribes of Israel), 1960–1962
Stained-glass window, 338 x 251 cm
Jerusalem, Synagogue at the Medical Centre
of the Hadassah-Hebrew University
Courtesy Hadassah Medical Relief Association

The Tribe of Simeon
(The Twelve Tribes of Israel), 1960–1962
Stained-glass window, 338 x 251 cm
Jerusalem, Synagogue at the Medical Centre
of the Hadassah-Hebrew University
Courtesy Hadassah Medical Relief Association

The Tribe of Levi
(The Twelve Tribes of Israel), 1960–1962
Stained-glass window, 338 x 251 cm
Jerusalem, Synagogue at the Medical Centre
of the Hadassah-Hebrew University
Courtesy Hadassah Medical Relief Association

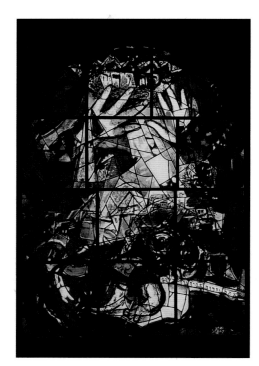

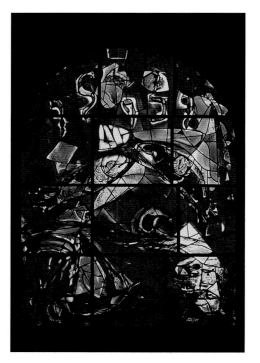

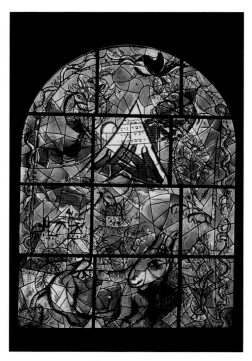

The Tribe of Judah
(The Twelve Tribes of Israel), 1960–1962
Stained-glass window, 338 x 251 cm
Jerusalem, Synagogue at the Medical Centre
of the Hadassah-Hebrew University
Courtesy Hadassah Medical Relief Association

The Tribe of Zebulun
(The Twelve Tribes of Israel), 1960–1962
Stained-glass window, 338 x 251 cm
Jerusalem, Synagogue at the Medical Centre
of the Hadassah-Hebrew University
Courtesy Hadassah Medical Relief Association

The Tribe of Issachar
(The Twelve Tribes of Israel), 1960–1962
Stained-glass window, 338 x 251 cm
Jerusalem, Synagogue at the Medical Centre
of the Hadassah-Hebrew University
Courtesy Hadassah Medical Relief Association

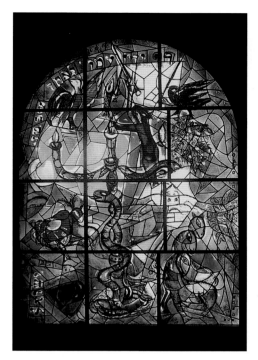

The Tribe of Dan
(The Twelve Tribes of Israel), 1960–1962
Stained-glass window, 338 x 251 cm
Jerusalem, Synagogue at the Medical Centre
of the Hadassah-Hebrew University
Courtesy Hadassah Medical Relief Association

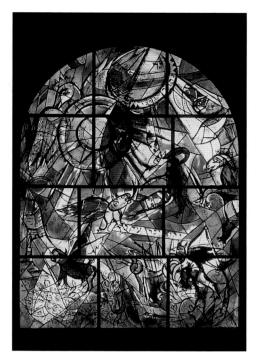

The Tribe of Gad
(The Twelve Tribes of Israel), 1960–1962
Stained-glass window, 338 x 251 cm
Jerusalem, Synagogue at the Medical Centre
of the Hadassah-Hebrew University
Courtesy Hadassah Medical Relief Association

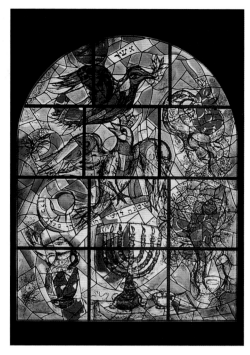

The Tribe of Asher
(The Twelve Tribes of Israel), 1960–1962
Stained-glass window, 338 x 251 cm
Jerusalem, Synagogue at the Medical Centre
of the Hadassah-Hebrew University
Courtesy Hadassah Medical Relief Association

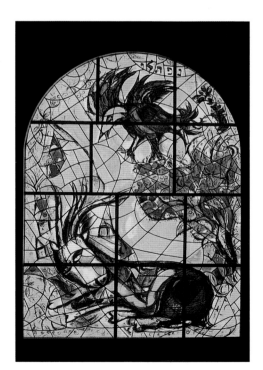

The Tribe of Naphtali
(The Twelve Tribes of Israel), 1960–62
Stained-glass window, 338 x 251 cm
Jerusalem, Synagogue at the Medical Centre
of the Hadassah-Hebrew University
Courtesy Hadassah Medical Relief Association

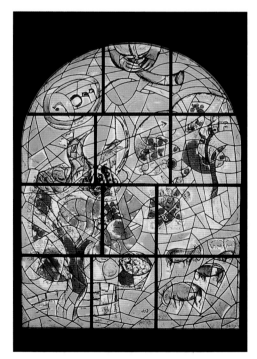

The Tribe of Joseph
(The Twelve Tribes of Israel), 1960–1962
Stained-glass window, 338 x 251 cm
Jerusalem, Synagogue at the Medical Centre
of the Hadassah-Hebrew University
Courtesy Hadassah Medical Relief Association

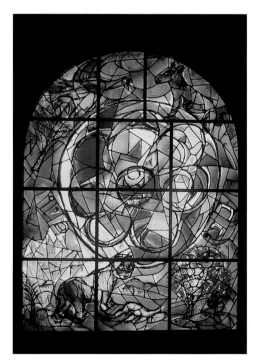

The Tribe of Benjamin
(The Twelve Tribes of Israel), 1960–1962
Stained-glass window, 338 x 251 cm
Jerusalem, Synagogue at the Medical Centre
of the Hadassah-Hebrew University
Courtesy Hadassah Medical Relief Association

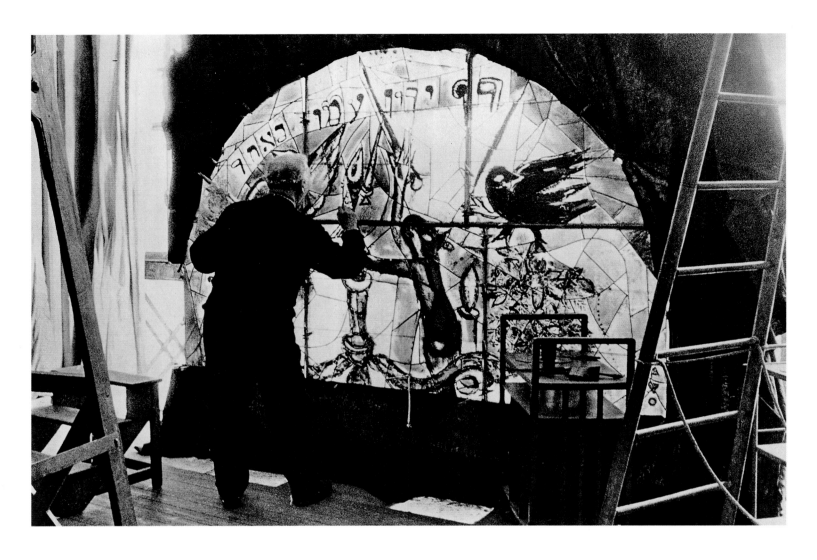

Marc Chagall Working in Reims on the Jerusalem Windows for the Synagogue of the Hadassah-Hebrew University Medical Centre (*The Tribe of Dan*)

49th chapter of 'Genesis' and the 33rd chapter of 'Deuteronomy', as a "great masterwork" and "the greatest achievement by any major painter since the war, [...] no one else has ever risen to such a challenge with such bravura." And *Time Magazine* hailed them as a "revelation in glass".

The French Culture Minister André Malraux was so impressed by the windows that in 1961 he arranged for them to be exhibited in a specially constructed pavilion in the grounds of the Louvre, where they were feted by both the public and the press. After Paris the windows made a guest appearance in the Museum of Modern Art in New York, where they likewise met with great acclaim. Finally, in February 1962, they were installed – in the presence of the artist – in Jerusalem. In an address Chagall said: "How is it that the air and earth of my home town Vitebsk, how is it that a thousand years of persecution find themselves mingled in the air and earth of Jerusalem? [...] I feel as if your tragic and heroic resistance in the ghettoes has blended with my flowers, my beasts and my fiery colours. [...] I feel as if lines and colours weep from my eyes, although I am not crying."

Abba Eban, Israel's Minister of Culture and Education at the time, said that Jerusalem had been enriched by "a new legacy of beauty and grace." The twelve Jerusalem windows, with their wonderful blue, red, yellow, green and purple tones, are the jewels in the crown of Chagall's stained-glass work. Though the subject, the 12 tribes of Israel, comes directly from Genesis, the images portrayed are only loosely connected to the Biblical text. To the New York magazine *Look* the artist declared: "In these glasses I wanted to convey the profound sense of mystery and spirituality that I feel in Israel. Even after trying my hand at the task, I still have no theory to explain my way of working. I did not try to follow any theory. God created man without a theory, and art is best created without a theory. All I can do is work for art. The rest is done by God."

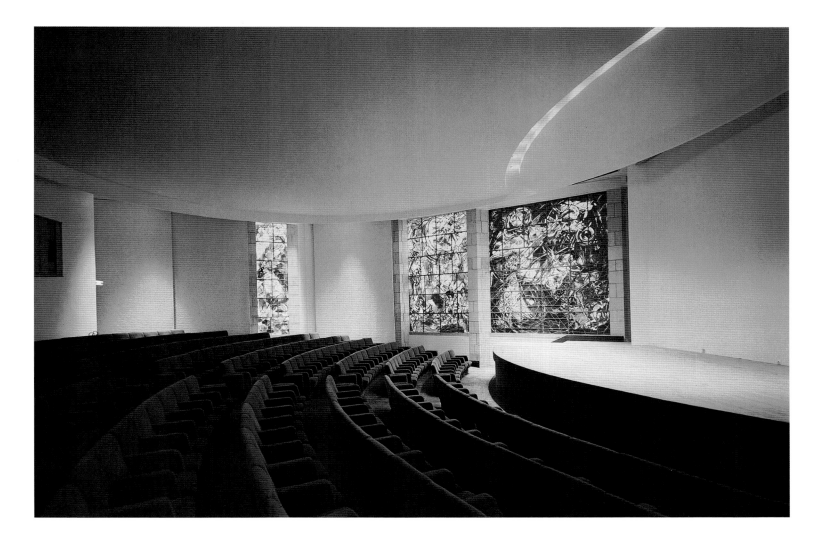

The Creation of the World, 1974
Three stained-glass windows, first window
465 x 396 cm; second window 465 x 266 cm;
third window 465 x 127 cm
Nice, Musée National Message Biblique
Marc Chagall, auditorium

In 1964 Chagall presented to the United Nations in New York his stained-glass window *Peace* (ill. p. 245), dedicated to memory of Dag Hammerskjöld, the organization's second secretary general. This exceptionally impressive window, dominated by Chagallian blue, was solemnly unveiled by U Thant, the then secretary general of the United Nations. Meanwhile Chagall created more windows for Metz Cathedral. However, one of the artist's most celebrated stained-glass works is the first of nine windows for the Union Church in Tarrytown, Pocantico Hills, in New York State, which was commissioned by the Rockefeller family after David Rockefeller and his wife saw the Jerusalem windows on display in Paris. This small Protestant chapel in the Gothic style is situated not far from the Rockefeller estate and has a simple round stained-glass window created by Matisse in 1954 in memory of Abby Aldrich Rockefeller. The Chagall window, which measures 4.5 metres high and 2.0 metres wide, commemorates John D. Rockefeller, Jr., and bears the title *The Good Samaritan* (1964, ill. p. 251). It was installed in September 1964 and consecrated on 10 October 1965 in the artist's presence. In 1966 Chagall completed eight further windows for the chapel, depicting cherubim, the prophets and the Crucifixion (ill. p. 250). In 1978 the preliminary gouaches and drawings for all nine windows were exhibited in the Museum of Modern Art in New York (ill. p. 254).

Chagall fulfilled other stained-glass commissions. In 1967 he was asked by the parents of Sarah d'Avigdor Goldsmid to do a memorial window as part of a cycle for All Saints Church in Tudeley in Kent, England, subsequently executing a further eleven windows (ill. p. 255). In 1970 he completed five windows for the Fraumünster cathedral in Zurich. Between 1971 and 1972 he worked on three windows for the Musée Message Biblique Marc Chagall in Nice, calling them *The Creation of the World* (ill. p. 249). From 1973 to 1974 he did three multipart windows

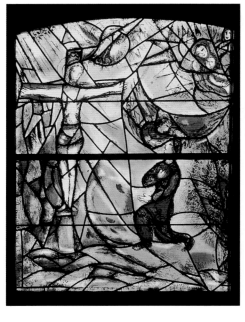
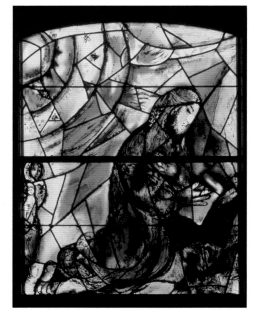
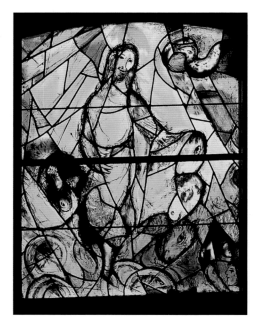

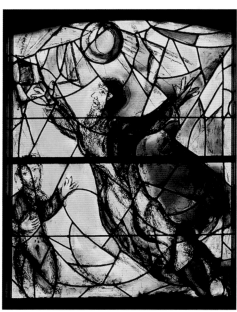
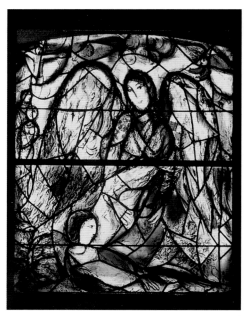
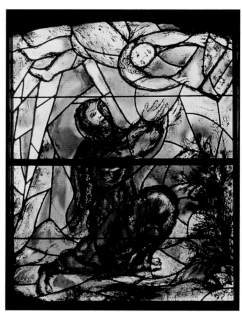

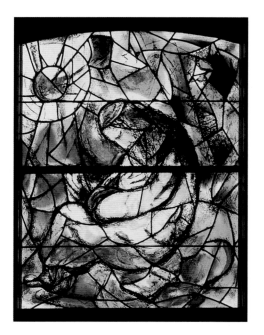
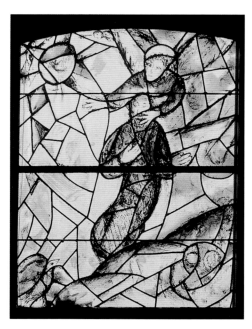

FROM LEFT TO RIGHT:

Crucifixion, 1967
Stained-glass window, 457 x 279 cm

Joel, 1967
Stained-glass window, 148 x 118 cm

Elijah, 1967
Stained-glass window, 148 x 118 cm

Daniel, 1967
Stained-glass window, 148 x 118 cm

Cherub, 1967
Stained-glass window, 148 x 118 cm

Ezekiel, 1967
Stained-glass window, 148 x 118 cm

Jeremiah, 1967
Stained-glass window, 148 x 118 cm

Isaiah, 1967
Stained-glass window, 148 x 118 cm

Tarrytown, Pocantino Hills (NY),
The Union Church, southside

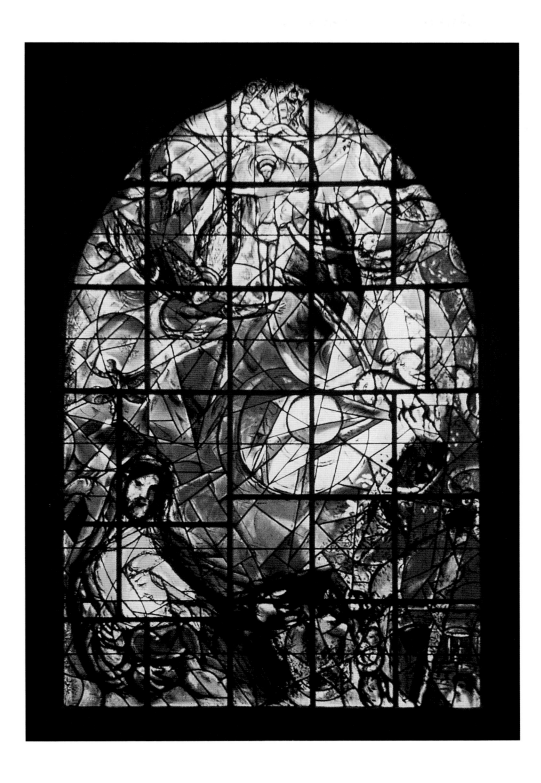

The Good Samaritan, 1967
Stained-glass window, 447 x 278 cm
Tarrytown (NY), The Union Church of
Pocantico Hills, westside

for the choir of Notre-Dame Cathedral in Reims. In 1978 he produced the stained-glass window *David* for Chichester Cathedral in Sussex, England, and the following year (1979), at the Art Institute of Chicago, three double windows, known as the 'American Windows', were unveiled which Chagall had designed to celebrate the 200th anniversary of the United States (ill. pp. 252, 253). Between the years 1977 and 1984 he worked on windows for the St. Stephanskirche in Mainz as part of the church's restoration after the bombing of Mainz in the second world war. Other Chagall windows can be found in the Chapelle des Cordeliers in Sarrebourg, Lorraine, and in the parish church of Le Saillant de Voutezac in the French department of Corrèze.

All Chagall's stained-glass windows, including the preliminary studies and final designs, have been collated by Sylvie Forester, the director of the Musée Message Biblique Marc Chagall in Nice, in a catalogue raisonné, published in 1987. The

PAGE 252/253:
*American Windows (Music and Painting,
Literature and Architecture, Theatre and Dance)*,
1976–1979
Three stained-glass windows, each 246 x 345 cm
Chicago (IL), The Art Institute of Chicago,
Gift of the Auxiliary Board of the Art Institute
of Chicago; in memory of Richard J. Daley

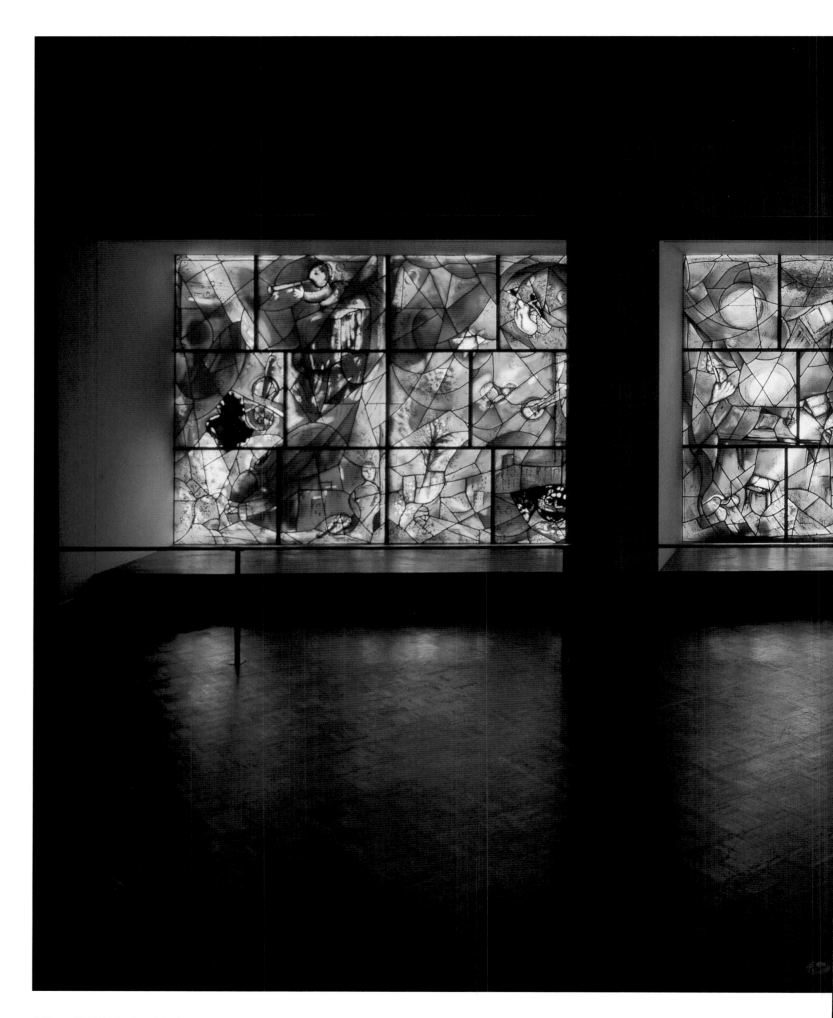

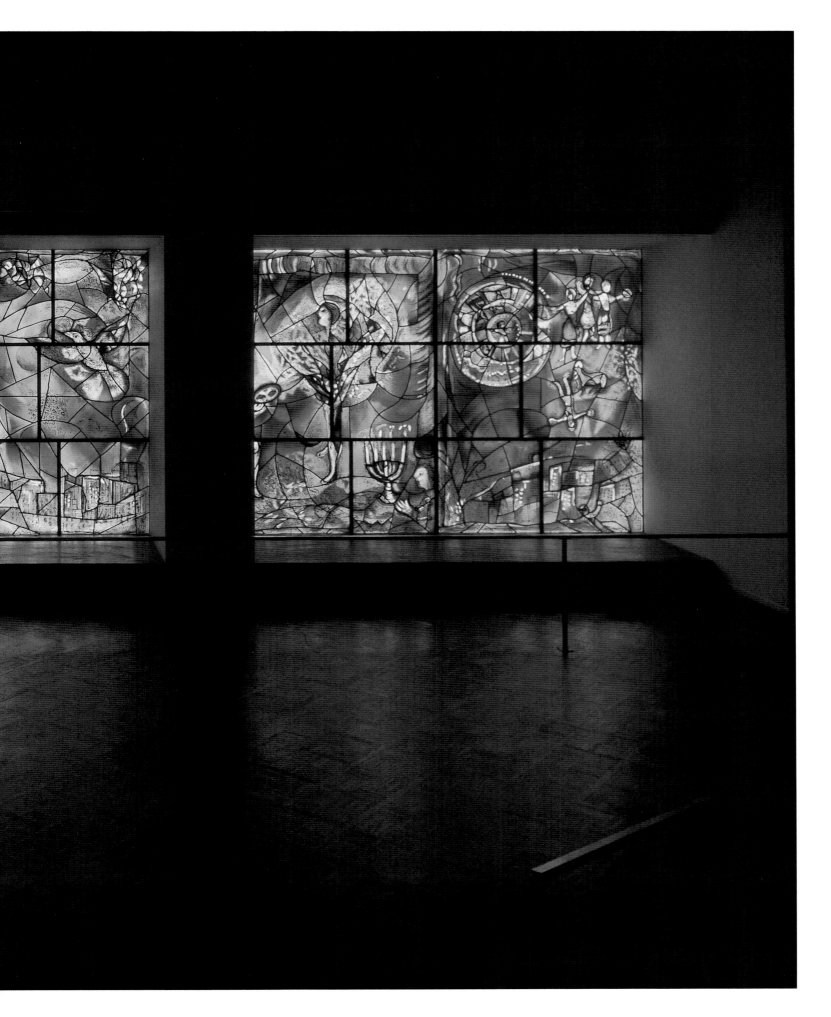

 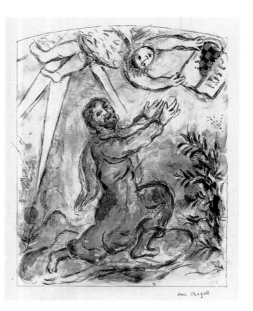 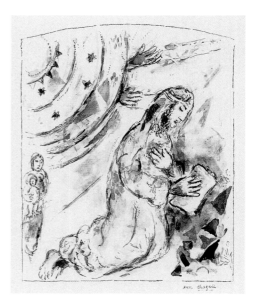

Study for the stained-glass window *Isaiah* (Tarrytown, New York, The Union Church of Pocantino Hills), 1965–66
Gouache, pen, ink, pencil, and collage of fabric on paper, 56.1 x 38 cm
Tarrytown (New York), The Rockefeller University Collection

Study for the stained-glass window *Ezekiel* (Tarrytown, New York, The Union Church of Pocantino Hills), 1965–66
Gouache, wash, watercolour, pen, brush and ink, pencil, and collage of fabric on paper, 56.5 x 37.5 cm
Tarrytown (New York), The Rockefeller University Collection

Study for the Stained-glass window *Joel* (Tarrytown, New York, The Union Church of Pocantico Hills), 1965–66
Watercolour, pen and ink, pencil, and collage of fabric, touched with gouache, 56.5 x 37.9 cm
Tarrytown (New York), The Rockefeller University Collection

very scope of Chagall's oeuvre in this challenging medium, which he only turned to at an advanced age, is breathtaking. Chagall was in his sixties when, with the help of Charles Marq, stained glass expert and director of the Simon workshops in Reims, he mastered the necessary techniques. John Russell wrote in the *New York Times*: "No matter what their size, all his stained-glass windows impress with their virtuosity, the way they harmoniously match their architectural setting and surroundings, and their innovative poetic sensibility."

Ceramics and sculpture

It was not until 1949, when he settled in the South of France, that Chagall turned to ceramics. In 1941 and 1945 the art dealer Pierre Matisse, who represented Chagall, had twice exhibited 'Miró' ceramics in his New York Gallery, created by the Catalan master ceramist Joseph Llorens Artigas. Chagall, who was then living in New York, saw the two exhibitions and was inspired by them to try his own hand at ceramics once he had returned to France.

His ceramic works – vases, plates, jars, dishes and large tiles which he himself described as 'wall ceramics' or 'ceramic murals' – are an important aspect of his multi-facetted oeuvre. Most of these unique pieces remained in the ownership of the artist. Owing to their fragility, he was reluctant to loan them to exhibitions, with the result that they are still largely unknown to the public. Chagall could easily be described as an 'artist-craftsman', and as such he was one of the most creative of our century. In keeping with his engravings and the other artistic media he explored, ceramics and sculpture also allowed the artist to give free rein to his imagination. In ceramics and sculpture there is no intermediary between the artist's creative hand and his raw material. Unlike other artists, Chagall was not content to paint on ready-made ceramics produced by a professional potter. He wanted to model the clay with his own hands in accordance with his own ideas. He executed

PAGE 255:
Angels and Animals (left), 1978
Stained-glass window, 157.5 x 40 cm
Tudeley (Kent), All Saints' Church, choir.
In honour of Lady d'Avigdor-Goldsmid

Trees and angels (right), 1978
Stained-glass windows, 131.5 x 34.5
Diameter of the round window 34.5 cm
Tudely (Kent), All Saints Church, choir, southside. In honour of Lady d'Avigdor-Goldsmid

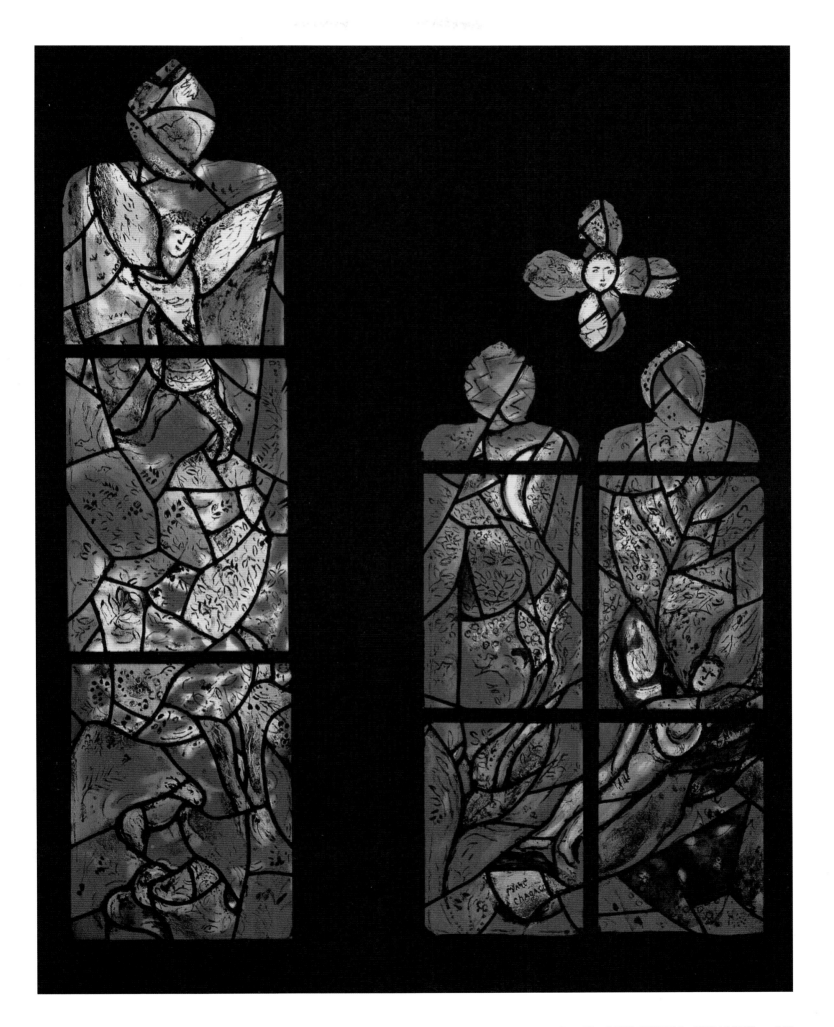

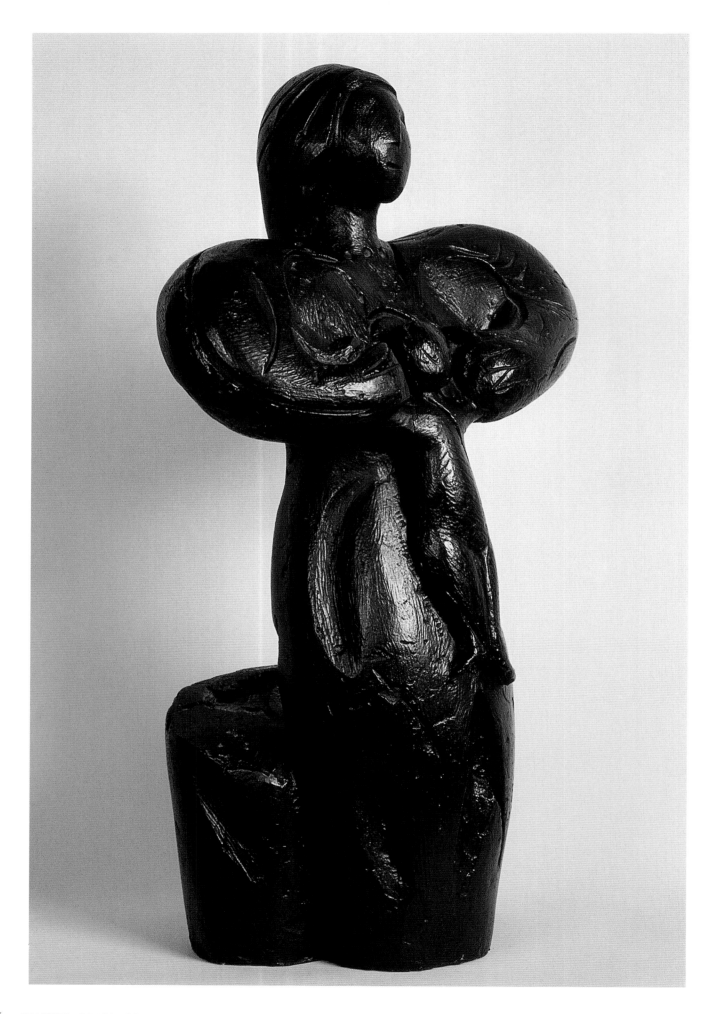

Nude, 1953
Marble, 21.5 x 42 cm
Private collection

Chagall turned his had to sculpture relatively
late in his career. He produced numerous pieces
in stone and marble but cast only half-a-dozen
bronzes. Beside his mother and child figures,
he sculpted birds, animals and nudes. This
nude was chiselled in stone in 1953.

The Birds, c. 1979
Stone relief at the entrance to Chagall's home
in St-Paul-de-Vence

PAGE 256:
Mother and Child, 1959
Bronze, 70 x 38 x 25 cm
Private collection

King David, c. 1952
Limestone, height: 54 cm
Private collection

Moses, 1969
Marble (Diptychon), each tablet 69 x 50 cm
Paris, Galerie Navara

his works in several different workshops, with Madame Bonneau in Antibes, with Serge Ramel in Vence, and at the L'Hospied pottery in Golfe Juan.

His most important ceramics, however, were produced at the famous Madoura workshops in Vallauris, set up and run by George and Suzanne Ramié since 1938. It was there that Picasso produced all his many ceramics, and met his last wife Jacqueline. Evidently he was none too pleased to keep bumping into Chagall working at the same place (cf. p. 184–188). Chagall's first exhibitions of his ceramics, which show all his characteristic subjects, were held in 1950 and 1952 at the Maeght gallery in Paris. A show which Curt Valentine mounted in 1952 in his New York gallery was well received. Other presentations were in the Palazzo Madama in Turin in 1953, at the Basle Kunsthalle in 1956, and in the Berne Kunsthalle also in 1956. But the largest exhibition, where 92 ceramics and 26 sculptures were on display, took place in the Grand Palais in Paris as part of the major Chagall retrospective 'Hommage à Marc Chagall' from December 1969 to March 1970. Never before had the general public been able to see so many of the artist's ceramics and sculptures. Chagall's largest ceramic-mural, *The Crossing of the Red Sea*, which measures 3.07 x 2.31 metres, is made up of 90 tiles and was installed in 1956 in the baptistry of the church of Notre-Dame de Toute Grâce on the Assy plateau, for which the artist also made two stained-glass windows and two marble bas-reliefs.

Chagall attributed his ceramics to his life in the South of France, where the tradition of this craft goes back centuries: "The very earth on which I walk is so luminous. It looks at me tenderly as if it were calling me. I wanted to touch this earth like the old artisans, wanted to distance myself from any accidental decoration, and, by staying within the limits of ceramics, breathe into the medium the

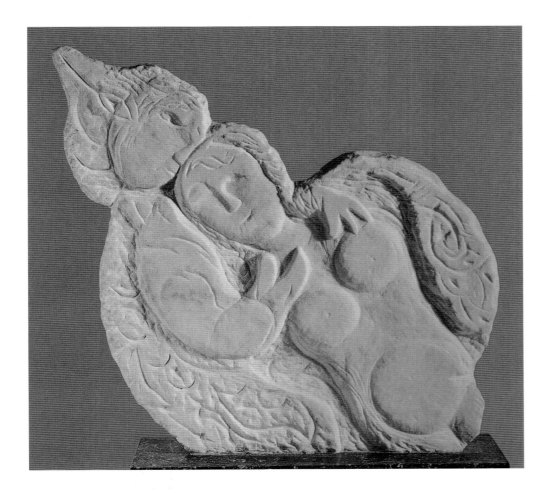

Lovers with Bird, 1952
Stone sculpture, 31 x 32 cm
Private collection

echo of an art that is at once nearby and far off. Suddenly it seems to me that this earth, so lucid, is evoking from afar the mute earth of my home town Vitebsk. But this earth, like the craft of ceramics, does not give easily of itself, and the kiln door returns my efforts sometimes in a pleasing form, but sometimes in a grotesque and ridiculous form. The old elements of fire and earth remind me only too well that my means are modest."

Chagall's most productive period in the ceramics field were the years 1950–52, during which time he produced 69 plates and dishes, 9 ceramic-murals, 10 plaques and 2 vases. Thereafter, in the ten years from 1953 to 1962, he produced a further 110 ceramic pieces.

"Painting and ceramics", Chagall said, "are made with the hands and the heart. Theories only come afterwards, when the work is done. They result from the work, but are not its source." "Ceramics is the alliance of fire and clay, nothing more; if what you entrust to the fire is good, the fire will return some of this goodness to you, but if what you offer is bad, everything breaks to pieces, and there is nothing you can do about it – the fire's verdict is merciless."

Ceramics is mostly considered to be a somewhat commercial and decorative art, more of a craft, but Chagall, Picasso, Braque and Miró brought about a new efflorescence of the medium, with its age-old aesthetic and practical function, elevating it to the realm of the fine arts. Chagall's last ceramics date back to 1972, 13 years before his death. In total he produced 240 pieces, all of which are reproduced in colour in the catalogue raisonné compiled by Sylvie Forestier together with Meret Meyer, the artist's granddaughter.

The vases and jugs personally modelled by Chagall often took on flowing 'baroque' forms, which could easily be integrated in the depiction of nudes, figures or mythical creatures. On the vessels the bodies of the figures gradually became independent. Starting out as a three-dimensional relief, they increasingly 'grew out' of the vessel until finally they turned into an autonomous sculpture. The first pieces were terracotta, later ones stone. Frequently the artist worked with marble,

The Lovers, 1952
Marble, height: 59.7 cm
Private collection

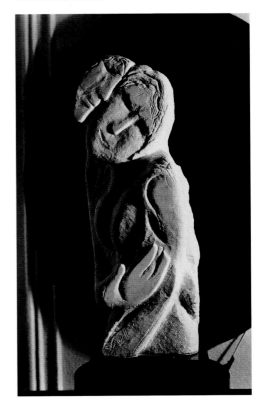

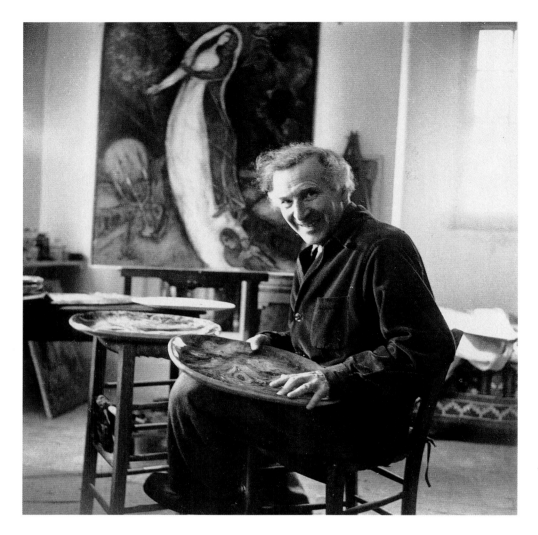

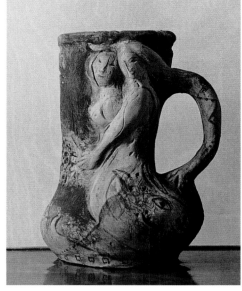

TOP:
Two Women, 1957
Ceramic vase, height: c. 31.7 cm
Private collection

LEFT:
Marc Chagall working on his ceramic plates in Cannes, 1951

LEFT:
Marc Chagall working on a ceramic vase, 1951

BOTTOM:
Untitled, 1962
Glazed ceramic vase, height 39 cm
Chicago (IL), The Robert B. Mayer Family Collection

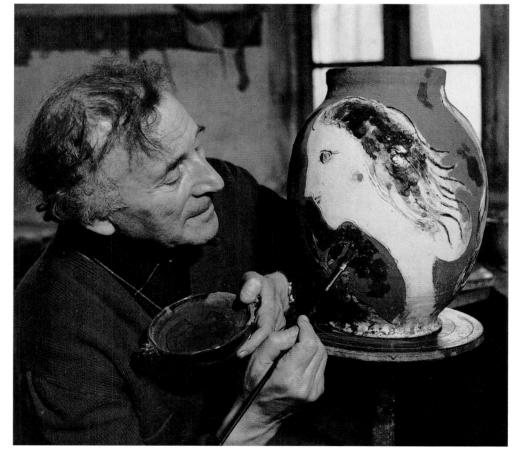

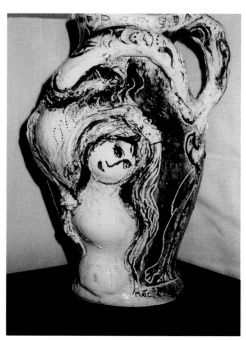

The Offer to the Lovers
(The Dream of the Couple), 1954
Ceramic vase, 43 x 17 cm
Paris, Collection Daniel Malingue

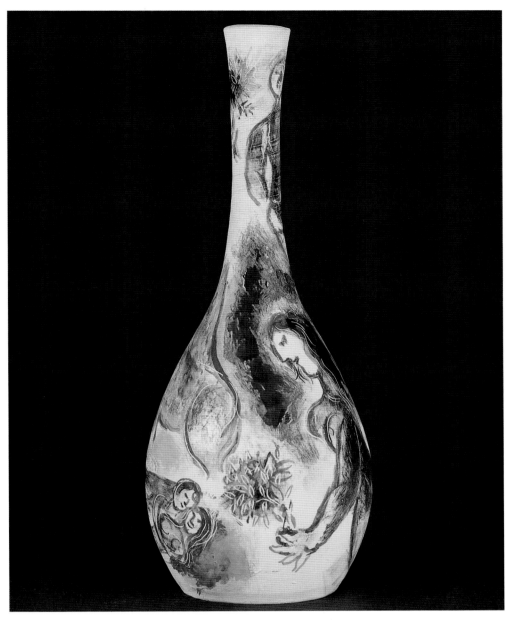

BOTTOM LEFT:
Woman and Bird, c. 1975
Ceramic vase
Private collection

BOTTOM RIGHT:
Lovers with Blue Jug, c. 1968
Glazed ceramic, diameter: 30.5 cm
Private collection

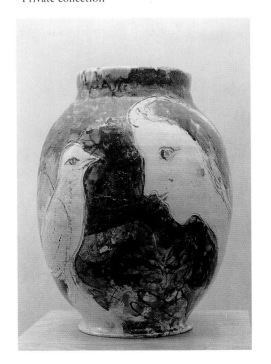

Vence II, 1962
Ceramic-mural, 51 x 77 cm
Basle, Collection Marcus Diener

Vence I, 1962
Ceramic-mural, 51.5 x 77 cm
Basle, Collection Marcus Diener

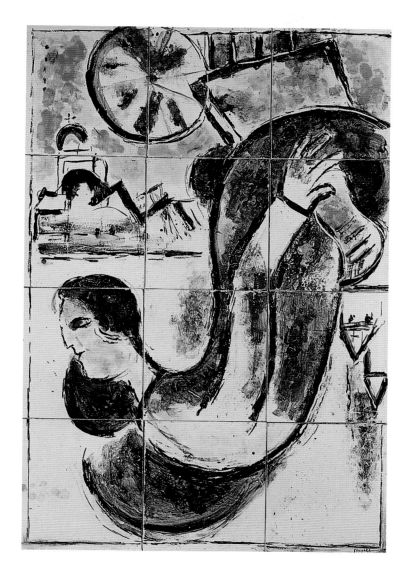

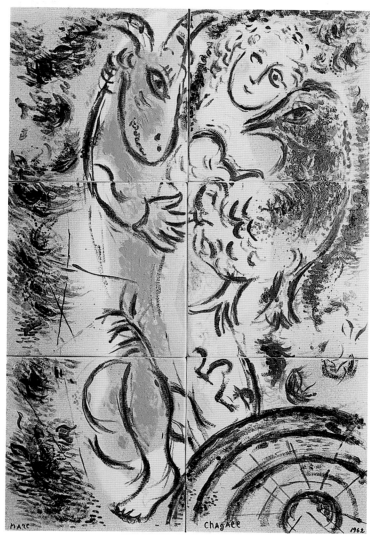

occasionally with sandstone or tuff. Only about half a dozen of his sculptures were cast in bronze, and then in very small editions (*Mother and Child,* 1959, ill. p. 256). However, the free-standing sculptural form is an exception in Chagall's work. Most of his sculptures from stone slabs or blocks have the character of a relief with a main view. Thematically, they are mostly half-length figures: *King David* (1952, ill. p. 258), *Moses* (1969, ill. p. 258), or also pairs of juxtaposed heads (*The Lovers,* 1952, ill. p. 259). Their style and narrative mode is reminiscent of late Romantic architectural sculpture, and in fact many of these relief-type sculptures were conceived of as decoration for an architectural context (ill. p. 257).

TOP LEFT:
The Holy Carter, 1962
Ceramic-mural, 120 x 82 cm
Basle, Collection Marcus Diener

TOP RIGHT:
Billy Goat and Figure, 1962
Ceramic-mural, 77 x 51.5 cm
Basle, Collection Marcus Diener

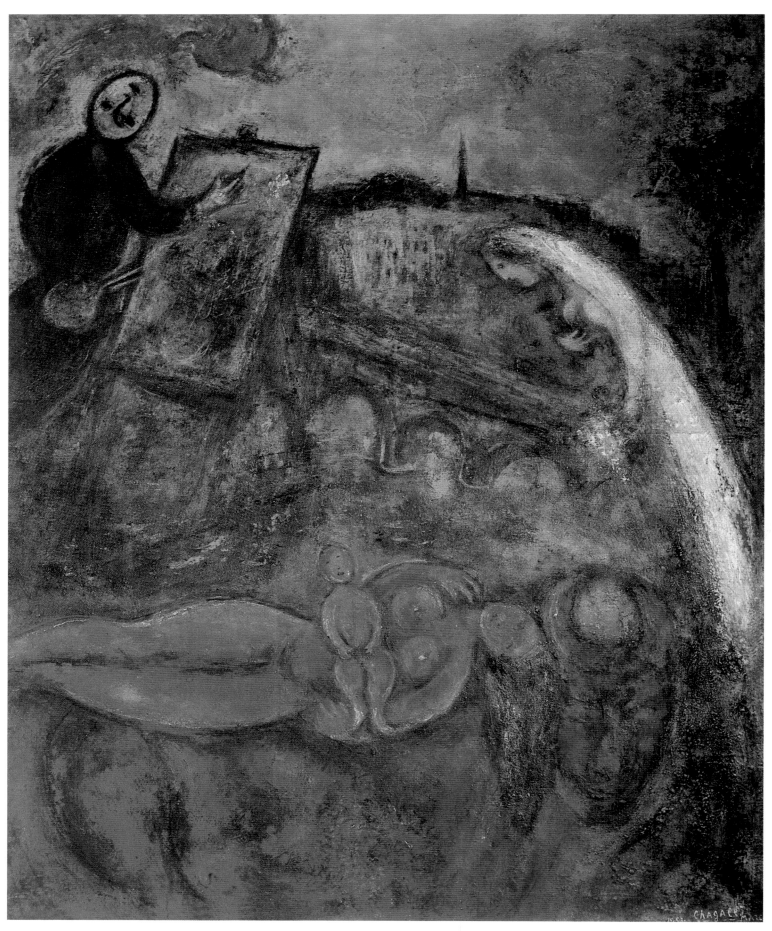

Pont Neuf, 1953
Oil on canvas, 100 x 81 cm
Private collection

Epilogue

"My paintings are my memories."

When Marc Chagall died in 1985 at the age of 97, he had lived longer than any other major 20th-century artist. The author met and talked to him many times after their first encounter in 1951. Chagall was a complex man, sometimes shy, sometimes brazen, simple and shrewd, naive and sophisticated, sometimes stingy, but also capable of generosity. He was sentimental and sensitive, but also sober and rational. He could be both calculating and spontaneous, witty and melancholic. When the mood took him, he could be outspoken, acerbic, even malicious. Despite being extremely sensitive to criticism, he did not mince his words when it came to criticizing others. He was reluctant to comment on contemporary artists, but when he did so, he pulled no punches. The old masters, by contrast, enjoyed his fullest respect. He preferred the company of poets and writers to that of his fellow painters, and was something of a poet himself, writing poems in Yiddish, Russian and French. In 1975 Gérald Cramer published 41 of Chagall's poems from the years 1909 to 1972 in Geneva, the volume being illustrated with 21 woodcuts by the artist himself.

When I once asked Chagall to explain a painting of a couple in which the girl's head was upside down, he replied: "It is quite simple. In Yiddish there is an expression that the man turns the girl's head, and that is what I painted, literally." Chagall, who considered himself a citizen of the world and a universal artist, did not want to be regarded only as a 'Jewish' painter. Often he addressed themes and motifs outside of the Jewish tradition, alienating some of his many Jewish admirers. His crucifixion scenes, to which he repeatedly returned from 1912 onwards, aroused considerable controversy among Jews. In 1912 he painted *Golgotha* (ill. p. 71), in 1938 *White Crucifixion* (ill. p. 149), in 1941 *The Descent From the Cross*, and in 1943 *Yellow Crucifixion*. The theme was also taken up in later years (c. 1955, ill. p. 266). The fact that these crucifixion scenes frequently included 'palliative' Jewish symbols such as the menorah (seven-armed candelabrum) or a prayer shawl was just further grist to the critics' mill. Much as Chagall might aver that the Crucifixion also represented the life of suffering of the Jewish people over the centuries – the discriminations, the expulsion from Spain, and latterly the Holocaust – , his critics dismissed his explanations, castigating him for using Christian symbols in his numerous church windows.

It seemed that Chagall regarded Jesus as one of the great Jewish prophets, which flew in the face of Jewish teaching. For his critics, there was absolutely no historical justification for depicting crucifixes in, for example, the painting *Jacob's Ladder* or the eye-catching stained-glass window *The Creation of the World* (ill. p. 249) in the Musée National Message Biblique Marc Chagall in Nice, just as there was no justification either for the crucifixion scenes in the works *Jacob's Dream* (ill. p. 244) and *The Creation of Man*. He was reproached for confusing a

Self-Portrait with Palette, 1954–55
Pen and ink, 60.1 x 42.6 cm
Private collection

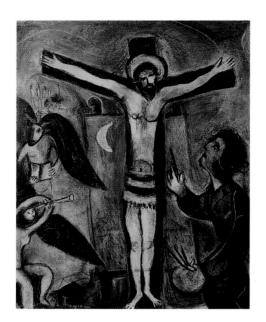

Crucifixion, c. 1955
Oil on canvas
Private collection

church with a museum. A church was not a place for seeking some abstract artistic truth, but a place subject to strict religious dogma. But what his critics were most reluctant to understand was that his artistic vision was based on a passionate love of humanity that linked all God-fearing people throughout the world. Just how important the 'official' Jewish position was to him is shown in the following episode. When in 1950 he was asked by Father Couturier to decorate the baptistry of the church of Notre-Dame de Toute Grâce on the Assy plateau, he sought advice not just from Jewish friends and French rabbis, but also – because the Vatican was "not favourably disposed towards Israel" – Chaim Weitzman, Israel's first president. Weitzman answered Chagall that he could only advise the artist to act "according to his own conscience and his own inspiration".

Chagall's relationship with the state of Israel was also complex, and at times tense. He had created three magnificent wall tapestries and 15 mosaics for the Knesset, the Israeli parliament, and had donated paintings to Tel Aviv Museum. But nothing came of plans to build a museum in Jerusalem for his paintings on biblical themes – plans which Marcus Diener, the renowned Swiss architect and an avid collector and admirer or Chagall, had already submitted in 1964. Chagall preferred France, his adopted homeland, as the site for this 'monument to himself' and in 1966 presented the picture series *The Biblical Message* to the French nation. Not long after, in 1969, the foundation stone for the Musée Nationale Message Biblique Marc Chagall was laid in Nice. In one of the author's last meetings with Chagall shortly before the artist's death, he asked me: "Are they still angry with me in Israel because I gave this monumental work to France?" When I did not react, Chagall provided an answer himself: "The Jews gave the world the Bible, and they know all about it. It is the 'goyim' (the gentiles) who need to know more about it." In an interview with Carlton Lake, published in July 1963 in the *Atlantic* magazine, he said: "My wife (Vava) is against my concentrating too much on Palestine. Neither she nor I have nationalistic feelings regarding Israel. But I love the Bible, and I love the race that created the Bible. And I am not going to buy myself a place in the pantheon of the French by refusing to work for these poor people in Israel if they want me to. In any case, the French will always say the same thing about me whether I work for Israel or not. 'Chagall belongs there', they will say. It is in their blood. That is the way they are, and I am not going to do something else in the hope that they will change their mind about me. [...] True, they say 'a great artist' – but 'over there, in Israel, where he belongs'." Nevertheless, ten years later the museum devoted to the *Biblical Message* was opened in Nice, the monument that André Malraux had built in the artist's honour.

In contrast to Chagall's first wife Bella, who was deeply rooted in Jewish culture and who loved the Yiddish language and its literature, his second wife Vava was more indifferent to Jewry, although her origins were Jewish. When the artist died in 1985, it was Vava who insisted on him being buried in the Catholic cemetery in Saint-Paul-de-Vence, although Joseph Pinson, the Chief Rabbi in Nice, had suggested burying the artist in the Jewish cemetery there. Thus it is that one of the greatest Jewish painters of all time found his last resting place in a Christian cemetery. For Teddy Kollek, the former mayor of Jerusalem, who was a friend of Chagall's, the circumstance showed "a great lack of sensibility on the part of his family".

Of all the great Jewish painters of the 20th century – Pissaro, Modigliani, Soutine and Chagall – Chagall was the only one who drew inspiration from his Jewishness and who unequivocally attested to his background in his art. While the others painted masterly landscapes, still lifes and nudes, Chagall's art would be unthinkable without his Jewishness.

Throughout his life Chagall had to contend with negative criticism of his work. In connection with an exhibition at the Tate Gallery in London, the conservative British critic Eardly Knollys wrote: "We are slapped in the face by a vortex of symbols, blaring out messages which may intrigue psychoanalysts and American women's clubs, but can give little pleasure to lovers of fine paintings." And Thomas Craven, considered the doyen of conservative critics, wrote in the late 30s: "His conceptions would be ridiculous if they did not convey a little of the vagabond

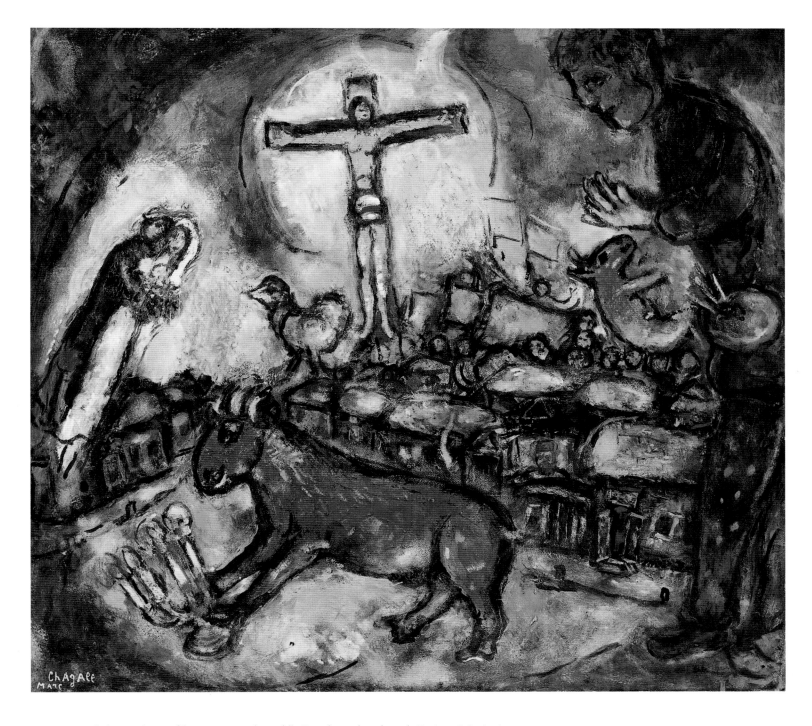

The Village, 1972
Oil on canvas, 55 x 61 cm
Private collection
Courtesy Galerie Maeght, Paris

poetry and the pathos of his uprooted soul." On the other hand, Raissa Maritain, the wife of the Catholic philosopher Jacques Maritain, thought that Chagall was a rare painter of joy: "Rouault is said to be the painter of original sin. But the universe Chagall has created knows nothing of sin, hatred and discord. It speaks of mercy and joy, of fraternity and love […]." And, according to the art historian Alfred Werner, Chagall's work is "somewhat related to that of another Christian artist, Fra Angelico, a Florentine painter of the early Renaissance whose saints and angels might feel at home in the humble ghetto streets of Chagall. Of course, Fra Angelico has been dead for many centuries, and dead too is the 'shtetl' of Vitebsk as Chagall knew it."

In the 1970s Sidney Alexander had a conversation (quoted in his 1978 Chagall biography) with Boris Aronson, who had got to know Chagall in Moscow and who subsequently met up again with the artist in Berlin, Paris and New York. Aronson said: "Today he is not the fine artist that he once was. Today he is a mixture of Dufy and Vitebsk. He is a very complicated person, always concerned to be the greatest. Chagall has fantastic talent as a painter. But, on the other hand, he is

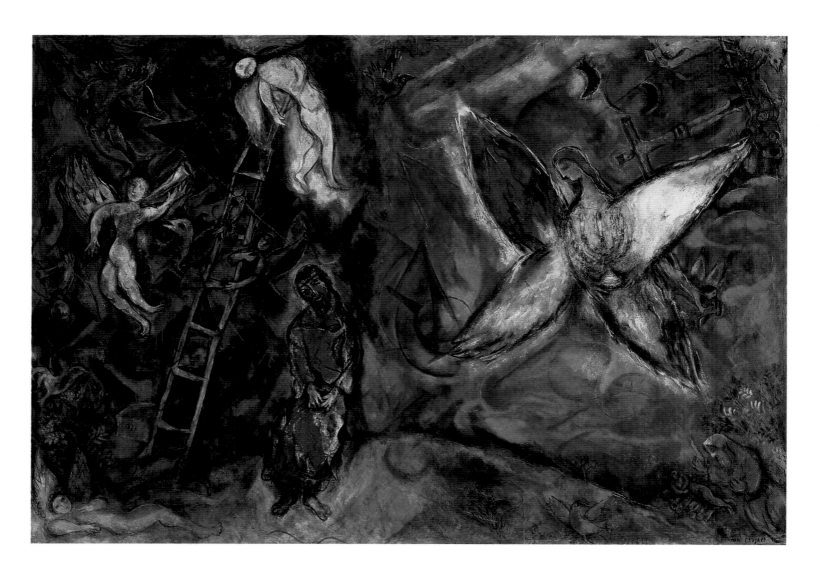

Jacob's Dream, 1960–1966
Oil on canvas, 195 x 278 cm
Nice, Musée National Message Biblique
Marc Chagall

also a businessman. I was at his house and I didn't like what I saw – the way he set about selling his pictures. And as a designer, he has never got beyond the fiddler on the roof. He is a little man who has made it big and can't handle it. That is the ugly side of him. Yet in his time he has been a very great graphic artist and a very great painter. He has accomplished beautiful work in many fields. His Hadassah windows in Jerusalem are original and fresh." Compared to Soutine, Chagall is decorative, thus Aronson: "But his decorativeness has great painterly qualities." Chagall always hated being criticized, Aronson maintained, and there was no such thing as 'Jewish Art'. "A Jewish cloud is a French cloud, or a German cloud, or a Russian cloud. There are Jewish subjects, but that does not amount to Jewish art. Chagall uses Jewish subjects. But Soutine paints a chair and it's sad, it's melancholy, it's Jewish." Aronson continued: "Chagall instinctively had it. But then he began to exploit it commercially. He is like a charming woman, nobody knows why she is charming, it is beyond explanation. Then when everybody tells her she is charming, she begins to use it consciously. But when charm becomes a system, the magic is gone. That is the late Chagall. […] Chagall wants to be a legend." "Chagall is", Sidney Alexander added, "a storyteller, which does not necessarily mean literature. Chagall is a painter, a real painter. But as a painter he is a storyteller, and as a storyteller a painter." To which Aronson replied: "Chagall is organized inspiration."

In his large Chagall monograph Franz Meyer draws interesting parallels between Chagall and Franz Kafka, who are both Jewish and belong to the same generation. Both used and created symbols in order to preserve the spiritual in the face of a sharply materialistic world. The assimilated Prague Jew Kafka remained trapped in his sophisticated urban milieu, however much he felt drawn to religious East

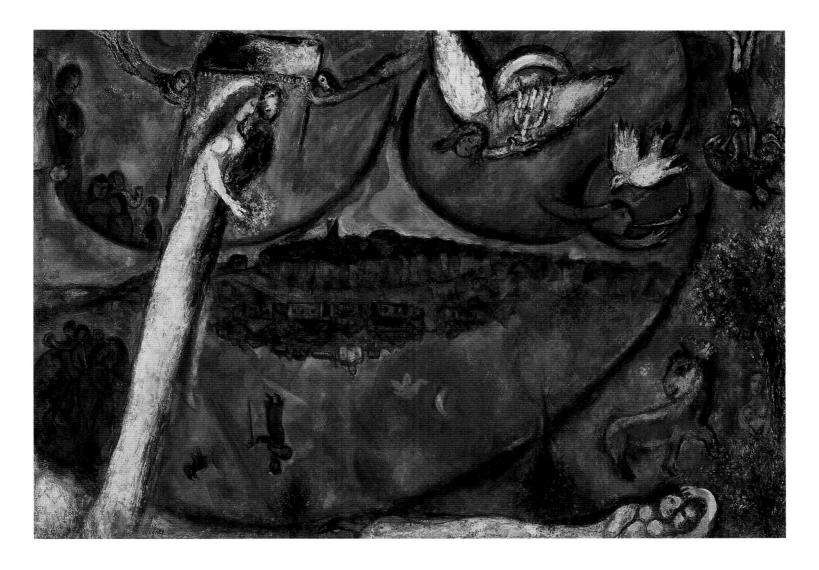

European Jewishness. Chagall, by contrast, never really left the traditions of the 'shtetl', in which he found answers to many of the questions for which Franz Kafka apparently could find no answers.

The art historian Herbert Read finds that Chagall's greatest strength lies "in the intensity of the emotions that he arouses by means of a more or less nostalgic symbolism." "Do you know who Vivaldi is?" the composer Igor Stravinsky once asked. "He is someone who composed only one theme in his life and a thousand repetitions of it." And some critics have accused Chagall of constantly repeating himself in his late work for commercial reasons, thereby devaluing himself. To the author Chagall explained: "Poets always use the same letters, but out of them they constantly recreate different words." André Malraux, the great French Minister of Culture, found Chagall one of the greatest colourists and "the greatest pictorial painter of the century".

In the almost 35 years that the author knew Chagall, it was always a great, enriching and fascinating experience for me to be in the artist's company. Chagall gave so much joy and pleasure to people of all races, colours and creeds. He reached out to people's hearts like no other artist this century. A painter of dreamscapes, he was in constant dialogue with his home town Vitebsk. He was the fiddler on the roof of modern painting. It is impossible now to imagine art history without Chagall's unique contribution to 20th-century art. Just as we enjoy his many-sided œuvre, so his important legacy will continue to delight and engage many generations to come.

Song of Songs, 1960
Oil on paper, mounted on canvas, 120 x 149 cm
Nice, Musée National Message Biblique
Marc Chagall

"For me, fulfilment in art and in life comes from this biblical source. Without this spirit, the mechanics of logic and constructivity in art, as in life, cannot bear fruit. Perhaps the young and the not-so-young will come to this house (the "Musée National Message Biblique Marc Chagall") in search of an ideal of brotherhood and love such as I have dreamed of in my colours and lines. Perhaps they will also speak the words of this love which I feel for everyone. Perhaps there will be no more enemies. And, like a mother bringing a child into the world in love and pain, the young and the not-so-young will build a world of love with new colouring … Is this dream possible?

In the arts, as in life, everything is possible provided it is based on love."

MARC CHAGALL

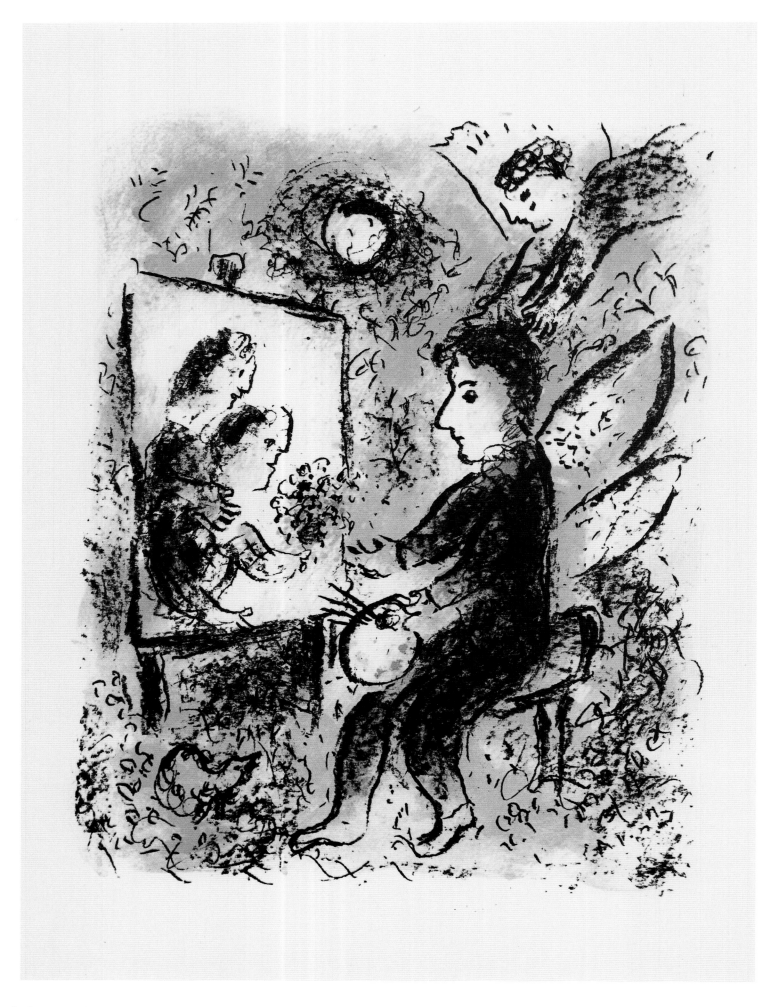

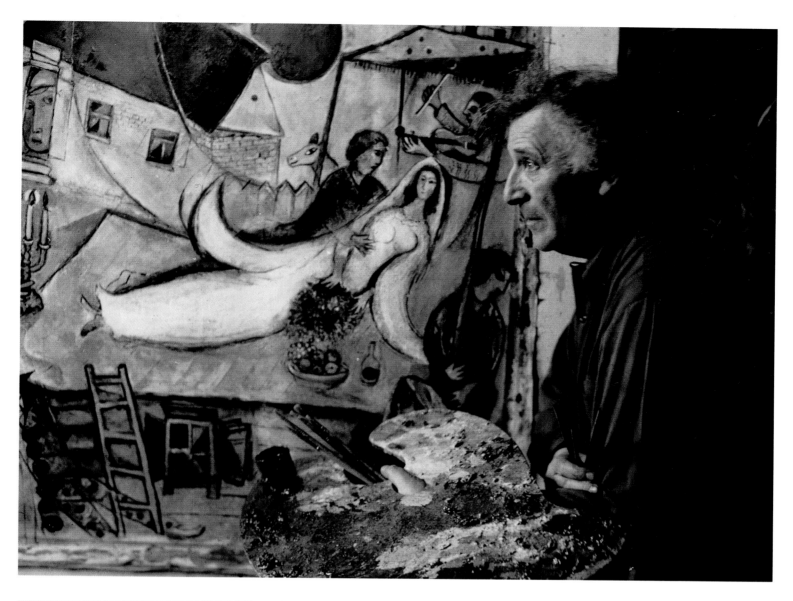

TOP:
Marc Chagall in his studio, c. 1945
Courtesy Virginia Haggard, Brussels

LEFT:
A drawing by Marc Chagall from a book about
the painting of the ceiling of the Paris Opera,
dedicated to Jacob Baal-Teshuva, 1966

RIGHT:
Cover of the Book of Chagall's Poems,
published by Gérald Cramer, Geneva 1975

PAGE 270:
Towards another Light
(Chagall's last colour lithograph, made the
day before he died), 1985
Lithograph, 63 x 47.5 cm
New York, Collection Jacob Baal-Teshuva

Marc Chagall – Life and work

1887 Marc Chagall is born on 7 July as Moische Segal, the oldest of nine children of Sahar and Feiga-Ita Segal. His father works for a herring merchant while his mother runs a grocery and rents out small wooden dwellings built onto their family house. Chagall attends Jewish primary school and later the regular municipal school of Vitebsk.

1906 Chagall enters the art school of the painter Yehuda Pen, where he meets and befriends Viktor Mekler. After only two months he leaves Pen's establishment and works as a retoucher for a Vitebsk photographer.

Marc Chagall, 1908

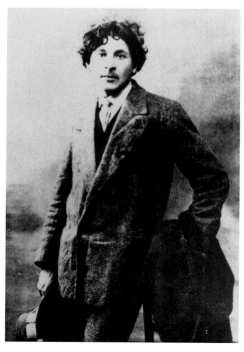

1907 In the winter Chagall and Mekler move without permits to St Petersburg, where initially they live in great poverty. Chagall takes up an apprenticeship as a sign painter, and picks up more work as a retoucher.
To provide the young artist with a permanent residence permit, the lawyer and art patron Goldberg pretends to employ Chagall as a household servant, allowing him to live in his house. Soon afterwards he is admitted to the painting school of the "Imperial Society for the Promotion of the Arts". Before long Chagall's work catches the eye of Nikolai Roerich, the school's director, who helps him get a small monthly grant.

1908 Chagall leaves the school of the "Imperial Society" and studies for some months at a private school run by the academic painter Pavel Saidenberg. He meets Maxim Vinaver, an

Chagall's parents Sahar and Feiga-Ita Chagall

influential member of the "Duma" or Russian parliament.

1909 Chagall changes to the liberal Svanseva School, where he studies with Léon Bakst, who is open to modern modes of artistic expression, and teaches Chagall to use colour as a basic element in his compositions. From time to time he visits his family in Vitebsk, where he meets Bella Rosenfeld, a well-to-do jeweller's daughter and aspiring actress who six years later becomes his wife.

1910 Chagall continues his studies at the Svanseva School. In an exhibition of works by students of the school, which was later seen as

Bella Rosenfeld, 1910–11

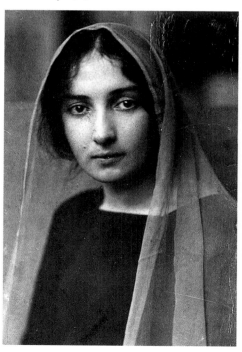

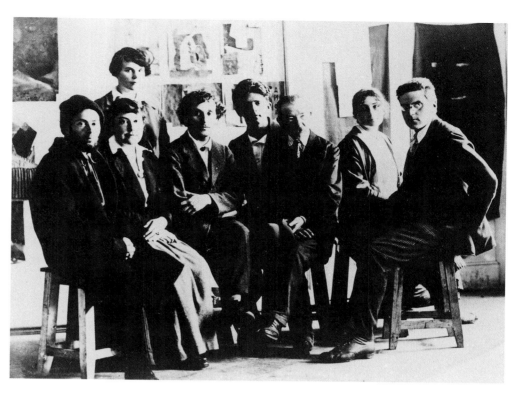

a manifesto of "new art", Chagall shows two
works, one of which is *The Dead Man* (ill. p. 25).
A grant from Maxim Vinaver enables Chagall
to study in Paris, where he attends the acade-
mies "La Palette" and "La Grande Chaumière".

1911 Chagall moves to "La Ruche" (beehive),
the later legendary Parisian artists' colony,
where among others Léger, Laurens, Archi-
penko, Modigliani and Soutine live and work.
Here he paints works such as *To Russia, Asses
and Others* (ill. p. 35), *The Holy Carter, I* and
The Village (ill. p. 51) and *Homage to Apollinaire*
(ill. p. 47). He gets to know the poets Max
Jacob, André Salmon and Guillaume Apolli-
naire. Blaise Cendrars, who speaks Russian,
becomes a special friend, later dedicating to
the painter his fourth *Poème élastique*.

1912 Chagall exhibits three pictures at the
"Salon des Indépendants": *The Drunkard*
(ill. p. 41), *Dedicated to my Fiancée* (ill. p. 43)
and *To Russia, Asses and Others* (ill. p. 35).
At the invitation of Delaunay, Le Fauconnier
and the sculptor Moische Kogan, Chagall
exhibits *Golgotha* (ill. p. 71) and two other
canvases at the "Salon d'Automne". Guillaume
Apollinaire introduces him to the Berlin
publisher and art dealer Herwarth Walden.

1913 Chagall is represented at the "Salon des
Indépendants" with *The Birth* (ill. p. 55) and
The Temptation (Adam and Eve) (ill. p. 59).

1914 At the "Salon des Indépendants" Chagall
exhibits *The Violinist* (ill. p. 57), *Maternity*
(ill. p. 53) and *Self-Portrait With Seven Fingers*
(ill. p. 73). In April Herwarth Walden organises
Chagall's first one-man exhibition in his Berlin
gallery "Der Sturm". Apollinaire dedicates to
the painter his poem *Rotsoge*, which is printed
in the show's catalogue. Chagall travels from
Berlin to Russia with a three-month visa, but is
prevented from returning to Paris, as he had
planned, by the outbreak of the First World
War.

1915 On 25 July Chagall marries Bella Rosen-
feld in Vitebsk. In the autumn he moves to
Petrograd, as St Petersburg is now called, where
Jacob Rosenfeld, Bella's brother, has secured
work for him as a clerk in the press department
of the War Economy Office in lieu of military

service. He makes the acquaintance of some of
the best-known Russian writers of the day:
Alexander Blok, Sergei Essenin, Vladimir
Mayakovsky and Boris Pasternak. In March he
shows 25 works from the previous year at the
Michailova art salon in Moscow.

1916 On 18 May Chagall's daughter Ida is
born.
In April, in Petrograd, he shows 63 works
from the years 1914 to 1915 in the exhibition
"Contemporary Russian Art" at the gallery of
Nina Dobitchine, and in November 45 works

in Moscow at an exhibition of the avant-garde
artists' group "Jack of Diamonds".

1917 Following the October Revolution,
there are plans to set up a Ministry of Culture.
Mayakovsky is to head the department of
poetry, Vsevolod Meyerhold that of the theatre,
and Chagall that of the fine arts. Urged by
his wife Bella, Chagall declines the appoint-
ment and returns with her and their daughter
to Vitebsk, where they stay with Bella's
parents.

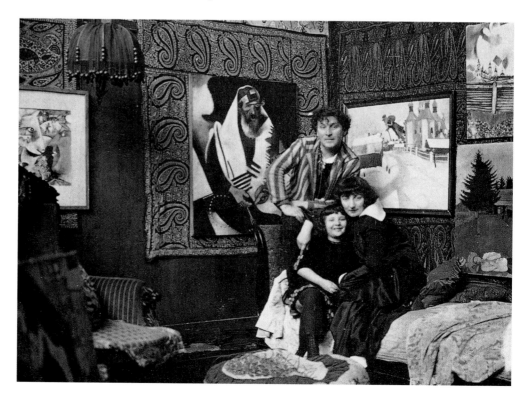

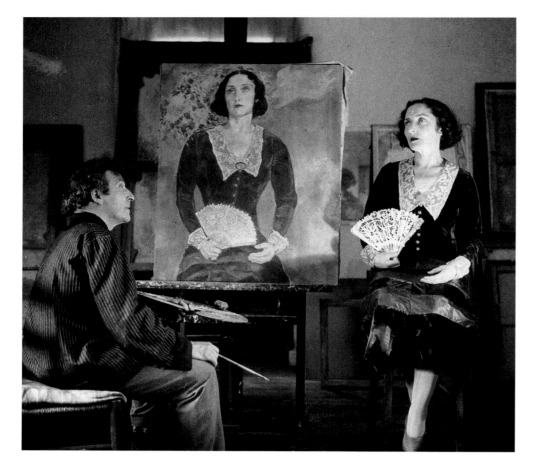

1918 The first monograph on Chagall's work is published by the critics Abraham Efross and Jacob Tugendhold in Moscow. Anatoly Lunatcharsky, the "People's Commissar for Cultural and Educational Policy", appoints Chagall "Commissar for the Fine Arts" in Vitebsk, allowing him to found an art school there. To celebrate the first anniversary of the October Revolution, Chagall mobilizes artists and craftsmen to decorate the town. The Communist functionaries are unimpressed by the results, asking what green cows and flying horses have to do with Marx and Lenin.

1919 At the "First State Exhibition of Revolutionary Art" in the Winter Palace in Petrograd, Chagall is given pride of place with the first two rooms. The State purchases 12 works – at knockdown prices.
On 28 January the Vitebsk School of Fine Arts, henceforth known as the Academy, is inaugurated. Among its teachers are El Lissitsky, Kazimir Malevitch, Ivan Puni and Yehuda Pen. Quarrels soon arise between Malevitch and Chagall.

1920 Chagall leaves the Vitebsk Academy, which has been renamed by Malevitch "Suprematist Academy", and goes to Moscow. Here he designs stage sets and costumes for Gogol's *Government Inspector*, John M. Synge's *Playboy of the Western World* and three one-act plays by Sholem Aleikhem: *The Agents, The Lie* and *Mazeltov*. Alexander Granovsky, director of the "Kamerny State Jewish Theatre", commissions Chagall to paint large murals for this studio theatre: *Introduction to the Jewish Theatre* (ill. p. 106), *Literature* (ill. p. 108), *Drama* (ill. p. 109), *Dance* (ill. p. 109), *Music* (ill. p. 108), and *Love on the Stage* (ill. p. 107).

1921 Chagall teaches drawing in two orphanages: one in Malachovka, and the other near Moscow. He begins writing his autobiography *My Life*.

1922 Chagall leaves Russia for good. The poet Jurgis Baltrusaitis, at the time Lithuania's ambassador in Moscow, enables him to send 65 pictures as diplomatic baggage to Kaunas. After a short stay in Kaunas, Chagall continues his journey with his paintings to Berlin. From the summer of 1922 until the autumn of 1923 Chagall and his family stay in Berlin. His first concern is to locate Walden, with whom he left numerous pictures eight years earlier. In the end he has to be content with recovering only three: *To Russia, Asses and Others* (ill. p. 35), *I and the Village* (ill. p. 51) and *Half Past Three (The Poet)* (ill. p. 39), as well as ten gouaches. Two pictures are hung at the 'First Russian Show' at the Galerie van Diemen. In Berlin Chagall makes his first forays into printed art. Besides various lithographs, he does 20 etchings on themes from *My Life* for the art dealer and publisher Paul Cassirer (ill. pp. 219–221).

1923 On 1 September Chagall is back in Paris again, where he finds that the paintings he left in his "La Ruche" studio have also disappeared. Intent on recovering his own past, he paints between 1923 and 1926 replicas, variants and new versions of his early works.
The publisher and art dealer Ambroise Vollard commissions Chagall to illustrate Gogol's novel *Dead Souls*.

1924 Chagall's friends include Sonia and Robert Delaunay, Louis Marcoussis and Juan Gris. He is invited by André Breton to join the Surrealists, but refuses.
The Parisian Barbazanges-Hodebert gallery mounts a retrospective with 122 works. Here Chagall is introduced to André Malraux, who comes to play a key role in Chagall's subsequent career.

1926 Commissioned by Vollard, Chagall paints some 30 large preparatory gouaches for his illustrations of La Fontaine's *Fables* (ill. pp. 222–223). He also does 15 etchings for *Les sept péchés capitaux* (The Seven Deadly Sins), a collection of texts by the French dramatist Jean Giraudoux, and five for *Maternité* (Motherhood), a novel by his friend Marcel Arland. Chagall gets to know the publisher Tériade, as well as Aristide Maillol, Georges Rouault, Maurice de Vlaminck and Pierre Bonnard. The Reinhardt gallery in New York mounts his first solo exhibition in the United States.

1927 Prompted once again by Vollard, Chagall paints 19 large gouaches on the theme of the circus. He signs a contract with the Parisian gallery Bernheim-Jeune, which guarantees him his livelihood. In November Robert Delaunay and Chagall make a six-day trip by car, visiting the writer Joseph Delteil in Limoux and Aristide Maillol in Banyuls-sur-Mer near Collioure.

1928 Chagall spends the summer alone in Céret, a small town in the Pyrenees, and the winter with his family in the Savoy alps. He starts work on the etchings for La Fontaine's *Fables*. Chagall's wife Bella translates his autobiography *My Life* into French.

1929 Together with Bella, Chagall travels in the autumn again to Céret. At the end of the year he buys the Villa Montmorency in Paris. The Wall Street crash forces Bernheim-Jeune to terminate its contract with Chagall. Only the work for Vollard guarantees him a modest income.

1930 The gouaches for La Fontaine's *Fables* are exhibited among other places at the Flecht-

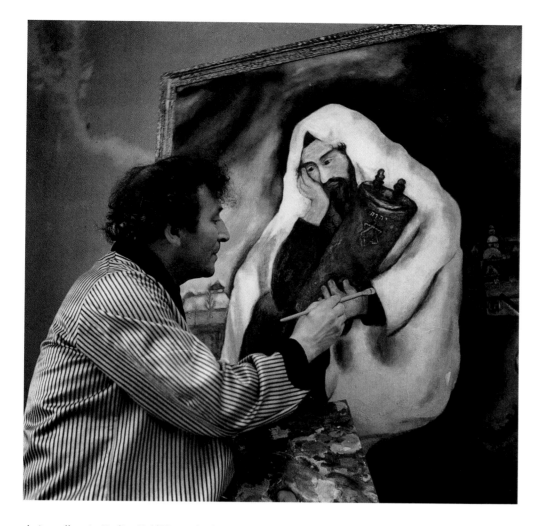

Of the 59 works confiscated three are shown in the notorious "Degenerate Art" exhibition. Chagall becomes a French citizen.

1938 Exhibition at the Palais des Beaux-Arts in Brussels.

1939 Shortly before the outbreak of war Chagall moves with his family to the relative safety of Saint-Dyé-sur-Loire, taking with him – with the help of his daughter Ida – his pictures from the Paris studio.
At the Carnegie Institute's "International Exhibition of Painting" in Pittsburgh, USA, Chagall is awarded third prize.

1940 Chagall takes part in the opening show of Paris' Mai gallery, organized by Yvonne Zervos. He frequently meets up with Picasso and Christian Zervos.
On the advice of André Lhote the Chagalls move to the South of France, to the small town of Gordes in the Vaucluse mountains. On 10 May, the day the Germans invade Belgium and the Netherlands, he buys an old schoolhouse in Gordes.
In the winter of 1940–41 Chagall is visited by Varian Fry, the director of the American "Emergency Rescue Committee", and Harry Bingham, the US consul general in Marseilles, who bring him an invitation from the Museum of Modern Art in New York to come to the United States.

1941 After much hesitation Chagall and his family go to Marseilles to prepare for their departure to America. On 23 June, the day the Germans invade Russia, they reach New York,

Marc and Bella Chagall with Pierre Matisse in his gallery, in front of Double Portrait with a Glass of Wine *(ill. p. 99), New York, 1941/42*

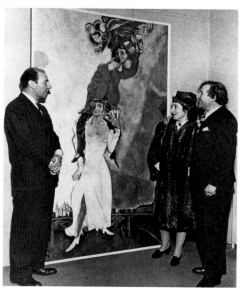

heim gallery in Berlin. Fulfilling a further Vollard commission, Chagall begins work illustrating the Bible, painting preliminary gouaches.

1931 At the invitation of Meir Dizengoff, the mayor of Tel Aviv, Chagall spends almost three months in Palestine with his wife and daughter. Inspired by this journey, the artist does the first etchings for the Bible project, as soon as he arrives back in Paris. However, by the time of Vollard's death in 1939 only 66 of the planned 105 print plates have been produced. Chagall takes up the project again in 1952, and the work is finally published in 1956 by Tériade.
Ma Vie, Bella's French translation of Chagall's autobiography, is published in Paris.

1932 On the occasion of the first Chagall exhibition in Holland, the artist travels with his wife to Amsterdam, where he visits museums and is particularly impressed by the works of Rembrandt. Chagall spends the autumn in Cap Ferrat near Bordeaux.

1933 At the Mannheim Kunsthalle a number of Chagall's works are publicly burned by the Nazis in connection with the exhibition "Cultural Bolshevism".
Retrospective at the Kunsthalle in Basle.

1934 Chagall spends the summer at Tossa del Mar, on the Costa Brava, with Bella and friends, including Jules Supervielle and Henri Michaux. From there he visits Barcelona, Madrid and Toledo, where he is deeply impressed by the works of El Greco.

1935 For the opening of the Jewish Cultural Institute Chagall travels to Vilna (now Vilnius), which in those days belonged to Poland. He also visits Warsaw, where the threat to the Jewish population is already unmistakable.

1936 Chagall moves into a new studio in Paris near the Trocadéro.
At the Café de Flore in Montparnasse he often runs into Picasso, who is just working on *Guernica*.

1937 Chagall spends spring in Villars-Colmars in the Vosges and in Villeneuve-les-Avignon. From there he travels with Bella to Italy. In Florence he visits the Uffiizi and the Palazzo Pitti, and is fascinated by Quattrocento painting. He finishes 15 etchings for his Bible illustrations in Tuscany, then goes on to Venice, where he studies the works of Bellini, Titian and Tintoretto.
On the orders of the Nazi regime all Chagall's works are removed from German museums.

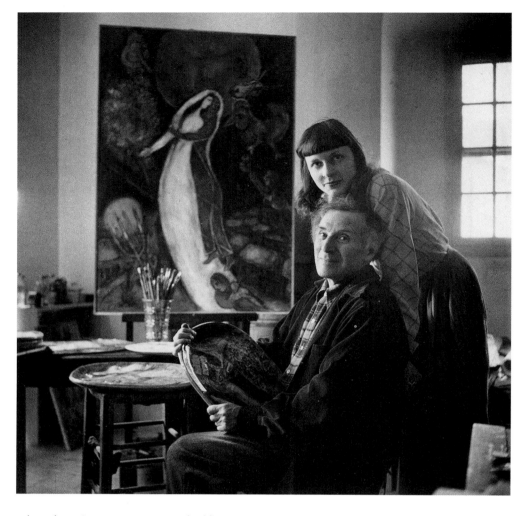

Maeght, who becomes his representative in France. The publisher Tériade brings out Gogol's *Dead Souls* with Chagall's etchings.

1949 Chagall paints murals for the foyer of the Watergate Theatre in London.
He rents studio space in Vence and creates his first ceramics with Madame Bonneau.

1950 In the spring Chagall moves to Vence, where he has bought the villa "La Colline". Intermittently he meets up with Matisse and Picasso.
He produces more ceramics, this time with Serge Ramel. Subsequent ceramic works are done at the "Madoura" pottery in Vallauris, run by Georges and Suzanne Ramié.
At Fernand Mourlot's in Paris Chagall studies graphic techniques, executing his first lithographic poster. Here he meets the master lithographer Charles Sorlier, to whom from now on he entrusts the printing of all his lithographic works.
Retrospective at the Haus der Kunst, Munich.

1951 Chagall travels to Israel for the opening of a retrospective held in Jerusalem, Haifa and Tel Aviv.
He spends the summer in Gordes where he and Bella lived from 1940–41.
Virginia Haggard leaves Chagall, taking with her their son David.

1952 Chagall meets Valentina (Vava) Brodsky, whom he marries on 12 July in Clairefontaine, near Rambouillet. The marriage gives Chagall new energy.
In June he visits Chartres Cathedral to study mediaeval stained-glass window painting.
Chagall resumes work on the Bible etchings.
The publisher Tériade commissions him to illustrate with colour lithographs the pastoral novel *Daphnis and Chloë* by the 2nd-century Greek writer Longos. To get into the mood for the new project, Chagall and his wife travel in the summer to Greece, visiting Delphi, Athens and the island of Poros.
Tériade publishes La Fontaine's *Fables* with Chagall's etchings.

1953 Chagall travels to Turin for the opening of a retrospective at the Palazzo Madama.

1954 Chagall and Vava make a repeat trip to Greece. In Italy they visit Ravenna, Florence and Venice, where he has another opportunity to study the works of Titian and Tintoretto.

1955 Chagall begins work on the series of paintings *The Biblical Message*, completed in 1966.

where the artist meets up again with old friends such as Fernand Léger, André Breton, and the couple Jacques and Raissa Maritain. Here he also meets André Masson, Piet Mondrian and the art dealer Pierre Matisse, who becomes his representative in the United States.
In November, in his first exhibition at Pierre Matisse's New York gallery, 21 works from the years 1910 to 1941 are shown.

1942 Chagall spends the summer in Mexico, designing the stage sets and costumes for the ballet *Aleko*, based on Pushkin's verse narrative *The Gypsies*.

1943 For some time Chagall lives with his family at Cranberry Lake in New York State. The news from war-torn Europe saddens Chagall enormously. He paints *The War* (ill. p. 161), *War Obsession* and *Yellow Crucifixion*.

1944 Chagall and his wife Bella spend the summer again at Cranberry Lake. Just before they intend to return to New York, Bella suddenly falls ill from a viral infection. She is taken straight to a hospital, but dies 36 hours later. Chagall is so overwhelmed by the loss that he is unable to work for nine months.

1945 Virginia Haggard becomes Chagall's housekeeper and later his lover and companion. In spring he starts painting again. He spends the summer at Krumville on Beaver Lake and at Sag Harbour on Long Island.
Here Chagall designs sets and costumes for Stravinsky's ballet *The Firebird*, a production of the "American Ballet Theatre" at the Metropolitan Opera in New York.

1946 Chagall buys a house at High Falls in the north-east of New York State. The Museum of Modern Art in New York holds a large retrospective, covering 40 years of his work. In May he returns to Paris for three months. On 22 June Virginia Haggard gives birth to their son David. He paints preliminary gouaches for the colour lithographs that are to illustrate *Tales from the Arabian Nights*.

1947 The Musée National d'Art Moderne in Paris reopens with a large Chagall retrospective. The artist travels to Paris for the event. Other retrospectives follow at the Stedelijk Museum in Amsterdam, the Tate Gallery in London, the Kunsthaus in Zurich and the Kunsthalle in Berne.

1948 Chagall returns to France for good and settles in Orgeval. He meets the art dealer Aimé

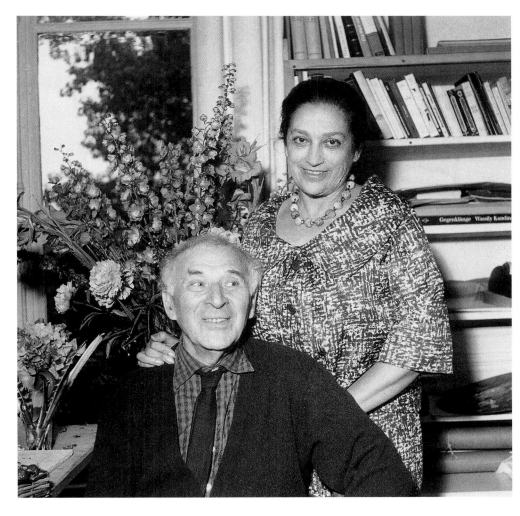

Marc Chagall with Valentina (Vava) Brodsky, his second wife

1956 Retrospectives at the Kunsthalle in Basle and the Kunsthalle in Berne.
Tériade publishes the Bible with 105 Chagall etchings.

1957 Retrospective of Chagall's graphic work at the Bibliothèque National in Paris.
Chagall designs his first wall mosaic, *The Blue Cock.* He completes the decoration of the baptistry of the church Notre Dame de Toute Grâce at Plateau d'Assy in Savoy.
At Mourlot's in Paris the first lithographs for *Daphnis and Chloë* are produced.

1958 In February Chagall gives a lecture on the nature of his painting at the University of Chicago.
Chagall meets the master glass worker Charles Marq, who directs the famous Jacques Simon glassworks in Reims, and begins work on his stained-glass window designs for St Etienne Cathedral in Metz.
Chagall designs the stage sets and costumes for a production of Maurice Ravel's ballet *Daphnis and Chloë* at the Paris Opera.

1959 Chagall visits Scotland to receive an honorary doctorate from Glasgow University. He is also made an honorary member of the American Academy of Arts and Letters. Retrospectives at the Musée des Arts Décoratifs in Paris, the Kunsthalle in Hamburg, and the Haus der Kunst in Munich.
Chagall works on stained-glass windows for the north apse of Metz Cathedral.

1960 Chagall starts work on stained-glass windows for the synagogue of the Hadassah Hebrew University clinic in Jerusalem. The windows depict the twelve tribes of Israel. Brandeis University in Waltham, Massachusetts, makes Chagall an honorary doctor. Together with Oskar Kokoschka, he is awarded the Erasmus Prize of the European Cultural Foundation in Copenhagen.
The stained-glass windows intended for Metz Cathedral are exhibited at the Musée des Beaux-Arts in Reims.

1961 The twelve stained-glass windows for the synagogue in Jerusalem (ill. pp. 246, 250–252) are exhibited at the Musée des Arts Décoratifs in Paris, and later at the Museum of Modern Art in New York.

1962 In February Chagall travels to Jerusalem for the consecration of the stained-glass windows in the synagogue of the Hadassah medical centre.

The Musée Rath in Geneva holds the exhibition "Chagall and the Bible".

1963 Retrospective at the National Museum of Western Art in Tokyo and at the Municipal Museum of Art in Kyoto.
André Malraux invites Chagall to paint a new ceiling for the Paris Opera.

1964 Chagall executes the stained-glass window *The Good Samaritan* (ill. p. 255), a memorial to John D. Rockefeller, Jr. to be installed in the Union Church in Tarrytown, Pocantico Hills, in New York State.
In the presence of the artist the stained-glass window *Peace* (ill. p. 249), dedicated to the memory of Dag Hammarskjöld, is unveiled on 17 September in the United Nations building in New York.

1965 The University of Notre Dame in the US state of Indiana awards Chagall an honorary doctorate. Chagall works on designs for the stage sets and costumes for a production of

ABOVE:
Marc Chagall dancing with the poet Jacques Prévert at Ida's wedding in 1952

RIGHT:
Marc Chagall with his daughter Ida, 1944/45

Mozart's *The Magic Flute* at the Metropolitan Opera, New York.

1966 Chagall and Vava move from Vence to neighbouring Saint-Paul-de-Vence.
Chagall works on two monumental mural decorations for the Metropolitan Opera in New York: *The Sources of Music* and *The Triumph of Music* (ill. pp. 204, 205).
He finishes a further eight stained-glass windows for the Union Church in Tarrytown.

1967 On 19 February the new building of the New York Metropolitan Opera is opened with Mozart's *The Magic Flute*, featuring Chagall's decor and costumes.
Retrospectives are organized in Zurich and Cologne to mark Chagall's 80th birthday.
From June to October the Louvre exhibits the picture series *Message Biblique*, donated to the French nation by Marc and Vava Chagall.
The Maeght Foundation in Saint-Paul-de-Vence holds the exhibition "Homage to Marc Chagall".
Tériade publishes the portfolio *Le Cirque* with a text and 38 lithographs by Chagall.

1968 Chagall and Vava visit Washington D.C. At the request of his friend Louis Trotobas, dean of the law faculty of the University of Nice, Chagall does a monumental mosaic *The Message of Ulysses* (ill. p. 243).

BELOW:
Marc Chagall in front of the tapestry The Entry into Jerusalem *(ill. p. 232) made for the Knesset in Jerusalem*

RIGHT:
Marc Chagall with Vava, Isaac Stern and Ida (left), and the Rostropowitsch's and their daughter (right) at a concert in Nice, marking Chagall's 90th birthday, Nice 1977

1969 The foundation stone for the Musée National Message Biblique Marc Chagall is laid in Nice.
Chagall travels to Jerusalem to take part in the inauguration on 18 June of the new building of the Knesset or Israeli parliament, for which he has created floor mosaics, a wall mosaic *From Exile to Return* (ill. p. 240), and three large tapestries – *Isaiah's Prophecy* (ill. p. 233), *Exodus* (ill. p. 232) and *Entry into Jerusalem* (ill. p. 232).
From December 1969 to March 1970 the exhibition "Hommage à Marc Chagall" with 474 works is held in the Grand Palais in Paris.

1970 From January to March the Bibliothèque Nationale in Paris mounts a retrospective of Chagall's graphic work.
The stained-glass windows in the Fraumünster in Zurich, which Chagall has worked on for many years in collaboration with the master glass worker Charles Marq and his wife Brigitte, are unveiled in the presence of the artist.

1971 In the spring Chagall revisits Zurich. He does a mosaic entitled *The Prophet Elijah* (ill. p. 237) for the Musée National Message Biblique Marc Chagall in Nice.

1972 Chagall starts work on a large-scale mosaic *The Four Seasons* (ill. p. 242) for the First National City Bank in Chicago.
A Chagall retrospective is held in Budapest.
Chagall starts work on 82 lithographs for Homer's *Odyssey*, which appear in two volumes in 1974 and 1975, and makes three stained-glass windows on the theme of *The Creation of the World* for the concert hall of the Musée National Message Biblique Marc Chagall in Nice (ill. p. 253).

1973 Fifty years after he left Russia Chagall travels with his wife at the invitation of the

Soviet Culture Minister Yekaterina Furtzeva to Moscow and Leningrad, where he is reunited with two of his sisters. However, he refuses to visit Vitebsk. In his honour the Tretiakov gallery in Moscow organizes an exhibition.
On 7 July, the artist's birthday, the Musée National Message Biblique Marc Chagall in Nice is officially opened in the presence of André Malraux.

1974 Exhibition at the Nationalgalerie in former East Berlin.
Chagall's stained-glass windows in the central choir of Notre Dame Cathedral in Reims are consecrated.
The Musée National Message Biblique Marc Chagall in Nice exhibits sketches and studies for his monumental works.
Chagall is given a triumphal welcome in Chicago on the occasion of the inauguration of his mosaic *The Four Seasons*.

1975 From May to September Chagall works on 50 lithographs illustrating Shakespeare's *The Tempest*.
Chagall paints several large canvases with mythical and biblical themes: *The Fall of Icarus, Don Quixote* (ill. p. 212), *Job,* and *The Prodigal Son* (ill. p. 213).
He designs a stained-glass window entitled *Peace or the Tree of Life* for the Chapelle des Cordeliers in Sarrebourg, Lorraine.
Chagall's poems, written between 1930 and 1964, are published by Gérald Cramer in Geneva.

1976 A Chagall mosaic is consecrated in the Sainte-Roseline chapel at Les Arcs in the department of Var.
Chagall illustrates André Malraux's text *Et sur la terre* (And on Earth) with 15 etchings. This old friend and companion of his dies on

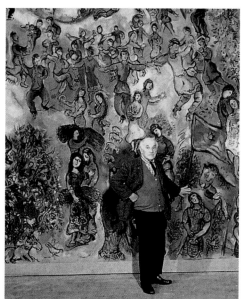

ABOVE:
Chagall completing the painting Jacob's Dream *for the exhibition in the Musée National Message Biblique in Nice, 1973*

RIGHT:
Marc Chagall sitting between the former French Minister of Culture, Jack Lang and the art dealer Adrien Maeght at the opening of his retrospective at the Maeght Foundation, Saint-Paul-de-Vence, 1984 (in the background: 'The Martyrs', 1940)

23 November in Paris. Chagall's graphic works are shown in the Albertinum in Dresden and in the Kupferstichkabinett in East Berlin.
In October 1976 and again in June 1977 Chagall travels to Florence for the official handing over of a self-portrait of his from 1945 to the Uffizi.

1977 On 1 January Chagall is awarded the Grand Cross of the Legion of Honour by the French president – France's highest decoration.
Chagall begins designing windows for the St. Stephanskirche in Mainz and works on his *America Windows* (ill. pp. 256, 257) for the Art Institute of Chicago.
Chagall's most recent paintings with biblical themes are exhibited in the Musée National Message Biblique Marc Chagall in Nice.
On 17 October the French president opens an exhibition of Chagall's works at the Louvre – the first time a living artist is honoured with an exhibition there. Chagall travels to Israel to be given the freedom of the city of Jerusalem.

1978 Chagall goes to Florence for the opening of an exhibition of his works at the Palazzo Pitti.
In September the first of nine stained-glass windows executed by Chagall between 1979 and 1985 for the St. Stephanskirche in Mainz is

consecrated, and in October his window in Chichester Cathedral is unveiled.
Chagall works on his aquatints for the *Psalms of David.*

1979 In September a further two stained-glass windows are consecrated in the St. Stephanskirche in Mainz.
In Chicago the *American Windows* are unveiled. The *Psalms of David* are exhibited at the Patrick Cramer gallery in Geneva and then in 1980 at the Musée National Message Biblique Marc Chagall in Nice.

1981 Retrospective exhibition of graphic works by Chagall at the Matignon gallery in Paris.

1982 Chagall finishes the stained-glass windows for the parish church of Le Saillant de Voutezac. Retrospective at the Moderna Museet in Stockholm and at the Louisiana Museum of Art, Humlebaek.

1984 The Musée National d'Art Moderne in Paris holds a large exhibition of Chagall's works on paper. In June the artist travels to Paris for the opening – his last trip to the capital.

1985 The Royal Academy in London holds a major Chagall retrospective, which then moves to the Philadelphia Museum of Art.
On 28 March Marc Chagall dies at home in Saint-Paul-de-Vence, aged 97.

The publishers wish to thank the museums, private collections, archives and photographers who granted permission to reproduce works and gave support in the making of this book. Unless stated otherwise, the copyright for the illustrated works is owned by the collections and institutions listed in the picture captions or the archive of the author.

Agence Novesti, Paris: 93, 74, 77, 81; AKG, Berlin: 8, 29, 53, 60, 161, 172; Leon Amiel Jr., New York: 232; Artothek, Peissenberg: 20, 68, 70; Art Resource, New York: 43, 73, 85, 87, 89, 198; Cinquini, Saint-Paul-de-Vence: 2, 257; Yvette Cauquil-Prince: 235; © Gamma, Vanves: 184; Patrick W. Goetelen, Geneva: 138, 152; Hadassah Medical Relief Association, Jerusalem: 242, 246–247; David Heald © The Solomon R. Guggenheim Foundation, New York: 32, 58, 69, 84, 115; Walter Klein, Düsseldorf © Kunstsammlung Nordrhein-Westfalen, Düsseldorf: 57; Charles Leirens, New York: 183, 188, 260, 271; Philippe Migeat, Paris © Musée national d'art moderne, Centre Georges Pompidou, Paris: 25, 34, 35, 36, 44, 63, 91, 94, 95, 96, 101, 110, 132, 140, 141, 144, 147, 167, 171, 176, 203; Eric E. Mitchell © Philadelphia Museum of Art, Philadelphia: 79; © 1997 The Museum of Modern Art, New York: 51, 71, 76, 103, 158, 159; Rheinisches Bildarchiv, Cologne: 15; © RMN, Paris: 237, 239, 241, 244; © RMN, Gérard Blot: 230; © RMN, R. G. Ojeda: 241; © Roger-Viollet, Paris: 166, 168, 183, 260, 274, 275, 276, 277; © Stills, Vanves: 236; © United Nations, New York: 245